A CROWDED HOUR

DEDICATION

To Laura, my wife, best friend and soul mate, for her unwavering love and support throughout this long, long journey. And to my late brother Steve, whose battle with cancer inspired me to see this project through.

A CROWDED HOUR

MILWAUKEE
DURING THE GREAT WAR
1917-1918

KEVIN J. ABING

AMERICA THROUGH TIME®
ADDING COLOR TO AMERICAN HISTORY

America Through Time is an imprint of Fonthill Media LLC
www.through-time.com
office@through-time.com

Published by Arcadia Publishing by arrangement with Fonthill Media LLC
For all general information, please contact Arcadia Publishing:
Telephone: 843-853-2070
Fax: 843-853-0044
E-mail: sales@arcadiapublishing.com
For customer service and orders:
Toll-Free 1-888-313-2665

www.arcadiapublishing.com

First published 2017

Copyright © Kevin J. Abing 2017

ISBN 978-1-63499-022-6

All rights reserved. No part of this publication may be reproduced, stored in a retrieval system or transmitted in any form or by any means, electronic, mechanical, photocopying, recording or otherwise, without prior permission in writing from Fonthill Media LLC

Typeset in Mrs Eaves XL Serif Narrow
Printed and bound by CPI Group (UK) Ltd, Croydon, CR0 4YY

ACKNOWLEDGMENTS

The process of researching and writing this book during evenings, weekends and vacations has occupied more than a dozen years. Life's twists and turns interrupted the project many times, and during my job changes and moves, I was often tempted to let it go and never see the light of day. But the topic was so fascinating and I had invested so much time and energy that I couldn't throw in the towel.

With the book completed, I want to thank all those who offered encouragement and assistance along the way. I owe a debt of gratitude to Steve Daily, my former boss at the Milwaukee County Historical Society, who indulged my combing through the Society's collections. In addition, the experience and expertise of the staffs of the National Archives, Library of Congress, Wisconsin Historical Society, Milwaukee Public Library, the University of Wisconsin-Milwaukee archives and the City of Milwaukee Legislative Reference Bureau proved invaluable. I want to especially thank Nicole Bauer and Valerie Phillips for their help sifting through manuscripts at U.C.L.A. and the University of Buffalo, respectively.

Above all, I want to thank my wife Laura for her keen editorial eye and her loving, but insistent, prodding that I get this damn book done!

INTRODUCTION

A large crowd gathered outside the Milwaukee Auditorium in the early evening chill of March 2, 1916, eagerly waiting for the doors to open. For months, the city's newspapers had promoted grandiose plans for a charity bazaar to help widows and orphans of German, Austrian and Hungarian soldiers who had fallen in the war raging in Europe. The doors opened at 7:00 p.m., and the crowd surged inside to witness what a *Milwaukee Sentinel* reporter called the "greatest enterprise of its character ever undertaken in the Cream city."

More than 2,000 workers, many of them the cream of Cream City society, transformed the auditorium into a "veritable fairyland." In Juneau Hall, Mrs. Gustav Pabst sold frankfurters and beer to patrons as they strolled through a miniature representation of Heidelberg, Germany. In Kilbourn Hall, Paula Uihlein greeted visitors as they enjoyed the fresh air of a "Biedermeier garten," and in the main hall, waitresses dressed in short, black-and-white Viennese skirts doled out light refreshments and steins of beer at a reproduction of a Viennese Wiener café. The basement contained a reproduction of the trenches in which the soldiers in Europe were fighting and dying, while other halls were devoted to vaudeville programs, billiards or displays of electrical machinery. The latter included an electric chair patterned after the one used at Sing Sing prison. Visitors could sit in the chair, and more daring souls could even take a slight shock if they wanted.

At 7:45, representatives from German, Austrian and Hungarian veterans' societies, resplendent in their regimental uniforms, marched into the main hall and took positions as guards of honor around a flower-decked pavilion in front of the stage. A trumpet blast at 8:00 announced the formal opening of the bazaar. At that moment in Washington, D.C., German Ambassador Count Johann von Bernstorff pressed a button, and a flash of light illuminated the pavilion in the auditorium. Leo Stern, head of the Wisconsin German-American Alliance, delivered an address to

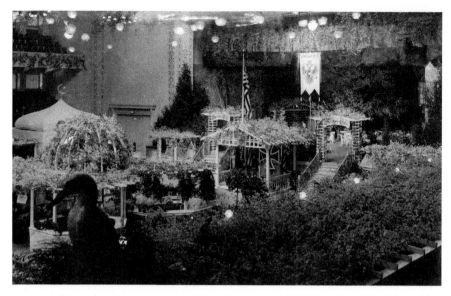

A scene from the German Austro-Hungarian Charity Bazaar at the Milwaukee Auditorium, March 1916. The German Iron Cross and reproduction of a Wiener Café illustrates the pro-German sentiment of the event, which became unthinkable a year later. (Photo courtesy of Milwaukee County Historical Society)

dedicate the Iron Cross positioned in front of the Wiener café. The people's thoughts and sentiments, Stern said, were not only with the widows and orphans of the dead heroes but also "with the maimed and blinded victims from the fighting lines, with those unfortunate prisoners of war suffering untold hardships in the ice and snow bound regions of Siberia." The bazaar clearly demonstrated Milwaukeeans' desire to help those to whom they were connected by blood or a common homeland. "Today," Stern concluded, "they are all our brothers—are the sons of so many nations, in the true sense of the word, who fight together for their ideals and rights, who are united in rain or snow or cold, in the terrible fire of bullets, in storm, in danger and victory, day and night."

When the bazaar ended five days later on March 7, more than 175,000 people had attended and more than $150,000 had been raised for the suffering women and children. Even the *Milwaukee Journal*, which vehemently supported the British and French in the war, admitted it was "impossible to conceive the immensity of the bazaar. The state fair and several circuses, together in one enclosure wouldn't be in it. It is without doubt the biggest thing ever attempted in Milwaukee."[1]

Three years later, the Pabst Theater was in the midst of its fall season and had presented a number of plays in the German language. On October 30, 1919, members of the Milwaukee County Central Committee

of the American Legion—representing some 4,000 ex-servicemen—visited the president of the German Theater Company, Adolph Landauer, and presented a resolution calling on the company to discontinue immediately any plays in German. The legion posts threatened to do "everything in their power to stop all such performances." Landauer ignored the petition. The next morning, however, a German 77-millimeter gun was positioned in front of City Hall, pointed directly at the Pabst Theater. The gun, a gift that was to be officially presented to the city on Armistice Day, had been temporarily stored in a barn at Lake Park until members of the American Legion liberated the piece in the middle of the night and dragged it all the way to City Hall in the rain and mud. C.S. Perry, secretary of the County Central Committee, claimed the legion would use only legal means to block further German productions and would not resort to any violence. But the intent behind the gun's positioning was crystal clear. The *Milwaukee Journal* reported it had a salutary effect and that "broad smiles were seen on many faces."[2]

The bridge connecting these dramatic swings in attitude was World War I—the "Great War"—also known as the "War to make the World Safe for Democracy" or the "War to End all Wars." It did neither of those things, but during its 18-month span, World War I reshaped Milwaukee's—and America's—social and political landscape.

To patriots who supported the war effort, Milwaukee was the worst of all worlds. They considered the city, a stronghold of labor union and Socialist activism, too radical for the "accepted" social, economic and political order. Above all, many within the city and across the country questioned where the loyalties of Milwaukee's large German-American population would lie after the U.S. joined the Allied Powers' struggle with Germany and Austria-Hungary. Super-heated patriotism unleashed by the war fused any and all dissenting elements into an anti-American bogeyman that needed to be stamped out no matter what the costs. Akin to the Vietnam-era strategy of destroying the village in order to save it, self-proclaimed patriots trampled cherished traditions and Constitutional rights in a hysterical drive to promote 100 percent Americanism. Their energy was misguided. No enemy spies were caught in Milwaukee; only one person was tried (and later acquitted) for sabotage in the city's numerous factories; and the vast majority of its German-Americans remained loyal or, at the very least, silent throughout the war.

Other developments filtered through the prism of the war effort added to the intensity of Milwaukee's "crowded hour." From mundane struggles to make ends meet amid skyrocketing prices to loftier questions regarding the meaning of citizenship within the increasing influence of a growing

government bureaucracy, the war affected every level of society and every aspect of people's lives. Gender norms were upset as women stepped into male-dominated occupations to meet wartime labor demands and to act as interim breadwinners for their families. Once in the workforce, many women were reluctant to go back to their socially sanctioned roles. Furthermore, women's war work provided fresh fuel for the long-debated suffrage movement and ultimately helped women gain the right to vote. A Spanish flu pandemic in 1918 compounded tension within the war-weary city, killing more than 1,000 Milwaukeeans and some 50 million worldwide.

While government contracts made factories hum, wages increase and profits soar, the war spelled disaster for one of Milwaukee's iconic industries. Since the mid-19th century, temperance boosters had waged a losing battle to decrease, if not eliminate, the evil influence of alcohol. Milwaukee breweries, however, buoyed by the city's large immigrant population, thrived. The war was the tipping point that allowed Prohibition efforts to gain steam. Supporters claimed alcohol had to be kept from the young men flocking to serve their country if various branches of the military were to operate at peak efficiency and successfully carry out America's moral crusade to save the world. What's more, the grain used to brew beer and distill spirits was more sorely needed to feed not only our own soldiers but our Allies as well. Milwaukee's beer barons could not stem the tide, and the "drys" gained the upper hand. Breweries either shuttered their doors or creatively adapted to stay afloat, manufacturing everything from candy bars and cheese to snowplows.

At war's end, Milwaukee had changed and was poorer for it, with the scales decidedly tilted toward what was lost rather than what was gained. The human cost alone—430 dead servicemen[3] along with those killed during the Spanish flu outbreak—drained the city of untapped potential. During the frenzy of the war, much of Milwaukee's German cultural heritage disappeared, and its labor and Socialist movements were seriously weakened. Hard feelings and intolerance lingered well after the signing of the armistice in November 1918.

Though the war was hailed as an opportunity for the U.S. to be a beacon to the rest of the world, it was hardly one of the country's or city's shining moments. As we mark the centennial of American involvement in World War I, Milwaukee's volatile, layered and often short-sighted experiences reveal the folly behind targeting a specific ethnic group during a time of crisis, not unlike current suspicions in today's world of international terrorism. The Great War's "crowded hour" brought out the best and worst in Milwaukeeans, and from households to City Hall, it is a story that deserves to be told.

1

For the important thing about Milwaukee is not its magnetic charm ... But it is that within a little while great factors have begun to move in relation to one another, and are struggling in new birth.
>Zona Gale, "Milwaukee," in *Good Housekeeping*, vol. 50, no. 33 (March 1910): 323

William George Bruce was one of Milwaukee's most prominent civic leaders of the early 20th century. A lifelong resident, newspaper reporter, president of a publishing company, chair of the Milwaukee Association of Commerce, Harbor Commissioner and local historian, he knew the city as few did.[1] And he certainly was not shy about singing his hometown's praises. In an introductory essay in the 1916 city directory, Bruce described Milwaukee as stretching ...

> from the green bluffs which front on Lake Michigan into a valley which is traversed by rivers and then rises westward and northward to splendid highlands. The business, shipping and manufacturing centers are clustered in the valley while the elevations are covered with homes, schools, churches and parks ... At the extreme north and south ends of the city wooded stretches of land extend far into the lake, known as North and South Points. These give the shore a semi-circular outline, which forms a magnificent bay and which has justly been compared with the Bay of Naples.[2]

Others who grew up in Milwaukee during the early 20th century reinforced Bruce's bucolic portrayal of the city, casting their childhood in a rosy hue. Life, in general, seemed leisurely and localized. The average Milwaukee consumer usually walked to and shopped in family-run grocery stores, bakeries and butcher shops that populated most neighborhoods. Other household necessities were home-delivered. Milk, for example, was

delivered daily by men on horse-drawn carts. Housewives waited for the milkman's arrival in their neighborhood and then brought containers out to the wagon to be filled. Likewise, vendors delivered ice for refrigeration or coal for heating to individual households. More extensive shopping was conducted in the shopping districts downtown, on the south side's Mitchell Street or on the upper reaches of Third Street. Carl Purin's family lived on Holton Street, and to him, Third Street was a magical place that "presented an endless array of commercial allure catering to every human need, desire or frailty." Visits to Schusters' Department Store at Third and Garfield streets were always the highlight of expeditions with his grandmother.[3]

Beyond window shopping at Schusters, children enjoyed numerous diversions in Milwaukee. On the sweeter side, Ewald Bethke recalled that the "waffle man" plied Milwaukee streets, using a bugle call to attract eager customers who devoured waffles sprinkled with powdered sugar. Like many Milwaukee children, Carl Purin learned to swim at Bechstein's, Whittaker's or Rohn's swimming schools situated above the North Avenue Dam or spent afternoons at Pabst Park riding small boats through the darkness in a "tunnel of love" or careening over the bumps of an undulating waxed slide.[4]

These idyllic recollections downplayed, if not completely overlooked, the social, economic and political upheaval that the twin forces of urbanization and industrialization wrought upon Milwaukee. For one thing, the pace and ambiance of everyday life changed. In 1916, a "passing of the torch" event occurred when, for the first time, the number of automobiles in Milwaukee surpassed the number of horses—10,636 to 9,444.[5] Entertainment changed as well. Concerts and theater productions had dominated Milwaukee's social scene for years but by 1910, the German theater company had been operating at a deficit and thus reduced the number of performances to two per week. A new medium—motion pictures—had surpassed the stage in popularity. In 1914, the City Club of Milwaukee estimated that at least 10 million people (some said as many as 29 million) flocked to the city's 64 movie theaters each year. Venues included the Princess, Butterfly, Alhambra and Strand, where moviegoers were mesmerized by Charlie Chaplin, "Fatty" Arbuckle, Mary Pickford, Clara Bow and Lillian Gish. Annual ticket revenues topped $2 million.

The cinema's allure alarmed social workers, reformers and religious groups. Darkened theaters encouraged flirtatious and even bolder behavior among the young. Even more damaging, indecent or "blood and thunder" films allegedly corroded the morals of the general population, especially children. A growing chorus to censor films prompted Mayor Gerhard Bading to appoint a Citizens Commission on Motion Pictures

in December 1913 to review movies and eliminate any objectionable material. Though the commission did not have any legal authority, it compelled exhibitors to abide by its recommendations or risk having their license revoked. The commission wasted little time in flexing its muscle. It condemned *The Dalton Boys* in January 1914 because the film "showed in too great detail the robberies and the killing of persons, and failed to show adequate punishment for those crimes." In 1916, the commission rejected or stopped after one showing seven movies and had portions of 33 other movies eliminated because they were "criminally educative," depicted "white slavery," contained nude scenes or featured other immodest or profane material.[6]

Beyond the changes Hollywood initiated, even the proverbial "face" of the city was changing. Visitors during the second decade of the 20th century may have been convinced—given the nearly 2,000 saloons and hundreds of church spires that pierced the city's skyline—that only sinners or saints called Milwaukee home. There were plenty of both, but a more accurate picture included a "veritable patchwork of nationalities" who populated the city. Much of the city's "old stock"—Yankees from New England and immigrants from western Europe—had long since moved away from the noise, congestion and pollution in the immediate downtown business district to the city's periphery on the west, north and east sides. The emergence of electric streetcars, interurban rail lines and automobiles in the late 19th and early 20th centuries hastened the exodus by facilitating separation of work and home lives. The wealthy built extravagant homes, which became tourist destinations. Visitors were often treated with excursions to the west end of Grand Avenue (now West Wisconsin Avenue), the "Gold Coast" along Prospect Avenue or Highland Boulevard (otherwise known as "Sauerkraut Boulevard") to admire the Pabst, Schandein, Miller, Plankinton, Merrill, Kane and Goll mansions.[7]

As the list of names indicates, Germans constituted a large part of Milwaukee's elite. Their peak wave of immigration occurred prior to the Civil War, and they quickly made a lasting impression upon the city. Many emerged as civic and business leaders, and German theater, music and literature dominated cultural and social life so much so that Milwaukee was dubbed the "German Athens." Acculturation, waves of new immigrants and novel entertainment outlets eroded the Germans' cultural dominance by 1910, but they still held a commanding position within the city. Seventeen percent of the population was born in Germany, and 53.5 percent was of German stock. Over the years, the more affluent moved away from the central business district to the north side, east of 3rd Street to the western border and nearly to Capitol Drive.[8]

The Irish rivaled the Germans as early immigrants to Milwaukee, though they were quickly outpaced. Most were peasants with little to no possessions who sought work in a booming frontier community. They settled for the most part in the Third Ward until they started filtering westward in the 1880s, a departure hastened by a disastrous 1892 fire that left some 2,000 homeless. By the early 20th century, the Irish dominated the Merrill Park neighborhood between 27th and 35th streets, and most found work in the nearby Menomonee River Valley at the Chicago, Milwaukee & St. Paul Railroad shops.[9]

The Poles emerged as the city's second largest immigrant group, with the majority arriving during the latter 19th century. By 1910, Milwaukee counted some 70,000 residents of Polish descent. The south side was their primary stronghold, but they were also clustered on Jones Island and in the area around St. Hedwig's on Brady Street. Most came from the German-controlled area of Poland, and they established a tightly knit, thriving community that revolved around their Catholic faith.

These Prussian Poles were not always welcoming of kin from the Russian and Austrian sectors of Poland. When Walter Zukowski was a young boy, his family immigrated from the Russian area and around 1907, settled on Milwaukee's east side near St. Hedwig's and St. Casimir Parish on Fratney Street. Zukowski recalled that he got along with the neighborhood kids, though some called him a "god damn polack." Until then, he had considered himself an American, but this turning point in Zukowski's life made him keenly aware of any slights because of his ethnicity. The most troubling fact was that many of the slurs were leveled by his own people from other parts of occupied Poland. Most of his neighbors were Prussian Poles, and "for some unexplained reason, they tried to make us feel we were less Polish and were called 'Ruski's.'"

Michael Kruszka, influential editor and publisher of the *Kuryer Polski*, the first daily Polish newspaper in the U.S., reflected that mentality. In a remarkable communication to the U.S. Attorney General in 1917, Kruszka offered his thoughts on Poles in America. The Prussian Poles, which included Kruszka, came to the U.S. to flee Prussian oppression. They quickly purchased land and built homes. They were "quiet, but progressive and anxious to acquire education." The Poles from the Austrian section "lacked education, and were not so steady as those from Posen. However, most of them were desirable immigrants, acquired land, homes and citizenship." The Russian Poles fled the turmoil during the Russo-Japanese War of 1904 and the 1905 revolution. They came to the U.S., Kruszka wrote, "still under the spell of the revolution, and were easily led into the folds of the German and Jewish socialists here." He added that they were a "vivacious people, naturally bright, but somewhat unsteady and shifty;

eager to learn." They would provide "fine material for citizenship," he surmised, "but many of them are still 'living in Poland.'"[10]

Kruszka's missive alluded to the ethnic and religious balancing act that Milwaukee's Jewish community faced.[11] The city's first Jews arrived in the 1840s as part of the flood of German immigration. They quickly adapted to the freedom of their new surroundings and, similar to German Christians, became fully enmeshed within Milwaukee's faith, cultural and political life. Many became prominent businessmen, especially in the clothing, dry goods, tobacco and liquor trades, and they tended to live and worship on the east side of the Milwaukee River. Those of more modest means congregated on the river's west side, capitalizing on their "Germanness" to secure jobs that afforded a comfortable life. Despite internal liturgical and economic divisions, Milwaukee's Jews successfully maintained their distinct ethnic and religious identities.

The arrival of Jews from Russian-controlled areas in eastern Europe in the late 19th and early 20th centuries introduced drastic, and not always welcomed, changes in the Milwaukee community. Impoverished peasants fleeing violent pogroms, the newcomers differed in appearance, religious practices and political persuasion from their German counterparts. Nevertheless, the Germans rallied to provide immediate relief and connections to jobs in Milwaukee factories as well as in lumber camps, farms and quarries throughout the Midwest. Beyond these efforts, however, there was relatively little interaction between the two groups. The growing contingent of eastern Jews in Milwaukee—5,000 by 1900—settled in an old German neighborhood in the Haymarket area near Fifth and Vliet. This hodgepodge of small houses, old mansions and factories was among the city's poorest neighborhoods, yet the inhabitants enjoyed a vibrant faith life, with synagogues for Hungarians, Polish, Romanians, Ukrainians and Lithuanians. Many, as Michael Kruszka indicated, carried their revolutionary political bent with them to Milwaukee and joined the Socialist Party. Moreover, having experienced the most brutal discrimination in Europe, many eastern Jews became rabid Zionists, believing their people in Europe could never be safe unless they had their own homeland in Palestine. These trends only heightened the differences between and tension with the acculturated and increasingly secularized German Jews.

The Italians were another group largely defined by their religion. Artisans from northern Italy—wood and stone carvers, as well as those who worked in marble—began arriving in Milwaukee during the 1860s and 1870s and settled primarily in the Bay View neighborhood and near south side of town. The next wave arrived around the turn of the century. In 1900, only 726 Italians called Milwaukee home, but a flood

of mostly young, single men from central and primarily southern Italy sought greener economic pastures in Milwaukee during the first decade of the 20th century, increasing the number of Italian residents to 4,788. They congregated in the Third Ward, replacing the Irish who vacated the area after the 1892 fire. Eventually, Italians overwhelmed the Third Ward and spilled over into Bay View. Most Italian men who came to the U.S. during this period were unskilled workers who typically took the lowest-paying jobs in Milwaukee's tanneries and foundries, on the coal docks and with the railroads. Others found work as fruit peddlers, eventually earning enough to establish their own wholesale produce distributorships. Italian women contributed to family incomes by taking in boarders, selling embroidery to local merchants and assisting with family-run businesses such as grocers. The focal point around which life in the Third Ward pivoted was Our Lady of Pompeii Catholic Church. From daily Masses to religious festivals, the "Little Pink Church" was an indelible touchstone to Milwaukee Italians.[12]

Most "new" immigrant groups came from rural areas and small villages and were thrown into a modern industrial society where they were limited in terms of full participation in the prevailing culture. Thus, they created close-knit ethnic colonies to cushion the cultural shock and overcome the helplessness of being uprooted from their comfort zones. Though these colonies enabled groups to survive in unfamiliar surroundings, they also reinforced isolation from the larger community.[13]

The deluge of immigrants from southern and eastern Europe during the late 19th and early 20th centuries and growth of ethnic neighborhoods exploded the fiction of America as a "melting pot" and sparked a great deal of concern among "old stock" Americans about "race suicide." They feared the new immigrants were unfit for citizenship and threatened the very survival of the republic. Starting with the Irish and German mass migrations of the 1840s, English Anglo-Saxons identified racial distinctions or degrees of "whiteness" between themselves and the Irish, Poles, Italians, etc.; that process accelerated as the flow of immigrants increased. Pseudo-scientific theories ranked ethnic groups into a hierarchy based on unique characteristics. Germans ranked at the top of the list because many Teutonic traditions closely aligned with those of the Anglo-Saxons. They were industrious, productive and frugal and moved easily into positions of influence, if not leadership, in Milwaukee society. Poles also were considered thrifty and industrious but not as stable and more quarrelsome than the Germans, while the Irish were considered riotous and savage. The Italians were untidy, lazy, violent, innately criminal and prone to too much drink. It was widely assumed that the Mafia or Black Hand infested "Little Italy" in the Third Ward and that Vitto Guardalabene

was the political boss or unofficial "king" of the Italian community. In Milwaukee, ethnic stereotypes dictated how and where immigrant groups lived, worked, prayed and associated with other groups.[14]

Despite ethnic divisions, the stream of immigrants combined to fuel a Milwaukee economy that was in transition. Grain exporting, meat packing, leather making and beer brewing still occupied commanding positions among Milwaukee businesses during the early 20th century, but the real money was in iron, steel and heavy machinery. In 1916, Milwaukee tallied 3,600 industrial factories, employing roughly 150,000 people and producing goods valued at nearly $500 million. Its 88 iron, steel and heavy machinery manufacturers accounted for $61.6 million. As the "machine shop of the world," the city's industrial sector had a voracious need for workers, and Milwaukee had plenty on hand.[15]

One group that did not share in the Cream City's industrial expansion was a small community of African-Americans. Less than 1,000 lived in Milwaukee by 1910, occupying a 35-block area bordered by State and Walnut streets on the south and north, respectively, and by Third and Eighth streets to the east and west. Once called the "Jewish Ghetto," the section abutted the "Bad Lands"—the city's vice district just to the south, dotted with brothels, saloons and gambling dens. A few African-American men joined the professional ranks as dentists, doctors, lawyers and newspapermen; some established small businesses, such as barbershops, saloons and rooming houses, but most were common laborers. While black women worked primarily in domestic or personal service positions, the men competed for factory jobs with a burgeoning supply of immigrant labor; more often than not, they came up on the short end. Hardships imposed by systemic racism and discrimination did, however, foster a sense of unity within the black community and development of a social service network to improve black lives in Milwaukee. Churches, especially St. Mark's A.M.E., were the oldest and most stable institutions. In addition to various lodges/fraternal organizations, women's clubs and literary societies, the Reverend Jesse Woods, pastor of St. Mark's, established the Booker T. Washington Social and Industrial Center on Cherry Street. It served as an employment agency—helping 75 women find work as domestic servants in 1917—and provided basic services, including dormitory rooms for 100 men as well as a reading room, café and day nursery.[16]

All told, Milwaukee crammed more than 400,000 people into a compact, 26 square-mile area that stretched to Oklahoma Avenue on the south, just beyond Sherman Boulevard and Washington Park to the west and Edgewood Avenue to the north, a footprint nearly one-fourth the city's current size. Only New York outpaced Milwaukee in terms

of population density.[17] A Merchants and Manufacturers' Association prospectus boasted that Milwaukee was a "city of homes" with "no congested slums or tenement districts," but multiple investigations found otherwise. City Clerk Carl Thompson observed Milwaukee's housing problem in 1910 was not as bad as Chicago or New York, but there were three slum areas: the Italian district in the Third Ward, the Polish area in the 14th Ward, and the Jewish district in the Fourth Ward. In the Third Ward, Thompson found one man, two women, ten children, six dogs, two goats, five pigeons, two horses, and "other animal life which escaped our hurried observation" living in one dwelling. The Fourth Ward was no better. One building housed 71 people from 17 families. Toilets clogged in summer and froze during winter. "The overcrowding here," he wrote, was "fearful and the filth defies description." Several years later, Milwaukee's Health Department found housing problems in 13 of the city's 25 wards and estimated that more than 12 percent or approximately 50,000 people lived in overcrowded conditions.[18]

Several factors accounted for the congestion. Milwaukee did not require building permits until 1888, allowing developers to carve out small lots and create tightly packed neighborhoods. Milwaukee's haphazard annexation of outlying areas during the 19th century slowed opportunities to expand in the 20th century. While the city's immigrant population valued home ownership, which led to innovations such as "Polish Flats," it made housing affordable but also led to overcrowding.[19] In addition, ethnic "clannishness," racism and low wages relegated the working poor to the most offensive areas. And there were plenty of poor. A City Club survey in 1915 found that 29,000 families lived below the poverty line, and another report estimated the average yearly earnings of men in Milwaukee factories was $548, which was about $100 less than what was needed to sustain an average-sized family.[20]

Overcrowding and the grittiness of daily life caused a number of problems, which in turn sparked reformers to improve conditions. The early 20th century is called the "Progressive Era" because most white, middle-class, Protestants embraced the conviction that society's ills could be eliminated through civic activism, government intervention, scientific study and professional expertise. One social ill was Milwaukee's meager street lighting. City dwellers brave enough to venture out at night risked being robbed or assaulted or colliding with automobiles, streetcars or horse-drawn wagons. By 1914, local residents had had enough and agitated to the point that the Common Council finally installed a new street lighting system.[21]

Increased crime and juvenile delinquency were other sources of worry. Some attributed the spike to character flaws in the immigrants themselves,

but poor housing was increasingly viewed as a root cause. The Health Department found that 30 percent of all cases from 1911 to 1915 in Juvenile Court came from districts with housing problems. In addition, a Bureau of Labor and Industrial Statistics study indicated that, despite the city's considerable investment in public schooling, 27 percent of children age 7 to 14 did not attend school. To combat the problem, reformers established 11 social centers as havens where kids could enjoy wholesome recreation and adults could socialize. The Wisconsin University Settlement Association provided another alternative when it established Milwaukee's first settlement house in the Polish 14th Ward in 1902, an area determined to have the most congested living conditions and highest rates of infant mortality and juvenile delinquency. The classes and programs offered at the Settlement House were "science going out to learn 'How the other half lives'" and rolling out those facts "upon the public in the interest of social advance." To the Rev. H. H. Jacobs, the Settlement House's warden, the project was nothing less than a battle to save the country because out of areas like the 14th Ward came "diseases, physical and moral, reaching to the highest and at last an assassin's hand to strike at the very life of our democracy."[22]

Addressing Milwaukee's urban environment to improve its citizens' health was another concern. Early 20th-century newspapers often complained about the "deplorable gloom" over the city because of coal dust. In addition, many alleys—especially in the most densely populated sections—were clogged with ashes, garbage and open or broken manure boxes. The Department of Health took an active role in making conditions better, licensing rooming houses to improve sanitation and launching a concerted effort to clean up trash in city alleys.

The Third Ward was one of the city's most noxious neighborhoods. A low-lying area nearly level with the Milwaukee River and Lake Michigan, it was prone to flooding and poor drainage, which made it a prime breeding ground for an assortment of communicable diseases. According to one report, warehouses, stables, homes and businesses combined to create a complex mixture of "vapors from the lake and river, smoke from chimneys and trains, gas from tanks, odors and insects from stables, and the crowding together of a population of workmen who often have no conveniences for cleanliness." The poor conditions posed a real threat to life. A Health Department investigation found that from 1911 to 1915, congested areas contributed to more than 27 percent of city deaths from tuberculosis and nearly 32 percent of deaths from typhoid. Furthermore, Milwaukee's infant mortality rate ranked 36th out of 46 major U.S. cities, and more than 21 percent of the city's deaths of children under age five occurred in overcrowded areas.[23]

The Milwaukee River, a health hazard of its own, added to the difficult environment. It was once clean enough for fishing; by 1912, however, one observer wrote that the river had become an open sewer. Its banks "littered with dilapidated ice and slaughter houses. The places between them harbored offal, ashes, tin cans and rubbish. The river stank to high heaven from the sewage of half the city."[24] As early as 1888, Milwaukee officials had tried to correct the problem by building a tunnel connecting Lake Michigan and the river above the North Avenue dam, but that fix only aggravated the problem by flushing pollution from the river into the lake, the city's source of drinking water. In the early 20th century, the city tried chlorine but that did little to improve the situation. The Health Department blamed polluted drinking water for a typhoid epidemic in 1916, resulting in 370 cases and 37 deaths.[25]

Milwaukee's government officials and Progressive reformers struggled to attack these challenges. One option put forth to relieve congestion in Milwaukee's core included constructing affordable public housing on the city's outskirts. Increased green space offered another desirable respite from urban life. Milwaukee already had several parks—Lake, Washington, Humboldt, Juneau, Mitchell, etc.—but reformers such as Charles Whitnall and architect Alfred Clas urged even more should be added. "With all of the resources of art and science now at hand," Clas argued in 1916, "there is no reason why we should allow ugliness, meanness, and squalor to exist and to deaden the external aspects of our cities to the extent we do." Expanding the park system, he added, would provide a place for rich and poor alike to "get away from the dust and smoke of the business district." U.S. entry into World War I, however, diverted capital away from city planning efforts and building activity, thus delaying any improvements related to the housing situation.[26]

These multiple troubles paved the way for a sea change in Milwaukee politics with the rise of the Socialist Party. The Cream City proved to be fertile ground for Socialism. Much of the German community embraced liberal causes, a legacy handed down by revolutionaries who came to Milwaukee after the failed 1848 uprisings in Europe as well as by freethinker societies and Turnverein halls. In the late 19th century, labor unions awoke among Milwaukee's huge pool of industrial workers an awareness of how political activism could protect their interests, diminish concentrated economic power of the capitalists and usher in a true urban democracy. All that was needed to turn these nascent movements into a political force was a strong leader.[27]

Victor Berger emerged as that leader. Born in Austria-Hungary in 1860 to Jewish parents, he received a taste of Socialist theory while studying at the University of Vienna and the University of Bucharest. His college

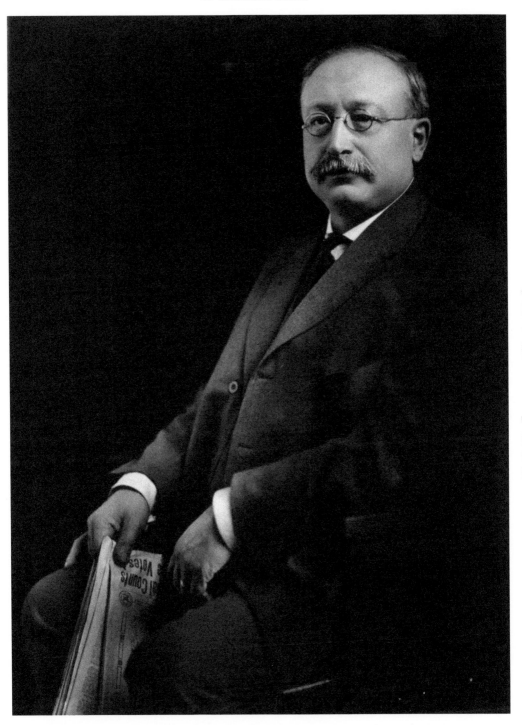
Milwaukee Socialist Victor Berger. Though twice indicted for violating the Espionage Act, Berger was elected to the U.S. House of Representatives in November 1918. (Photo courtesy of Milwaukee County Historical Society)

education, however, was cut short when he and his family immigrated to the U.S. in 1878. They settled in Connecticut, but Victor drifted west, taking odd jobs—even cow punching—until he settled in Milwaukee in 1881, where he taught German, history and physical geography in the city's public schools. Already grounded in Marxist theory, he immersed himself in the liberalism of the local Turner societies. Discovering political activism was his true calling, he resigned his teaching position to focus on growing socialism in the U.S.

Berger seemed an unlikely "Moses" (as historian John Gurda calls him) for the Socialist movement. He was a bundle of contradictions. He had a solid build, but his glasses and fastidious dress gave him a scholarly appearance. He possessed a good sense of humor, an irresistible charm—women flocked around him—and genial disposition to his friends and even his enemies, but he also had a volatile temper and could be something of a bully to those who disagreed with him. Even his daughter Doris called him "wise and loving but very temperamental" and a "benevolent tyrant in the family." Though he worked to improve conditions for the working class, he had an enormous ego and always seemed to be "talking down to a world of intellectual inferiors." He loved being in the spotlight. A contemporary recalled that at political meetings, Berger would wait until the last moment before the main speaker was introduced and then make his entry. He marched down the center aisle and basked in the warm reception from the audience, stealing the thunder from the keynote speaker. Berger's own speaking talents were mixed at best. His thick, German accent, faltering English, faint voice and awkward gestures hindered the effectiveness of his public speeches, but he still won over audiences through the sheer force of his personality and fervent belief in the Socialist cause.

His foibles notwithstanding, Berger's genius stemmed from an ability to adapt Socialist orthodoxy to political and economic realities of the U.S. He firmly believed labor would inevitably triumph in the class struggle against capitalism, but victory would not be achieved through violent revolution. Rather, it would happen gradually after years of education and practical political reforms realized through the ballot box. "I am a historical Socialist—not a hysterical Socialist," he wrote, "and do not believe that revolutions can be manufactured overnight." This conservative, practical approach made Socialism more palatable to American sensitivities, but it put him at odds with more doctrinaire left-wing elements of the Socialist Party. Nevertheless, his organizational skills, prowess as editor of the *Vorwärts* and *Milwaukee Leader* and willingness to partner with the city's trade unions, helped Berger and the "gradualists" become the strongest faction within the party. Starting with the 1898 mayoral race, the Socialist Party steadily increased its share of the vote, thanks in part

to the morally bankrupt administration of Mayor David Rose, until they won in a landslide victory in 1910. Voters elected Socialists Emil Seidel as mayor, Victor Berger to the U.S. Congress and 21 of 35 aldermen.[28]

Daniel Webster Hoan, Jr., was part of the Socialist rout in 1910, winning the post of city attorney. He was born on March 12, 1881, the youngest of four children. His Irish father was a Civil War veteran who settled in Waukesha, Wisconsin, after the war and eked out a living by digging wells, working in a quarry, running a boarding house and operating a small bus line that hauled visitors from Waukesha to Pewaukee and Delafield lakes. He had experienced hard times and was more than willing to help the less fortunate. Hoan called his father one of the first "near-Socialists" in Waukesha whom the townspeople no doubt "regarded as one of the town cranks, and a very peculiar one at that."[29] Infused with an idealistic sympathy for the underdog, Dan, Jr., had to grow up at a young age. His parents divorced, and his mother left when he was seven; his father, whom he idolized, died when Dan was thirteen. From 1895-1902, the young Hoan worked in restaurant kitchens in Waukesha, Milwaukee and Chicago rather than complete his schooling because he considered being in debt a "fearful thing."

As a teenager, he followed his father's political leanings and delved into more radical doctrines. He eventually joined the Socialist Party and decided to study law to rise above his humble origins. Needing to improve his education, Hoan took special classes to finish his elementary schooling. Without the benefit of a high school education, he enrolled at the University of Wisconsin in Madison in 1902. A politically active student, he organized a Socialist society and campaigned for Socialist candidates, which drew the attention of Victor Berger and fellow Socialist Frederic Heath. After graduating in 1905, Hoan bought a restaurant in Chicago to help pay for law school but sold it after a short time because it was not very profitable. Instead, he clerked for a Chicago law firm while taking night classes at the Kent College of Law. He passed the Wisconsin and Illinois bar exams in 1908 and opened his own practice in Chicago. Shortly thereafter, Berger and Heath traveled to Chicago to persuade Hoan to relocate to Milwaukee. It took several hours, but the newly minted lawyer finally relented, with the condition that he not be asked to stand for political office.

Hoan set up shop in Milwaukee and quickly gained a reputation for sound judgment, honesty and a sense of justice. He devoted much effort to various labor cases and helped draft the nation's first workmen's compensation legislation, which Wisconsin Governor Francis McGovern signed into law in 1911. When the 1910 elections approached, the Socialists needed a qualified and personable candidate to run for city attorney. Dan

Hoan was their choice. His loyalty to the Socialist movement overcame his reluctance to abandon a career as a labor lawyer, and he narrowly won the election. As city attorney, Hoan waged successful battles against the utilities, street railway company and other powerful political/economic interests to protect consumers. His solid record kept him in office while other Socialists were bounced from city government in 1912 and 1914, thanks in large part to Democrats and Republicans throwing their support behind "fusion" candidates. The Socialists were determined to reclaim City Hall in 1916, and Dan Hoan was the undisputed option to run for mayor. Gerhard Bading, the incumbent and fusion favorite, portrayed the race as a vote between "Americanism vs. Socialism," but Milwaukee residents opted for Hoan by a margin of some 1,500 votes.[30]

The new mayor was now a close second to Victor Berger in terms of influence within Milwaukee's Socialist Party. Physically, the two could not have been more different. Hoan's build resembled that of his personal hero, Abraham Lincoln. The mayor was tall and lanky with a thick head of hair, though he sported a mustache rather than a Lincolnesque beard. But by and large, Berger and Hoan were cut from the same political cloth. Both believed the concentration of economic power in the hands of a few blocked the emergence of a collectivist state. Similarly, they argued that Socialist theory must be tempered to fit existing American political and economic structures and that only organized, concerted political action would enable the country's laboring class to wield power. Toward these ends, both were energetic and effective campaigners for the Socialist cause, though both had to overcome personal obstacles—Berger, his thick German accent, and Hoan, a high-pitched voice that one reporter said sounded like a "weak whistle letting off steam." Nevertheless, Hoan won numerous mayoral elections—he served for 24 years—because he possessed a common touch that Berger lacked. Perhaps it was his humble beginnings, combative spirit, sympathy for the underdog, mischievous sense of humor or his sometimes off-color language that helped him connect with constituents. Or it could have been that Hoan, given his Midwestern upbringing, was more amenable to tweak Socialist theory to reach a wider audience. For example, Berger, though his parents were Jewish, was, like many Socialists, an agnostic and often called the Bible a "humbug." This anti-religious bent roused the enmity of organized religions. Archbishop Sebastian Messmer and many Catholics disparaged Socialism for sharpening class distinctions and emphasizing materialism, ignoring the spiritual side of human existence. Messmer went so far as to threaten excommunicating any Catholic who joined or even voted for the Socialist Party. Hoan, on the other hand, believed that people of any faith could be a Socialist. "It always appears to me," he mused,

"that one of the aims of Christianity is, according to the Lord's prayer at least, to established [sic] the Kingdom of God on earth." In a similar vein, Socialists were "trying to make this a better world in which to live and establish a system whereby it will be possible to practise the teachings of Christianity."[31]

Hoan's view may have converted a few to the Socialist side, but it did little to sway Berger to retreat from his position. Tension stemming from their divergent views was not evident during the heady days of 1910-1916, but given their strong personalities and independent streaks, it seemed inevitable that chinks in the collective Socialist armor would develop. Likewise, the simmering ethnic, political and economic frictions that developed during Milwaukee's transition of the early 20th century would be exposed raw by a conflict in far-off Europe.

2

There is a feeling here which is daily growing that if war is declared there will be insurrection in Milwaukee. ...
>Special Agent William Fitch to A. Bruce Bielaski, Bureau of Investigation, March 23, 1917

Given its often senseless death and destruction as well as post-war political, economic and social upheaval, World War I appropriately started as the result of a wrong turn. On an official visit to the small town of Sarajevo in Serbia, Archduke Franz Ferdinand, heir to the throne of the Austro-Hungarian Empire, and his wife Sofie were traveling in a motorcade that took a wrong turn. As the drivers tried to correct their route, a Serbian nationalist stepped forward, pulled out a revolver and shot the Archduke and Princess to death. The assassination triggered a chain reaction that pulled all European powers into the greatest armed struggle the world had seen.

Almost immediately, the war sparked a debate in the U.S. about its role in the conflict. President Woodrow Wilson called upon the country to remain neutral "in thought as well as in deed." That, however, was easier said than done. Both the Central Powers (Germany and Austria-Hungary) and the Allies (Great Britain, France and Russia) had their supporters among the polyglot community in Milwaukee. Most German-Americans sided with their kin in the fatherland and favored the President's policy of neutrality. The Irish were not about to support any cause in which the English were involved and, thus, came down firmly on the side of Germany/Austria-Hungary. The Poles, on the other hand, viewed the war as a chance for their homeland to throw off the yoke of German rule and once again become an independent state. Italians firmly ensconced in Milwaukee generally supported the Allies, while more recent Italian immigrants, many of whom embraced radical politics, opposed the war as a venture to enrich the capitalist class. The "old stock" middle/upper-class Anglo-

Saxon Protestants sympathized with the British and French. They saw no disingenuousness in President Wilson providing food and armaments to the Allies, especially in light of Germany's invasion of neutral Belgium, the news of German atrocities against innocent women and children and the use of submarine warfare. Sinking of the passenger liner *Lusitania* in May 1915—killing 128 Americans—confirmed in their minds the worst of the German character.[1]

An exchange between Milwaukeeans Frederic Cook Morehouse and Erich Stern reflected the growing divide within American ranks. Morehouse, editor of *The Living Church*, was one of the most influential voices within the Anglican Church. Stern, a well-respected lawyer and member of the Progressive wing of the Republican Party, was part of the celebrated Wisconsin legislature that passed the nation's first workers' compensation laws as well as measures that reined in child labor and facilitated use of the recall and initiative to make Wisconsin government more responsive to the will of its people. In December 1915, Morehouse asked Stern to comment on an editorial he penned in *The Living Church*. Morehouse argued the U.S. must continue to adhere to its policy of neutrality, even though it was disappointing "to us to seem compelled—by duty rather than by inclination—to hold aloof in this hour of great need of those whom, on the best evidence we can discover, we believe to be the party of right in this present war." Austria-Hungary's ultimatum to Serbia, Germany's ultimatum to and atrocities in Belgium and the use of U-boats proved conclusively in Morehouse's mind that the Central Powers were responsible for the war.

Stern thought the editorial was "admirably reasoned and lucid" but protested the fact that anyone reading it "would naturally assume that Americans, as a unit, were pro-Ally, probably Anglo-Saxon, and that there existed among them no notable division of opinion with regard to the War." German-Americans, he went on, were treated as if they did not exist and that their opinions "would weigh as feathers in the balance." If they did not share the view that Germany was "all wrong" and the Allies "all right," it must be assumed, Stern asserted, that those residents "do not properly belong within the pale of the American people." "Isn't it a fact," he asked, "that German-Americans...have become a kind of ogre to you, second as an object of disgust only to the Germans themselves?" But German-Americans, Stern wrote, were not a "pure abstraction" but men and women with whom Morehouse interacted every day. Morehouse admitted the editorial was directed to the largely Anglo-Saxon clientele of the Episcopal Church, but he objected to the claim that he harbored any negative feelings toward German-Americans. He had carefully weighed the evidence as fairly and justly as he knew how. Stern replied that he did

not mean to couch his letter as a personal criticism of Morehouse; rather, Stern's sentiments were the "cumulative result of constant expressions (far less guarded than yours, tho of similar tenor) in the American...press from the very beginning of the war."[2]

The civil tone of the Stern-Morehouse correspondence became increasingly rare as stories of German spies and saboteurs in the U.S. amplified the growing drumbeat of war.[3] The resulting frenzy ignited demands for the nation to embark upon a preparedness campaign so that the U.S. would be ready should war come. Outspoken preparedness advocates such as former President Theodore Roosevelt and the National Security League popularized the view that anyone who opposed the movement was a danger to society. President Wilson traveled to Milwaukee in late January 1916 to address that very issue in a speech specifically directed at the city's large German population. An overflow crowd filled the Milwaukee Auditorium and several thousand more vainly tried to get in to hear the President speak. With typically soaring rhetoric, Wilson informed the throng that he had come to discuss a vital matter "when all the rest of the world is on fire and our own house is not fireproof." "America," he continued, "has drawn her blood and her strength out of almost all the nations of the world." It would be impossible to ignore those roots, and at the start of the war, those bonds made it seem as if there were differences of opinion that might have led the U.S. "to some errors of judgment and some errors of action." But that danger, he claimed, had passed. The "magic of America" and the "great principles which thrill men in the singular body politic" were enough that "whenever the test comes every man's heart will be first for America." The real danger was not being ready for that test. Wilson knew the people depended on him to keep the U.S. out of the war, and with God's help, he pledged he would do so if possible. At that, the crowd erupted in sustained, raucous applause.

Pausing, Wilson added that the people had laid another duty upon him—defending the country's honor—something that was not under his control. Depending on the actions of others, he said, there may be a time when he could not "preserve both the honor and the peace" of the United States. In that moment, he would rely on the "great host of free men" to rally to the country's defense. This, of course, dictated that a system be devised to provide the general population with the necessary military training so that Americans were not "mere targets for shot and shell."

As the speech wound down, Wilson indicated how touched he was that every house along the train route into Milwaukee was flying the American flag. "Do not deceive yourselves, ladies and gentlemen," he added, "as to where the colors of that flag came from. Those lines of red are lines of blood, nobly and unselfishly shed by men who loved the liberty of

their fellow-men more than they loved their own lives and fortunes." He concluded with a theme that permeated his thinking throughout the war—equating the possible contest to a moral crusade: "God forbid that we should have to use more blood of America to freshen the color of that flag; but if it should ever be necessary again to assert the majesty and integrity of those ancient and honorable principles, that flag will be colored once more, and in being colored will be glorified and purified."[4]

Shortly after Wilson left town, the *Milwaukee Journal* launched its own effort to purify the Milwaukee community. Owner/editor Lucius Nieman was the *Journal's* standard bearer. He was born in Sauk County, Wisconsin, in 1857, but his family moved to Mukwonago, located southwest of Milwaukee, two years after his father died. His mother remarried but passed away shortly thereafter, and Lucius and his older sister were raised by their grandparents. He had long wanted to work as a newspaperman, so his grandparents arranged for him to learn the trade at the *Waukesha Freeman*. He eventually got a job with the *Milwaukee Sentinel* before becoming part owner of the struggling *Journal* in 1882. He quickly transformed it into one of the state's leading Democratic publications. A quiet, austere man, Nieman valued the comforts of home and being with close friends. When war erupted in Europe, he urged people to adhere to Wilson's policy of neutrality because it was their patriotic duty to stand with the President. Initially, the *Journal* gave equal attention to both sides of the war, but by late 1915, Nieman had become alarmed at the pro-German sentiment coming from some of the Milwaukee press—in particular the *Milwaukee Free Press* and the *Germania-Herold*—which criticized Wilson's favoritism of the Allies. A headline in the *Journal's* February 10, 1916, edition blared, "Does Milwaukee Favor Disloyalty?" The accompanying article condemned the *Free Press* for "preaching un-American doctrines and doing un-American things." To counter any voice that stained Milwaukee's reputation around the country, the *Journal* embarked on a "Campaign for Americanism" in 1916.[5]

This crusade often degenerated into nothing more than a testy editorial war with the *Free Press* and *Germania-Herold*, but it did its best to fan the patriotic fervor surrounding preparedness in Milwaukee. During the wildly successful Austro-Hungarian Charity Bazaar in early March, the *Journal* provided diminishing coverage of the obviously pro-German event. By the final day of the bazaar, the paper relegated any mention of the event to the back page. Instead, the *Journal* filled its pages with articles that stressed the loyalty of the vast majority of German-Americans and the need to be ready for war.

Despite constantly hammering away on both topics, the *Journal* made little headway. Erich Stern called the *Journal's* effort "one of the most

insidious, ruthless and mendacious campaigns against German Americans that has been attempted anywhere." Using a "lofty patriotism and a patronizing defense of German Americans," Stern charged, the newspaper had "really stirred up more race consciousness and race hostility in this community than existed from all other causes combined previous to the *Journal* campaign." In addition, the *Free Press* reported in April that ten Milwaukee Lutheran churches with predominantly German-American congregations sent anti-war resolutions to President Wilson. The missive signed by some 1,500 members of the Bethlehem Evangelical Lutheran Church, located at Cold Spring Avenue and 24th Street, reflected a common theme: it would be "nothing less than a crime" if the U.S. entered the war "on no better grounds than those so far advanced."[6]

Preparedness advocates around the country staged parades in support of the President's policy; pressure mounted in Milwaukee to do the same. In May, patriotic organizations in New York and Chicago urged Mayor Dan Hoan to join the movement and organize a parade in the Cream City. Hoan ignored these appeals, realizing it was a no-win scenario. Beyond personal feelings as a pacifist, Hoan was well aware of the political danger that backing a parade posed. Munitions manufacturers would point to it as proof that he and the general population endorsed militarism and a standing army. Furthermore, it would anger the trade unions, which opposed preparedness as a capitalist plot to weaken the working class. Milwaukee's Federated Trades Council argued that a nation whose workers were "mercilessly exploited by unrestrained capitalism is a nation that, though it be equipped with great armaments and 'prepared' for war, has suffered an injury from the enemy within, that has unfitted it to cope with the enemy without."[7] On the other hand, refusing to call for a preparedness parade would imply that Hoan was disloyal and undermine any middle-class support he might have.

He insisted, therefore, that the meaning of "preparedness" had to be clearly defined before endorsing a parade. The preparedness Hoan desired should mean "peace not militarism. It should strengthen democracy and oppose imperialism." It should also include three propositions: improving the condition of the masses, government ownership of munition factories and the principle of an organized and prepared citizenship rather than a standing army. He finally agreed to take part in a parade when the Rotary Club assured him that preparedness was just a "catch title," and participation would not commit him to supporting a specific kind of preparedness. The parade would be a purely patriotic demonstration to help "tune up a partially unstrung national will to revive a somewhat moribund national conscience." On July 15, 1916, an estimated 150,000 spectators watched the mayor, 52 bands and 28,000 Milwaukeeans

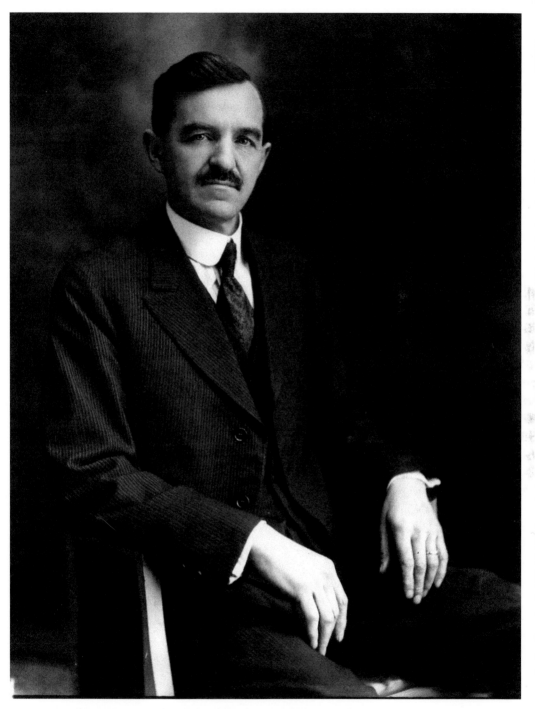

Socialist Dan Hoan faced the difficulty of fulfilling his duties as mayor to assist the government's war efforts and his personal opposition to war. His tightrope act sparked conflicts with war supporters and fellow Socialist Victor Berger. (Photo courtesy of Milwaukee County Historical Society)

march along Wisconsin and Grand (now West Wisconsin) avenues. As the last filed past, Governor Emanuel Philipp declared it was a remarkable demonstration that proved to everyone around the country that Milwaukee citizens were thoroughly patriotic and loyal to the country.[8]

The Socialist response to the Milwaukee Preparedness Parade foreshadowed deeper splits to come within the party. In general, Milwaukee Socialists backed Hoan, but the state Executive Committee, which typically followed Victor Berger's direction, resolved that the mayor had committed a "tactical error" in participating. Berger opposed standing armies but advocated short-term military training for young men in order to repel any invasion of U.S. soil. That was why he supported U.S. retaliation against Mexico's Poncho Villa in 1916. Berger's remarks stung Hoan, who thought he had his fellow Socialist's clearance to march in the parade. The two drifted apart from that point on.[9]

Likewise, party faithful outside Milwaukee blasted Hoan's actions. Herbert Bigelow in Cincinnati called it "cheap advertising" for Hoan's political ambitions. Eugene Debs, the venerable leader of the national Socialist Party, was particularly troubled. He denounced as lies any dispatches about Hoan marching in a preparedness parade and wrote the mayor that he simply could not believe anything of the kind. Hoan replied that not taking part would "probably cripple the party locally for years." Every Socialist, he argued, was "imbued with a genuine patriotic spirit," and it was preferable, "rather than scoff at the word patriotism, to seize upon it and make it a word to express our ideas and popularize our thots [sic]." Debs' brother Theodore was not convinced and accused the Milwaukee Socialists of perverting party principles. Hundreds of "red-blooded" Socialists, he wrote, left the party because of these "vote-seeking, office-hunting" practices. "I would have been eternally damned," he thundered, "before I would have marched in it."[10]

All of this played out against the backdrop of the 1916 Presidential campaign. Wilson was the clear choice for the Democrats while Charles Evans Hughes grabbed the Republican nomination. Not surprisingly, loyalty was the key issue during the contest. According to one study, the campaign was a "breeding ground for conformist definitions of patriotism and loose accusations of disloyalty."[11]

Even before the nominations were secured, Leo Stern, president of the German-American Alliance and assistant superintendent of schools in Milwaukee, designed a plan to protect the political and cultural interests of German-Americans. His "Wisconsin Idea" stipulated that one-fourth to one-third of the Wisconsin delegates at the Republican Convention should be German-Americans to nominate a candidate who "represents the neutral American situation desired by us." Moreover, Stern urged all

Germans who had not already done so to become U.S. citizens so that they could vote in the political battles to come.

The *Milwaukee Journal* naturally railed against these bold-faced efforts to promote pro-German goals at the expense of "true" Americans. The newspaper had legitimate reasons to be concerned about Stern's influence. The German-American Alliance had 37,000 members in Milwaukee alone and more than 100,000 nationwide. Stern's attempts to deliver the German-American vote as a unified block did nothing more than foment ethnic prejudice. The *Journal* ran stories that insisted most German-Americans thought and voted independently, but it was quick to identify any and every instance of what it saw as German collusion to subvert American democracy. As an example, the *Journal* pointed to meetings at the Republican House hotel on October 24. G.H. Jacobson of the American Independence Conference invited German Lutheran and Catholic clergy from around the state to Milwaukee to hear speeches in favor of Hughes' candidacy for President. Because the American Independence Conference paid all of the meeting expenses, the *Journal* compared the attendees to Judas Iscariot and chastised them for participating in "one of the sorriest, most distressing scenes that it is possible to imagine."[12]

The *Journal's* tone reflected the general demeanor of the Presidential campaign. The war dominated all discussion, and both candidates assailed each other for their stance on that issue. Hughes derided Wilson for not forcefully defending American rights while the Democrats, brazenly exploiting the loyalty issue, charged that anyone who accused Wilson of favoring the Allies was pro-German. The result illustrated deep divisions that the war provoked. Wilson won the election by a razor-thin margin, largely because of the Democrats' slogan, "He kept us out of war."

But by early 1917, war with Germany seemed inevitable. On January 31, Germany announced it would resume unrestricted submarine warfare. After the sinking of the *Lusitania* as well as merchant ships in 1915, Wilson sent a note to Germany, demanding it cease attacking unarmed merchant ships. Not wanting to antagonize the U.S. further, the German government constrained the use of U-boats to the point that the German navy suspended submarine warfare altogether in September 1915. Naval commanders deeply resented this policy, and by January 1917, they convinced the German government that unrestricted U-boats could turn the tide and help win the war before the Americans had a chance to become fully engaged. Three days after the German announcement, Wilson severed diplomatic relations. As American shipping losses mounted and foreign trade was effectively shut down, the President asked Congress for authority to arm merchant ships as part of an "armed neutrality" policy. Wilson strengthened his hand at the end of February when he released

the intercepted Zimmerman telegram in which Germany tried to entice Mexico to go to war against the U.S. But there was still strong anti-war sentiment within Congress. A group of senators—including Robert La Follette of Wisconsin—used a filibuster to stall the bill. With the request bogged down, Wilson bypassed Congress on March 8 and ordered arming American ships. In addition, he announced he would call Congress into a special session on April 16.[13]

National tensions hardened the lines dividing Milwaukee's pro- and anti-war factions. Immediately after the Germans resumed sinking ships, the Emergency Committee of the national Socialist Party, which included Victor Berger, telegrammed the President and urged him to institute a complete embargo of American goods to all belligerent nations. This was the only way to maintain complete neutrality. The message criticized U.S. policy for favoring the Allies since the start of the war, a flagrant violation of neutrality that only enriched American capitalists while staining the nation with the "guilt of murder," driving up the cost of living and increasing suffering among the masses. In contrast, a total embargo would end the war.[14] Wilson ignored the advice, but Socialists in Milwaukee and around the country staged peace meetings to demonstrate that most Americans wanted nothing to do with the fight overseas.

Keenly aware that pacifist actions harmed Milwaukee's national reputation as well as its financial interests, city patriots were not about to let the Socialists go unanswered. The Women's Club of Wisconsin wanted to demonstrate that Milwaukee women were loyal and asked all other women's groups in the city to form a unified patriotic league. The club also sought Mayor Hoan's approval. He again walked the fine line between personal and political opposition to the war and his civic duty as mayor. In response, Hoan commended the Women's Club for its foresight and added, "While I personally believe every living soul would regret to see our country involved in a war, still if war would come, then the loyal support and assistance of every citizen will be absolutely necessary." On March 7, 1917, delegates from 109 women's groups joined ranks to form the League of Patriotic Women of Milwaukee. Mrs. John Mariner was elected president, and resolutions were adopted offering the league's services to Mayor Hoan if war should be declared. Local colleges also made their voices heard. In mid-March, the dean of Marquette University's School of Engineering formed a company of about 50 students to take part in rudimentary military drills because Germany threatened "the sacred honor of the nation upon the sea."[15]

In a concurrent effort, a group of Milwaukee bankers, lawyers and businessmen formed the Citizens' Committee on February 27 to support President Wilson and articulate Milwaukee's loyalty to the rest of the

country. The committee included such luminaries as August Vogel of the Pfister & Vogel tanning company, John Cudahy of the meat-packing firm, Henry Campbell, assistant editor of *The Milwaukee Journal*, former U.S. District Attorney Guy Goff, Frederick Morehouse and Willett Spooner, an attorney and son of a former U.S. Senator from Wisconsin.

At this stage, a new voice emerged to join Lucius Nieman and *The Milwaukee Journal* as a leader of the 100 percent American faction. The aptly named Wheeler Peckham Bloodgood was one of the city's more prominent attorneys. His ancestors immigrated from Holland in the 17th century and settled on Long Island, New York. His grandfather, William, graduated from West Point in 1824 and was stationed for a time at Fort Howard in Green Bay, where his son, Francis, was born in 1827. Francis studied law and moved to the fledgling city of Milwaukee in 1854, eventually establishing a successful practice with his son, Francis, Jr. Francis, Sr.'s, youngest son, Wheeler, was born in 1871 and educated at St. John's Military Academy in Delafield, Wisconsin. He followed his father and brother in the study of law and joined the family firm in 1894. A staunch "Bull Moose" Republican, he was imbued with the Progressive ethos that public service could fix society's ills. Though he sympathized with the poor and also tried to balance the goals of labor and capitalism, he believed socialism was one of those ills, and when war was on the horizon in 1917, it was not surprising he grasped the opportunity to counter the Socialists' anti-war propaganda.[16]

In mid-March, Bloodgood and the Citizen's Committee met at the University Club and issued a "Call to Americans." They pledged to support any action President Wilson deemed necessary to protect American rights and honor against German provocations. The committee also invited like-minded patriots to attend a mass loyalty meeting at the Milwaukee Auditorium on March 17. Two days before the event, a postal carrier collected a half dozen postcards containing threats to blow up the proceedings and kill the speakers, including Bloodgood, John Cudahy, August Vogel, Senator Paul Husting and U.S. Representative Irvine Lenroot. Bloodgood took the threats seriously and pressed upon the Department of Justice (DOJ) to have agents inspect the auditorium and protect the speakers. William Fitch, special agent to the Bureau of Investigation, also approached Chief of Police John Janssen about beefing up security for the event. Janssen, a grizzled, hard-nosed veteran of the force, listened politely but decided there was no real threat.

Exhibiting excessive suspicion that clouded so many minds, the Citizen's Committee was not about to leave matters solely in the hands of local police. U.S. Attorney H.A. Sawyer telephoned the DOJ division superintendent in Chicago and urged him to provide a squad of six special

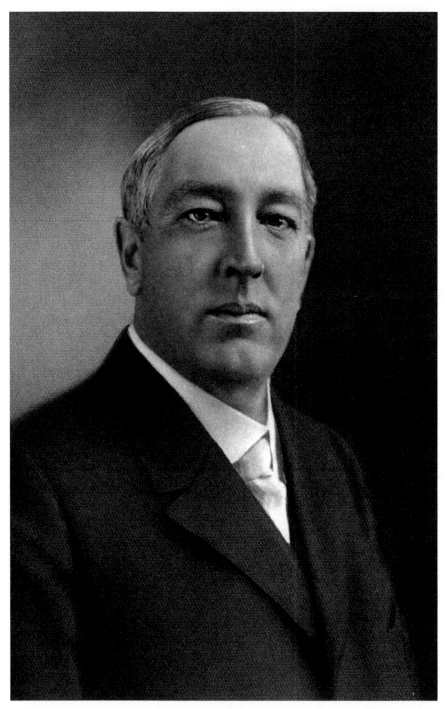

Attorney Wheeler P. Bloodgood spearheaded Milwaukee's pro-war efforts. After strong Socialist support in the spring 1918 elections, Bloodgood traveled to Washington, DC, and advocated for establishing military tribunals to prosecute war dissenters. (Photo courtesy of Milwaukee County Historical Society)

agents to examine the building and protect the speakers. The agents arrived the morning of the meeting. One of them and Sawyer met with Police Chief Janssen and again tried to convince him to provide extra security. The DOJ agent reported that Janssen was at first indignant at the request but after "considerable argument" about the extraordinary need for caution, agreed to detail at least 20 plain-clothes men and 100 uniformed officers for the meeting. Federal agents and police spent the entire day checking numerous nooks and crannies in the auditorium for bombs or suspicious characters. In the end, the safety measures were not needed. The rally was a raucous success, and only one minor heckling incident occurred. A brave but misguided individual stood up during one speech and demanded to know if the speaker would join the military if war should come. Immediately the crowd shouted "Throw him out!" The man was removed from the hall.[17]

Flush with the rally's success, Bloodgood and other executive committee members embarked upon a clandestine campaign two days later to strengthen their hand against pro-Germanism in Milwaukee. On March 19 and 21, Bloodgood met with Special Agent William Fitch of the Bureau of Investigation to discuss forming a "Vigilance Committee" of several hundred loyal citizens who could cooperate with the federal government in any emergency. Bloodgood went a step further and urged that the federal government officially sanction the group. Though Fitch thought such a committee would definitely help the DOJ identify neutrality violations or those indulging in seditious talk, he discouraged the idea of any explicit federal approval, stating that the committee should be an independent organization. Undaunted, Bloodgood pressed Fitch to confer with U.S. Attorney Sawyer and U.S. Marshal Samuel Randolph about the matter. Both Sawyer and Randolph rejected the idea of sanctioning the proposed Vigilance Committee. They believed loyal citizens should furnish a confidential list of names out of pure patriotism. In addition, Milwaukee's large German-American population influenced their decision. Fitch commented that his colleagues denied Bloodgood's request because such a move "might itself be construed as inciting to riot."

Fitch reported how a growing fear that Milwaukee was a tinderbox ready to explode should war be declared fueled Bloodgood's actions and those of other patriots. Such was their concern that they argued for more federal agents, swearing in deputy marshals and stationing army and navy officers in Milwaukee to command military forces if necessary. Fitch thought there were many alarmists in the city, and much of what the Bureau of Investigation heard was "mere talk." As proof, Fitch mentioned a rumor that Henry Campbell of the *Milwaukee Journal* spread regarding the Philip Gross Hardware Company, which allegedly sold 6,000 to

7,000 repeating rifles within the past six months. The guns were allegedly shipped in the middle of the night in small batches of four or five at a time. Fitch investigated the matter and found the rumor baseless. It turned out that Gross Hardware sold about 100 guns the previous year, mostly during the 1916 hunting season. Another rumor that Campbell fed Fitch was that Count von Bernstorff, the German ambassador who opened the Charity Bazaar in 1916, funneled money through wealthy Milwaukee tanners Gustave and Albert Trostel to editors of the *Milwaukee Free Press* for printing pro-German propaganda. This claim, too, was never proved.[18]

Unfazed by rebukes from Fitch, the U.S. Attorney and U.S. Marshal, patriots tried a different approach. Democratic Senator Paul Husting, a vocal supporter of President Wilson, boarded a train to Washington to press the "loyals'" case with the U.S. Attorney General and the Secretaries of War and Navy. Prior to Husting's trip, Guy Goff wrote to Solicitor General John W. Davis and informed him that Husting would provide a full account, but he wanted to apprise Davis that the situation in Milwaukee was in "very, very bad shape." The letter was an S.O.S. because Goff feared that as soon as war was declared, "the trouble will begin, and it will be real trouble." The DOJ should post at least ten special agents in Milwaukee as soon as possible. Davis forwarded Goff's note to the Attorney General stating, "I do not think [Goff] is an alarmist." Though the patriots failed to secure federal sanction for the Vigilance Committee, they formed the Wisconsin Defense League (WDL) on March 24 to assist military branches with recruiting and providing any help requested by federal authorities.

The March 25 *Milwaukee Journal* fueled even more patriotic apprehension with a story that the Secret Service had uncovered a plot to destroy large manufacturing plants in Buffalo, New York, and that one plant owner had approached state authorities in Albany seeking militia protection. That same owner telegrammed Ellis Usher of the WDL that the plot targeted other manufacturing cities on the Great Lakes and that "utmost precaution" should be taken. This information triggered prompt action by the WDL. Bloodgood sent Goff and Willett Spooner to Madison on March 26 to ask Governor Phillip to station the 2nd Regiment of the Wisconsin National Guard at the State Fair Grounds near Milwaukee to quell any kind of uprising. They returned to Milwaukee late in the evening of the 27th to await Phillip's decision. No word was received the following day, so at a meeting that evening in the U.S. Marshal's office, Spooner called Phillip and was apprised that the governor refused to order troops to Milwaukee because the Secret Service in Chicago told him no plots or uprisings had been reported, and there was no cause for alarm. The governor had also communicated with Chief of Police Janssen,

who likewise dismissed any potential danger. In a campaign speech the following summer, Phillip claimed Spooner and Goff feared German reservists would destroy the waterworks and burn the city, but they offered no concrete proof. They also told the governor there were 250 dangerous men in Milwaukee who were sworn to the Kaiser and set to attack strategic points in Milwaukee and then escape to Mexico. Again, according to Phillip, they provided no details other than "they knew it." "Think of it," he chided, "if I had sent two regiments to Milwaukee to watch the Germans, what an insult that would have been. It would certainly have been resented."

Husting had better luck in Washington. He met with Secretary of War Newton Baker who advised that he contact General T.H. Barry, Commander of the Central Department in Chicago, and Orlando Holway, Wisconsin Adjutant General, about mobilizing troops at the fairgrounds. Furthermore, Husting persuaded Attorney General Gregory to authorize U.S. Marshal Randolph in Milwaukee to choose at least 100 local citizens who could be sworn in as deputy marshals in an emergency.[19]

The WDL reached out to Charles King, retired Brigadier General of the Wisconsin National Guard, a man whom many on the committee considered a friend. A WDL member called King to a meeting at Goff's house on the night of April 1. It was obvious to King that the group had been meeting for some time. For two hours, he listened to their pleas that military help was needed. Henry Campbell told the general that, according to an informant whose name Campbell did not divulge, there were 4,600 German army reservists and seven members of the Pan German Union in Milwaukee poised to attack Americans. Other committee members argued that Buffalo and Detroit successfully secured military protection with no tangible evidence; thus, it was the WDL's duty to get a regiment for Milwaukee. Everyone in the group admitted they did not fear for personal safety or that of their businesses. They also admitted that troops at the fairgrounds would not prevent a bomb from being detonated; however, as Milwaukee residents, they believed the "firing of a single bomb would be the signal for instant uprising of indignant Americans, and a riotous assault upon the life and property of citizens of German descent." King wrote General Barry that some of Milwaukee's very best citizens comprised the committee, and he appreciated their patriotic motives and desire to secure Milwaukee from attack. Yet a dozen equally prominent residents had told King the previous week that there was no need for troops. For all the committee's talk, King was not convinced and did not recommend mobilizing troops to Milwaukee. Besides, he added, 800 National Guardsmen within Milwaukee could be ready at a moment's notice if any trouble arose.[20]

Bloodgood, Goff and Spooner refused to give up. They traveled to Chicago the following day to state their case to General Barry. Barry reviewed the situation with them, sharing communications he received from Governor Philipp, Adjutant General Holway and General King. Barry offered to telegraph the governor that the Citizen's Committee was in Chicago repeating its opinion that troops were needed in Milwaukee and that the 1st Regiment was available. But Bloodgood and the others wanted no such thing, perhaps realizing that Philipp would view their efforts as circumventing his authority. Barry told the group that he was ready to do whatever he could, but he could not place troops in Milwaukee against Philipp and Holway's wishes. The committee's ambassadors were no doubt disappointed, but Barry thought they went away "satisfied with the interview."

A grudging, uneasy calm seemed to settle upon the WDL. Holway wrote King on April 2 that he was "glad to know that the Milwaukee gentlemen are recovering normal vision" (years later, King admitted that helping defuse the situation was one of his proudest achievements). It was easy, he added, to get alarmed at a time like this, but "if repressive measures are used without cause, the result is very much worse than if nothing at all was done." There were "sources of information" in place in Milwaukee that would provide advanced warning at the slightest hint of trouble.[21]

One of those sources was Louis Alsted, a Milwaukee paper manufacturer. On March 26, Guy Goff arranged a meeting during which Alsted explained to Special Agent Fitch that he wanted to raise about $4,000-$5,000 among other manufacturers and prominent people in Milwaukee to hire 30 private detectives from Chicago (it was important to have men who would not be known in Milwaukee). These men would report to Fitch and help gather information and, if necessary, assist with any emergencies. Fitch was not concerned about any overlap between these extra-legal efforts. He thought the idea a "splendid thing." It meant the DOJ would have access to 30 more men with the "further advantage of their working under cover."

Fitch helped orchestrate the formation of still another organization, which was spreading across the country. A.M. Briggs, vice-president of a Chicago advertising firm, formed the American Protective League (APL) in February to assist the nascent and undermanned Bureau of Investigation by having American citizens serve as an unofficial undercover spy network. Securing the approval of the Bureau of Investigation, Briggs set up APL branches in cities with large alien populations. He arrived in Milwaukee on March 26; Fitch escorted him to a meeting of a dozen leading citizens at Bloodgood's office in the Mitchell Building. Briggs explained the purpose of the APL and its plan of organization, all of which, according to Fitch,

was "greeted with the utmost enthusiasm." Fitch and Briggs then met with Chief of Police Janssen to let him know an APL branch was being formed in Milwaukee and asked for his cooperation. Janssen assured them they would have it and could depend upon the Milwaukee Police Department at all times.[22]

To conservative businessmen and like-minded citizens, groups such as the APL and WDL were needed because it was clear much of Wisconsin opposed joining the carnage in Europe. In late March, the Emergency Committee of the national Socialist Party wrote to Senator La Follette, urging him to oppose any declaration of war. Instead, American citizens should be warned to stay out of danger zones declared by the belligerents. "Foolhardy persons who deliberately put their country in danger of war do not deserve protection," the committee argued. But if the question of war should be voted on, it should be put to a referendum of all adult men and women in the U.S. The committee put the responsibility of any bloodshed squarely upon Wilson's shoulders: "Will your conscience permit you to do so when you can avoid it by voting against war, or by letting the people decide the question themselves?"

President Wilson knew better than to let the citizens of Wisconsin have a say in the matter. In early April, a referendum on entering the war took place in Monroe; only 95 voted in favor while 954 voted against the measure. Citizens in Sheboygan also voiced their opinion. Incomplete results from a vote showed 17 yes votes and 4,112 no votes. And an unofficial referendum in Manitowoc resulted in 15 votes in favor of joining the fight and 1,460 against. The German-American Alliance held a similar referendum in Milwaukee. The results, given the city's large German population and strong Socialist party, were not surprising. It was reported the totals ran 300 to 1 against the war.[23]

In light of Milwaukee's questionable loyalties, the Marlin Arms Corporation of New Haven, Connecticut, wrote to the Milwaukee Chamber of Commerce in late March, stating that protection of local interests required the purchase of firearms by the city's "Home Guard companies" or private interests. The company indicated it could quickly supply any machine guns, rifles or riot guns "for buck shot loads" that may be needed.[24] Thankfully, the offer was ignored, but calm, rational thinking was becoming increasingly rare in Milwaukee; with DOJ agents and APL operatives in place, the structure for a campaign to repress antiwar dissent was ready. All that was needed was the green light. President Wilson provided that when he asked Congress on April 2 to declare war on Germany.

3

> Where has there been incendiary explosions … ? Have we had any anarchy here?
> Dr. Charles McCarthy to Theodore Roosevelt, May 14, 1917

The declaration of war on Good Friday, April 6, stirred conflicting emotions and actions among Milwaukee citizens. Those who had clamored for war, such as Lucius Nieman and the *Milwaukee Journal*, were thrilled that the U.S. was finally defending its rights and liberty throughout the world. A *Journal* editorial asserted that the country was fighting "against barbarism such as has never been known in history." The triumph of German militarism would mean that all societies would be ready "to cover the fair face of the earth with desolation, to wreck homes and happiness and send the horrid alarm of war among peaceful and simple people." The declaration had a very different effect upon nervous Milwaukee housewives, whose households were already being squeezed by spiraling inflation. They went on a buying spree, stockpiling flour, sugar and other staple goods for fear that prices would rise even more. Steinmeyer grocery sold 40,000 pounds of sugar per day the week after war was declared. Women were "buying their heads off," said one grocer, "many of them seem to be trying to get in enough provisions for a year." The panic made things worse. Dwindling sugar and flour supplies and inevitable price gouging by area merchants drove prices even higher. The price of a barrel of wheat flour rose $2.50 in the ten days after war was declared, and grocers resorted to limiting the amount customers could purchase.[1]

William George Bruce, one of the city's few audible voices of reason, seemed to speak for the majority of Milwaukeeans. He criticized the "bubblings of inflamed minds" at both ends of the spectrum, especially the "vainglorious citizen who has been a failure in the arts of peace… and proclaims patriotism in noisy accents." Those people, Bruce asserted, reveled in the attention they received, but as a rule they had not enlisted

and were not likely to do so. But beneath the hysteria lay a "stern reality, a serious purpose and an unescapable duty." The declaration of war demanded a united citizenry to meet this reality. "The hour of quibbling has gone by," he concluded. "Regrets are in vain. Action is the order of the day."[2]

Bruce's sentiment reflected the widespread sense that Americans had a duty to make sacrifices for the country's best interest. This sense of obligation stemmed from many sources: the political tradition of republicanism that valued the common good over individual liberty; Christian beliefs that characterized duty as a virtue; and paternalistic ideals that demanded obedience to established social hierarchies. Rapid changes in society during the Progressive Era prompted native-born Americans to redefine citizenship as a process to "Americanize" immigrants or elevate the working-class to middle-class norms of behavior. The Progressives' active participation in voluntary associations—churches, clubs, schools, unions—organized much of public life in order to speed up the process. Civic voluntarism helped Americans develop a collective identity and shaped social bonds to each other and to the state.[3]

But World War I fundamentally altered Americans' relationship to the state. Extraordinary demands for the war effort spurred tremendous growth in federal bureaucracy and prompted government intervention into, as one historian wrote, "American bedrooms, kitchens, and congregations, places where the federal government hadn't always been before."[4]

To reach those areas, the federal government—lacking a full-fledged bureaucracy—relied on volunteers at state and local levels to facilitate the massive war build-up. And the unlikely pair of Dan Hoan and Wheeler Bloodgood spearheaded the effort in Milwaukee County. A couple days after war was declared, Bloodgood visited the mayor's office and asked Hoan his opinion on the best way to help the war effort. The mayor pointedly stated he did not support the Socialists' anti-war plank adopted at an emergency convention in St. Louis and outlined a plan to coordinate all war-related activities. Realizing the importance of Hoan's stance, Bloodgood informed President Wilson that the Socialists were not united in their opposition to the war and invited the mayor to reiterate the details to a group of citizens that Bloodgood wanted to bring together. In a private dining room at the Plankinton Hotel, Hoan met this illustrious group, which included Reverend Herbert Noonan, Marquette University president; Walter Davidson of the Harley-Davidson Company; and August Vogel of the Pfister-Vogel tanning company. Hoan later learned that these men were the Executive Committee of the Wisconsin Defense League.

Hoan, ever the fervent Socialist, told the gathering that most Milwaukeeans believed the conflict was a rich man's war. To gain the citizens' cooperation or, better yet, their enthusiastic support, the first thing that should be done was to form a Council of Defense that represented and gave a voice to every faction in the community. In addition, Hoan urged his audience to use its influence on Congress to pass legislation that would prevent the wealthy from "waxing fat on the war." Most people naturally loved their government, he said, and if political leaders demonstrated an understanding of problems the working class faced and "play[ed] fair," the people would learn to "love, admire and respect" the government. Therefore, the Council of Defense should include an industrial committee to manage production and employment issues and a financial committee to handle financial matters. It should also include a welfare department to assist those in need and sell food and fuel directly to the population at or near cost to battle runaway prices. When Hoan finished, the group unanimously decided that such a Council of Defense be established and charged Hoan and Bloodgood to immediately inform Chairman of the State Council of Defense Magnus Swenson that efforts were underway. The State Council endorsed the plan on April 26; four days later, representatives from a mixed bag of labor, civic, religious, patriotic, manufacturers' and women's organizations met and formally established the Milwaukee County Council of Defense, naming Hoan chairman and Bloodgood vice-chairman. The council's effective leadership would meet every wartime demand, but the group itself was eventually caught up in the war's hysteria and became a battleground of its own.[5]

Addressing needs of physical battlegrounds in Europe was top priority, however. Mobilizing a military force to fight a modern war justified the federal government's first intrusion into the lives of American citizens. When Congress declared war, U.S. armed forces were woefully inadequate. It was determined that an army of millions was needed. How to raise such a force provoked a vigorous debate in Congress and around the nation. The majority of Americans, especially those who opposed the war or centralized state power, advocated for the longstanding tradition of a volunteer army. But others insisted conscription was the most effective and efficient method to raise needed troops. Draft boosters believed the volunteer system had other defects. Milwaukee Attorney Herbert Laflin indicted it as "undemocratic, unfair and unjust placing the burden of the country's defense upon the loyal and patriotic youth of the land, permitting the slackers and cowards, the poltroons and the quitters to go scot-free of the hardship and responsibility."[6] Once it was obvious war was on the horizon, President Wilson reluctantly came around to supporting conscription and threw his weight behind the Selective Service

Act, which became law on May 18, 1917. All males between the ages of 21 and 30 had to register on June 5 for federal service at polling places run by local draft boards. The measure brilliantly deflected opponents by giving the compulsory draft a veneer of voluntarism by using the term "service." Moreover, placing local citizens in control of draft boards linked the process with democratic political participation, providing residents a personal stake in its success.[7]

As registration day neared in Milwaukee, uneasy patriots again raised the specter of pro-German resistance. The *Sentinel* noted how wild rumors of anti-registration plots involving some of Milwaukee's leading citizens coursed throughout the city to the point that these claims were treated as a joke. The Department of Justice confiscated a large number of cards circulating in Milwaukee, which read:

<center>
ENLIST
Die for England. Feed the war. Starve America.
Read the *Journal*. A great British daily printed in America.[8]
</center>

Fearful of the pervasive anti-war feeling in Milwaukee, Guy Goff wrote the U.S. Attorney General that "the local situation may be expected to show its ugliest features not later than June 5th." Senator Husting chimed in as well, telling Secretary of War Baker that registration in Wisconsin would fail because Republican Governor Philipp sympathized with the Germans and had surrounded himself with "pro-German if not disloyal people and would deal so feebly with pro-German manifestations that riotous disorder would certainly take place in Milwaukee." Baker contacted Provost Marshal General Enoch Crowder, who then reached out to Governor Philipp to determine if troops were needed to crush any anti-registration agitation. Philipp telegrammed Crowder that he had heard of no opposition "of any consequence" in Wisconsin. "I hope that the Secretary of War," he added, "will not lend his aid to any scheme or suggestion that may come to him from hysterical people in our state. I feel that we are masters of the situation and if anything should arise that would require federal aid, I will notify you promptly."[9]

Philipp had a better grasp of the patriotism or, at the very least, sense of duty of Milwaukee citizens. Mayor Hoan, ever concerned about balancing his official duties with personal opposition to conscription, consulted Victor Berger about the path he should follow regarding the draft. Berger told him to comply with the law because that was the "only way to make a bad law odious...and have it abolished."[10] Despite the Socialists' position, the city's police department was ready for any emergency—just in case. On June 5, Police Chief Janssen dispatched officers to each registration

station with orders to arrest anyone who tried to disrupt the proceedings or made any remarks against the draft. Once again, the hand wringing was for nothing. At the end of the day, nearly 49,000 men had registered; only one disturbance occurred, though details of the incident differ among various sources. The *Milwaukee Sentinel* reported a fight broke out when one man, anxious to get back to work, cut in line ahead of another, while other sources indicate the altercation stemmed from two men vying to be the first in line to register. Another example of Milwaukee's patriotism was identified in the *Sentinel*, which recounted that, for the first time in its history, the city was completely "dry" when all of the nearly 2,000 saloons complied with Governor Philipp's request to close for the day. Patriotism, however, only went so far. As soon as the registration stations closed at 9:00 p.m., the bars reopened and did a very brisk business.[11]

The absence of any mishaps convinced Secretary of War Baker that Husting and other patriotic citizens had cried wolf once too often. Baker wrote President Wilson that, from the very start of the draft law, Husting "has been wrong in his judgment and in his forecasts." Wisconsin's registration was a model of efficiency, and Philipp cooperated more zealously than any governor in the nation. Husting, Baker concluded, "has gotten into a frame of mind where he suspects upon less ground than would afford a proper basis for action by those of us who are charged with the responsibility for action which must stand criticism."[12]

Troops practicing a tent drill at Marquette University stadium. (Photo courtesy of Milwaukee County Historical Society)

Milwaukee's patriotism and support for the military knew no bounds. In addition to assisting with draft registration, the Council of Defense and its far-reaching organizational structure helped various military branches recruit by mailing notices to single men in each ward, calling them to meetings where officers spoke. Flags were displayed by churches, schools, homes and businesses. The Milwaukee Baptist Association passed a resolution encouraging pastors to stage patriotic programs and give speeches that promote "virile and noble Americanism." Archbishop Sebastian Messmer exhorted Milwaukee Catholics to, "as true and patriotic citizens of the land, and faithful followers of God's holy law, do our full duty to our country in this time of trial and sacrifice." Women— including nearly 98 percent of the student body of Milwaukee-Downer College—joined the Red Cross or other service groups, knitting wool garments for soldiers. By year's end, more than 500 "Soldier' Pals" were writing regularly and sending local newspapers to Milwaukee men in military camps. Milwaukee draftees were treated to banquets and parades; one such event in September drew a crowd of 75,000 to watch 6,000 men march. Blaring factory whistles escorted troop trains as they passed through the city at any time, day or night. Bands and choral groups often regaled soldiers at train stations, and women of the Red Cross "Canteen Committee" doled out more than 3,000 "cheer gifts" of chocolate, cigarettes, fruit, sandwiches, coffee and postcards to the Doughboys. One soldier wrote to the Red Cross that "of all the cities we passed through none of them had anything on Milwaukee in the way of treating soldiers."[13]

While Milwaukee passed its first test with flying colors, the Council of Defense turned its attention to other vexing interrelated problems that the war triggered: labor shortages, increased industrial and food production, food conservation and raising funds needed to fuel the war effort.

As the military drained men from the workforce, Milwaukee manufacturers scrambled to find people to keep factories operating at peak capacity and fulfilling the glut of war contracts secured from the federal government. The Council of Defense's first step was to try to coordinate the existing labor pool to ensure the least amount of disruption for employers. The Selective Service Act exempted workers who were deemed vital to essential war industries. Thus, the council sent questionnaires to Milwaukee manufacturers in June, asking each of them to rank employees as essential, highly desirable or able to be released for military service. The council's Department of Manufactures then worked with local businesses and the Wisconsin Industrial Commission to connect workers with available jobs. The department realized that mobilizing the public's patriotic spirit had to "in every case precede the mobilization of their

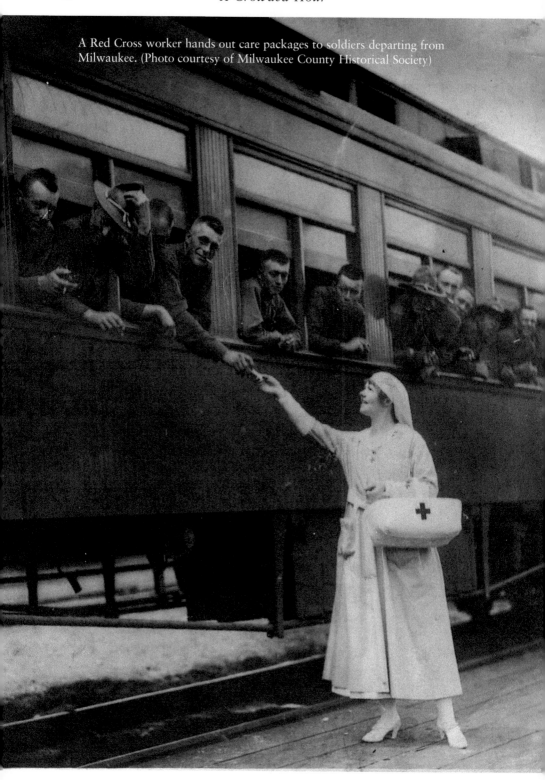
A Red Cross worker hands out care packages to soldiers departing from Milwaukee. (Photo courtesy of Milwaukee County Historical Society)

physical powers" and launched a publicity campaign through newspapers, posters and church pulpits urging everyone to do their bit by getting a job and sticking to it. If persuasion failed to do the job, the State Council of Defense directed every policeman and sheriff in Wisconsin to enforce vagrancy laws and give idle men three choices: enlist, get a job or go to jail, where they would have to do hard manual labor.

Even the most enthusiastic enforcement did not compensate for the loss of so many men to the military. Consequently, employers turned to other sources of labor. One option was African-Americans from the South. Spurred by corporate agents and dreams of a better life, millions of blacks migrated to industrial cities in the North. Milwaukee's share of this exodus was negligible compared to Chicago, but the increase of the Cream City's black population was enough to gain the notice of one police captain, who told the *Milwaukee Leader* in late July he estimated some 500 to 600 African-Americans had arrived in Milwaukee during the first half of the year. Later in 1917, Reverend Jesse Woods of St. Mark's A.M.E. claimed that about 800 new residents had relocated to Milwaukee, raising the city's black population to nearly 2,000. Most Milwaukee businesses ignored this labor pool, however. No more than 11 of the city's 2,000 manufacturers hired black workers, and only six of those companies—Plankinton Packing, Trostel Leather, Pfister-Vogel Tannery, Allis Chalmers, Falk Manufacturing and Milwaukee Coke and Gas Company—hired more than 75 percent of all black workers. Lumberyards and railroads also hired African-Americans, including some black women. But since the vast majority of black workers were unskilled, the jobs they filled tended to be the dirtiest and most unpleasant "bottom-of-the-barrel" tasks.

Whites could no longer ignore the growing black population, and for various reasons, the increased African-American presence did not sit well with labor leaders or some politicians. Frank Weber of the Federated Trades Council claimed the only reason Milwaukee businesses sought black laborers was to reduce wages. There was no labor shortage he charged, but employers simply did not want to pay a living wage. Socialist Alderman William Coleman likewise decried the influx of blacks. Worse yet, he said, is that "certain types of negro women who are a menace to the morals of the city" were coming with the men. And a Council of Defense Department of Administration report concluded that importing blacks was the path of least resistance with regard to the labor problem, but the "social and economic consequences…are too serious to contemplate except as a last resort. The better plan seems to be to mobilize and utilize our available labor so as to get the most out of it and to avoid the saddling upon the country of a race problem which should and can be avoided."[14]

A more palatable option for unions and politicians—at least to a certain extent—was to employ women. Women had been working in American factories since the early 19th century, and that number climbed steadily into the early 20th century, with the flood of immigrant women who helped fill America's voracious industrial demand for labor. But the national crisis of World War I was the catalyst for more than one million women nationwide to do their part for the war effort and take on jobs in the country's defense plants. Milwaukee women were up to the task. In July, the *Milwaukee Sentinel* reported that several large firms had hired women and that approximately 5,000 more positions would open in the county by the fall. The Lindemann & Hoverson Company, manufacturer of pots and stoves, hired women during the summer for its new enameling works, and there was "no hesitation" to hire others when a wick department was established. By August, some two dozen women were loading cars, piling lumber and pushing trucks at the Milwaukee Refrigerator Transit and Car Company, and the Briggs & Stratton factory alone had nearly

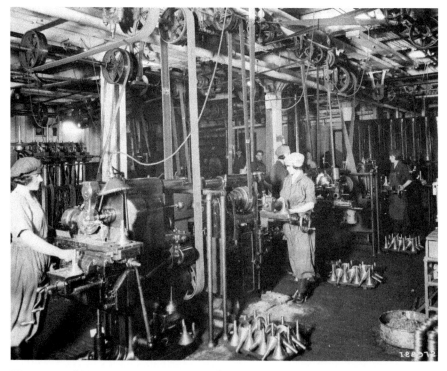

Women machining parts at International Harvester's Milwaukee Works, ca. 1918. With so many men in the military, Milwaukee businessmen desperately needed a new supply of labor to keep factories humming. Thousands of women picked up the slack and took on formerly male-dominated jobs in Milwaukee factories. (Wisconsin Historical Society, WHS-8156)

200 women running press machines and assembling auto parts. Women across the board were praised for their dependability, dexterity, patience and concentration.

But concern arose for their well-being in these unfamiliar settings. A Briggs & Stratton foreman noted there was a danger of women getting their dresses caught in the machinery, and he commended the "most progressive" of them who wore overalls. These coarse, bloomer-style overalls were often called "womanalls," and one Milwaukee businessmen predicted they would be the "greatest dress reform wave this country ever experienced." A *Sentinel* reporter assured readers that they were not *too* masculine. The ones worn at the Briggs & Stratton plant were "pretty, checkered ones, radically new in style, and lend their wearers a look of uniqueness as well as usefulness." In addition to fashion matters, there was widespread belief that working the same hours as men would lead to fatigue and absenteeism, thereby reducing output. To combat the problem, many employers instituted 15-minute breaks in the morning and afternoon.

Despite the increased role of women in industry, there was some resistance on the part of organized labor. W.J. Alldridge, an official of the machinists' union, saw the trend as a question of securing cheap labor and not a scarcity of labor. If employers, he added, really wanted to demonstrate their patriotism, they would pay women the same wages and give them the same conditions as men, and the union would not object. But he was not confident of that happening. Alldridge then voiced the opinion that hounded female industrial workers constantly: "Women are not fitted by nature for the various work that men can do. It also will tend to deteriorate the standard of the future generation." After Marquette University President Father Noonan echoed those sentiments, Lutie Stearns, the guiding force behind the establishment of Wisconsin's public library system as well as a determined advocate for women's suffrage, challenged his assertions.[15] "It is difficult," she noted, "for certain men devoted to the old type of home and mother to reconcile themselves to the new world movement of women." When these men "took industries out of the home they took the old type of women with them." The present duties and responsibilities differed greatly from the old days, and "old-fashioned men may as well make up their minds to honor and respect the new position of women."[16]

Thanks to women taking on "new positions," local manufacturers could confront other labor-related issues. Ensuring the motivation and loyalty of the working class was imperative for the success of any mobilization effort; therefore, the Wilson administration tried to placate the labor movement rather than crush it as many business leaders wanted. The

President found a willing partner in Samuel Gompers, president of the American Federation of Labor, who viewed cooperation as an opportunity to advance the labor cause. As the price for Gompers' collaboration, the government agreed to impose guaranteed wages on government contracts and an eight-hour work day. In return, Gompers did not insist on closed shops; he also undermined radical unionists and resisted strike efforts. Other local businesses turned to detective agencies to maintain labor "peace." They furnished spies to infiltrate the workforce and not only identify "chronic kickers and the agitators" but also promote harmony and good cheer to enhance worker satisfaction with the company.

Still, labor turnover was a chronic problem throughout the war. Heightened demand for a shrinking supply of workers forced Milwaukee businesses to offer wages that were on average 10 to 15 percent higher than in 1914; however, Socialists and union leaders claimed the increase was not high enough to offset the inflated cost of living, which had jumped 40 percent. These circumstances prompted many workers to act essentially as free agents, changing jobs whenever they found a higher-paying opportunity. In mid-July, the Council of Defense indicated that employee turnover hovered around 20 percent in the metal trades—nearly double the rate from the previous ten years. The textile industry faced a 15 percent turnover rate, and the tanning industry, 23 percent. Instability in the labor market was not completely due to worker greed. The Council of Defense found area manufacturers resorted to "a good deal of stealing of help." In addition, Milwaukee's labor unions flexed their muscle when deemed necessary. Though most of Milwaukee's union rank and file opposed entering the war, they did not resort to widespread strikes to disrupt production and wring wage concessions. Nevertheless, confrontations did occur. On July 16, for example, 100 members of the United Brotherhood of Leather Workers Local 54 walked off the job at the Wallace & Smith Company, protesting that some men were paid as little as 28 cents per hour on a government contract for harnesses and saddles. A federal mediator was called in to settle the dispute. Similarly, a department at the Globe Seamless Steel Tube Company struck for higher pay. The Council of Defense Department of Manufactures investigated and found that these men had received better wages than those in surrounding shops. Council officials persuaded most of the strikers to return to work. Those who balked were replaced. Trouble flared up again shortly thereafter, and two agitators were "effectively silenced."[17]

Having to face these minor bumps in the road, Milwaukee businesses churned out every conceivable necessity for the military—from underwear, leather mittens and saddles to rifle grenades, truck frames and ship engines—and they reaped huge profits. The Council of Defense helped

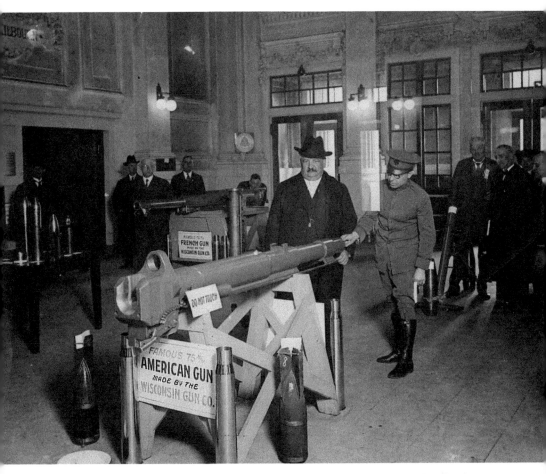

Milwaukee factories produced an array of goods for the military from shoe leather to field artillery pieces from the Wisconsin Gun Company. (Photo courtesy of Milwaukee County Historical Society)

secure government contracts totaling an estimated $30 million to $50 million, and the value of goods produced in Milwaukee in 1917 soared beyond $595 million, an increase of more than $125 million compared to 1916.[18]

Food was every bit as crucial to the war effort as industrial production, with Governor Philipp claiming, "Bread is as essential as bullets in carrying on a war." Complicating the situation, the U.S. faced the possibility of a food crisis because food production had not kept pace with population growth, and bad weather in 1916 resulted in poor harvests. To forestall troubles at home and to satisfy our military and allies' acute need for foodstuffs, the federal government adopted a three-pronged approach developed by Magnus Swenson of the Wisconsin Council of Defense:

increased production, food conservation and the use of substitutes for several commodities. To coordinate the effort at the national level, President Wilson encouraged Congress to establish the Food Administration and named Herbert Hoover to lead. Increasing the food supply was the easiest part of the plan. Farmers were more than happy to do their patriotic duty and concurrently take advantage of soaring food prices by planting as much as possible. Rural areas, however, felt the pinch of a reduced labor force just as urban industries did. To help Wisconsin farmers, the Milwaukee County Council of Defense established a division within its Labor Bureau, collaborating with local agencies to recruit high school boys for working on farms all over the state. Some were sent to Sturgeon Bay to help with cherry picking, and others went to Turtle Lake to work with the Wisconsin Pea Canning Company. By the end of the summer, more than 700 boys participated. While difficult to assess the program's impact, Wisconsin increased its food production by 25 percent while sending 50,000 farmers to war.[19]

Milwaukee women also took steps to increase food production. The National League for Woman's Service in Wisconsin established four "demonstration gardens" in each part of the city to serve as models for vacant lot gardeners. Displaying the efficiency and organization that characterized the Progressive ethos as well as the military spirit of the time, Woman's League Treasurer Mrs. Louis Auer outlined a master plan during a mass meeting at the Davidson Theatre on April 20. For example, the east side garden, a five-acre lot at Hartford Avenue between Oakland and Maryland avenues, would be divided into twenty, 150' x 20' lots. The 160 clubs that made up the league should form detachments of 12 and work in squads of three, each woman working one morning per week. The league also secured promises from six school kitchens to can surplus produce from the gardens, which would be used to help needy families in Milwaukee. During the east side garden's opening ceremony on May 9, the Boy Scouts raised an American flag on the flagpole placed in the middle of the plot. Throughout the summer, the scouts raised and lowered the flag every day, and when it was time to harvest, they patrolled each of the four city gardens to prevent the vegetables from being stolen. At the end of the season, the Woman's League had produced 4,200 containers of canned fruits and vegetables and gathered numerous bins and bags of root vegetables for distribution.[20]

Compared with food production, having people change eating habits and conserve food proved to be more problematic. At the national level, Hoover rejected the unpleasant option of outright rationing or coercion to encourage saving. Instead, he appealed to Americans' patriotism and voluntary impulses through a massive propaganda campaign by the

Committee of Public Information. The government appealed to women—the moral guardians of American society—to become "culinary soldiers" and facilitate the country's military success. To Hoover, this effort was much more than a pragmatic solution to an immediate problem. Accomplishing the desired ends through voluntary exertions spoke to the very essence of democracy. He wrote to John G. Gregory, editor of the *Evening Wisconsin*, that if successful, "We shall have demonstrated the ability of democracy to defend itself through its own instinct of organization, for if it cannot rise to this situation, it will have proved itself a faith which cannot endure in competition with the forces of autocracy."[21]

The Food Administration greased democracy's "instinct of organization" by employing non-too-subtle propaganda to encourage women nationwide to sign pledge cards, indicating they would do their duty and conserve as much as possible. Women's clubs across the country put the plan into motion. In Milwaukee, the Women's League and Women's Council within the County Council of Defense (with shared leadership, these organizations effectively were one), gathered more than 3,000 volunteers to canvass every household in the county; the police handled Milwaukee's more "undesirable" districts. To aid planning efforts, the County Council of Defense went a trifle further than the Hoover cards. It developed cards that requested additional information, such as how many mouths each household had to feed, how many rooms had to be heated and how many family members were serving in the military or industrial armies. Apparently, enough suspicious housewives questioned the purpose of the census and the method to collect the information, causing Council of Defense Secretary Willits Pollock to address the misconceptions. He reiterated that the information was to be used only for Council of Defense planning. The women collecting signatures would not examine anyone's basement or see if there was a stock of food on hand, nor would they ask questions about family income or names of people living in the house. Women fanned out across the area in August and collected roughly 25,000 signatures, though they encountered "great difficulties" in some areas. More than likely these occurred in immigrant neighborhoods, where inhabitants understandably were wary about answering questions from middle-class women at their doors. A second pledge drive was held in the fall with the goal to get signatures from 75,000 of Milwaukee's 110,000 households. To counter the "great difficulties," the Council of Defense issued instructions for workers: "Be polite—be cheerful. Don't Insist. Don't appear officious. Don't go into the house. Don't ask unnecessary questions." The council hedged its bets by enlisting the aid of area clergy and children in local elementary schools. The move was spectacularly successful. By early November, Milwaukee school children had procured between 40,000 and 50,000 signatures.[22]

A billboard in the Court of Honor on Grand Avenue (now West Wisconsin Avenue) encourages Milwaukeeans to conserve food. (Photo courtesy of Milwaukee County Historical Society)

With the support of Milwaukee housewives, Hoover's food program focused on conserving essential foodstuffs—wheat, meat, milk, fats and sugar. A directive from the Food Administration designated each Tuesday, starting September 18, 1917, as a "meatless" day and each Wednesday, starting September 19, as a "wheatless" day. Households, restaurants and hotels were encouraged to find alternatives to each staple. The County Council of Defense and area restaurants experimented with bread recipes to find a combination that was palatable. Milwaukee bakers developed a "War" or "Liberty Bread" that used oatmeal to reduce the amount of wheat by 25 percent. On the first day it was available, Milwaukeeans bought 10,000 loaves. Combinations of corn and wheat as well as rye and wheat were also tried. Housewives were encouraged to serve more fish and poultry, and the *Milwaukee Sentinel* reported on August 19 that Anton Bulgor, an enterprising Milwaukee butcher, was selling horse porterhouse steaks at 12 cents per pound, round steaks at ten cents and soup meat at nine cents. Horse sausage would be available soon. "Horse meat has been used in European countries for many years and there is no reason why it

should not be a satisfactory substitute for beef," he was quoted as saying. "In six hours I sold more than 163 pounds, and the women who tried it said it was good."[23]

Beyond feeding American and Allied armies, distributing food locally was an equally thorny problem. Allied demands for food pushed prices higher well before the U.S. joined the fray, causing food hardships and even demonstrations in 1916 and early 1917. No doubt fearing a similar situation in Milwaukee, Mayor Hoan appointed a commission in December 1916 to investigate the soaring cost of living and study the feasibility of establishing municipal markets to reduce prices by eliminating the middleman. The program remained in limbo until the buying binge and profiteering that occurred when war was declared convinced Hoan that city-run markets were essential. He telegrammed Governor Philipp that the present moment was "the most serious in the history of the city" and urged the governor to support a bill that gave the mayor authority to appoint a commission with the power to seize and distribute food and fuel to the public at cost. The Wisconsin legislature had already granted this power to the State Council of Defense, which was then extended to the County Council of Defense. Consequently, Hoan put his plan into action on May 18. The County Council sold 2,000 pounds of fish at the South Side Public Market on Mitchell Street and Eighth Avenue (now South 13th Street) and the Central Market in the Second Ward at five cents per pound; the entire amount was sold within an hour. The *Milwaukee Journal* reported it took two policemen to prevent a "near riot" at the South Side Market, with hundreds of Polish women jostling for position in line.

The situation was desperate enough that Hoan sent a telegram to Wisconsin Senators La Follette and Husting in July as Congress debated a food bill. He advised the senators that the federal government take immediate action to control the food and fuel situation in order to keep peace and maintain order in Milwaukee. Between 15 and 25 percent of Milwaukee families lived in poverty during peacetime and the current situation, he wrote, was infinitely worse. Instead of suppressing free speech and freedom of the press, the government could win the confidence and loyalty of these people by stamping out the treason of "coal, rail and food hoarding Benedict Arnolds" and taking over these activities before the people resorted to another Boston Tea Party.

The mayor had reason to worry, though not necessarily about a tea party. A committee representing an Italian neighborhood in Bay View complained to Hoan about increased food prices on a number of items but particularly the rise in the price of a bottle of beer from five to ten cents. The committee considered this an outrage. It asked, "How can a poor man with a family spend ten cents for a can of beer…? Without

shoes or money the people will freeze." Even worse, Milwaukeeans would "consequently have to drink water," a proposition that, given the state of the city's water, would be enough to spark a revolution on its own. The Milwaukee situation received a boost when Daniel W. Norris offered to back a $100,000 fund that would allow the Council of Defense to stabilize food prices and alleviate suffering among the poor during the winter. In addition, the city market system was expanded so that by the end of the year, Hoan and the Council of Defense had furnished three carloads of apples, 2,500 pounds of cheese, 30 carloads of potatoes, 140,000 pounds of fish, 4,000 pounds of split peas and 25,000 loads of vegetables.[24]

Yet, feeding the war effort involved more than foodstuffs; full mobilization also required exorbitant amounts of money. There was a vigorous debate within the Wilson administration regarding how to raise needed funds. The Secretary of Treasury rejected a direct tax—which would have made the war even more unpopular among many people—and ultimately decided to again rely on American voluntarism and patriotism to finance the war through bond drives. Socialists countered that the plan demanded unfair sacrifices from the poor while the wealthy accumulated obscene profits from the war. A direct tax, they asserted, especially on excess profits, was the fairest way to finance the war. Despite this argument, the First Liberty Loan Bill passed Congress easily and was signed into law on April 24. When the first bond drive took place in June, Milwaukee patriots looked upon the event as a litmus test of the city's loyalty. Thousands of volunteers swarmed every part of the city, encouraging all citizens to do their part—sometimes employing subtle pressure or outright violent threats to sell the bonds. Posters, parades and "4 Minute Men" speaking at venues around the city contributed to the sense of urgency. Even school children were urged (some said pressured) to purchase government war savings stamps or donate to the Red Cross. In late 1917, for example, the School Board chided Principal Thomas Boyce of Cass Street School for having children who had purchased stamps parade all around the school as examples to the rest of the students. Boyce denied this was a coercive tactic. "I am teaching my boys and girls to play the game for Uncle Sam," he was quoted as saying, "I am inculcating the idea of thrift in my school." The pressure on students led to some unintended consequences. Parents complained to School Board member and Socialist Elizabeth Thomas that some children resorted to stealing money to avoid being humiliated in front of their classmates. Thomas cited one case in which a kindergarten pupil stole $5 from his grandmother to give to the Red Cross, but on his way to school, an older boy stole the money from him. Whether given voluntarily or through pressure, Milwaukee once

more went above and beyond. An estimated 25,000 residents purchased $16,164,700 in bonds, which far exceeded the city's $14 million quota. A second bond drive during the fall was oversubscribed by nearly $8 million. In comparison, the state as a whole fell far short of the assigned goals in the first two bond drives.[25]

By any measure, Milwaukee met every challenge to its patriotism, giving credence to Dr. Charles McCarthy's words to Theodore Roosevelt. But that did little to remove the taint of treason from the minds of loyalists.

Two young boys salute America's war effort. Posters directed at adults and children alike were one of the government's most effective propaganda tools to stir up patriotic support of the war effort. (Photo courtesy of Milwaukee County Historical Society)

4

> It is about time for a court martial, a brick wall and firing squad for some of these traitors, the higher up the better.
> R. A. Dousman to Wheeler Bloodgood, September 1, 1917

"Patriotism," wrote William George Bruce, "has its lights and its shadows—lights that guide the way to true citizenship, that unite a nation in thought and action, that steel men against a foreign foe, that stir the heart and soul to love for flag and country." The shadows, however, "whither, stifle and kill a better self." Hatred run amok can "turn a beneficent stimulant into a vicious poison." It "projects its fangs into the finer relations of man, ruthlessly inserts its poison into cultural aspirations, and aims to kill the things that ought to live. Even the fate of birth is no longer sacred."[1] For all the "lights" Milwaukee displayed during the war, an equal number of shadows darkened Milwaukee society and fractured the community along multiple fault lines.

These shadows—over-the-top suspicion, hatred and slander—certainly extended beyond Milwaukee, smothering lights across the nation. Historians have grappled with why such oppression occurred in a society that characterized itself as a progressive beacon to the rest of the world. Many confrontations revolved around something as base as individuals using the cloak of patriotism to settle petty personal, professional or political scores. Some disgruntled parishioners of St. Stephen's Catholic Church, for example, charged their pastor Father Polomsky with disloyalty because they preferred the priest who had previously run the parish. In another instance, a 12-year-old girl at Dover Street School informed the Department of Justice that Charlotte Albert, a teacher of German, refused to permit students to salute the flag. The investigating agent found the young girl "rather inclined to be 'forward'" and dismissed the allegation.[2] Other studies insist the war tapped into middle- and upper-class anxieties among those threatened by cultural disunity and provided the opportunity

to enforce a cohesive, like-minded American society. Anyone who did not adhere to idealized citizenship endangered the fragile American state and weakened republican government; thus, such persons had to be silenced.

Still others point to the climate of fear that President Wilson and the federal government incited. Realizing the war was unpopular among many Americans, government officials manufactured public support and manipulated public opinion through a barrage of speeches, posters and movies as well as the press to promote hatred for all things German and loyalty to the flag.[3] In his war message to Congress, Wilson made the distinction that the U.S. was going to war against an irresponsible, autocratic German government and had no quarrel with the German people. The President explained how Americans would prove their friendship through treatment accorded to millions of German-Americans in the country—as long as they were loyal to neighbors and government in the "hour of test." But if they were disloyal, he warned, they would be dealt with by "a firm hand of stern repression."[4] Convinced that the nation in particular and democracy in general were fighting for survival—though there was no evidence Germany intended to invade the U.S.—the American public seized upon the raucous rhetoric and resorted to any means necessary to stamp out dissent in all its forms, while Wilson's administration did nothing to rein in the oppression.

Milwaukee patriots had other reasons to clamp down on what they considered pro-German propaganda. Ethnic tensions certainly played a role. On April 7, Michael Kruszka, editor of the Polish newspaper *Kuryer Polski*, informed the U.S. Attorney General that he had many German friends who were "so honest and so trustworthy that I would without hesitation trust them with everything I have." But at that particular time, he added, "I would not trust them with the guarding of a 5-foot American bridge" because they would destroy it if they felt it helped the Germans and harmed the U.S. Though they may swear loyalty to the U.S., "the slightest discussion of war with Germany changes them into the most fanatic Germano-maniacs and Americano-phobes, and then some of them are ready to kill every American and every anti-German on sight, even if they should die for it on the spot." Later in the year, two Polish women working at the Phoenix Hosiery Company reported to the DOJ that two other women at the plant were so pro-German that the other "loyal American girls" were on the verge of quitting their jobs. A DOJ agent interviewed the accused agitators. One admitted she made inflammatory remarks to get even with the Polish women who provoked her. The other claimed, "We Germans are always having trouble with the Polacks in my department, they are always talking against the Germans and that makes us Germans sore."[5] Beyond the ethnic sparring, another motivation for

loyalists was the almost feverish desire to redeem the city and state's patriotic reputation across the nation.

Perhaps these multi-layered or overlapping motivations made it difficult for loyalists to discern any grey areas of dissent, but given that propaganda spewing from the Committee on Public Information portrayed German soldiers as raping, child-butchering, cannibalistic apes, it was not surprising that the first casualty of the war was toleration for any tangible evidence of Germanic heritage. On a superficial level, sauerkraut became "liberty cabbage" and dachshunds became "liberty pups." In Milwaukee proper, federal agents had Jacob Best, a prominent wholesale liquor salesman, remove a calendar that had pictures of Kaiser Wilhelm and Field Marshal Von Hindenburg. Best explained that the calendar had been in his store for two years, and he had simply forgotten about it. He quickly complied with the order. DOJ Agent J.B. Barry said displaying pictures of enemy leaders was against the law, and violators could be criminally prosecuted for giving "aid and comfort to the enemy." In addition, DOJ agents flexed their muscle in ridiculous fashion, insisting that flour in containers with the legend "Ueber Alles, Pure Rye Flour" must not be sold in Milwaukee. They ordered one downtown grocer to transfer the flour into "Americanized" containers. To Erich Stern, these "pathetically ludicrous" examples of petty persecution proved German-Americans were not furnishing war propagandists with any concrete evidence of wrongdoing.[6]

German-Americans knew it would be nearly impossible to convince neighbors of their patriotism. The *Germania-Herold* cautioned readers to "exercise superhuman restraint....You may have proven your loyal citizenship for a generation or longer, you may have given evidence of loyalty and patriotism during the present crisis, by your readiness to serve your country with soul and body and fortune—nevertheless you will be suspected of disloyalty."[7] Rumors of German-American disloyalty in Milwaukee, mingled with stories of German spies across the nation, intensified after Wilson declared war. Albert Trostel, owner of a Milwaukee tannery, was an inviting target. A caterer once relayed a story about a wildly successful secret fund raiser at Trostel's home prior to the war, which German Ambassador von Bernstorff attended. The guest list included members from some of the city's wealthiest families, including Pfister, Brumder, Uihlein and Vogel. Trostel was also accused of funding a pro-German publication in New York and the anti-war *Milwaukee Free Press*. Another DOJ report mentioned a long tunnel that ran under Trostel's home on Lake Drive all the way to the lake, insinuating that it was used for some underhanded purpose. A reporter for the *Kuryer Polski* had heard frequent rumors that Trostel stored rifles to be used against the U.S.

That reporter contacted Trostel, who vehemently denied the accusation.[8] He was far from the only one to be accused. A citizen reported that 42 Austrians living in a building on 18th and Clybourn were making bombs and explosives and hiding them under the pantry floor. Furthermore, each of them had a distinctive tattoo on their arm. A DOJ agent and five members of the American Protective League searched the place. Finding nothing, they had several men take off their shirts but found no tattoos.

The passions of the time prompted some intemperate remarks from German-Americans. A self-professed loyal American residing at the Republican House told a government agent that the place was a "nest of German sympathizers" and the "most radical hotbed of Germans in town." He mentioned specifically an elderly, grey-haired German who shined shoes in the hotel. He had been outspoken in his support of Germany and called President Wilson "a dog" until Alvin Kloetsch, proprietor of the hotel, told him to stop because it would hurt business. In another instance, a government agent listening in on telephone party line conversations (itself a violation of privacy) overheard Max Reiche, a chemist, tell his brother-in-law that he hoped someone would shoot President Wilson and the others responsible for the war. When L.E. Lewis put up an American flag in his barber shop on National Avenue, he reported that his employee Henry Wallschloeger snarled, "What do you want to put that G___ d-____ thing up for? It is not good enough to wipe my nose on." A neighbor of Alex Rautman told DOJ agents that his wife's niece refused to join the Red Cross until "Uncle Sam made some arrangements to protect the nurses; that at that time there were returning to this country from France, five-hundred nurses who were pregnant as the result of the evil conditions under which they were compelled to work by the government." Rautman also allegedly spread a rumor that 119 caskets were shipped to the Great Lakes Naval Training Station for soldiers who died from overwork there and that three to five soldiers were cutting their throats each day at Camp Custer rather than endure the misery of intensive training.[9]

Loose lips frequently provoked violent responses. In May, an argument about the war sent five Milwaukeeans to the hospital with knife wounds and bruises. And Ralph Izard, a DOJ agent in Milwaukee, sent a note to Captain Moffet, commandant of the Great Lakes Training Station, explaining why Frank Christy was late reporting for duty. Christy was locked up in jail for a "physical demonstration of his loyalty as applied to the faces of one or more pro-German disturbers." The facts, Izard thought, constituted a valid excuse for Christy's tardiness. Most Germans who favored their homeland, however, learned quickly to keep their opinions to themselves. DOJ Agent William Fitch commented that the attitude of

the pro-German element had "changed materially" shortly after war was declared, "doubtless owing to exaggerated rumors that a number of their kind have been severely dealt with by officials of the Government. It is difficult to get other than a moderate expression in favor of Germany from them if they consent to speak at all."[10]

The prevailing intolerance motivated many German-Americans in Milwaukee to deny their ancestry and take steps to minimize any harassment. Within four months of the declaration of war, 250 people shed their German-sounding names. Julien Gauer, tired of being followed by private detectives and the subject of libelous gossip, changed his name to Saint Marie de Joannis. Name-changing continued throughout the war. In June 1918, Edward Lutzenberger changed his name to Edward Lutze because his friends ridiculed him for having a name with "berger" in it; Wilhelm Kramer changed his name "for obvious reasons" to Lincoln Williams, and Judge John J. Gregory granted Emma Carson a divorce as long as she changed her maiden name: Emma Kaiser. This trend did not sit well with some German-Americans. Anita Nunnemacher Weschler was stunned when she learned that her neighbors had changed their name from Schwartzburg to Harrison. One of the family's children told Anita that his mother said they changed their name because Schwartzburg "wasn't a nice name." Anita considered this an insult to "every one bearing a German name. As tho one had to change their name to be patriotic. I feel I am as loyal to my country as anyone else—and I am doing as much as I can to help—but I can't see the use of changing one's name."[11]

In this climate, the friendship that President Wilson's war-time message had asserted would be shown to German-Americans became harder to see after a proclamation issued on April 6. He placed a litany of restrictions upon all "enemy aliens," defined as males over the age of 14 who were not naturalized citizens of the U.S. Such persons could not possess weapons, aircraft, wireless radios or cipher codes. Wilson's proclamation limited their movements as well. They could not be present within one-half mile of federal or state military installations or factories or workshops that produced munitions or goods for the military. In addition, they had to have a permit from the President to live in or enter any prohibited area where their presence constituted a danger to peace and safety. Lastly, any enemy alien who posed a threat could be "apprehended, restrained, secured, and removed" without a warrant, court proceeding or hearing before a magistrate.[12]

Enforcing the aforementioned guidelines, government agents arrested 63 enemy aliens across the U.S. immediately after war was declared. The number grew to 295 at the end of June and 895 by November. By war's end, the government had imprisoned 6,300 enemy aliens in internment

To protect bridges, waterways and factories engaged in defense work, the federal government issued passes such as this to restrict the movements of German-Americans. (Photo courtesy of Milwaukee County Historical Society)

camps, including 38 from Milwaukee.[13] The tremendous need for labor and the general law-abiding nature of Milwaukeeans no doubt precluded more widespread arrests. Among the other 8,500 enemy aliens in the city—including at least ten from the School Sisters of Notre Dame—Wilson's provision concerning the forbidden zones was the most consequential. Because manufacturers worked on military contracts in nearly every area, essentially the entire city was barred to enemy aliens unless they had a permit signed by the U.S. Marshal and U.S. District Attorney. Residents from German-controlled areas of Poland avoided being designated enemy aliens by noting on their registration card that they were "Pole claimed by Germany as subject." But for Germans, Wilson's proclamation caused real hardships. They flooded the third floor of the federal building, waiting in line for hours to be photographed and fingerprinted in order to submit their application to the U.S. Marshal's office. Then they waited to see if it was approved so that they would not be forced to move or give up their job. Some whose loyalty was questioned by authorities had to post a $2,000 bond for good conduct. Those lucky enough to secure a permit were still restricted; they were allowed merely to live in a certain area, go to their place of work and then return home. An applicant's employer also had to certify his wish to employ the applicant and guarantee the person's good behavior. By September 1917, restrictions fortunately had been relaxed to an extent. The number of forbidden factory districts in Milwaukee was reduced to three: the Menomonee Valley, the area along

the Milwaukee River north of Mason Street and the zone along the south shore.[14]

The assault on all things Teutonic extended beyond freedom of movement, family names and flour can labels to include German language and culture. The language issue focused primarily on the press, churches and schools. With so many German priests and ministers, Catholic and Lutheran churches in Milwaukee were especially vulnerable to charges of disloyalty. The patriotic element had reason to suspect Archbishop Sebastian Messmer. He openly favored Germany at the start of the war, and he strictly forbid priests to speak publicly about it or the 1916 Presidential election. But American entry into the conflict muzzled Messmer's support of Germany, and he went out of his way to prove his loyalty. In November 1917, he issued a "War Pastoral" that assured parishioners the war was a just cause, and they should do all they could to support it. Messmer's enthusiasm was rather tepid, however, for he clamped down on priests who expressed support for the Allies but did nothing to curb their critics. Suspicions about Catholic loyalty trickled down to the Catholic flock at large. An American-born priest told a DOJ agent that, in his opinion, all German-speaking priests in Milwaukee failed to "carry out to the greatest extent, the spirit of patriotism demanded at this time." And a woman on a streetcar overhead an exchange implying that 1,000 rifles were hidden in "some German church." This prodded William Fitch and other DOJ agents to search 15 German Catholic churches, but nothing turned up. It was no surprise that loyal Americans pressured Catholics and Lutherans alike to discontinue German-language services.[15]

Milwaukee schools were the flashpoint for the debate over the German language. For decades, German classes were an integral part of the curriculum. In his 1909 annual report, School Board President William Pieplow applauded the teaching of German. It opened up to students "broad fields of literature and as rich mines of modern thought as [were] to be found in any language." Studying German, he went on, strengthened pupils' minds, giving them a stronger power of application than those who studied English only. As evidence, Pieplow pointed out that two-thirds of the students who failed in 1908 had not studied German. A mere eight years later, many government and school officials as well as the patriotic public clamored to eliminate the study of German altogether from the lower grades. Only days after the U.S. declared war, a special committee of the Milwaukee School Principals' Association unanimously approved a recommendation to phase out teaching German in grades 1-4. What was needed, the committee wrote, was "more intensive work in the language of America until the fundamentals are mastered." It was too confusing to teach children the writing, phonics and alphabet of a foreign language

before their own language was "fairly started." Others argued that only English should be taught to speed up the Americanization process of Milwaukee's sizable immigrant population. Not only did students learn the language and culture of their adopted land, but their parents benefited also when they brought those lessons home.[16]

Milwaukee citizens furnished more prosaic reasons. Casimir Gonski, an attorney who led the drive to include Polish language instruction in public schools, wrote the School Board that he now advocated eliminating all foreign language in elementary schools. Gonski explained his earlier agitation was to help Americanize Polish children but also to correct an injustice against the Poles, who paid taxes to support public schools that taught German. Yet another consideration was the "deeply rooted and fully justified aversion which my fellow citizens of Polish birth or extraction have against anything that smacks of the German 'kultur,' which has been forced upon us at the point of the bayonet and by incarceration and upon innocent Polish children, by the cruel rod of the Prussian school master." So why, he asked, should foreign languages continue to be taught in grammar schools? Because German interests "insidiously cultivated and foisted" the system upon Milwaukee. To allow pan-German beliefs and agitation to continue unopposed was "undesirable and impractical and dangerous to our republic." English alone was sufficient for the needs of the people. Another citizen exclaimed, "Only in the United States would it be possible for state money to be used to educate people in alienism rather than to unfold to them the beauties of the republic, the principles of liberty and freedom." To American patriots, teachers of German, with enthusiastic backing of the German-American Alliance, were nothing more than propagandists who eternally pushed the interests of a foreign country and derided American principles.[17]

The result was inevitable. At the end of June 1917, the School Board's Committee on Textbooks voted 3 to 2 to end all foreign languages in the first three grades. At the start of the fall semester, the number of elementary students taking German was approximately 7,000 less than when school had ended in June. In October, the Textbook Committee recommended adopting a resolution by Superintendent Milton Potter, which allowed that only one foreign language would be taught in one building, and after the first two weeks of a semester, teaching that foreign language would be discontinued if less than half of the students enrolled in those classes. In addition, all foreign language classes would be progressively phased out of grade schools as the students completed their work. Potter insisted he did not consider the present war situation when drafting the resolution, a curious claim considering later in the war he asked teachers to stop any conversations in German on school playgrounds and also had German

"war" songs torn from school songbooks. German music societies, such as the Musikverein, Leiderkranz and Mannerchor, as well as the Turnverein appealed to Milwaukee citizens to not let themselves be intimidated and allow teaching of the German language, but their pleas were drowned out by the anti-German din. According to a *Milwaukee Free Press* report, H.R. Graham spoke at a January 1918 Wisconsin Loyalty Legion meeting: "There is one way to do it in Milwaukee….Let the crowd follow me and we will march on every school in the city and burn the darn old German books so there will be no more from which to teach our children." In summer 1918, the School Board formally adopted the plan to end all foreign language instruction by the end of the 1918-1919 school year, and the number of schoolchildren enrolled in German classes tumbled to a scant 400.[18]

Other organizations followed suit and abandoned using German. The Milwaukee Turnverein began using English only for its meetings and even ruled that only U.S. citizens could join. Individuals had to be careful as well. If they were heard speaking German in public, they were often spat upon or pushed aside. They suffered other indignities. As one teacher of German crossed the playground of the 27th Avenue School one day, a group of kids threw stones at him, all the while shouting "Kraut"—even though a number of the children were of German descent themselves.[19]

German theater, the heart of Milwaukee's social scene, similarly suffered, though it took some time before the hysteria took effect. Directors of the German Theater Company debated whether to proceed with its slate of German-language plays for the fall 1917 season. They decided to move ahead, declaring in an open notice in the *Milwaukee Journal* that not staging the plays would be a great loss to Milwaukee's artistic culture and "probably sound its death knell." A full house at the Pabst Theater to see *Das Ewig-Weibliche* validated the decision. "That is as it should be," editorialized the *Milwaukee Sentinel*, describing the Pabst as "a temple of art pure and simple and art proper [should be] above the ephemeral invidious distinctions of racial prejudice and politics." The *Milwaukee Journal* acknowledged German plays aroused conflicting emotions within those "interested in the cultural development of Milwaukee," but they represented the best of German culture. Any study of human motives or the struggles of human nature were "stimulative, inspiring, conducive to the biggest and best in human nature, no matter from what country the plots are taken nor in what land they are presented." The *Journal*'s only regret was that the dramas were not given in English as well as German, or in English alone. The strength of this sentiment was not enough to overcome the anti-German backlash, especially with one-third of the company registered as enemy aliens. The cultural value of German productions was

quickly forgotten, and the Pabst decided not to stage German plays for the 1918-1919 season.[20]

Milwaukee Germans were unprepared for the firestorm that scorched the community during World War I. It must have been a bitter pill to swallow after being held in such high esteem for so many years. Everything they had cherished—the theater, Turnverein, singing societies, even drinking beer—was viewed by the patriotic element as a treacherous plot to Prussianize America. Historian Carl Wittke's study argues that German-Americans fell prey to their success in the U.S. "Stubborn arrogance" in maintaining their past cultural superiority and isolation as well as their uncritical and sometimes strident defense of Germany during the period of U.S. neutrality added fuel to the "spreading flames of intolerance and national hatreds."

As noted earlier, some German-Americans' comments exhibited a lack of good judgment, but in general, those individuals who harbored misgivings about the war maintained an uneasy silence. The prospect of seeing his sons fighting in a war weighed heavily upon Julius Gugler, founder of a successful lithographic company. He confided to a friend that since the U.S. declared war, he had "been praying for an altered state of mind. One that would permit me to become enthusiastic concerning the issues involved in this strife: a state of mind that would kindle in me the spirit of sacrifice for a great object." But it was all in vain because he failed "to feel the driving power in my heart that I experienced on other occasions during my long life." It was best, he thought, to avoid discussing the war at all. But even this course placed Gugler and fellow German-Americans in a no-win situation. If they did not support the war effort with much enthusiasm, they were branded as unpatriotic, but if they embraced the Allied cause wholeheartedly, they were suspected of being two-faced hypocrites.

Most German-Americans, recognized their obligation to the U.S. Frederick von Cotzhausen, for example, came to Milwaukee after the 1848 revolutions in Germany. In July 1918, he celebrated his 80th birthday and looking back, he was satisfied that he returned a "full equivalent" for the opportunities and advantages his adopted country provided. He acknowledged that it was difficult to suppress feelings of sympathy for his homeland, but that in no way detracted from his allegiance to the U.S. As a naturalized citizen, he was especially aware of his duty during this trying hour. "I do not need to drop the 'hyphen,' he wrote, "as I dropped it many years ago." He was not ready "to accord to any one of my fellow citizens, whoever he may be, a higher standard of patriotism and Americanism than I claim for myself."[21]

The war hysteria not only engulfed German-Americans but also targeted any and all opposition to the war. The most extreme form of

dissent—suicide—was beyond the patriots' control. One Milwaukeean committed suicide by drinking carbolic acid after he had received his draft classification. He told a friend he preferred dying in the U.S. rather than dying in France. In two other cases, a father shot himself in the head and another jumped off the Grand Avenue (now West Wisconsin Avenue) bridge because they were so despondent about the possibility of their sons being drafted and killed overseas. Others resorted to less drastic means and simply avoided military service. Marriage was one way to secure an exemption, and the problem was enough for Governor Philipp to assert that any marriage after May 18 was *prima facie* an effort to avoid service. In 1917, there were 291 more marriages in Milwaukee than during the previous year, but the extraordinarily high cost of living, Philipp claimed, should have dampened the number of weddings; thus draft registrants bore the burden of convincing their draft board the marriage was legitimate. Consequences for those who could not were severe. One Milwaukee man told his draft board that he was his wife's sole source of support. The board worked with federal agents and found that the man did not live with his wife and did not provide any support, so they arrested him. But since he was physically fit, the board had him removed from jail after he agreed to be drafted. Informants around the city assisted authorities in their efforts to round up anyone who resorted to marriage to side-step the draft. Even one's own mother would turn in a wayward son as Frank Leashel discovered to his dismay.[22]

The majority of Americans who tried to evade military service, however, did not do so by abusing the rite of marriage. Of the 24 million men in the U.S. who registered for the draft, several million simply did not sign up and another 300,000 failed to report for duty or deserted. The problem did not seem to have been widespread in Milwaukee or Wisconsin. At war's end, the Adjutant General indicated that 3,338 military men out of a pool of roughly 600,000 in the state were draft delinquent, with 1,400 from Milwaukee County. Putting a more positive spin on the situation, Governor Philipp estimated that fewer than 100 were bonafide deserters. No matter what the number, "slackers" were despised by patriots. A column in *The Conveyor*, the newsletter for the Milwaukee Coke & Gas Company, charged that anyone who avoided his duty was "a coward at heart" and was no "worthier of being trusted than the thug who steals up behind a man in the dark and assaults him." Anita Nunnemacher Weschler was equally blunt, grumbling during summer 1918 that men who had not enlisted made her sick, "always crawling behind somebody's skirt."[23]

Those who opposed the war on political or personal grounds also felt the wrath of war supporters. Socialists were an especially inviting target. During spring 1917, Socialists fought a losing battle to stem the

growing tide of war. Party leaders called for an emergency convention in St. Louis to formalize the Socialists' stance toward American intervention. Unfortunately for the party, the convention took place only two days after the U.S. declared war. For years, Socialists were split between radicals who favored using force to bring about a socialist state ("Impossibilists" Victor Berger called them) and Berger's conservatives who advocated a gradualist approach. Berger's faction held most positions of power within the party, but the war undermined the group's authority. Emboldened, the radicals pushed through an anti-war platform at the convention that denounced the war as a capitalist scheme caused by munitions manufacturers and

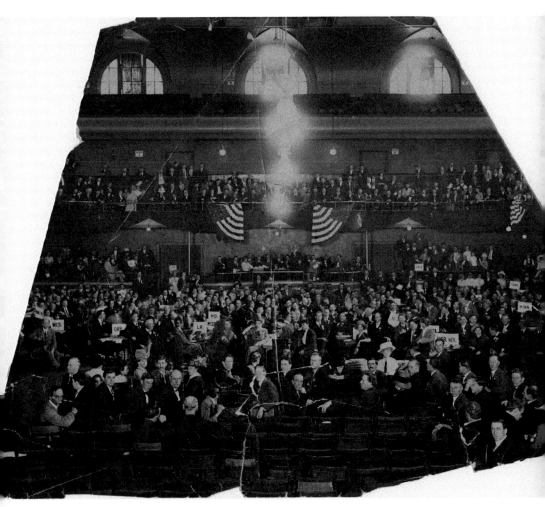

The Socialist convention held in St. Louis, days after the U.S. declared war on April 6, 1917. War supporters branded the convention's anti-war resolutions as traitorous. (Photo courtesy of Milwaukee Public Library)

other profiteers. The platform called for active opposition to the war, conscription and censorship of the press and mail. Berger, who was on the War and Militarism Committee, did not agree with all of the platform's language, but he feared that if he did not endorse it, something even more radical would emerge. Nevertheless, the proclamation caused the patriotic element around the nation to brand Socialists as nothing short of traitors.[24]

The St. Louis Platform not only hardened the divide between radicals and reformists, but it also split the party's right wing. Algie M. Simons, for example, a Wisconsin native and former social worker in Cincinnati and Chicago, witnessed the exploitation of industrial workers and the devastation poverty wreaked among those workers. He counted himself among the radical faction of Socialists but gradually came to believe that party members could hold local political offices and still hold true to the hope for nationwide change. His career path shifted to journalism, and he edited several Socialist newspapers before joining the staff of the *Milwaukee Leader* in 1913. Initially, he and Berger shared like views about class struggle and best ways to realize the triumph of Socialism, but the war permanently ended their working relationship and personal friendship. Simon and his wife, May, had many British friends and believed the future hope of socialism and internationalism lay with the British. He became dismayed at Milwaukee and Berger's pro-German sentiment and left the *Leader* in December 1916. Shortly thereafter, Simons wrote articles for *The New Republic* and *Milwaukee Journal*, claiming the Socialist Party was no longer an American party; rather, it promoted German interests and German militarism. He saved his most vitriolic comments for Berger and the St. Louis Platform. He wrote a colleague that "when the St. Louis convention lent its support to the cause of Kaiserism, it left Socialism, democracy and everything else for which it has always stood." This was the culmination of years of "lying, schemeing [sic], intriguing and trickery without an equal in labor history." He accused Berger of doctoring cablegrams and distorting facts to fit his pro-German stance, and his close connection with the German-American Alliance and involvement in the German-Austrian Bazaar proved his support of the Kaiser. (Later in the war, Simons also told a DOJ agent that the German government was subsidizing the *Leader*.) He feared the platform made any Socialist vulnerable to mob violence or internment by the government. "No words are strong enough for the accurate characterization of the contemptible treason to Socialism...committed at St. Louis." Socialism was the one thing worth fighting for, and Simons was not about to let those who betrayed the cause "escape without punishment."[25]

Winfield R. Gaylord was another prominent defector from the Socialist ranks. He had been a Congregational minister for 13 years in Minnesota,

Illinois and Wisconsin before jumping into Socialist Party politics. An excellent public speaker, Gaylord became a national lecturer as well as state organizer in Wisconsin; in 1908, he was elected to the Wisconsin State Senate to serve the Sixth District, which included Milwaukee's Ninth, Tenth, 20th and 22nd wards.[26] He voted against the St. Louis Platform because it failed to condemn any government except that of the U.S., and it crystallized needlessly "the ignorant and vicious anti-Socialist prejudices," giving "reckless occasion for those rantings by the capitalist press which will most effectively close the public mind completely for many months to all effective and constructive Socialist propaganda." Like many other intellectuals within the party, Gaylord left because he felt German autocracy was as much a foe of socialism as capitalism. Both he and Simons forwarded information concerning the convention proceedings to Senator Paul Husting, who in turn passed it on to the U.S. Attorney General. They also warned Husting that the opposition called for in the St. Louis Platform could be violent. Husting shared that warning with the Attorney General and the commanding officer of the Army Department in Chicago. Similar to Simons, Gaylord took to excoriating the Socialists in the "capitalists'" press, primarily the *Milwaukee Journal*. Gaylord was well known for his eccentric personality and volatile temper, which in part explained his "extreme, even paranoiac hostility" toward Socialists. It was not surprising that the National Executive Committee expelled both Gaylord and Simons from the Socialist Party in May 1917.[27]

Berger downplayed the effect that Simons and Gaylord's denunciations would have on the party. He told a colleague that "99 per cent of our party in Wisconsin will stand like a stone wall—in fact we are gaining more adherents now than we ever did in the past." But his analysis was too sanguine. Shortly after the St. Louis Convention, four employees of *The Leader* wrote Berger that the U.S. District Attorney threatened to prosecute for treason anyone who published the platform; therefore, they declined to be involved in any way. Others such as Attorney F.P. Hopkins and former Alderman Albert Welch followed Gaylord and Simons and left the Socialists, claiming the party was controlled by an anti-American element.[28]

Because of the party's anti-war stance and Victor Berger's German heritage, Milwaukee Socialists were doubly cursed. It seems surprising that they, similar to the German-American community, were stunned by the vehemence with which they were assailed on every side. But Meta Berger asserted that the Socialists naively and ardently believed in the Constitution and the guarantees of freedom of speech and the press; thus, Socialists continued their opposition to the war "quite unconsciously of the dangers that lay ahead." The *Milwaukee Journal* and other pro-war newspapers gleefully played up any defections from the party and

persistently railed against their pro-German leanings, despite all the work Mayor Hoan and other Socialists had done in support of the war effort on the Milwaukee County Council of Defense. Patriotic zealots "decorated" Victor and Meta Berger's lawn nearly every morning with garbage and broken milk bottles. And the Bergers could not even count on their "friends." School Superintendent Milton Potter was a staunch war supporter, but he also frequently visited the Bergers' home. Meta recalled Potter saying he could sit at Victor's feet and "learn and learn," but he considered Victor "a criminal just the same." Dan Hoan fared no better than Victor Berger; both received enough threats of violence that the mayor took to carrying a gun no matter where he went. Years later, he recalled that he had made up his mind that "if anybody got anywhere near me, or grabbed me, in an attempt to kidnap me, he would get a bullet."

Other Socialists also suffered personally and professionally as did those who were branded Socialists because of their anti-war views but really were not. Among these were Erich Stern and Edwin Gross. Like Stern, Gross was an attorney who belonged to the Progressive wing of the Republican Party; however, once his views against the war were made public, a group of his friends decided the best way to deal with him was ostracism. Whenever Gross entered a room or street car, these "friends" would exit as soon as possible. Stern had a number of friends who stood by him and pleaded that he not become a martyr in the name of his principles, while Marion Ogden wrote to Stern, "They tell me our war has gone hard with you....There are so many sides to the truth, and it <u>cannot</u> be that you are unpatriotic." But as the war dragged on, the ever-increasing hostility dismayed Stern. In May 1918, his fractured friendship with Arthur Van Dyke and his mother particularly hurt: "With all our beautiful common memories—as recent as last summer—how, how can they judge so harshly, condemn without giving me a hearing of any kind[?]" He felt it necessary to drop out of his circle of friends, and he was eventually pressured to give up membership with Milwaukee's University Club.[29]

Beyond personal recriminations and indignities, a great deal more was at stake. The Espionage Act was the anvil upon which the federal government hammered away at the civil liberties of American citizens. Almost immediately after Wilson's war message to Congress on April 2, a bill was introduced that would empower the government to censor the press, punish any interference with activities connected to military service (such as recruitment) and control the mail to prevent distribution of treasonable material. The censorship provision raised a storm of protest from newspaper publishers and defenders of free speech; thus, it was dropped. While Congress debated the bill, some representatives voiced fear that it was too vague and could be used to violate long-held and

cherished individual liberties. But the drumbeat of war drowned out any critics, and the bill passed in June 1917. In its final form, the Espionage Act allowed federal authorities to hand out prison sentences up to 20 years and $10,000 fines for interfering with the draft, spreading rumors that aided the enemy or making insulting remarks about the government, military or flag.

Critics' fears about the act's vagueness came true. The legal profession in general was politically and jurisprudentially conservative and embraced the fierce patriotism of the war. Most judges used a "bad tendency" approach, allowing juries to *infer* the intent of a defendant without having to rely on an explicit denunciation of the war or government. As long as remarks had the probable tendency of producing results that violated the Espionage Act, then they should be suppressed. This opened the door to all sorts of abuses of individual rights; as a result, any genuine discussion about the justice and wisdom of continuing the war became perilous. It is interesting to note that the Wilson administration enforced the Espionage Act selectively. Leftist, anti-war groups bore the brunt of the government's wrath, while conservative, pro-war individuals such as former President Theodore Roosevelt could excoriate Wilson's handling of the war with impunity. The Espionage Act also granted the Postmaster General authority to suppress anti-war newspapers. Victor Berger certainly thought the government had overreached. "The man who would suppress free speech and who advocates press censorship," he wrote to the *Chicago Examiner*, "is the most dangerous foe of this country because under the pretext of extending democracy in Europe, he is willing to abolish democracy at home." He believed the law was unconstitutional and a "violation of the spirit of our political institutions and should not be tolerated." Berger had reason to worry.[30]

Armed with this powerful weapon, Postmaster General Albert Burleson clamped down on Socialist newspapers, including the *Milwaukee Leader*. Erich Stern wrote that each day brought a "new shock of the reality of living under an autocracy." Suppressing papers for writing about peace or criticizing the government, he bemoaned, "was one of the supposed sins of the German autocracy." For his part, Berger did not go down without a fight. In July, he boldly mailed a copy of the *Leader* to Burleson and then wrote him, hoping to arrange a meeting with not only the Postmaster General but the President as well. Berger unabashedly reminded Burleson that President Wilson had received 400,000 Socialist votes in the last election, which helped him carry some doubtful states. Berger went on to make the case that the Socialists were a loyal opposition, and efforts to suppress their newspapers would only make the movement "secretive, vicious and really dangerous." A meeting with the President, he intoned,

would settle the affair "for the welfare of the country, the benefit of the Socialist Party and the honor of the administration without any difficulty." Berger traveled to Washington in August to meet with Burleson and Wilson and left town feeling the President would do his best to restore a free press. He would soon learn that was not the case.[31]

Department of Justice and Secret Service agents were the federal government's primary "boots on the ground" in Milwaukee to enforce the Espionage Act.[32] The growth of the government's police power was one of the most important effects of World War I, and it was the DOJ that really emerged to the forefront. Individuals suspected of violating the Espionage Act were called to the Federal Building, where DOJ agents grilled them about their alleged offense. The case of Karl Schauermann, a teacher at the German-American Teachers' Seminary and publisher/editor of a political magazine *The Western Critic*, was typical.

On May 14, a federal agent arrived at Schauermann's home, demanding that his wife turn over recent issues of *The Western Critic* and insisting that her husband come down to the Federal Courthouse the following morning. When Schauermann returned home from his business, he called William Fitch, head of the DOJ office in Milwaukee, and asked why he needed to report to the authorities. Fitch would not tell Schauermann the reason and threatened to send two U.S. marshals after him if he did not comply. The next morning, Schauermann went to the Federal Building and was ushered into an inner office where Fitch and two other agents told him that his name had been mentioned in connection with pro-German propaganda. The agents then peppered Schauermann with questions, asking if he was a Socialist, whether he would fight for the U.S. or if he believed the war was a Wall Street affair. Schauermann told them he was not a Socialist and would fight for this country, but he did not have enough evidence to determine if it was a Wall Street war. As the interrogation ended, one of the agents threatened Schauermann not to publish anything about the interrogation or else the district attorney would suppress his publication. The next day, Schauermann called the Assistant U.S. District Attorney to complain about the invasion of his rights as an American citizen. In reply, the assistant said Schauermann could register a complaint, but it would not do him any good because "We back up our men." The assistant finally agreed to look into the charges and found that *The Western Critic* was "just within the law" and warned Schauermann "to be very careful in the future." Incensed, Schauermann sent a notarized description of the incident to Senator La Follette in Washington. La Follette's office had received enough complaints about the high-handed intimidation of federal agents that the senator sent his private secretary to Milwaukee to investigate; however, nothing came from it, and the intimidation continued.

Despite 2,000 indictments that the DOJ obtained nationwide for violations of the Espionage Act, none of them actually involved people accused of being a spy. Most involved people who opposed the war or criticized Wilson and his handling of it.[33] As accusations against Milwaukee citizens flooded the DOJ office, federal agents continued to rely on voluntary groups such as the American Protective League to investigate most complaints. The government recruited individuals who offered particularly useful skills, such as speaking German or understanding the law or banking systems. But the DOJ also hired physically powerful men who could be "depended upon in the event that it should be necessary to employ any roughneck methods." This was a recipe for disaster. Ordinary citizens who comprised these quasi-official organizations were not trained detectives; making matters worse, they received little to no guidance from the DOJ on how to execute their duties. Overzealous patriots who could gain local recognition or score political points often resorted to "highly questionable if not outright illegal" methods of gathering information against suspected traitors. Breaking and entering into homes and offices, rifling through personal effects, listening in on telephone conversations and opening private mail were all too common.[34] Local businesses and individuals were ever vigilant for any hint of anti-war activity. Two neighbors informed authorities that Louis Weitmann, a draftsman for Vilter Manufacturing Company, made slighting remarks about Polish recruits as they marched past his house, while the International Harvester Works dismissed two employees for making unpatriotic remarks about Liberty Bonds, claiming that any employee could not be loyal to the company if he was not also loyal to the U.S. Vigilantes smeared yellow paint on the houses of the disloyal or would force them to kiss the flag. A *Milwaukee Journal* editorial panned this particular type of punishment. The flag, it read, was for those who love it, and it should not be desecrated by having someone kiss it who felt revulsion for it and America.[35]

The DOJ and its citizen informants were not the only eyes and ears on Milwaukee streets. The local police and court system added another layer to the mix. Anyone expressing contrary opinions about the war was subject to arrest for disorderly conduct and hauled before the district court judge, who invariably fined the offender $25 plus court costs. For example, Jacob Best, the liquor dealer who had the calendar with pictures of the Kaiser and von Hindenberg in his store, came under fire again. On June 7, two Liberty Bond salesmen stationed on the corner of Third Street and Grand Avenue approached Best about purchasing bonds. Best brushed past them, snarling "To hell with Liberty bonds." One of the salesmen complained to John Stover of the APL. Because of Best's prominence in

the community, Stover was determined to make an example of him. He had the city attorney swear out a warrant, and Best went before Judge George Page who fined him for disorderly conduct. The affair garnered a great deal of coverage in the local press, and DOJ Agent Julius Rosin thought the demonstrated cooperation between Milwaukee citizens, the city attorney, the court and the DOJ would have a "wholesome and deterrant effect upon possible future offenders."[36] While this daunting array of political, legal and public pressure did cow many of Milwaukee's anti-war crowd into silence, a vocal minority tried to make itself heard. As the nation's war effort lurched forward, it became increasingly difficult for those voices to rise above the patriotic din.

5

The 'War Psychology' has been aroused, sanity drugged, madness enthroned, & the least approach to fairmindedness, probity & sober judgment outlawed & mobbed.
 Erich Stern, October 3, 1917, journal entry

As summer heat faded into autumn chill, tensions between Milwaukee's pro- and anti-war crowds escalated into more confrontational episodes. Whatever common ground may have existed between the two camps vanished as American troops set foot on European soil and the terrible news of Milwaukee's first war casualties arrived.

The first clash involved the People's Council, an organization that inspired revulsion among war supporters. Pacifists, Socialists and labor representatives gathered in New York in May 1917 to lay the groundwork for the People's Council of America for Democracy and Peace. After several discussions, they planned an organizational meeting to be held in Minneapolis in early September. In the meantime, Milwaukee labor unions and Socialists staged a mass meeting at the auditorium on July 9 on behalf of the People's Council. About 4,000 people attended and adopted several resolutions, including repeal of the draft law. At the end of the month, more than 200 gathered in a room at the public library to formally organize the Milwaukee chapter of the People's Council. Victor and Meta Berger played active roles during the meeting, helping formulate six demands for the Wilson administration. Above all was the demand for an early, negotiated peace without forcible annexations or punitive indemnities. Meeting participants urged the federal government to state immediately its war aims; defend the Constitutional rights of free speech, free press and peaceful assembly; eliminate war profits and tax the wealthy to pay for the war; amend the conscription law; and hold a referendum on war, peace and democratic foreign policy. Meta Berger nominated Edwin Gross to serve as president of the council, but he declined, stating

he was not very enthusiastic about "participating in a movement that was attended by too many Socialists." The Bergers asked Gross if he believed in the council's principles as stated. Because he did, Gross felt obligated to accept the nomination, and he was overwhelmingly elected.

As he was inclined to do, Victor Berger took much of the credit for getting the organization off the ground. "Let me tell you as a great secret," he wrote to fellow Socialist Morris Hillquit, "that if I didn't back that People's Council in Milwaukee and Wisconsin, and in the middle West for that matter, in every way and particularly with the *Leader*, there would be no People's Council in this neck of the woods." He added that the organization would thrive in Milwaukee because trade unions were socialistic, and there were many middle-class Germans disenchanted with the war and willing to listen to the Socialists' arguments.

Loyalists deemed the People's Council treasonable. A *Milwaukee Journal* editorial accused it of being comprised of members from the German Socialist party and other pro-Germans as well as individuals whose intentions were better than their judgment. "If they had done a little thinking," the *Journal* went on, "these blind pacifists would have realized that the very forces with which they were asked to ally themselves had encouraged the German government to commit one crime after another against America and therefore were largely responsible for forcing America to enter the war." Gross attempted to diffuse this over-the-top rhetoric, asserting the council represented all political beliefs and not just the Socialists' position. The organization's purpose was not to violate any laws but to encourage the government to state its war aims in concrete terms. Evidently, Gross' words fell on deaf ears for he received several threats that he be hanged for his involvement, no doubt compounding the misgivings he had about leading the organization.[1]

The national People's Council fared no better. Plans to hold the organizational convention in Minneapolis were thwarted by opposition from Samuel Gompers of the American Federation of Labor, local patriotic groups and the governor of Minnesota. Council delegates tried to shift the location to Fargo, North Dakota, but local citizens blocked this effort. On August 29, Mayor Hoan telegraphed the People's Council secretary that the Constitutionally guaranteed rights of free speech and peaceful assembly, which had been suspended in Minnesota, were "living realities" in Milwaukee, and the council would be welcome if it chose to hold the convention in the Cream City. Governor Philipp, however, quickly squelched the possibility. Delegates made plans to move the venue to Hudson, Wisconsin, only 25 miles from Minneapolis and along the Mississippi River. Hudson proved to be no more hospitable than the other sites. The delegates who made

their pitch to stage the convention there barely escaped being tarred and feathered or perhaps a worse fate.

While convention planners desperately sought a suitable location, a special train carrying some 150 council delegates, including Senator La Follette's daughter Fola, left New York on August 30 for the as-yet-unknown convention site. Dubbed the "Hohenzollern Special" by loyalty organizations, the train was supposed to make a half-hour stop on the evening of August 31 at Milwaukee's Union Depot, where representatives of the Milwaukee chapter of the People's Council planned to greet the group with a brief program. Everything seemed ready to take place without any complications until the headline in the August 31 morning edition of the *Milwaukee Journal* blared "Danger In Outburst At Pacifists' Train." Events of the past 24 hours, the article read, had "impressed the state and city authorities with the necessity of preventing a demonstration arranged by Milwaukee sympathizers" at the train station. The *Journal* urged its readers to avoid the event. "The present situation is tense," it warned, and sometimes a "mere spark starts a conflagration."[2] The *Journal's* warning perhaps derived from a suspected—though unfounded—link between the radical International Workers of the World (I.W.W. or "Wobblies") and the People's Council. Given the Wobblies' reputation for violence, there was no telling what might happen if a gang of them should be at the station.

Journal editors fanned the flames even more, asking if the governor or mayor had considered that there might be bloodshed should the demonstration take place. "The temper of loyal Milwaukee has already been tried almost beyond endurance," they asserted, by the disloyal acts and writings of hostile pro-German newspapers, agitators and organizations in Milwaukee. Without a hint of contradiction, the *Journal* claimed that because of conditions created by "these breeders of disloyalty" (as opposed to conditions created by the *Journal* itself), the People's Council, a "motley crowd of German Socialists and other pro-Germans, of I.W.W.'s and anarchists, with a small scattering of pacifists who are stupidly casting their lot against America," could not be allowed to meet in Milwaukee "without subjecting the temper of the Americans here to too severe a test." There was danger that "much harm" would result from such a meeting, not the least of which would be Milwaukee earning "the ill name of being the host of this group of disunionists." The blame for any dire consequences, concluded the *Journal*, would fall squarely on the heads of those who failed to heed the warnings about conditions in Milwaukee.

Despite the *Journal's* histrionics, it was the loyalists and not the People's Council who seemed spoiled for a fight. Both Edwin Gross and Erich Stern noted that there were plenty of people who embraced the council's aims but were "frightened into silence" or rather "tame & timid." Fortunately,

the opportunity for a confrontation never took place. Mechanical problems delayed the delegates' train in Indiana, and the program at the Milwaukee station was cancelled. Milwaukee sheriff's deputies were on hand to control the crowd just in case, but the gathering soon melted away. Once repaired, the train made it to Chicago, where the People's Council convention was held before Illinois Governor Frank Lowden had police break up the proceedings. At that point, the delegates dispersed to hold prearranged meetings at various homes and hotels.[3]

Though disheartened by the circus-like conclusion to the national convention, the Milwaukee chapter soldiered on. Two weeks later, chapter Secretary Carl Haessler contacted Governor Philipp to let him know that the People's Council invited journalist and fellow Socialist Lincoln Steffens to give a lecture on "The New Russia" at the auditorium on September 21. Haessler pointedly asked the governor if there would be any government interference with the event. Philipp's response was printed in the *Milwaukee Sentinel* before it reached Haessler, but the governor declared that as long as Steffens restricted his talk to the topic at hand, there would be no trouble. Philipp added that so long as people assembled in and confined their discussions to the "American interest," their right of free speech would not be assailed in Wisconsin. But any talks that criticized the President, government or war effort and destroyed the people's confidence in any of those were not in the American interest and, therefore, were "undesirable at this time." Haessler assured Philipp that the lecture would be confined to the Russian Revolution and would not digress into some mythical American revolution engineered by the "arch traitor" George Washington against the King of England. Just to be sure, government agents, Milwaukee police, deputy sheriffs and even a stenographer "infested" the standing-room-only crowd in the auditorium on the night of the lecture. But, according to the *Sentinel*, Steffens was "exceedingly tame" and never discussed the war or the People's Council.[4]

Events in Bay View definitely were not tame when the Reverend August Giuliani sparked a riot on September 9 that resulted in the city's first "home" casualties. Giuliani was born in a small town northwest of Rome. He studied for the priesthood and was ordained in 1902, but he converted to Methodism in 1909, possibly because he was excommunicated by the Catholic Church or because he met Katherine Eyerick, an American missionary on a pilgrimage to Rome; she eventually became Giuliani's wife. Eyerick arrived in Milwaukee in May 1908 to launch efforts to convert Italians in the city's Third Ward to Methodism. Giuliani followed three years later. From the very beginning, he was a controversial figure because his aggressive evangelism set him at odds with Roman Catholics in the Third Ward. In 1917, Giuliani decided to extend his field of work to

the Italian community in Bay View. He held his first meeting there, along with about 25 members of his congregation, on the corner of Potter and Bishop avenues. Some 100 onlookers witnessed Giuliani mix religion with patriotism. In addition to his preaching, he displayed an American flag, urged the Italians to do their part in support of the war and had the crowd sing patriotic songs accompanied by a portable organ and two cornetists. Some in the crowd told Giuliani they were anarchists and did not believe in his religion or the American government. Others warned Giuliani not to come back.

Undaunted, Giuliani and his flock returned the following Sunday. The crowd threatened the minister, but he stood his ground. Ten minutes into the meeting, Giuliani sent an assistant, Maude Richter, to fetch the police. According to Giuliani, Maria Nardini urged the crowd to get rotten tomatoes and other potential projectiles to hurl at him. By that time, however, the police arrived and dispersed the crowd. Giuliani asked Police Chief Janssen and the DOJ to provide protection for another rally the following week.

On Sunday, September 9, two detectives and two patrolmen accompanied Giuliani and 30-40 supporters to the corner at Potter and Bishop. The crowd that gathered was in no mood to listen to the minister. Detective Paul Weiler confronted a leader of the group, Vincenzo Fratesi, telling him to leave and not disrupt the proceedings. A scuffle broke out, at which point Tony Formaceo pulled a revolver and fired a shot at Weiler. The crowd scattered as the four policemen and several Italians exchanged gunfire. In the ensuing confusion, Giuliani continued singing while Maude Richter played "America" on the organ. The melee lasted no more than two minutes but left Formaceo dead at the scene along with two injured police and three Italians. Another Italian died from his wounds a few days later. Immediately after the shooting, police fanned out across Bay View's Italian neighborhood looking for suspects. "As is the case in all Italian outbursts of disorder," reported the *Sentinel*, "quiet reigned Sunday night in the vicinity of the riot. The Italians kept to their homes and darkened the houses." That did not stop the police from arresting 11 Italians on the first day and 15 more the next. Rather than pointing to religious reasons for the clash, authorities and newspapers resorted to the "all-purpose" condemnation of the day and blamed malcontent anarchists from a study group called the *Circolo di Studi Sociali*, linking the event to a nationwide sweep of I.W.W. offices a few days before the riot. As part of that dragnet, DOJ agents raided three Wobbly headquarters in Milwaukee on September 5 and confiscated some literature. No arrests were made, however, and no evidence was found connecting the I.W.W. to the Bay View riot. On September 12, District Attorney Winfred Zabel, a Socialist,

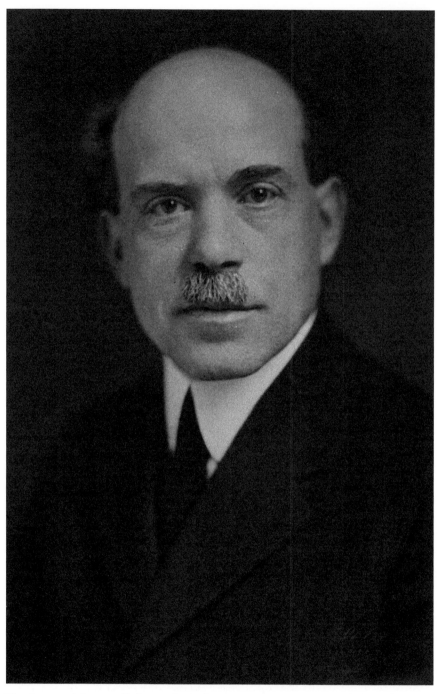

The Reverend August Giuliani. His inflammatory pro-war/anti-Catholic rallies held among the Italian community in the Bay View neighborhood sparked a riot. Eleven Italians were arrested and later convicted based on unfounded conspiracy charges and accusations of being anarchists. (Photo courtesy of Milwaukee County Historical Society)

examined the Italian defendants in his office. Since the police force had no one who spoke Italian, Reverend Giuliani acted as interpreter, raising objections from the Italians who claimed he deliberately misinterpreted their remarks. Furthermore, the interrogations were a sham. Zabel neither had the authority to administer oaths to the suspects, nor did he warn them about self-incrimination. In the end, he charged 11 of the defendants, who waited in jail for the trial to start.[5]

The riot, its suspected connection with the I.W.W. and even the popularity of the People's Council unnerved the loyalists. In early September, Senator Paul Husting wrote that as long as the council did not cross the line where treason begins, the only way to combat its influence was through patriotic writing and speeches and by "aggressive organization." The Wisconsin Loyalty Legion (WLL) was the result. It succeeded the Wisconsin Defense League, which lost influence and membership with the formation of the state and county Councils of Defense. But the WDL's leaders were dissatisfied with Governor Philipp's commitment to the war effort—especially after he rejected Wheeler Bloodgood's plea to send a militia company to maintain order in Milwaukee—and were alarmed by the perceived growth of pro-German influence in the city. Bloodgood warned prominent citizens throughout Wisconsin about the "agents of Germany and the friends of autocracy" at work in the state. It was time, he concluded, for loyal citizens to unite and make a strong patriotic stand against the corrosive effects of the anti-war throng and redeem the state's reputation around the country.[6]

Remnants of the Wisconsin Defense League held a meeting in mid-August and laid the groundwork for forming the WLL. Guy Goff, working in the War Department in Washington, applauded the action. "This is no time to take chances," he wrote or "permit any element of our population to traffic in our liberties, and to profess to misunderstand our purposes. There is no room for any thought except Americanism." When Victor Berger first learned of this new loyalist group, he sneered: "'Loyalists' was the name of the English Tories in America that fought George Washington and the American Revolution." The WLL was officially organized on September 17. It differed little from its predecessor, retaining the same "defensive" and "parochial" tone and leadership, including Wheeler Bloodgood and erstwhile Socialists Algie Simons and Winfred Gaylord. But what had changed was the temperament of the members. The WLL constitution reflected a growing intolerance of any dissent. After outlining grievances against Germany that led to America's entry into the war, the document proclaimed the need to unite the people of Wisconsin in "loyal, active and efficient support of the Government." To do that, the WLL must "sternly repress" pro-German propagandists at work individually

or "under the disguise of peoples' councils and similar organizations." Members pledged to "bring traitors to punishment, hold up slackers to public contempt, and oppose disloyalty and dissension wherever it may appear, and however disguised."[7]

Not everyone in the WLL accepted the unbridled determination to stamp out free speech. Milwaukee Attorney George E. Morton was on the committee to draft the group's constitution, and he informed the executive council that he disagreed with language that essentially indicted as traitors everyone connected to the People's Council. "No one," he admitted, believed "in calling things by their proper names more than I do on a proper occasion." But, he argued, "there are times when giving offence defeats all further effort to gain an objective." The WLL wanted Wisconsin German-Americans' support during the war, but calling someone a traitor was "to put yourself in a position where he will listen to nothing else you have to say." Such a drastic indictment was bad policy and could only dissuade the German-Americans who were "ignorant of the real issues of the war, its causes and the results of losing it." But Morton's warning went unheeded.[8]

Uppermost in the minds of WLL leaders was redeeming the state's reputation; thus, they circulated a petition statewide that repudiated the actions and words of Senator La Follette and other members of Wisconsin's congressional delegation who opposed the war. By year's end, the WLL claimed it had 150,000 signatures. Another component of its reclamation effort involved chopping away at the alliance between Milwaukee's unionized labor and Socialists. The loyalty issue had already fomented cracks within the alliance, but the Federated Trades Council (FTC) remained firmly in the Socialist camp—though Victor Berger suspected that FTC leader Frank Weber's Socialism "represented only a very thin coating." In mid-September, unions were in the process of voting on whether to endorse the People's Council, and the WLL viewed this as an opportune moment to strike. The WLL asked Samuel Gompers to send an AFL representative to Milwaukee to explain the consequences to Frank Weber should organized labor support the People's Council. A letter was also sent to Weber asking him to sign the loyalty pledge and use his influence to urge laborers to do the same, warning that they had "nothing to gain and much to lose by permitting even a suspicion of disloyalty to be attached to them." The effort was marginally successful. Milwaukee Typographical Union No. 23 sided with the WLL—a fact the *Milwaukee Journal* trumpeted—but the FTC officially endorsed the People's Council.

No doubt disappointed by the outcome, the WLL forged ahead with a patriotic education program linked to a colossal propaganda campaign. This drive included disseminating literature from the Committee on Public

Information, the Universal Military Training League, the YMCA and the Red Cross as well as conducting mass patriotic meetings. The campaign also included speaking tours. The WLL sought 200-500 suitable speakers among priests/ministers, lawyers, newspapermen, doctors and college/high school faculty. It seems the WLL pushed its luck when it asked Mayor Hoan to participate.[9]

While the WLL stoked patriotic fires in Milwaukee, the federal government stepped up its attacks against Socialists in general and the *Milwaukee Leader* in particular. The paper had printed several editorials that postal authorities deemed seditious. As a result, Postmaster General Albert Burleson ordered Victor Berger to appear in Washington on September 22 to answer charges why the *Leader's* second-class mailing privileges should not be revoked. A stunned Berger assured Meta that he could take care of her and the children for a year or two no matter what happened in Washington, but he was not going to submit quietly. He asked Burleson for a face-to-face meeting. The administration, he insisted, was making a fateful mistake suppressing Socialist papers. Such a course would only make the movement "ill-natured and ill-balanced" and spur the more revolutionary branch of the party. At the hearing, the Third Assistant Postmaster General focused on the *Leader's* tendency to oppose the war and introduced several *Leader* editorials that he claimed violated the Espionage Act; he did not, however, identify any specific comments. The outcome was never in doubt, and the *Leader* lost 17,600 out-of-town subscribers—roughly 40 percent of its base—and nearly $70,000 in annual subscription revenue.

To make matters worse, advertisers began withdrawing their support, a move which cost the *Leader* another $50,000 in revenue. Berger blamed the WLL while his friend, Oscar Ameringer, charged government agencies with blackmailing advertisers. Berger allies came to his defense. He raised money through a "Press Defense Fund," and a protest meeting at the auditorium garnered $4,000 in support of the Socialist paper. Mayor Hoan telegrammed President Wilson and charged that Burleson's action would only drive a wedge between the administration and those Milwaukeeans who had supported the war. None of these efforts was enough to stem Berger's financial problems. At times, Berger doubted he could pay his employees, and he and Meta often considered shutting down the operation. But he refused to give up. He pleaded his case to Colonel Edward M. House, a confidant of Wilson, asserting that the *Leader* supported many of the President's goals. Wilson, however, turned a deaf ear when House brought up the subject. Berger took his case to the federal court to compel Burleson to define specifically why the paper's mail privileges were revoked, but the courts sided with the Post Office.

Lastly, Berger tried to reach readers beyond Milwaukee County by having volunteers or express companies hand deliver issues of the *Leader*. The DOJ thwarted the effort by warning carriers that they would violate the Trading with the Enemy Act if they continued.[10]

Berger was not the only one who felt under siege; because Milwaukee's elementary and secondary teachers were so instrumental in developing future patriots, they were primary targets of the WLL campaign. The legion sought permission from the School Board to distribute patriotic literature in schools and to circulate the loyalty pledge for children to sign. Several board members, especially Meta Berger, objected on the grounds that the pledge was a political document, amounting to a thinly veiled attack on La Follette. Some teachers believed as she did that the war was a capitalistic war and argued that no teacher should be forced to sign the pledge. In addition, the pledge was unnecessary because children recited the Pledge of Allegiance every week at school assemblies. Meta asked that the board not allow the WLL petition in order to keep hatred and petty politics out of the schools. If a mere pledge of loyalty were required, Berger suggested the school superintendent should develop one that removed any political aspect, a move that the board approved along with the use of all government-sanctioned literature in civics, history and English classes, and the daily singing of patriotic songs. Speaking on behalf of the WLL, Winfred Gaylord criticized the board's action, asserting the original pledge was not political. He vowed to continue the WLL's fight[11], while Superintendent Potter formulated a pledge that read:

> I believe in representative government, in loyal obedience to the law, and in unswerving support of the officers of the government in executing the law. I love my dear country, the United States of America, as against all other earthly powers. I intend to be a good American citizen. I will defend America against her enemies by word and act. In sunshine and storm, on land or sea, in heat and in cold, at home or abroad, in daylight and darkness, I will serve America. For her I will save and sacrifice. I will live for her and if need be I will die for her.[12]

According to Erich Stern, Potter's language appeased the WLL's "hunger for forced lip service," but it was still controversial among the board and some parents. German-American Ernst Goerner demanded that the principal and teachers at Jefferson Street School stop "terrorizing" his brother-in-law's four children, ages six to 12, because their father refused to allow them to sign the loyalty pledge. Goerner asserted the pledge was beyond the school's educational scope and inappropriate because young children did not really understand what they were signing. The principal

and teachers all denied that they had intimidated or embarrassed the children.[13]

Beyond the pledge issue, the WLL did not win any friends among the School Board with regard to the legion's stance on enemy aliens teaching in schools. In October, Superintendent Potter investigated how many aliens were teaching in the Milwaukee system in order to certify them with the U.S. Marshal. He counted18, 11 of whom were of German descent, but stated they would not be discharged unless there was proof of disloyalty. John Stover, director of the WLL's Publicity Bureau, zeroed in on Gertrude Reinke, a teacher in Milwaukee schools for 18 years. In a letter published in the *Milwaukee Journal* before it reached the School Board, Stover demanded on behalf of Milwaukee's loyal citizens that Reinke be dismissed because she was born in Germany and was still a citizen of the German Empire. In addition, her father was registered as an enemy alien. "It is important," Stover concluded, "that only an American citizen should have the care of the morals and patriotism of our little children." Attacks such as this prompted Erich Stern to describe Stover as one of the "bigoted little petty-fogging beaurocrats" who owed their positions to political favoritism and were determined to make the most of their chance. Stern added that Stover routinely "bully-ragged" inoffensive and innocent enemy aliens, calling them "damn Dutchmen" and questioning them in a tone reserved for a "recalcitrant canine." Reinke admitted that her father was not a citizen. He brought his family to the U.S. when Gertrude was 13 months old and took out his first citizenship papers more than 30 years before the war but never filed his second papers. "It was not my fault," she told a *Journal* reporter, "that I was born in Germany." She insisted she was a loyal American and had bought Liberty bonds and did Red Cross work. The case certainly raised the ire of the School Board. One director objected to "making the terms patriotism and persecution synonymous." Reinke's principal and co-workers sung her praises, and the board postponed the matter indefinitely. Board President William Pieplow went on the offensive and denounced Stover's "feverish haste and frantic desire" to drag such matters into the public eye before they could be fully investigated. Stover, Pieplow charged, ignored common courtesy and subverted the aims and goals of the WLL to "gratify the morbid desire of the 'publicity department' to produce 'publicity.'"[14]

The WLL's Executive Committee certainly noticed the bad publicity and discussed the effect Stover's actions had on the legion's work. During a November 8 meeting, WLL Secretary Walter Goodland was asked to advise Stover that the legion was "not a punitive institution" and if in the future, Stover felt compelled to take similar actions that he would "kindly do so in some other capacity than as an official representative of

Flag-raising ceremony at Holy Trinity School, May 1917. Milwaukee's public and parochial schools became a battleground for those who wanted to encourage 100 percent Americanism among students. (Photo courtesy of Milwaukee County Historical Society)

the Wisconsin Loyalty Legion." Subsequently Goodland asked Stover to come to WLL headquarters as soon as possible to talk about the matter and reach a satisfactory understanding. Apparently, the lesson did not sink in because Stover soon became embroiled in another controversy.

In early November, Stover and a WLL delegation visited the 25th Avenue School and noticed that the American flag was not raised on the school grounds. They learned that it had not been flown for several weeks. Stover immediately filed a complaint with the School Board against Principal Theodore Oesau, intimating that Oesau did not fly the flag because he opposed the war. At a subsequent hearing, the principal admitted his neglect in making sure the flag was raised every day, a task relegated to an elderly janitor who no longer had the strength to raise the heavy flag. Oesau expressed his regret and said his only excuse was being distracted by his father's ill health and death during the fall. Several witnesses testified to Oesau's patriotism. *Sentinel* Reporter Charles Kennedy, who happened to be on furlough from military service, attacked Stover for staging another publicity stunt, noting that Stover had given him the Oesau letter for publication a full eight hours before Superintendent Potter received it. The principal convinced the School Board of his patriotism, and Kennedy called upon Stover to apologize for persecuting a loyal American. It is unclear if Stover ever issued an apology, but the School Board ended the matter by simply reprimanding Oesau for neglecting his duty.[15]

Stover likewise caused problems for the Milwaukee branch of the American Protective League. According to national APL Director Charles Daniel Frey, the DOJ agent in Milwaukee, Ralph Izard, was "not at all well pleased" with Stover. Perhaps there was a lack of cooperation or communication between Izard and APL operatives, or perhaps the amateur sleuths overstepped their investigatory boundaries. In either event, Izard indicated he would welcome a change in the Milwaukee organization if it could be done tactfully. The complicating factor was that Stover's brother was the U.S. District Attorney in Milwaukee, which Frey insisted was the only thing that prevented Stover's removal long ago. In early January 1918, Frey wrote APL founder A.M. Briggs, who considered Stover one of the organization's weakest chiefs, that it would be "fatal to permit this man to have anything more to do with any town outside of Milwaukee." The most desirable result would be to appoint a "big capable individual" who could effectively organize the rest of Wisconsin and then "come in and clean out the Milwaukee situation" and thus, "accomplish the thing we have wanted to accomplish for some time." Stover, however, evinced a changed attitude in late 1917, prompting Agent Izard to tell Briggs that Stover was "not only working with him in every particular and working exactly as [Izard] tells him to but is showing a renewed interest in the

work and is building his organization up in good shape." Briggs talked with Stover and believed he was thoroughly aware "to the necessity of a little more vigorous and intelligent direct effort than they have been making in the past." As a result, Briggs delayed taking any action.[16]

Stover's overly aggressive tactics along with the constant pro-war pressure of other patriots spurred a backlash from some Socialists. On November 8, DOJ Agent Julius Rosin investigated claims that Arthur Shutkin's drug store on the corner of Seventh and Germania streets was a hotbed of traitorous talk. Shutkin, a naturalized American citizen from Russia, was very involved in Milwaukee's Jewish community and also a Socialist. According to Rosin, Shutkin immediately "bridled up" when confronted and assumed an aggressive attitude. He called Rosin a "God damn fool" and asked, "Who the hell are you to ask me such questions?" The DOJ agent explained he was there to determine if Shutkin was a loyal citizen who tolerated if not condoned seditious talk by Socialists who frequented the store and that it was ill-advised for him to display such antagonism toward the U.S. government. As Rosin left the back office, Shutkin grabbed the agent by his coat lapel. Rosin jerked free and continued toward the front of the store. Just before he reached the door, Shutkin again called him a fool and said he was "nothing but a damn spy." Rosin turned and warned Shutkin that his conduct would certainly get him into "speedy difficulties," at which point the store keeper made a menacing lunge over the counter toward Rosin, who fended off the attack with a blow. "I'll fix you!" Shutkin shouted and ran to the back of the store. Assuming Shutkin was going to get a gun, Rosin pulled his pistol but put it back in his pocket after a few seconds, feeling it was injudicious to get involved in more serious trouble. As Rosin backpedaled toward the door, Shutkin emerged with a pistol, leveled it at Rosin and told him to "get the hell out of this store."

The agent immediately relayed his account of the incident to Special Agent in Charge Ralph Izard. Izard had Shutkin report to the DOJ office the following morning and interrogated him to see if he was an alien. The questioning turned up nothing, but Shutkin went to District Attorney Winfred Zabel and had a warrant issued, charging Rosin with assault and battery. Izard claimed the warrant was a "deliberate frame up" on the part of Shutkin that had Zabel's blessing. The DOJ worked with Assistant U.S. Attorney Paul Stover to pressure Zabel into dropping the charges. The matter ended, but Izard believed this episode, coupled with bitter Socialist propaganda in Milwaukee and Wisconsin, made it unsafe for agents to conduct investigations alone.[17]

The Socialists pushed back again after a federal agent and three deputy sheriffs broke up a meeting staged by Polish Socialists on November 8 at

Pulaski Hall on Grant Street and American Avenue. The main speaker at the event was Vincent Dmowski, a Russian Pole and editor of the Socialist paper *Glos Robotniczy* (*The Voice of the Workers*) in Detroit. The *Journal* reported Dmowski "launched into a harangue" against capitalists who started the war to line their own pockets and hoodwink the ignorant working class. He warned that if conditions deteriorated further, workers would revolt, just as they did in Russia. At that point, authorities stationed in the rear of Pulaski Hall marched to the stage, halted Dmowski's speech and placed him under arrest, though he was soon released.[18] The next day, former sheriff and county organizer for the Socialist Party, Edmund T. Melms, took up the issue with District Attorney Zabel, who swore out warrants for the arrests of the DOJ agent and deputy sheriffs for violating the Socialists' right to peaceful assembly. This decision set off a storm of protest. At the initial hearing before Judge George E. Page, attorneys for the four defendants condemned Melms and Zabel, asking Judge Page to dismiss the action because the defendants only did their legal duty in stopping a speech that was not only seditious but anarchistic. In reply, Zabel said he was as ready as any of the defendants to stamp out anarchy, but he swore an oath to uphold rights guaranteed in the Constitution. Meanwhile, more than 1,000 Milwaukee citizens signed petitions demanding that Governor Philipp appoint a special prosecutor and take the case out of Zabel's hands. "Matters are getting fierce here," wrote attorney Fred Lorenz to Senator La Follette, and with Judge Page presiding, "the outcome of these proceedings, of course, is not in doubt."

There was no doubt, especially after Zabel asked Judge Page to dismiss the charges because, after talking with Dmowski, Zabel believed the agents' actions were justified. Page did so and then turned the tables on Melms. Without a trial or hearing any testimony, Page decreed Melms acted maliciously or "at least with a wanton disregard of the rights of public officers performing their duties" and ordered him to pay $36.48 in court costs or serve 30 days in jail. Declaring he acted to protect the right of peaceful assembly, Melms refused to pay and was held in the county jail for two hours. After conferring with his attorneys, Melms decided to appeal to the municipal court, and he was released on $40 bail. Page clearly overstepped his judicial authority (Judge A.C. Backus dismissed Page's action the following June), and that only served to heighten the combative mood of the pro- and anti-war forces.[19]

As both sides sparred with one another, the true cost of the war was brought home when news arrived of Milwaukee's first war fatalities. On October 22, newspapers reported that John Bright, an infantry private, was lost at sea after a German U-boat torpedoed his transport ship *Antilles*. One month later, Milwaukee suffered its first combat casualty

overseas. Sergeant John Czajka, the son of Mary and Albert Czajka of Milwaukee's south side, had been in France for only ten days when he was killed by a German sniper. The family had not received any notification from the War Department before a *Milwaukee Sentinel* reporter delivered the tragic news to Czajka's mother, who collapsed sobbing. Speaking through her ten-year-old daughter, Mary told the reporter, "I know it is to be expected in war, but I did not think my boy would be the first from Milwaukee to go." Czajka was hailed as a hero, and overflow crowds thronged memorial services on November 27 and Thanksgiving Day, November 29. An empty casket stood before altars decorated with American and Polish flags.[20]

The deaths of Bright and Czajka certainly hardened lines between pacifists and patriots, but tension escalated to a fever pitch in late November after Milwaukee suffered domestic casualties. On Saturday morning November 24, a cleaning lady discovered a bomb placed near Reverend Giuliani's Evangelical church on Van Buren Street. Nothing was done until early afternoon when Maude Richter, Giuliani's assistant, arrived at the church. She called the police and was told an officer would

Milwaukee's central police station (on the right), Broadway and Oneida (now East Wells Street). A bomb exploded at the station in November 1917, killing nine policemen—the single largest loss of police lives until the 9/11 attacks. (Photo courtesy of Milwaukee County Historical Society)

come at once. No one had arrived by 6:00 p.m., so Richter had a boy carry the bomb to the central police station on Broadway and Oneida (now East Wells Street). While the police were inspecting the device, it detonated. An unlucky civilian woman along with seven detectives, a police sergeant and a police alarm operator were killed—the single highest loss of police lives in the U.S. until the 9/11 terrorist attacks 84 years later.

Mayor Hoan called the tragedy a "soul-sickening disaster" and had all flags fly at half-mast. Everyone immediately linked the bombing to anarchists who supported the 11 Italians awaiting trial for their part in the Bay View riot. Congressman William Carey telegrammed the chief of the Department of Justice that a "terrible calamity has come to the City of Milwaukee." Carey had no doubt it was the work of anarchists or the I.W.W. and demanded the DOJ cooperate with Milwaukee authorities to solve the crime. Toward that end, some 50 Milwaukee police arrested more than 30 Italian suspects during the days after the bombing. It seems they were taken into custody, not for any specific connection to the bombing, but for being suspected anarchist members of the *Il Circolo di Studi Sociali*. Without any tangible evidence, all of the Italians were soon released. The police continued making arrests throughout December but never solved the crime.[21]

During this super-charged atmosphere, the trial for the "Bay View 11" began in Judge A.C. Backus' municipal court. The defendants never had a chance: Giuliani served as interpreter for the prosecution, and Backus allowed Winfred Zabel, the prosecuting district attorney, to add conspiracy charges, bully witnesses and refer to the defendants as anarchists, implicitly linking them to the police station bombing. The trial devolved into a farce with constant bickering between Zabel and the lawyer for the defense, William Rubin. Despite no evidence of a conspiracy, it took the jury only 17 minutes on December 20 to convict all 11. Backus then sentenced them to 25 years of hard labor at the state penitentiary.[22] The guilty verdict certainly aroused hard feelings among Italians and leftist, anti-war individuals. Socialist Carl Haessler, for example, accused Giuliani of provoking the September 9 riot to give him credibility as a patriot in the Italian community. The undoubtedly bitter defendants believed the real conspiracy involved Giuliani, who used the bombing incident as a "put up job" to secure convictions and severe punishments against them. In addition, the vigorous prosecution by Zabel, a Socialist, was unintelligible to Haessler except "as a political play to get non-Socialist votes from the 'law and order' element." A letter in the *Social War Bulletin* from Chicago bluntly charged "Com-rat" Zabel with betraying fellow workers. To think, it added, that the Socialist Party allowed "such a dirty, yellow, contemptible pig in their ranks." Such was the animosity toward Zabel

that he received several threatening letters, and the following spring two bombs—one identical to the police station bomb—were placed along his house but neither exploded.[23]

Despite convictions of the "Bay View 11," federal and local authorities believed more stringent measures were needed to clamp down on wartime dissenters in Milwaukee. DOJ Agent Ralph Izard blamed U.S. Attorney H.A. Sawyer for his casual attitude about enforcing the Espionage Act. "The lack of energy," Izard wrote, had the "effect of increasing the boldness and violence of Socialistic utterances." The Wisconsin Assistant Attorney General told Erich Stern that he was willing to suppress democracy altogether in order to wage the kind of war demanded by circumstances. In essence, the government should "out-Kaiser the Kaiser" and not allow dissenters at the polls to register their opposition to the war. Wheeler Bloodgood and the Committee on Administration of the Milwaukee County Council of Defense adopted a resolution at its December meeting—a meeting at which Mayor Hoan was absent—insisting there was a "growing public demand...for a more rigid dealing with those who perpetrate disloyal acts." The committee endorsed any action taken by the Wisconsin Council of Defense to improve efforts at identifying and prosecuting subversives. On the day after Christmas, the *Milwaukee Journal* editorialized that the tense situation frayed the patience of loyalists: "Men who love their country are no longer in a mood to submit to attack upon it. Men whose near ones are facing German bullets, or on the way to do so, are likely to lose self-control where they discover agitators engaged in shooting these defenders of the nation in the back." These men were organizing and beginning to act in crowds, and whenever "one hostile crowd meets another, there is grave danger that human passions will sweep beyond all barriers." "Mob violence would be deplorable," the editorial concluded, and the only way to prevent any bloodshed would be for Governor Philipp to instruct law enforcement to stop all "German Socialist" meetings.[24]

The bluster of the most rabid patriotic citizens was even more ominous. The *Milwaukee Leader* reported that John Stover told a crowd at Harmonie Hall how he was fearful "lest some traitor cause me to take my revolver and kill him like a dog." Algie Simons proclaimed to the Collegiate Alumnae Association that, though he desired peace and freedom of speech, he was willing "for the time to fight under military orders and to gag all those who would destroy free speech forever....We are at war. War means killing....We are as much justified in killing those who stab our soldiers in the back as those who spray liquid fire upon their faces." Another Milwaukee citizen believed the federal government should organize an army of 600,000 citizens of English and French descent,

excluding Germans and laborers, to maintain order across the nation against those hindering the war effort.[25]

Socialists voiced their own concerns about the patriotic element. Victor Berger cautioned his daughter not to talk about the war with anyone, not even her best friends. "You will be misunderstood or misquoted," he added, "or your friend will tell it to somebody else, and that person will misunderstand or misquote." Meta Berger dreaded going to the School Board meeting in early December. "The spirit down there is vicious and extremely partisan," she wrote Victor. And Louis Arnold, the party's acting state secretary, wrote Governor Philipp protesting the "continued lawlessness of the so-called Loyalty legion." The WLL, noted Arnold, intimidated hall owners to prevent them from renting out their venues for Socialist meetings or conspired to bring mobs to break up Socialist gatherings. Arnold asserted these meetings were peaceable gatherings meant to present the party's political and economic views and did not violate any state or federal laws. "Wherever there were outbreaks of violence," he concluded, "they were not precipitated by our speakers…but from such who are not in accord with our view and have no scruples when it comes to violating the constitutional provision insuring the right of free speech and free assemblage."[26] Clearly the mood on both sides of the war issue was sour. The coming winter would not improve matters.

6

> My Tuesdays are MEATLESS;
> My Wednesdays are WHEATLESS;
> I am getting more EATLESS each day.
> My home it is HEATLESS;
> My bed it is SHEETLESS;
> They've all gone to the Y.M.C.A.
> The bar rooms are TREATLESS;
> My coffee is SWEETLESS;
> Each day I get poorer and wiser.
> My stockings are FEETLESS;
> My pants they are SEATLESS.
> My Gawd! How I DO HATE THE KAISER!!!
> —*The Conveyor* (Milwaukee Coke and Gas Co.), April 1918

The winter of 1917-1918 tested the endurance of the heartiest Milwaukeeans like no other up to that point. The fall weather had plenty of omens that the winter was going to be bad. An early frost hit in September, and the first measurable snow fell on October 19. Resident Harriet Richardson recorded in her diary that October 29 was an "awful day, snow, rain & sleet." The next day, she noted, the sidewalks were still "pretty well covered with snow." In fact, it was the coldest October in the city's recorded history, measuring eight degrees below normal. Residents enjoyed mild weather in November, but the cold and snow returned with a vengeance in December. Temperatures on December 8 hovered around zero degrees, while gale-force winds from the north made conditions especially dangerous. Seven Milwaukee men lost their lives when winds and rough waters on Lake Michigan capsized the steamer *Desmond*. A blizzard on December 13 dumped seven inches of snow in the midst of a cold snap, with temperatures dipping to six degrees below zero. Two weeks later, the mercury sunk to ten degrees below zero.[1]

Challenging weather compounded the difficulties Milwaukee residents had been enduring because of the war. The scarcity and high cost of food and fuel always were primary concerns, and both sides of the war issue feared that discontent might erupt into something more dangerous. In early October, Winfield Gaylord of the Wisconsin Loyalty Legion wrote Senator Paul Husting that "unless the wives and housekeepers of the nation can be satisfied as to the intelligence and fair play shown in the food and fuel administration, there is going to be a break in the line of loyalty which cannot be easily repaired." The government's "wheatless" days, Gaylord admitted, "make women smile—grimly." At the same time, Mayor Hoan confided to a relative that he feared if conditions got worse, "Milwaukee may be visited with food riots this winter." Even with municipal markets in place, Hoan felt duty-bound to expand the amount and types of foodstuffs that could be sold directly to the people. The Council of Defense Food Board brought in carloads of rice, rutabagas and other produce to help alleviate the suffering. A.T. Van Scoy, the council's food administrator, also took on the responsibility of fixing prices of staple goods listed in the Hoover Act, such as meat, wheat and produce, and had prices published in daily newspapers. He tried to maintain prices that would keep wholesale and retail profits at pre-war levels. But the *Milwaukee Leader* reported Van Scoy's efforts did not satisfy the Polish Good Housewives League or other women's organizations, which asserted that prices set by Van Scoy were higher than those charged in retail stores.

Nor did Van Scoy win any admirers among those with a sweet tooth. Because of the shortage of sugar, he asked people to drastically reduce the lumps people put in their coffee, eliminate frosting from cakes and substitute honey and jelly for sugar whenever possible. Milwaukee children no doubt looked upon Van Scoy and the County Council of Defense as Scrooge incarnate when these adults asked all organizations that offered entertainment during the Christmas season to stop distributing candy and instead provide fresh or dried fruit, dates stuffed with nuts, maple sugar candy, butter taffy and "marble foam" (commonly known today as "fairy food.") "We do not believe that it would be any hardship on the children," Council of Defense Secretary Osmore Smith insisted, "to ask them to help their country by denying themselves candy at such a time as this."[2]

The coal situation was equally vexing. As the primary means of heating Milwaukee homes, any shortage would inflict widespread suffering. The problem stemmed not from a lack of supply but rather from poor planning and congestion along railroad lines, which hampered coal deliveries. In late August, Governor Philipp notified the Food Administration in Washington that Milwaukee was short 650,000 tons of coal. Matters improved somewhat during September when the Council of Defense

reported the city's coal supply was at 80 percent of normal levels. But when winter arrived, so did trouble. In early December, Wisconsin Fuel Administrator W.N. Fitzgerald observed that there was a good deal of coal hoarding throughout the state. Consumers, he asserted, went to several coal dealers in the same town and obtained more than they needed, leaving those in want literally out in the cold. To combat the problem, the Fuel Administration issued special forms that every consumer and coal dealer had to complete for each order. To help the poor cope with the shortage, the Milwaukee Kiwanis Club pledged to furnish 75 tons of coal during the winter months, but by mid-December, Fitzgerald warned that one dock would be completely out of anthracite coal at year's end, and the other docks would follow suit by mid-January. It was imperative, he added, that consumers conserve their current supply as much as possible because war demands and congested railroad lines would hinder bringing in more. The *Milwaukee Free Press* reported in late December that, with plunging temperatures, the city's poor swamped the county poor office and charities with requests for aid and that large quantities of coal and warm clothing were distributed.[3]

In addition to individuals tightening their collective belts, the federal government tried another tack that left some of the country in the dark.

The winter of 1917-1918 was one of the harshest in Milwaukee to date. Work crews deliver precious coal to William George Bruce's home in January 1918. (Photo courtesy of Milwaukee County Historical Society)

U.S. Fuel Administrator Harry A. Garfield issued an order effective November 15 that prohibited the use of coal to generate electricity before 7:45 p.m. and after 11:00 p.m. for electrically lighted signs, advertisements and other external illuminations. The order did not apply to interior lighting, government buildings, street lights, porch lights, lighting for railroad platforms and other safety-related illumination. One month later, Garfield amended the directive to institute "lightless" nights. As of December 15, all external signs as well as interior lights for stores not open for business were to be turned off on Thursday and Sunday nights. Only outdoor lighting essential for safety on streets, in passages and around "dangerous spots" was allowed. Households also were urged to use as few lights as possible on those nights. Milwaukee experienced its first lightless night on Sunday, December 16. The *Milwaukee Sentinel* reported that the change from "a blaze of lights to almost stygian darkness was most noticeable," as buildings along Wisconsin and Grand avenues were "shrouded in darkness." Outside the downtown business district, however, it was hard to tell that Garfield's order was in effect. Fitzgerald threatened to take action against any stores that did not abide by the restrictions. "On Thursday night," he insisted, "I will have inspectors on the job who will make a note of every offender and we will find means to bring them into line."[4]

While shivering in the cold and dark was bad enough, Milwaukee's drinking water was yet another source of irritation. The city drew its water supply from Lake Michigan, and by December 1917, Health Commissioner George Ruhland asserted the drinking water had become contaminated to such a degree that it was "more or less dilute[d] sewage." Bacteria in the sewage was responsible for outbreaks of diseases over the years, particularly typhoid fever. Milwaukee had begun adding chlorine to the water supply to destroy harmful germs, but cold weather had made the odor and taste of chlorine very noticeable, prompting numerous complaints to the Health Department. Ruhland shot back that it was the public who should be blamed for the situation. For more than 25 years, the city had been warned about the dangers of drinking contaminated water, but the warnings went unheeded. Until a new water intake, sewage disposal system and filtration plant were ready, he concluded, Milwaukee just had to "make the best of a bad situation." The amount of chlorine was reduced, but the quality of the water became so poor that the day after Christmas the Health Department advised residents to boil any water before using it.[5]

Milwaukeeans no doubt hoped 1918 would bring better times, but those dreams quickly faded during the brutal month of January. A blizzard on January 6 buried the city under 21 inches of snow, the highest total

recorded since 1898. Winds gusting to 38 miles per hour compounded the misery and brought all train, street car and automobile traffic to a complete standstill. Making a bad situation even worse, coal, food and milk deliveries came to a halt. Residents had not yet finished digging out when a more severe storm hit on January 12. Again, all traffic was hopelessly snarled. William George Bruce commented that the snow was piled "mountain high about the streets and houses." Harriet Richardson's weary resignation was almost palpable in her diary entry: "Snowed in again. Snowed for 31 hours…never seen such a storm & so much snow." Public officials urged every able-bodied person in the city to pick up a shovel. By month's end, a record 52 ½ inches of snow had fallen; thousands of wagonloads of snow were removed from the central business district alone and dumped into the Milwaukee River. Unrelenting cold made matters worse. The average temperature was ten degrees—the second coldest January in Milwaukee at the time. Only once did the temperature sneak above freezing and that was for only one hour on January 25. According to the *Sentinel*, the only ones who enjoyed the frigid temperatures were Sultan and Sultana, the polar bears at Washington Park Zoo.[6]

The tortuous winter exacted a heavy toll upon Milwaukee residents. The fuel shortage, wrote William George Bruce, was "beginning to pinch." The war and weather, he added, made "economy the watchword of the hour—economy in fuel, food and clothing."[7] The most frugal, however, could not have been prepared for the drastic edict from U.S. Fuel Administrator Harry Garfield on January 17. Without warning, he ordered all factories east of the Mississippi River that were not producing foodstuffs to close from January 18-22 and for the next ten Mondays as a fuel-saving measure. Stores and offices were spared from the first week but had to close on Mondays as prescribed. This dictate was a "thunderclap from a clear sky" to Bruce. At a moment of widespread suffering, Garfield shut down more than 2,500 Milwaukee factories, put more than 130,000 employees temporarily out of work and cost them approximately $1 million in wages. The *Milwaukee Leader* echoed a nationwide outcry, editorializing that the Wilson administration had a "perfect genius for bungling," and Garfield's action was "its crowning achievement of inefficiency." Even the more restrained William George Bruce admitted it was a national disaster and a "humiliating admission of national unpreparedness and weakness."[8]

Stunned Milwaukee businessmen and workers grudgingly obeyed the order, yet another testament to the city's willingness to support the war effort. The administrative flexibility of Dan Hoan and the County Council of Defense also facilitated compliance with Garfield's order. Some local officials around the country resorted to commandeering coal trains as they passed through their districts because their constituents were desperate

for heat; in other areas nationwide, police guarded industrial coal piles to prevent thefts by local citizens.[9] Nothing comparable occurred in Milwaukee. The County Council of Defense helped with the heating situation by opening coal stations at 11 fire engine houses during the week of January 13. The make-shift stations sold roughly 30 tons of coal during the first week. Meanwhile, Hoan found a mixed blessing in the January 12-13 blizzard: despite the hardships it caused, the storm offered the only available opportunity for work. During an emergency meeting on January 18 in the mayor's office, Hoan and a group of business and labor leaders decided the city should hire idle workers to shovel snow at 35 cents per hour. These measures helped, at least in part, preserve an uneasy calm. On Monday, January 21, the *Leader* reported no disturbances as the city experienced the most complete suspension of business in its history—even the city's 2,000 saloons closed. The only businesses open were drug stores, groceries, theaters, restaurants, bowling alleys and banks.[10]

As if the harsh weather and layoffs were not enough, gossip that enemy agents poisoned or put ground glass in various foodstuffs ran rampant throughout the city. The discovery of ground glass in cans of tomatoes in Manitowoc, Wisconsin, no doubt fed the swirling rumors. Frightened residents sent hundreds of samples of flour, candy and sugar to the city's Health Department for testing. In February, Health Commissioner George Ruhland assured citizens that no signs of poison or ground glass had been found.

Ruhland's news, though welcome, failed to placate disgruntled Milwaukeeans. Government officials' constant harping on food conservation during wheatless and meatless "Hooverized" weeks and the unending stream of new federal rules raised troubling questions whether the government accurately anticipated the nation's domestic needs. Recent experience no doubt convinced many citizens that was not the case, and some took steps to ensure they had enough food to avoid starvation, even if that meant consuming something as unappealing as horse meat. Health Commissioner George Ruhland relayed in early February that Milwaukeeans were eating an average of 11,000 pounds of it per month.

That might have driven some to take more desperate action. The *Leader* reported that near riots broke out at the central and south side fish markets on January 18, requiring the police to restore order. Even more troubling to federal officials was rampant food hoarding in Milwaukee. Each household was allowed a 30-day supply of food. Anything beyond that was considered hoarding. Given food shortages, skyrocketing prices and general dissatisfaction among many Milwaukeeans, William George Bruce imagined that the average cellar and pantry were better stocked than before the war. He was not far from the mark. By mid-February, there

were so many reported food violations that the Secret Service dispatched Peter Drautzburg from Chicago to assist A.T. Van Scoy with investigating all abuses of government food regulations. "We are going after food violators," Van Scoy told the *Sentinel*, and "Mr. Drautzburg has the reputation of getting what he's after." On the first day, the Secret Service agent and Van Scoy interrogated nine residents for not complying with the meatless and wheatless orders. All nine were warned that, in the future, rules would be enforced to the letter; no excuses would be accepted.[11]

Given Milwaukeeans' preoccupation with the cold, snow, food shortages, etc., it would seem plausible that there would be a temporary dulling of hostilities between the pro- and anti-war camps. But that was not the case. A renewed volley occurred in December 1917. E.T. Melms, the controversial former sheriff who had government agents arrested for breaking up a Socialist meeting, was the Socialist candidate for Wisconsin's eighth state senate district. Though not a Socialist himself, Erich Stern wrote a letter to Milwaukee voters in support of Melms. According to Stern, Democrats and Republicans were determined to make loyalty the only issue of the campaign, which was a danger to American democracy. He insisted the real issue was the right of citizens to express freely their beliefs at the ballot box. The Socialist Party was the only political organization to stand courageously against interfering with Constitutional liberties. To attack the Socialists' loyalty, he concluded, was to "confess to a lack of faith in our cause in this war and in the very fundamentals of democracy itself."

One recipient turned Stern's letter over to the *Milwaukee Journal*, which published it on December 31—a move that caused personal headaches for Stern. In early January 1918, Milwaukee Attorney Herbert Laflin wrote Stern in disbelief that such a letter as was printed in the *Journal* could have come from someone Laflin "esteemed as a friend." He looked upon Stern's position with regard to the war "only with the deepest abhorrence and contempt" and told Stern bluntly, "I want no friends among the enemies of my country." The quintessential Victorian gentleman, Stern responded that he deeply felt the loss of Laflin's friendship and respect and appreciated the depth of Laflin's conviction and "capacity for righteous indignation." But Stern could not understand why his former friend failed to appreciate the earnestness of his motives. Stern closed by expressing hope that they would live "to see brighter days, when we shall feel chagrined, not to say shamed, by the thought of such misunderstandings, and shall be glad to forget them." In addition to Laflin's reaction, several members of the University Club called for Stern's expulsion because of his seemingly disloyal stand. The club's board of directors investigated the matter and determined there was no basis to expel Stern. Frustrated club members

terminated their memberships, claiming Stern's continued presence was inconsistent with their respect for and obligation to American servicemen. Stern resented the fact that he was not given an opportunity to refute the charges against him, but considering the widespread animosity toward him, he felt he should also resign his membership to spare the board and club any embarrassment.[12]

Stern's letter in support of Melms hounded him on a professional level as well. It raised such a howl of protest that some people refused to aid the Milwaukee Citizens' Bureau of Municipal Efficiency because Stern was a trustee. He defended his position, saying it was his public duty to rebuke various forms of intimidation used against Melms' supporters. Nevertheless, Stern did not want to hinder the bureau's work and tendered his resignation. He received a small measure of satisfaction with regard to his work at Marquette University Law School. On January 3, 1918, the *Milwaukee Journal* printed an article noting that a group of law students was circulating a petition that called for his dismissal from the law school faculty because of his connection to the People's Council and support of Melms, who backed the St. Louis platform of the Socialist Party. The timing of the story—it was printed only three to four hours after students returned from Christmas break—caused Stern to question if the petition was truly a spontaneous student action or if some outside party (i.e., the *Journal*) put students up to it (one wag in the *Leader* called the *Journal* and other capitalistic newspapers "noose-papers" because "they usually lynch the truth by hanging"). In either event, a large number of signatures was gathered and the petition presented to Marquette President Herbert Noonan, S.J.

In his defense, Stern submitted a letter to Noonan, which was reprinted in the *Marquette Tribune*. The embattled faculty member reiterated that he acted purely out of patriotic motives and the desire to protect the right of free speech. To the students who signed the petition, Stern professed that, in his eyes, their loyalty was honorable. They may have misunderstood or disagreed with his standpoint, but loyalty was a matter of the heart and not opinion. Any honest opinion may cause harm, but it was never disloyal. Stern contended, "In a democracy no honest conviction fearlessly expressed can do the country as much harm, as the unwarranted forceful suppression of that opinion." At the same time, he could not resist taking a swipe at some in the patriotic camp. The only type of loyalty safe for a nation to build upon, he declared, was that which was …

> an attribute of character and not mere lip-service. The person who is truly loyal to his country, will also be loyal to his family, to his friends, to his teachers, to his pupils—in short, he is loyal in all the relations of

his life, simply because that is the manner of man he is. The man who is the loudest shouter on his own safe side of the fence, often has the most unaccountable change of heart when circumstances thrust him among his opponents, or when the majority opinion shifts. His loyalty is only apparent and of little value.

Stern concluded by stating his relations with Marquette had been very pleasant, and he would be happy to continue teaching there. But if Fr. Noonan thought it best, Stern offered to resign "without the slightest feeling of resentment on my side." Stern's vigorous refutation persuaded the Marquette president that he was not a Socialist and did not support the St. Louis platform; the case was closed, and Stern remained at Marquette.[13]

Stern was not the only one to feel political heat during the Melms' campaign. Since the start of the war, Dan Hoan had walked a fine line between his Socialist principles and political necessity, but that balancing act stumbled in the waning days of 1917. On December 27, he appeared with Melms at a campaign event, during which the mayor was asked if he approved of the St. Louis platform. Sidestepping the question, Hoan said he would provide an answer when he was a candidate for office. Victor Berger, who had suffered a good deal of abuse for his support of the platform and who was always somewhat skeptical of the mayor's commitment to the Socialist cause, immediately attacked Hoan's "wobbling." "Any man who can not stand on that platform," railed a *Leader* editorial, "be that man a mayor or a constable—must get out of the party in justice to himself and the party." The Mayor's Advisory Committee, whose members supported the war, also demanded a definitive stand from Hoan.

Sick with a severe cold, the mayor delayed responding. On January 4, he issued a statement regarding the extensive publicity of which he had been "lately so generously blessed." He asserted he did not answer the question at the Melms' rally because he hoped to discuss his position with the Socialists' Platform Committee first while it decided to support Hoan as a candidate for mayor. But circumstances—Berger's public attack and the Advisory Committee's resolution—forced him to reply. "I am a Socialist," he declared, "My whole soul rebels at the thought of war and the horrors of it." His fervent hope was for immediate negotiations for a just and general peace. "If it is some great offense to feel like this," he added, "I plead guilty. Make the most of it." He acknowledged he had voted against the St. Louis platform because its provisions made it impossible for him to fulfill his duties as an elected official. He left it to the Milwaukee County Central Committee as to which course he should follow, and that body unanimously encouraged him to continue as mayor and execute the laws of the U.S. Hoan ended with a direct challenge to Berger. The Socialist

Party, the mayor wrote, was not "an organization of one man," and party members should not privately or publicly be "bossed by individuals, however high the claim to the contrary."[14]

Hoan's statement did little to quiet the situation. Victor Berger insisted that, by opposing American entry into the war and calling for immediate peace negotiations, Hoan had effectively adopted the same position as the St. Louis platform; the rest of the mayor's message was "all camouflage, evidently uttered for the benefit of the *Milwaukee Journal* and of the Loyalty Legion." Meta Berger feared a permanent split between her husband and the mayor would be a godsend for the *Journal*, *Sentinel* and the rest of the patriotic camp. Victor, she confessed to her daughter, "is so bitter toward Hoan for being cowardly that his (papa's) temper may over rule his judgment or his political sense & then it has happened.... It seems that we are always in one damn thing after another." Meta was not too far off the mark. Both the *Journal* and the *Sentinel* crowed that Hoan's "swift, sure stroke" overthrew Berger's dictatorship of the Socialist Party. It also appeased many among the war supporters. W.A. Hall, principal of the Milwaukee Normal Training School, was gratified that Hoan "came out for America and Americanism," while Attorney J.E. Dodge appreciated the mayor's courage in taking a stand "to the jeopardy of your standing with your political associates." After a heated debate, the Mayor's Advisory Committee overwhelmingly expressed confidence in the mayor's personal loyalty. Wheeler Bloodgood and other loyalists on the County Council of Defense likewise commended Hoan's service on the council. Much to the disappointment of the patriots, Hoan and Berger eventually patched over their breach—at least publicly—for the upcoming spring elections.[15]

Not everyone was in the mood to mend fences, however, resulting in a number of tragi-comic episodes. John Stover of the APL again took center stage in one notable incident. Stover, who according to the *Leader*, "froths at the mouth wherever he gets a whiff of sauerkraut and whose sensitive American imagination runs riot when he sees a stuffed dachshund," was in Judge John J. Gregory's court on January 19 when he noticed that Attorney A.W. Richter wore a ring with what appeared to be a German Iron Cross. According to the *Journal*, an indignant Stover asked Richter, "What do you mean by wearing an Iron Cross ring in these times?" Richter replied that it was too tight and would have to be filed off, to which Stover snarled, "You have had eight months' time in which to have the ring filed." He asked Judge Gregory to fine and exclude Richter from the courtroom. Gregory asked for an explanation about the ring, and Richter said he had received it for making a generous contribution several years ago to German war sufferers; it had nothing to do with the Iron Cross decoration. Richter

volunteered to have the ring removed. This satisfied Gregory, who took no action.[16]

Apparently, rings were a great source of irritation to other government agents. In mid-February, Martha Huettlin accused APL operative Harry King of bullying her during an interrogation and brutally yanking an Iron Cross ring off her finger. As it turned out, it was a ring she also received for contributions during the 1916 charity bazaar. The shocked and distraught woman fainted and had to be taken to a hospital. A *Leader* reporter filed an affidavit on Huettlin's behalf, asking Agent Ralph Izard to investigate the matter, which became a "they said, she said" incident. King said Mrs. Huettlin voluntarily surrendered the ring, and Izard exonerated King, claiming the story was fraudulent and "manufactured in every detail." A *Milwaukee Leader* editorial called the decision a "miserable whitewash."[17]

Milwaukee's Common Council added yet another layer of animosity against the disloyal. Alderman John Koerner introduced an ordinance to increase the fine for anti-war statements from $25 to $250. Complaints arose concerning vagueness of the ordinance's language and how it could be abused to infringe on personal rights. In addition, District Lodge 10 of the International Association of Machinists urged Mayor Hoan to veto the measure because it would throttle attempts to organize labor. Hoan was more than willing to comply. The ordinance, he wrote, was discriminatory because it did not furnish the means to punish profiteers or millionaire capitalists who sold rotten beef that poisoned soldiers or who furnished shoddy clothes and other inferior material to the military. Hoan resented the insinuation the ordinance cast upon the city. "The great mass of our citizens," he intoned, "deserve praise rather than condemnation for the part they have played in assisting our government during the war." The proposed legislation dealt with matters that were better left to the federal government. The council upheld Hoan's veto by the slimmest of margins when non-Socialist Alderman A.E. Wittig voted with the Socialists.[18]

As the pro- and anti-war factions sparred with one another, the dreadful cost of the war again hit home. Newspapers broke the story on February 7 that a German U-boat torpedoed the American transport ship *Tuscania*, which carried a large contingent of Wisconsin troops. Frantic relatives flooded Milwaukee newspaper offices with telephone calls, desperately seeking names of the victims. On February 11, the *Milwaukee Leader* reported that five Milwaukeeans were among the missing. All told, 171 American servicemen, including two from Milwaukee, perished. The tragedy escalated determination among the patriotic element to clamp down on war-time dissent. The day after the story broke, Wheeler

Bloodgood addressed ward organizations of the Milwaukee County Council of Defense at City Hall. "The time has arrived when man is either for this government or against it," he claimed, "There is no place on the fence for anyone." He asked the audience what would happen if it learned that casualties from the *Tuscania* and future military actions were caused by information leaked from foes in the U.S. "Are we going to temporize with such a situation?" he inquired. "By the God in heaven, I say we are not."[19] Bloodgood's ominous warning foreshadowed that the upcoming spring elections were going to be especially confrontational.

7

The eyes of the world are on this community, and as a result of the verdict at the polls...the announcement is going forth in glaring headlines in every paper in this land that the Kaiser and not our President, has the confidence of the majority of this county.
 Wheeler Bloodgood to city editor of *Milwaukee Free Press*,
 March 21, 1918

On March 3, 1918, Russia—preoccupied with its own brewing revolution—signed the Treaty of Brest-Litovsk, negotiating a separate peace with Germany. A stroke of the pen deprived the Allies of a key partner and allowed Germany to focus the full force of its military on the Western Front. It did not take long to unleash that concentrated might. On March 21, the Germans launched a massive offensive. Within a week, they routed British and French forces along a 43-mile front, capturing 1,200 square miles of French territory. With the Germans' stunning success, the Allied cause teetered on the brink of disaster. Only two U.S. engineer companies participated in this titanic battle, but the American public knew that the Doughboys would soon be fully engaged in the carnage.[1]

Against this gloomy backdrop, Milwaukeeans prepared for two crucial political contests. The first involved the mayor's office, and the second was to fill a U.S. Senate seat that had remained vacant since October, when Paul Husting was killed in a hunting accident. Many viewed the campaigns not only as referenda on the war but also as struggles for the soul of the city and state.

Both campaigns essentially kicked off in late February when Milwaukee Socialists endorsed Dan Hoan to stand for re-election as mayor and Victor Berger to fill the U.S. Senate position; at that time, the party also approved its platform for the mayoral race. Never mentioning the St. Louis platform specifically, the party reaffirmed its assertion that the U.S. was fighting

a rich man's war: "The American people did not want and do not want this war. They were plunged into this abyss by the treachery of the ruling class of the country." Milwaukee Socialists called for a speedy, democratic peace without any annexations or punitive indemnities. In a departure from the St. Louis platform, the Milwaukee manifesto asserted that party members would obey all laws but fight any attempts by the federal or state governments to impinge upon the established rights of free speech, free press, free assemblage and free organization.

Dan Hoan opened his re-election effort with a speech at Bahn Freie Turn Hall on March 1. He called the upcoming election the most important in Milwaukee history. He derided his opponents for focusing solely on the loyalty issue and not having a plan or program to benefit the city. He chastised the press for accusing Socialists of having pro-German sentiments. This was a "contemptible lie." To demonstrate his and his family's patriotism, Hoan mentioned how his father fought in the Civil War and that, during the current crisis, he had never advocated any principle or took any action not in the best interest of the American people. In addition, the Socialist Party had fought "political Kaiserism, Junkerism, Czarism, Kingism, and Industrial Monarchism of every form and description." The mayor predicted that on election night, April 2, a Socialist victory would "send a message and good cheer, hope, peace and democracy throughout the entire world."[2]

The patriots (or "pay-triots" as some called them) exhibited little good cheer toward the incumbent mayor or the Socialists. The *Milwaukee Journal* quickly denounced the local Socialist platform as having the same "illogical and basic hatred of the war, the same attack of our nation" as the St. Louis program. If the Socialists' claims that the ruling class brought on the war were true, then a crime was committed against every soldier sent to France. But if it were not true, the platform was "not only demoralizing, but a menace to the army." It stabbed American soldiers in the back. It was "infamous beyond power of words to express," and it and its authors should be suppressed for the war's duration.

The Wisconsin Loyalty Legion chimed in as well. A WLL committee asked Hoan to clarify his attitude toward the war and the federal government by answering "yes" or "no" to four questions: 1) Did he endorse the war plank adopted at the St. Louis convention? 2) Did he believe the U.S. was justified in declaring war? 3) Had he given wholehearted support to the U.S. government's effort to win the war? and 4) Did he pledge, if elected, to assist to the utmost the successful prosecution of the war? In response, Hoan reiterated his opposition to the St. Louis platform and that he had complied with every law and supported every part of the government's war effort. He reminded the committee

that two months earlier, Wheeler Bloodgood and the County Council of Defense had praised his work, and in July 1917, Senator Husting had expressed his "warmest admiration" for Hoan's "unselfish and devoted service." The mayor challenged anyone to cite a single instance in which he had not fulfilled his official duties. "I have nothing to conceal," he concluded, "but I caution [the committee], however, to be very careful not to misrepresent facts, concerning my conduct, to the public." Hoan would take any such action "as willfully intended to injure me in this most patriotic community." At that same March 8 gathering, Wheeler Bloodgood said if Hoan won re-election, it would be construed that Milwaukee was "prepared to meet the fate of Russia." He echoed the *Journal* that the platform was the same as that adopted in St. Louis and asserted that if Hoan believed the war was unjustifiable, he should not continue leading the County Council of Defense and should withdraw from the mayoral campaign.

The *Milwaukee Leader* gleefully tweaked Bloodgood's change of heart towards Hoan, comparing the WLL leader to the "little girl with a curl" nursery rhyme. The little girl, when she was good, was very, very good, and when she was bad, she was horrid. In January, the "good" Bloodgood "thought Mayor Hoan was oh, so awfully nice that every loyalist could almost hug him to death." By March, however, the "horrid" Bloodgood "spit and used naughty words" about Hoan and "could just scratch the mayor's political eyes out."[3]

Primaries for the mayoral and senate contests were set for March 19, but shortly before the vote, bombshells dropped on both Socialist candidates. On February 2, a federal grand jury in Chicago handed down indictments against Victor Berger and four other Socialists for violating the Espionage Act. The move was based on a single article published in the *Leader* on June 20, 1917, which argued that the U.S. entered the war because of capitalist interests and not to spread democracy. But the U.S. District Attorney suppressed the indictments until March 9, when the *Journal* reported the announcement. The timing, declared the *Leader*, was a blatant political move to injure Berger's candidacy. Apparently any bad blood that existed between Hoan and Berger was set aside, for the mayor also came to Berger's defense. The indictments, Hoan charged, were not only blows against freedom of the press and free speech but also menaced the right to organize a political party. Rather than injuring the Socialists, he wrote, the indictments "solidified every Socialist and every lover of liberty into a solid phalanx."[4]

As for Dan Hoan, his troubles were orchestrated by the "horrid" Wheeler Bloodgood. On March 11, Bloodgood, August Vogel and other members of the Administration Committee of the County Council of Defense

visited Hoan in his office. They read a communication to be forwarded to the Council of Defense Executive Committee, asking it to hold a special session on March 14. The purpose: accept Hoan's resignation as chairman of the Council of Defense or, barring that, remove him from the post. The mayor asked these messengers if they could mention a single occasion when he failed to perform any duty in support of the war effort. They could not. The entire issue then, Hoan said, was that committee members did not like his politics. Bloodgood admitted that he could not serve on a council with someone who supported a platform that condemned the nation's entry into the war while his two sons were in the military. Hoan wondered why Bloodgood waited until the election campaign to raise his objections and not voice them in January, when the mayor laid out his stance on the war. He suspected that a WLL leader goaded Bloodgood into taking this step to remove the mayor from the Council of Defense. Hoan did not name the culprit. He did, however, mention that the individual was fulfilling a lucrative government contract and violently opposed the mayor's assertion that wealthy industrialists were destroying the health of American workers, accounting for the large number of men who were declared unfit for military service.

Hoan informed the executive committee that he would continue to aid the government no matter what action it took. Furthermore, he contested its right to remove a city executive from such an important post. After all, it was Hoan who organized the Council of Defense and invited the committee members to participate regardless of their politics or religion. With their guidance, the Milwaukee Council of Defense became one of the most efficient in the nation and was adopted in Washington as the model for other cities to follow. Up to this time, Hoan added, the council's work had been accomplished with the utmost harmony. But, he charged, this politically driven move threatened to disrupt everything. He mentioned that Bloodgood had approached him some time ago and asked the mayor to prevent the Socialists from placing a candidate in the U.S. Senate race and to throw the party's support behind Democrat Joseph Davies, Woodrow Wilson's hand-picked choice. Hoan would not say if his refusal prompted Bloodgood's action but strongly hinted it may have been a factor. Removing him would not be in the country's interest and would violate any rule of decency. It would be "bare ingratitude" to remove the person who invited them to join the council and was an insult to Milwaukee citizens who would soon choose their mayor. He vowed to continue his service to America as a member of the council. "I defy you," he challenged, "Now do your worst."[5]

During the special session, the *Journal* reported that Bloodgood told the executive committee that he and other committee members respected the

mayor's ability, character and valuable service to the Council of Defense. They were willing to leave politics aside until Hoan came out in support of the Milwaukee Socialist platform. Bloodgood recounted how he had defended the mayor in January when Berger accused him of straddling the St. Louis platform, but after Bloodgood had traveled to Washington to say goodbye to his sons who were leaving for the front, he found Hoan in favor of a platform that essentially called his sons, the President, Congress, 500,000 boys in France and the one million soon to sail overseas "criminals." Bloodgood claimed he implored Hoan to sever ties with Berger and the adopted platform. If the mayor did so and remained loyal to the government, Bloodgood said he and the Council of Defense would back any social or economic reforms Hoan wanted. If he continued his partnership with Berger, however, Bloodgood threatened to remove Hoan from the Council of Defense and urge the federal government to prosecute him. The mayor refused to repudiate the platform. According to Bloodgood, Hoan—though not personally threatening Bloodgood—advised that if he followed through on this course, neither his nor his family's lives would be safe. That point of departure compelled Bloodgood to move for Hoan's dismissal as chairman. Charles Allis simply asked Hoan if he would resign. The mayor declined, saying it would put him in a position of not serving his country. A vote was taken, and the motion for removal was approved 16 to 5. In spite of the vote, Hoan, as promised, continued his work with the council.[6]

Nor did the council vote derail Hoan's candidacy. As one Milwaukeean wrote to the mayor, "I never voted socialist before...I shall vote the ticket straight next week as well as the week after." He promised to secure at least ten more votes from people who had never voted Socialist: "Votes of protest I call them. Slanderers and villifiers must be silenced."

While the loyalty issue ultimately did not arouse much enthusiasm among Milwaukee voters, loyalists made plenty of noise prior to the March 19 primary. Wheeler Bloodgood warned that if any Socialist candidate who supported the St. Louis platform were elected, he would take the fight to the Supreme Court to prevent that individual from being seated.

In addition to Bloodgood's bluster, the *Leader* described an attempt by the Home Guard—a group of "stay at home" soldiers—to break up a Socialist rally staged at the South Side Armory on the eve of the election. Approximately 1,500 people packed the armory to hear Dan Hoan and other Socialist candidates, but the meeting turned into "veritable bedlam" because of the din of a Home Guard brass band coming from a smaller hall on the second floor. The *Leader* claimed it was a bold-faced effort to provoke a riot, but no violence occurred because of the

Socialists' "exceptional self-control." Somehow, Hoan made himself heard above the music. He dismissed Bloodgood's vow of a court fight if he were elected. During his time as city attorney, Hoan noted, "I defeated every big law firm in Milwaukee, and I assure you that I can bust [Bloodgood's] law firm too." Despite the clamor and threats, Hoan easily outpaced the other candidates in the primary. Percy Braman, acting commissioner of Public Works, emerged as Hoan's opponent for the general election on April 2. Victor Berger likewise received strong support from Milwaukee voters in the primary, and he would face two "loyalty" candidates in the general election: Republican Irvine Lenroot and Democrat Joseph Davies.[7]

The Socialists' solid showing infuriated Bloodgood and fellow patriots. As reported in the *Chicago Tribune* and *New York Times*, he demanded that Hoan be indicted for violating the Espionage Act and called for the federal government to declare Milwaukee a military zone under the aegis of military courts to eliminate all treasonable talk and printed material. To prepare for the possibility that either of these demands failed to materialize, Bloodgood helped organize a "Next of Kin" Society. It was made up of men who had sons or brothers fighting in France and was committed to take its own steps against the Socialists. The *Tribune* compared this organization to the Ku Klux Klan, a charge Bloodgood emphatically denounced. He said men of "quiet and determined character" comprised the group, and though they were not bloodthirsty vigilantes, they would not tolerate a Socialist government in Milwaukee or Wisconsin. Bloodgood envisioned that, as the Next of Kin Society grew, it would generate a public sentiment that would force the federal government to discipline the traitors, or Germany's "third line of defense" as Bloodgood referred to them. His indignation knew no bounds as Bloodgood described the proper punishments: the "stone wall and the firing squad, and to their followers, concentration camps, hard and useful labor under armed guards." While steadfast to the Next of Kin and its purpose, Bloodgood denied newspaper reports that he called for martial law. In a letter to the U.S. District Attorney, however, he declared that "unless the government acts in this matter immediately we will have a condition in this community which will make it necessary to declare martial law."[8]

Erich Stern decried Bloodgood's appeal to subvert the will of the voters, advocating that his name should now be "Bad Blood." Governor Philipp also had a dim view of "Bad Blood's" call and affirmed that whomever the citizens of Milwaukee elected as mayor would be inaugurated without any disturbance.[9]

All sides waged a bruising campaign leading up to the April 2 mayoral election. The *Journal* and *Sentinel* urged Democrats and Republicans to

put aside political differences and unite in support of Percy Braman. The *Journal* insisted he was the only choice because he had been "outspokenly American in every word and act before and since we were forced into the war." The Wisconsin Loyalty Legion delved into the political fray and used its organizational power to sway voters to support such a patriotic candidate. For example, Bloodgood penned a widely circulated letter that maintained the Socialists were asking voters to desert the government. He proclaimed no American could endorse the Socialist platform "without being false to all the traditions and ideals of this nation." He asked how Milwaukee could ever "hold up its head among American cities" if the Socialists won.[10]

In turn, Hoan ridiculed the patriots for "hurling mud-balls as well as lying and making vicious attacks," and for enlisting former Mayor David Rose—the "world champion enemy of democracy and decency both in home and city"—to stump for Braman. Instead of the loyalists praising the record of Milwaukee and the Council of Defense, Hoan pointed out how they were boosting a "crooked bunch of politicians who are willing to crucify the name of this city as well as myself to gain a few 'dincky' political jobs." Hoan devoted every moment and ounce of energy to "give this crowd of camouflage patriots the worst licking they ever got." He composed a letter detailing the Socialists' accomplishments and included a plea to voters not to elect him mayor without a Socialist majority on the Common Council. Failing to do so would put "shackles on my hands, hobbles on my feet and a millstone around my neck." To ensure the letter reached every possible household, Socialists distributed 30,000 copies around the city.[11]

The U.S. Senate contest was equally combative. President Wilson did all he could to influence the Wisconsin campaign because the Democrats' thin Congressional majority was vulnerable; Paul Husting was one of eight Democratic senators who died during the 65th Congress. To address the situation, Wilson persuaded Joseph Davies to resign as chairman of the Federal Trade Commission and return to Wisconsin to stand for office. The President subsequently issued a public letter asking Wisconsin voters to consider three neutrality-era measures as the "acid test" of loyalty and Americanism. This was a calculated move to undermine Lenroot and Berger, who had both opposed Wilson on those measures, while Davies—due to his position on the FTC—was unsullied by a public vote. Meanwhile, Lenroot, who had broken from the La Follette wing of the Republican Party over the war, portrayed himself as a member of the ultra-patriotic party. Fearful that two loyalist candidates would split the patriotic vote, the WLL tried to persuade one of them to step aside and unite behind a single

candidate. But loyalty could not overcome long-held political ties, and the effort failed.

On the other side, Berger had difficulty broadening his appeal beyond Milwaukee County. He tried placing ads in newspapers across Wisconsin, but many refused to print them because of his anti-war stance. In addition, vandals smeared paint over Berger posters located throughout the state, and patriotic groups broke up Socialist meetings in Horicon, Fond du Lac, Theresa, Chilton as well as another rally at Milwaukee's South Side Armory. The night before the election, Berger delivered a blunt message at the Bahn Frei Turn Hall. "We are living in a remarkable epoch," he stated. "The bird of liberty nowadays...is the jail bird." If you stood for peace as he and hundreds of other Socialists did, you broke the peace. If you refused to kill, you were branded a "criminal worse than a murderer." American patriots were so hysterical that they were color blind. Berger elicited laughter from the crowd when he noted that many of his campaign posters had been painted yellow. "Now this is the first time I have been accused of being yellow," he deadpanned. "They always said I was red."

The election outcomes reflected Milwaukeeans' weariness with President Wilson, high prices, non-stop regulations, food shortages, suppression of free speech and over-the-top patriotism. The Socialists prevailed in the mayoral contest, with Hoan outpolling Braman by 2,000 votes. Though Lenroot won the Senate seat, a particularly stinging blow to Wilson, Berger finished a strong third. He had 26 percent of the vote overall in Wisconsin but garnered nearly 42 percent in Milwaukee County, outpolling both "loyalty" candidates. The WLL claimed the Senate results—Lenroot and Davies' combined total votes were nearly three times greater than Berger's tally—constituted a great victory for Wisconsin's loyal citizens and requested 100 newspapers across the nation to print editorials emphasizing the state's patriotism. Not every publication accepted this line of thinking. The assistant editor of *The Christian Science Monitor*, for example, told the WLL that such a request would have been unnecessary if Wisconsin citizens "could have forgotten party lines and united in a common effort to elect a loyal American to take the place of the late Senator Husting." Having two loyalty candidates, he chided, risked the election of a disloyal Socialist who was under indictment by the government.[12]

The results were equally distasteful to Wheeler Bloodgood. Two days after the election, he traveled to Washington to consult with various officials and testify in front of the Senate Committee on Military Affairs, which was considering a bill to use military tribunals to try civilian traitors. Assistant Attorney General Charles Warren was the architect

of the Espionage Act, but he soon came to believe it was inadequate for suppressing radical, anti-war dissidents. Only the use of military tribunals and the threat of execution, he argued, would effectively discourage any who willfully obstructed the war effort. President Wilson, however, believed the Espionage Act effectively smothered anti-war activity, and he and Attorney General Thomas Gregory opposed Warren's attempts to broaden military jurisdiction. Undeterred, Warren sought to circumvent the Department of Justice by seeking out supporters among Congress and influential members of the public. In August 1917, he found two willing collaborators in Senator Paul Husting and Wheeler Bloodgood. Both were angry that Victor Berger's *Milwaukee Leader* was still in operation two months after passage of the Espionage Act, and they persuaded Warren to draft a legislative memorandum providing the legal justification for trying anti-war agitators as spies in military courts.[13]

The spring 1918 elections in Milwaukee spurred Warren's efforts. In March, Bloodgood returned to Washington, incensed at Dan Hoan's embrace of the Socialist platform and concerned about the possibility of Victor Berger being elected U.S. Senator. The Milwaukee attorney encouraged Warren to circulate his memorandum. The memo and a draft bill to establish martial law found its way to Senator George Chamberlain, an Oregon Democrat and chair of the Military Affairs Committee. Chamberlain eagerly introduced the proposed legislation on April 16 and held hearings to consider the bill.[14] Bloodgood testified before the committee on April 17 and assured its members that the proposed bill was absolutely necessary. It was not possible in Wisconsin, he asserted, to prosecute men like Victor Berger in civil courts, when 25 percent of the state voted for someone who campaigned on the Socialist platform. As a result, the *Milwaukee Leader* had become "vile and more vile" after Berger was indicted than it was beforehand. Milwaukee was a conservative community, Bloodgood claimed, and had been patient up to the present time, but if nothing were done to counteract this dangerous propaganda, patriotic citizens were "apt to go back to primitive methods" to deal with the situation, especially as American troops became increasingly engaged in combat and casualty lists mounted. Every hour's delay in enacting the legislation meant "thousands of unnecessary casualties and needless millions of money losses." The people must awaken, he concluded, to the fact that "to win the war we must be ready to cheerfully sacrifice some end, if it need be all, of 'the sweetness of our liberty,' unless we prefer to lose all."[15]

Even President Wilson, whose record of protecting civil liberties was spotty at best, realized this legislation went too far and directly challenged his authority. He took decisive steps to block Chamberlain's bill from

being considered by Congress. His public letter to Senator Lee Overman insisted he opposed the measure because it was unconstitutional and its passage would put the U.S. "upon the level of the very people we are fighting and affecting to despise." Facing a Presidential veto, Chamberlain reluctantly withdrew the bill. Milwaukee and the nation dodged this proverbial bullet, but loyalists had plenty of firepower left and were more than willing in the months ahead to tighten the screws against dissidents.[16]

8

It is alright to talk about the patriotism of the people, etc. and etc., but their stomach seems to effect [sic] their patriotism in many instances.
A.T. Van Scoy, Milwaukee County Food Administrator, to Magnus Swenson, October 1, 1918

To Milwaukee patriots, the April election results were yet another body blow to the city's reputation, and only determined action on their part could redeem the Cream City. Shortly after the contest, the County Council of Defense formed a publicity committee consisting of members from the Rotary and Kiwanis clubs, the Chamber of Commerce, the Association of Commerce and Milwaukee Ad Club to combat Milwaukee's questionable reputation around the country and celebrate the city's wartime accomplishments. In addition to distributing material that touted the city's exploits, the committee planned to stop anti-Milwaukee propaganda "at its local sources" and eliminate sensationalist newspaper reports that reinforced the idea disloyalty was rampant in Milwaukee and Wisconsin. The committee blamed Socialists, dissidents and the *Milwaukee Leader* as the culprits behind the city's scandalous image while the *Milwaukee Journal* and Wisconsin Loyalty Legion figured prominently in the committee's plans to combat those naysayers.[1]

Others had a much different interpretation of the matter. Shortly after being reelected, Dan Hoan wrote, "In my humble opinion, any unsavory advertising which has gone out of Milwaukee has come from the local press." He pointed out that the *Milwaukee Journal* and other newspapers delighted in highlighting incidents of minor importance, which normally would have received scant attention or been ignored entirely. But none of those papers extolled the city's patriotism or accomplishments—the oversubscribing of bond drives, the effectiveness of its military registration and the minimal labor trouble. "In all this work," he added, "all classes

of citizens and members of all political parties have joined in, uniting in meeting the needs of the government and this community." The press and patriotic contingent's constant harping about the city's disloyalty arguably did just as much if not more damage to Milwaukee's standing than any action by malcontents.[2]

Even those who vigorously supported the war echoed Hoan's sentiment. Otto Falk, president of Allis-Chalmers Company, contended, "The kind of self-asserted loyalty that casts disparagement on citizens of German extraction is damnable." Falk preferred that the matter be dropped and forgotten, but there were "some in this community who seem bent on not allowing this to be done." Likewise, Republican Congressman James A. Frear from Wisconsin's Tenth District censured Wheeler Bloodgood, the *Milwaukee Journal* and all other superpatriots in a June speech before the House of Representatives. All the prattle about patriotism during the recent elections, Frear charged, was a "fictitious and false issue," a convenient smokescreen to elect Democratic candidates and protect Bloodgood's financial interests. The congressman pointed in particular to Bloodgood's ties to J.P. Morgan and other eastern financiers as well as to a deal he negotiated for purchasing an International Harvester plant in Illinois at 50 cents on the dollar. The sound and fury only obscured contributions and sacrifices Milwaukee citizens made in support of the war.[3]

Beyond appearance sake, loyalists feared Milwaukee's reputation would cause dire economic consequences. As proof, a local manufacturer forwarded to the *Milwaukee Journal* a clipping from an Iowa newspaper that intimated loyal businessmen in that state would boycott doing business with Milwaukee because of the April election. This would not only divert millions of dollars from the city's economy, but the manufacturer feared similar steps would spread across the country. "The whole situation is so disgusting," he argued, "that one is almost forced to admit that Milwaukee citizens have deserved almost anything that is handed them by the loyal sections of the country."[4] Industrial rivals undoubtedly leveraged Milwaukee's unsavory reputation to steer business elsewhere; August Vogel, chairman of the Council of Defense's Department of Manufactures, decried the fact that 75 percent of defense contracts went to businesses in the north Atlantic states, but given the enormous profits Milwaukee businesses amassed during the war, it seems the true impact of the city's reputation was less than devastating. Nevertheless, the Council of Defense stepped up efforts to help Milwaukee industry do more than hold its own. The group raised $30,000 from area businessmen to establish a central bureau in Washington to facilitate connections between government officials and Milwaukee firms. By April 20, the bureau was up and running,

and it helped the Worthington Pump and Machine Corporation secure contracts for piston pumps, Cutler-Hammer win deals for battery and door switches, and Wisconsin Iron and Wire Works capture agreements for steel wire weaving.[5]

In addition to improving the local financial picture, the Council of Defense aggressively worked to ensure success of fund raising efforts for the Third Liberty Loan Drive. It was slated to begin in mid-April, and this effort took on a heightened sense of urgency as an important step in rebuilding Milwaukee's reputation. Planning began in early March. Women's groups directed an educational and publicity campaign in Milwaukee schools to keep the effort constantly before teachers and children and urged clergymen in the city to encourage bond sales among their respective congregations. Men and women sold bonds at booths located on busy streets and in department stores and also conducted house-to-house canvasses.

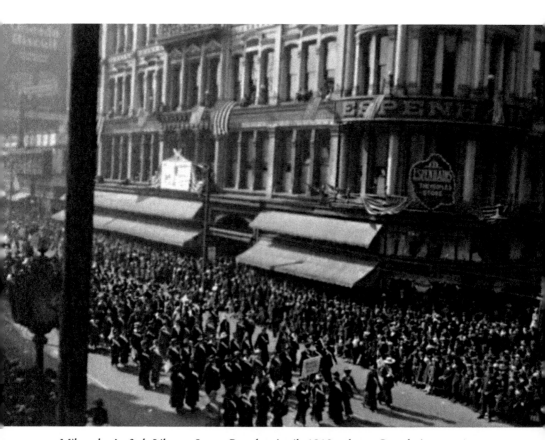

Milwaukee's 3rd Liberty Loan Parade, April 1918, along Grand Avenue (now West Wisconsin Avenue). The large crowds along the route visibly demonstrated Milwaukee's patriotic spirit. (Photo courtesy of Milwaukee County Historical Society)

The Liberty Loan Parade on April 12 was a tremendous spectacle. Starting at 2:00 p.m., whistles all over the city blew to announce the start of the parade. The *Milwaukee Journal* estimated that some 25,000 military personnel, teachers, ministers, school children, factory workers as well as members from various ethnic organizations and women's groups marched, while another 100,000 residents lined the streets to view the three-hour procession. Roughly 700 students from West Division High School marched, carrying white canes festooned with red, white and blue streamers; a corps of girls in "Jackie" (sailor) uniforms paraded alongside as others carried posters. One read, "If you don't come across, Willy Will." Milwaukee residents once more rose to the occasion and oversubscribed the city's $14.8 million allotment by more than $8 million.

Complaints, however, again surfaced that some people used coercion to sell bonds. Ultra-enthusiastic employees at the International Harvester Plant painted two other workers yellow and "forcibly ejected" another from the plant for failing to purchase bonds. Even Victor Berger and fellow Socialist John Work bought bonds because they feared violence from overly zealous patriots. Children in Milwaukee's schools also felt pressure to contribute to the cause; indeed, the School Board received numerous complaints that teachers publicly humiliated students who did not. For example, Mildred Atwell, a second grade teacher at the school on 12th and Center streets, ordered children who did not buy Thrift Stamps to stand. When they did, she pointed her finger at them and cried, "Shame! Shame! Shame!" On another occasion, she called children who did not purchase stamps "slackers."[6]

The *Milwaukee Journal's* editorial board, however, could not understand what the fuss was about. Someone with only five cents, it argued, could not be forced to buy a bond. Coercion only affected those who could afford bonds but opted to let others foot the bill. The board admitted that some "over-enthusiastic" persons may have resorted to coercion, but these cases were rare. "In general," it concluded, "it is not coercion that is operating in this country today. It is human nature. There is no help for it. The wise man will accept it—and do his duty."[7]

Whether they were pressured or not, Milwaukee citizens did their duty during the bond drive and beyond in myriad ways. Elizabeth Upham Davis, an instructor of applied arts at Milwaukee-Downer College, for example, gave a speech in 1917 on the "Desirability of Vocational Education and Direction for Disabled Soldiers." Her work gained attention from the Federal Board of Vocational Education, and the board's director asked Davis to lead its research efforts. Milwaukee-Downer granted her a leave of absence, and for the next two years, she visited every training hospital or school in the U.S. and Canada. She wrote two bulletins for the

government, which for years were used as texts at occupational therapy schools, including the one established by Milwaukee-Downer in 1918.[8]

Milwaukee's Slavic groups—Poles, Czechs, Serbs, Croats, Slovaks, Slovenes and Ukrainians—also did their part. To them, the war offered the cherished hope of liberation for their respective homelands, and they were more than happy to demonstrate loyalty to their adopted country. Many joined the armed forces. In addition, delegates from each group met and formed the "United Slavs" to pledge their efforts, finances and lives to help the government win the war. They decided to stage a parade on June 9 as a launching pad for a permanent Slavic organization. On that day, more than 20,000 braved a downpour to march through the streets to the auditorium, where they heard patriotic speeches and sang patriotic songs. According to the *Milwaukee Sentinel*, the spectacle took "its place with the other great patriotic pageants in this city."[9]

Late in the summer, William George Bruce reaffirmed the city's patriotism in a report to the Military Intelligence Division. He related there was no evidence of enemy espionage or sabotage and "very little if any" pro-German propaganda. The relationship between capital and labor was very good, while women and the working class were generally optimistic about the war's outcome. Among the city's various ethnic groups, he added, only the Germans and Austrians demonstrated a trace of disaffection toward the war.[10] Bruce's evaluation, though overly positive, was on the whole accurate. Most Milwaukee residents continued doing their part to bring a swift end to the fighting.

Nevertheless, the all-consuming attention the war demanded eroded many Milwaukeeans' enthusiasm, cracking their patriotic facade. They received a welcome respite on April 21, when Herbert Hoover lifted restrictions against selling hens. For the first time in several months, city residents could enjoy an old-fashioned Sunday chicken dinner. But this kind of reprieve was atypical. Above all, Milwaukeeans lived with the constant uncertainty and anxiety surrounding the well-being of loved ones in the military. "Every conversation," noted William George Bruce, "reverts to friends and relatives who are in camp or at the front." In June 1918, Anita Nunnemacher Weschler wrote her husband serving with Base Hospital 22 in France: "I wonder how long I will be able to keep up this strain of being separated from you, darling. It is so hard!" Though she put up a brave front for her friends, the continuous worry gnawed at her. Still, she wrote, "Don't let this distress you honey—I can stand it if you can I guess—so cheer up sweetheart."[11]

War-time tensions shattered some families. Jeanette Fillman divorced her husband William in July 1918 because he lived in the "twilight zone of patriotism" and would not allow her to display an American flag,

place a food conservation placard in the window or participate in any patriotic demonstrations. And with so many husbands and fathers in the military, the war disrupted family life, which caused a spike in juvenile delinquency. The *Milwaukee Leader* commended Reverend S.H. Anderson of Summerfield Methodist Episcopal Church for warning his congregation about the war's brutalizing effect. "Our children," he intoned, "play war, talk war, think war. And what is war? In the last grim analysis it is killing and killing. Say what you like, it is not a saintly business." The war's damage to children and adults, reported the *Leader*, was "beyond calculation." It was the duty of all parents to not have military toys for their children to play with and to oppose all military training in the schools.[12]

Beyond the war's impact on individuals, some newspaper accounts focused on war-time changes to the city landscape. In May 1918, the *Leader* commented that the old Jewish ghetto bounded by Fourth, Eighth, Poplar (currently McKinley) and Walnut streets would soon be a thing of the past. The area, with its fish, vegetable and meat markets, bookstores, and, of course, places of worship, provided a "patch of oriental color on the staid background of our matter of fact civilization that proved so attractive and humanly appealing." But multiple forces prompted the Jewish community to move to the north and west. The war blocked new immigrants from settling in Milwaukee and recreating their life in Europe, while young members in the existing community adopted a more Americanized lifestyle. Lastly, the surge of blacks from the South stretched boundaries of the "traditional habitat" of Milwaukee's African-Americans. There were distinct differences, commented a *Milwaukee Free Press* reporter, between these new arrivals and the city's long-term black residents. The "northern negro" dressed much like any Milwaukeean, and he walked with a "firm tread" and "seemed to know just where he [was] going." In the patronizingly racist language of the day, the reporter observed that a southern black "just rolls down the street," shuffling along happily whistling and smiling without any cares. The higher wages blacks earned in Milwaukee shops and factories, added the reporter, were spent on outlandish clothing. The African-American community sharply rebuked this characterization as a "disgrace to any community, and is bound to be a hindrance to our social system generally." Reverend Jesse Woods, the leader of the city's black community, assured *Free Press* readers that the newcomers were good workers and the churches, clubs and social centers would help them secure an "industrial foothold in the city." But until then, they were forced to live in homes "not in keeping with their income."[13]

The Central Council of Social Agencies reported in September that housing conditions for Milwaukee's African-American population were

the poorest in the city. A council committee visited a number of black households and declared one-half were unfit for habitation. Committee chairman E.W. Frost commented that the black community would have to work out its own problems, but an "interest and tolerant viewpoint" among whites would alleviate much of the existing difficulties. In addition, the committee recommended that Milwaukee expand the field for negro labor where the demand for skilled black laborers was negligible. This would increase their earning power and allow them to "seek districts where they may live a freer and purer life." Unfortunately, none of those things transpired, and Milwaukee's blacks continued to live in poverty in the city's inner core.[14]

Truthfully, the housing problem affected all of Milwaukee's working class. The Building Inspector's Office estimated there was a shortage of 5,000 homes in the city for the throng of industrial workers who flocked to Milwaukee. Moreover, housing quality was extremely poor. Mayor Hoan feared things were "rapidly approaching a critical situation." To address the issue, he established a Housing Commission in May. In an editorial, the *Leader* wished the commission well in its important work. The places where many workers lived were called houses "by courtesy" only. They were small, cheaply built, lacked basic conveniences and "wouldn't know a porcelain bathtub if they saw it waddling down the street on its four short legs." In addition, these hovels were located in areas choked with trash and dust or were built so close that "a summer breeze would get curvature of the spine trying to weave among them." The remedy, claimed the *Leader*, was public ownership of rented properties. The Housing Commission did not go quite that far. To try to meet immediate needs, the commission investigated rent profiteering and also dispatched Chairman William Schuchardt to Washington to urge the federal government to build homes for industrial workers and sell them at pre-war prices. Schuchardt returned in September empty handed. The U.S. Department of Labor developed a Byzantine method of applying for aid, and Schuchardt despaired that the city could prove its housing situation materially impeded war production. The Housing Commission looked into various employer and municipal housing projects in the U.S. and Europe to develop a long-range program. The war ended before the Hoan administration could implement a coordinated effort, but the Socialists' dream of a cooperative housing project finally materialized with the Garden Homes project on Milwaukee's north side in 1921.[15]

In addition to housing, the chronic problems of soaring inflation and labor shortages continued squeezing families and small businesses alike. Food prices increased 73 percent from 1915 to July 1918, wreaking havoc with family pocketbooks and swelling relief rolls. Small businesses also felt the economic pinch. In May, the *Milwaukee Leader* reported

25 percent of the city's 228 drug stores were for sale because the cost of drugs had doubled, and experienced help was in short supply. J.J. Pessehl, president of the Milwaukee Druggists' Association, said pharmacists were discouraged because "everything seems to be against them." At least half of local drug clerks had been drafted, forcing owners to work 15-hour days, seven days a week, and the high cost of drugs substantially cut their profit margins. Under these conditions, Pessehl added, it was not surprising that many decided to give up their businesses.[16]

The shrinking labor pool continued to be a thorn in the side of businesses across the nation. Milwaukee business owners voiced persistent complaints about employees who exploited the labor shortage by jumping from one business to another that offered higher wages. To help stabilize the situation, Provost Marshal General Enoch Crowder issued a more stringent "work or fight" order in May 1918 that called for all men of draft age to leave non-essential industries for "productive" businesses; otherwise, local draft boards would enlist them in the army. The order prompted thousands of Milwaukee men to leave their jobs as waiters, elevator operators, sales clerks, theater ushers, etc. and seek factory jobs. The exodus sparked an unprecedented demand for women in these vacated roles. Hotels, for one, heavily recruited women, and Schuster's was the first department store in the U.S. to hire women to drive light delivery trucks. Anita Nunnemacher Weschler noted girls were operating the fountain at the pharmacy and wrote her husband that "it seems every one is using girls for all kinds of work these days. Only Chapman's [Department Store] still run the 'Old Men's Home' as their elevator operators are so old...." But, overall, these businesses struggled to fill vacancies despite increased salaries because most of the estimated 8,000 female laborers in Milwaukee preferred the even higher wages offered at factories working on defense contracts. One local hotel went so far as to seek ten black women for employment—a situation, according to the head of a woman's employment bureau, that was impossible before the war.[17]

The labor shortage motivated some businesses to hire teenagers. The state legislature amended Wisconsin's child labor law in 1917 to allow children 12 to 14 years old to work in any office or store that had no factory attached. Youth between 15 to 17 years old could do light machinery work in factories. Any child who desired the required permit, however, had to produce a birth certificate upon registering. In June 1918, more than 4,000 children received permits. The high wages offered for factory work prompted some to claim they were older than 17 so that they would not have to bother with a permit, and the press of war contracts made some employers less careful in determining a child's exact age.[18]

The County Council of Defense and Wisconsin Loyalty Legion tried to assist employers dealing with labor issues by staging Americanization classes for foreign workers. The drive to transform immigrants into productive citizens coincided with the pre-war flood of newcomers from southern and eastern Europe. This effort reflected the rank nativism of many Americans who believed the new wave of immigrants lacked thrift or industry to become "real Americans." The war and concurrent emphasis on national security and questioning of immigrant loyalties fueled the undertaking. In December 1917, Walter Distelhorst of the Milwaukee County Council of Defense acknowledged that the problem of "unassimilated foreigners unaccustomed to our modes of life, unversed in our language and thought, and not fully acquainted with our ideals has passed from the chronic stage which existed in peace times to the acute stage which now exists." Milwaukee businessmen certainly were aware of the issue. Frank Cobb of the Schlitz Brewing Company reported in July 1918 that the brewery had 1,200 employees, and about 300 of them did not speak English fluently. Business and civic leaders argued that teaching English to immigrant employees would make them more efficient and less prone to accidents. Equally important, it would remove them from the influence of "irresponsible agitators" (i.e., Socialists) and reduce labor unrest that would interrupt wartime production. Beginning in fall 1917, the Council of Defense and Milwaukee schools held night classes, but recruiting efforts received lukewarm interest. Consequently, May Wood Simons, who spearheaded the Americanization Committee of the Council of Defense, encouraged factory owners to conduct classes in the workplace, but that did not generate much excitement among them—no more than five participated in the program.[19]

Food production, conservation and distribution were other pervasive concerns. On the distribution side, Milwaukee's six municipal markets continued to function effectively. Osmore Smith of the County Council of Defense claimed the markets' work "convinced all thinking persons" that the "Government can enter into the management of food distribution to the benefit alike of the producer, the food handler, and the consumer."[20] As for production, Milwaukee's youth once again did their part to help increase the food supply. More than 12,000 enrolled as "Junior Gardeners." Girls from city Bible clubs picked cherries on a farm near Sturgeon Bay, and several hundred boys from area high schools enlisted as "patriotic soldiers of the soil" to help Wisconsin farmers. As early as January, Assistant State Superintendent of Instruction J.E. Borden urged local school boards to have a placement program ready as soon as possible. "Milwaukee would probably be starving," he warned, "if the war continued another year, because the world's reserves are exhausted." As

she did the previous summer, Bessie Buckley again coordinated placements in conjunction with the Council of Defense. The boys were released from classes between April 15 and October 1, and they received school credit if they successfully completed the farm work. To ensure the boys were placed in suitable homes, rural mail carriers and town clerks had to vouch for a farmer's good character. The boys were paid $16 per month and could bargain with the farmer for a higher wage after one month. Lectures on various topics such as "The Horse—Feed—Care—etc." were offered as were training sessions for farm chores.

Not everyone was enamored with the plan, however. Ignatz Mazurek's son was a freshman at South Division High School. The father admitted that his boy was not a very good student and his primary reason for attending school was to become a football star. But in order to play, his son had to maintain an acceptable academic standing. Mazurek feared the plan to award credit for doing farm work would poison the 15-year-old's mind against keeping up with his studies. Meta Berger likewise argued that paying students undermined their desire for school work, and she also cited occasions from the previous summer when farmers mistreated boys by withholding wages unless they stayed until the harvest was over. Despite objections, the plan was put into effect, and several hundred students took up hoes, forks and shovels in the countryside. As the growing season ended, women laboring in Milwaukee factories and businesses pitched in as well. The Council of Defense devised an arrangement through which businesses formed squads of women to be driven out to area farms to help with harvest work until sundown. Cutler-Hammer Company created five squads, and Northwestern Mutual Life Insurance Company established six, with the women earning 20 cents per hour.[21]

While most Milwaukeeans pitched in to help with the food situation, a growing number became disenchanted with the Food Administration's wide-ranging restrictions. In late June, County Food Administrator A.T. Van Scoy levied 47 fines ranging from $5.00 to $100.00 against individuals who hoarded flour, bakers who did not use the required amount of wheat substitutes and those who charged prices for foodstuffs beyond administration-approved limits. The government imposed a fine of $568 on one baker who used more wheat flour in certain sweet yeast dough goods than was permitted and forbid him from baking any sweet treats until after December 1. The problem worsened as summer gave way to fall. Van Scoy hauled another 100 people to his office for violating wheat and sugar regulations. He complained to Magnus Swenson on October 1 that people who were not "playing the game fair" constantly demanded his attention. They purchased flour in amounts far in excess of what they should, and in a particularly flagrant breach, one family bought 20, 100-

pound sacks of flour. A few weeks later, Van Scoy raged that Italians gave him "more trouble on substitutes than any other people here in the city, with the possible exception of the Russian Jews." Despite repeated threats of punishment, Van Scoy believed he made no impression on Italian merchants as they continued selling wheat flour without substitutes, "doing it very frequently at night, and generally very late at night." As a result, Food Administration officials in Washington revoked licenses for F. Tarantino, C. Maglio, Frank Balistieri, Frank Italiano and the Cianciola Brothers, effective from December 20, 1918 until February 1, 1919.[22]

The increased number of violations reflected a growing undercurrent of dissatisfaction among city inhabitants with the drastic changes and pressures engendered by the war. For their part, Milwaukee patriots were determined to keep that attitude under wraps while they ramped up efforts during the summer to thwart slackers and malcontents. Too often, however, jingoistic zeal boiled over, alienating law-abiding citizens even more.

9

The situation in Milwaukee, as you know, has always been complex.
Special Agent R. B. Spencer to Bruce Bielaski, Bureau of Investigation,
September 17, 1918

The College Inn restaurant on Grand Avenue was bustling on Wednesday, May 23, 1918. Among the many patrons was Thomas Burke, a 36-year-old transplant from Cincinnati and employee of the John Pritzlaff Hardware Company. He was enjoying dinner with Josephine Suratt when, around 11:00 p.m., the orchestra played the "Marsellaise." Most diners jumped to their feet and applauded, but Burke and Suratt remained seated. Angelo Cerminara, a Milwaukee attorney and acting royal consul for the Italian government, was at a nearby table. When he saw Burke, he stepped over, explained that the French national anthem was being played and asked why Burke did not stand. Burke replied, "To hell with you." Cerminara then remarked that France stood for the same democratic principles as the U.S. There are discrepancies concerning what Burke said next, but in essence it was, "To hell with France and England. To hell with the allies and to hell with democracy."

At these words, Cerminara's temper got the best of him. He grabbed Burke, pulled him to his feet and demanded his name and address. Undoubtedly shaken, Burke gave a false name and address, then told Suratt that they had better leave. As they stepped outside, Cerminara followed and berated Burke, calling him a skunk and traitor to the common cause. The crowd that poured out of the restaurant became agitated, and cries of "lynch him" and "hang him" were heard. No policemen were in sight, and Cerminara and his brother-in-law, Sergeant Edward Heul of the Medical Corps, sensed the situation could easily get out of hand. They hustled Burke into a car and took him to the Federal Building, where he later provided his true name and address. He claimed he and Suratt had stood up for a few minutes, and that Cerminara accosted him after the music

stopped. Burke added that he was a member of the Red Cross, had bought a Liberty Bond, had tried to enlist and always "respected the stars and stripes." After reviewing the case, the U.S. Attorney surmised no federal violations took place and released Burke.[1]

Burke's narrow escape illustrated how the hostility that festered within Milwaukee patriots had reached a boiling point, and the slightest provocation could trigger an ugly confrontation. The widespread fear of an Allied defeat stemming from Germany's spring offensive and the angst due to the increased presence of U.S. troops in harm's way easily transformed into an unbridled fury against those who opposed the war and, in effect, stabbed U.S. doughboys in the back. National unity became an obsession.

State and federal governments continued to fan the flames. On March 8, the state legislature passed a law that imposed fines of $100 to $1,000 or imprisonment in the county jail for three months to one year for any person who advised Wisconsin citizens not to enlist in the military or assist the U.S. in prosecuting the war. The federal government passed a more drastic measure—the Sedition Act—on May 16, 1918. The 1917 Espionage Act did not apply to casual or impulsive disloyal utterances by individuals, a situation that sometimes prompted mobs, angered by the inadequacy of the federal law, to take matters into their own hands. Congress closed the loophole in the Espionage Act to prove to the American people that the government was doing all it could to stifle dissent. In addition to prohibiting any speech that hindered prosecution of the war, the Sedition Act made it a crime to make *any* statements against the government, the Constitution or the U.S. flag. Violators could be fined up to $10,000 or sentenced to prison for up to 20 years. The sweeping powers the act gave the government frightened dissenters. John Work's editorial in the *Milwaukee Leader* read, "The Impossible Happens." Even one year ago, he lamented, "no one would have believed that such a return to the dark ages was possible." Dissenters had reason to fear. The act was interpreted so broadly that any minor statement could be prosecuted. John Lord O'Brian, an assistant in the U.S. Attorney General's office, later said the Sedition Act was so vague that "all degrees of conduct in speech, serious and trifling alike, and, in the popular mind, gave the dignity of treason to what were often neighborhood quarrels or barroom brawls."[2]

And Milwaukee had plenty of barroom brawls over the war. In March, for example, George Utteck apparently had a few too many drinks at a local saloon and uttered some profanity against the U.S. government. Bar patron William Morris took offense at the remark and punched Utteck, who staggered outside and complained to a police officer. Once the policeman heard the story, he promptly arrested Utteck instead.

Judge Page found him guilty of disorderly conduct and fined him $25.00. Another saloon altercation in August prompted the first conviction under the state law. Charles Sauer was accused of making derogatory remarks about Red Cross nurses and doctors and also stating that "every ------ that goes across to fight ought to be killed and never come back." Several of the bar's patrons took exception and beat Sauer badly before throwing him out of the establishment along with Michael Legoth, who evidently approved of Sauer's remarks. Both were arrested and tried before Judge Schinz in Municipal Court. They were found guilty, and Schinz sentenced Sauer to nine months in the House of Correction and Legoth to three months. Before pronouncing sentence, Schinz berated the two men and "expressed a sorrow that, due to Sauer's wife and the law, he could not send him to prison for several years."[3]

To its credit, Milwaukee never succumbed to vigilante violence that resulted in anyone's death. Perhaps it was due to city residents' law-abiding nature, a fact that Wheeler Bloodgood and Dan Hoan both touted. Even the Wisconsin Loyalty Legion passed a resolution condemning mob violence; though it also condemned any "individual utterances which might virtually lead" to confrontations. Maybe the presence of such a large German-American population prevented patriots from resorting to violent outbursts for fear that it might spark a backlash. Nevertheless, there were occasions—such as Thomas Burke's close call—when things nearly spiraled out of control. Another near riot took place in Kosciusko Park in early August. A crowd of 3,000 south siders was giving a send-off to recruits when Albert Tardowski made disparaging remarks about the Polish army. A policeman immediately arrested him and rushed him from the park amid shouts of "lynch him, hang him" from the crowd. Tardowski pleaded guilty for disorderly conduct. He was fined court costs but managed to avoid jail time by acknowledging he was drunk when he made the offending statements and that he had five cousins serving in the Polish army.[4]

Rather than resorting to violence, Milwaukee patriots typically relied upon symbolic gestures to demonstrate their distaste for anything that smacked of pro-German or anti-war sentiment. In March, students at the German-English Academy, long considered one of Milwaukee's finest schools, signed an agreement to forego use of the school's name and call the institution the Milwaukee Academy. According to the *Milwaukee Journal*, students made the move not because they opposed the German language or people, but because of unpleasantness associated with the current name. The agreement was supposed to last for the duration of the war, but school officials made the name change permanent. Likewise, the board of the Deutscher Club changed its name to the Wisconsin Club in April.

In mid-May, Milwaukee patriots took on weightier matters when the 15-ton "Germania" statue was removed from the Germania Building, home of the *Germania-Herold* newspaper. Lieutenant A.J. Crozier of the British-Canadian recruiting station instigated the removal after he publicly criticized the statue and other building ornaments for representing Germany. The editor of the *Germania-Herold* pointed out that the statue's name was a Latin term representing the Germanic race from the days of the Roman Empire, when it comprised various tribes including the Anglo-Saxons. Nevertheless, the building owners complied with the demand since the statue gave "reasonable offense to some of our fellow citizens." Going beyond renovation, the Wisconsin Loyalty Legion attempted to rewrite history in June when Legion officers tried to stop a local publishing company from circulating a Milwaukee guide book that praised the Germanic influence on the city's development. "Milwaukee is not the German Athens of America, and we do not wish it to be advertised as such," was the WLL decision. WLL's Frank Harland declared, "It was high time that more be said about Milwaukee institutions and living, and less about German."[5]

Treatment accorded enemy aliens also grew more stringent. In addition to restrictions outlined in his April 1917 proclamation, President Wilson issued an order in November 1917 that prohibited German aliens from being within 100 yards of waterways, wharfs, docks, railroad terminals, warehouses or canals. Nor could they loiter or even stop on any bridge that spanned a waterway. The ruling affected 3,600 Milwaukeeans and threatened to cripple several area businesses such as Pfister & Vogel Leather Company, A.F. Gallun Tanning Company, Pritzlaff Hardware, Plankinton Packing Company and the Pabst Theater, where 22 of the 26 actors/actresses were enemy aliens. Citing grave economic consequences, local businessmen, the Association of Commerce and County Council of Defense vigorously protested and managed to have the order modified, thus preventing any interruption of government contracts.

This effort in no way diminished widespread harassment. In late January, federal agents arrested two men on a picket line at the Carpenter Baking Company plant for violating their work permits as enemy aliens. One was threatened with internment if he did not go back to work. Organizers from the bakers' union complained to the city attorney's office and were told that they had a right to picket as long as they used only American citizens for that purpose. In addition, all male enemy aliens were required to register at the police station and be photographed and fingerprinted. On February 4, 300 men waited for hours in sub-zero temperatures for the process to begin at 6:00 a.m. Any who were not registered by midnight on Saturday, February 9, were considered an enemy and subject to internment

for the rest of the war. Registered aliens were issued a certified card that they had to carry with them all the time. Furthermore, they could not change their place of residence without first obtaining permission from the chief of police. On April 10, law enforcement demonstrated they meant to carry out the provisions. DOJ agents and 100 deputy marshals rounded up 200 aliens for making pro-German remarks or failing to notify officials about a change of address or job. The men were taken to the Federal Building where they nervously awaited their turn to be interrogated. The restrictions continued to mount. In May, Milwaukee government officials announced German enemy aliens would not be allowed on lake excursion boats in accordance with President Wilson's April 1917 proclamation, and the federal government ordered all enemy alien women over the age of 14 to register between June 17 and June 26. The Milwaukee Police Department appealed to the National League for Women's Service to carry out the order within the city. At the end of the registration period, more than 11,400 women submitted to questioning and fingerprinting.[6]

Even the property of enemy aliens was within the government's reach. At the start of the war, U.S. policy forbid confiscation of their assets, but there was widespread concern these possessions could be used to aid the Germans. Consequently, Congress passed the Trading with the Enemy Act in October 1917, which authorized appointment of a custodian who would hold enemy aliens' private property in trust. Section 12 of the act vested the custodian with power to dispose of the property by sale or otherwise "if and when necessary to prevent waste" and to preserve and safeguard U.S. interests in such property as well as the rights of persons who "may ultimately become entitled thereto." Property Custodian A. Mitchell Palmer was determined to use his position as a "fighting force" in the war. He asked for, and Congress approved in March 1918, the power to sell or "Americanize" all enemy property and interests in the U.S. The cash received would be invested in Liberty Bonds and held in trust for the German interests. Thus, asserted Palmer, "the enemy's dollars and his property are made to work in defense of our country instead of against her."

During the war, the government seized approximately $600 million of enemy-owned property and funds. Of that total, roughly $2 million came from Milwaukee-area businesses, and more than $1.7 million included stocks and bonds owned by the Pabst Brewing Company.[7] The Wisconsin Trust Company held the property on the federal government's behalf, but company officers and government officials assumed this was but a fraction of the property that should be reported to U.S. authorities. Palmer urged lawyers across the country to notify the government if they handled any transaction involving enemy-controlled assets. The penalty

for enemy aliens who failed to report such property was a maximum of ten years in prison and a fine of $10,000. D.F. McKey of Wisconsin Trust indicated the securities probably would not be sold since they were not "in the same class as profitable munition plants and other factories which might yield large profits to the enemy." Many factories were held in trust for several years after the war ended, and then were sold at inadequate prices, expressly to injure the owners, but as McKey explained, securities were typically returned to the owners. Still, the owners incurred financial losses. To reacquire Pabst Brewery stock, Gustav Pabst paid $1,473,917 for securities valued at $1,755,900.[8]

Private individuals also had assets seized. The property custodian, for example, took control of property valued at more than $3,000 from Carl Thienhaus of Milwaukee. Thienhaus' experience illustrated heightened suspicions directed toward German-Americans. Born in Dusseldorf, Germany, in 1868, he studied medicine at the University of Berlin, graduating in 1895. Five years later, Thienhaus arrived in Milwaukee and established a thriving surgical practice. His reputation was such that, since 1912, physicians from across the state requested his expertise to perform various surgical procedures. When war erupted in 1914, he and his second wife, a member of the Gallun family, were vacationing in Europe. His wife remained in Switzerland—federal agents insinuated it was because of domestic problems—while Carl returned to Milwaukee. Shortly after the U.S. entered the war, the DOJ received a report that Thienhaus had never filed his second naturalization papers. Despite Thienhaus' enemy alien status, agent William Fitch thought the doctor was a "harmless German of the old school."

Fitch's successors thought otherwise. They kept Thienhaus under surveillance immediately after he registered as required by the federal government. In 1918, Agent Harry King constructed a case against Thienhaus based on hearsay and questionable leaps of logic. King noted that Thienhaus always had large sums of money in his possession—apparently an unusual situation for a successful surgeon who married into a wealthy Milwaukee family—and his "wine suppers" for men and women were quite notorious. Several people accused Thienhaus of spreading pro-German propaganda and making insulting remarks about the U.S. A newsboy, for example, told King that Thienhaus would stop at his stand, scan the headlines and scoff that English papers did not know what they were talking about and were all humbug. King also referenced an occasion before the U.S. entered the war when some German army prisoners enroute from China to Germany met with Thienhaus while in Milwaukee. King wondered how the doctor knew them, and Thienhaus replied, "well they all know about me in Germany." From that King inferred that Thienhaus

was connected in some way to the German government and that the prisoners must have had orders to report to him. In addition, the DOJ interrogated Thienhaus several times for violating zone restrictions of his enemy alien permit. The doctor claimed the incidents were trips he made to perform surgeries, but that did not satisfy the DOJ. He was arrested on April 24, 1918, because he appeared to be a man of "unsavory character, is constantly associated with disloyal persons, and shows entire disrespect for the regulations." Thienhaus was interned at Fort Ogelthorpe, Georgia, for the rest of the war and did not receive parole until September 1919.[9]

Even the most influential members of Milwaukee's German-American community were subject to intense scrutiny. The Uihlein family certainly counted among the city's elite, with connections to the Schlitz Brewing Company and Second Ward Savings Bank, among other business enterprises. The DOJ launched an investigation in spring 1918 after a woman vacationing in Daytona, Florida, reported gossip about the Uihleins' pro-German sentiments. The Military Intelligence Section of the War Department also requested that the DOJ look into the family after Joseph Uihlein visited Georgia with the purpose of locating deposits of bauxite, used in the production of aluminum and explosives. What aroused the military's curiosity were second-hand reports that Uihlein's interest while in Georgia was not in bauxite but what local residents thought about Germans. DOJ agents in Milwaukee interviewed neighbors, friends and business associates about the Uihlein family in general but Joseph and Robert Uihlein in particular. About half of those interviewed vouched for the family's loyalty. Wheeler Bloodgood, however, told an agent that the family was openly and emphatically pro-German before the U.S. entered the war, and he believed they had not undergone any change of heart since then. Though there was no evidence, Bloodgood further suspected Joseph Uihlein financially supported Victor Berger's U.S. Senate campaign. Others such as Willet Spooner of the County Council of Defense and Henry Campbell of the *Milwaukee Journal* admitted that family members had not made any pro-German statements since the U.S. joined the fight, but their patriotism was only for show, and they were not to be trusted as loyal citizens. John Stover of the APL acknowledged that the Uihleins had purchased $300,000 during the Third Liberty Loan, but that was "not at all commensurate with their enormous fortune."[10]

Suspicion trickled down to the city's working class as well. Fear of German saboteurs preyed heavily upon the minds of Milwaukee industrialists, though by-and-large businesses encountered few troubles. Nevertheless, problems arose occasionally. In June, officials from the Bailey Manufacturing Company on the city's south side found coarse gravel inside an air compressor. Suspicion immediately fell upon two enemy aliens,

who quit their jobs at the factory just days before the compressor was damaged. No arrests, however, were made. The Allis-Chalmers Company also experienced trouble. Already an industrial behemoth in Milwaukee County, the company grew by leaps and bounds during the war. A military intelligence report indicated the company worked on 5,000 to 10,000 government contracts during summer 1918, totaling an estimated $30 million. Allis-Chalmers churned out steam turbines and 75-mm shells among other items with minimal labor squabbles or work interruptions. But trouble arose in early June. George Lamois, a 20-year-old Greek immigrant, had worked with the firm for only a few days. On the night of June 3, the foreman assigned Lamois to the shell manufacturing shop at the West Allis plant, where he had to use a pair of tongs to lift 75-mm shells out of an oil drip pan onto a conveyor line. In the early morning of June 4, the machinery in Lamois' department stopped working. After several hours, a repair crew found the tongs stuck in the conveying machine on which Lamois worked. Company executives had an agent from the Military Intelligence Division investigate. Co-workers intimated Lamois purposely damaged the conveyor because he did not like the work and hoped to secure a higher-paying job in another department. Based on this evidence, federal agents arrested Lamois for violating the Sabotage Act, the first—and, as it turns out, only—person in the area arrested for sabotage. The trial took place the following March in the federal courthouse, but the government's case was too weak; the jury found Lamois not guilty.[11]

Though Milwaukee business owners did not experience widespread sabotage, they did confront energized labor unions in 1918. Local unions persistently proclaimed their loyalty, but in view of the huge profits made by Milwaukee-area businesses, they pursued their interests more aggressively in terms of organizing or insisting on better working conditions. In April, 13 workers with Kearney & Trecker in West Allis went on strike. The following month, 20 to 30 electricians employed in Milwaukee breweries walked off the job as did some 800 employees of the Power Mining and Machinery Company in August. The cause behind all three incidents was management's refusal to meet labor's demand for higher wages. Poor working conditions were another chronic complaint. Labor leaders at a September mass meeting of Briggs & Stratton employees charged that sanitary conditions for women workers in Milwaukee shops were among the worst in the country. A lack of washing facilities at the Briggs & Stratton plant forced women to walk home so dirty that people living in the neighborhood "concluded the Stratton plant employed only negro women." A report from the Military Intelligence Division substantiated claims concerning poor working conditions. Toward the end of the war, an MID inspector found women at Briggs Loading Company

suffering from serious skin rashes due to the fumes and dust resulting from the production of rifle grenades. The situation was serious enough that the inspector feared it could hinder the company's war work. The obvious solution was to clean the assembly building daily and wipe all grenades before they were brought inside, but the company blithely ignored the inspector's recommendations. Speakers at the September gathering concluded that the only remedy was for women to join organized labor. Efforts were made to unionize, but many women, according to newspaper reports, felt intimidated by Briggs & Stratton management and feared losing their jobs if they joined.[12]

Business owners and government agents generally dismissed legitimate worker grievances and blamed pro-Germans or Socialists for any labor agitation, portraying them as part of a conspiracy to aid the enemy. The Milwaukee Coke & Gas Company put it bluntly: "The striker is a slacker, a traitor, and an enemy of us all." John Ferris, resident agent for the Plant Protection Section of the Military Intelligence Division, charged that Austrian enemy aliens were behind the trouble at Kearney & Trecker. They were content employees, Ferris wrote, until they found the company was engaged in rush work for the government. At that point, they "sought to cripple the production, and aid the enemy by demanding increased wages, as an excuse in the plot." Ferris threatened to have the agitators interned for the rest of the war if they did not return to work. Unwilling to risk that punishment, all 13 went back to their jobs. Similar threats of "serious trouble" were made against labor organizers at the Wisconsin Motor Company and also among shoe leather manufacturers in Milwaukee. Ferris' bludgeon-like tactics sparked an angry letter from labor lawyer William Rubin to the Secretaries of War and Labor. Ferris, wrote Rubin, was "nothing more nor less than a strike-breaker." The District agent-in-charge reminded Ferris that the laboring class had a right to organize—as long as it was intended to improve working conditions and wages—but under no circumstances, as in the Kearney & Trecker case, could this be brought about by enemy aliens.[13]

On another occasion, Henry Wiegand, a manager of the Wisconsin Gun Company, met with John Stover of the APL in July about labor agitation in Wiegand's shop. Wiegand was sure disloyal and pro-German influences fomented the trouble. Stover and Assistant Superintendent of Mails William Smith went to the factory and interviewed four suspected ring leaders: Ernest Wagner, Herman Redlin, Hugo Reiske and Joseph Gerber. All four men gave depositions that the two government officials badgered them and accused them of trying to incite a strike. Moreover, they claimed Stover threatened to change their draft classifications and send them to the military, give them 30 years in prison, or, one said, "back

you up against the wall." Stover hauled Gerber to the police station and detained him overnight without giving him a chance to call his wife. Stover claimed he and Smith conducted the interviews with dignity and directness, appealing to the men's patriotism to prevent any disruption of factory production. Stover admitted he discussed the provisions of the Sabotage Act and possible punishments for violating the act, but, he insisted, never mentioned the death penalty. The episode was controversial enough that the Chief of the Bureau of Investigation and the Assistant U.S. Attorney notified National APL Director Charles Frey that there was "something radically wrong in the undue activities of A.P.L. operatives at Milwaukee" and he should investigate. Frey did not make it to Milwaukee until September, by which time Stover had taken a position with the Judge Advocate General's office in Washington.[14]

In addition to industrial workers, government agents and APL operatives directed their wrath upon draft evaders. On June 5, another draft registration was held for men who had turned 21 years old since the registration one year previous. Local draft boards again received assistance from the Council of Defense and American Protective League—despite a warning from Governor Philipp about the APL becoming a "busy-body" or doing "detective work of a very amateur quality" that drowned draft boards with reports of trivial offenses. Nevertheless, the process went smoothly once again; according to the *Milwaukee Journal*, there were no slackers. But slackers remained in the minds of government officials, and tolerance for shirking one's patriotic duty grew thin. Draft evasion was such a problem that the DOJ and local law enforcement staged raids in cities across the country to snare men who evaded military service or failed to register. Milwaukee's round-up began Friday evening, July 19. Around 8:00 p.m., DOJ agents, APL operatives and police officers swept into the Plankinton Arcade. Guards at the doors prevented anyone from leaving while officers questioned everyone present. Roughly 500 men who could not produce draft cards or those working in nonessential industries were taken to a temporary headquarters set up in the Goldsmith Building on East Wisconsin Avenue. At 9:00, officers halted the show at the Empress Theater and took another 300 men into custody. Additional agents fanned out throughout downtown Milwaukee to search pool halls, restaurants, public parks, train depots and various hotels. They also stopped people on the street. By early the next morning, nearly 2,000 men crowded the Goldsmith Building's halls and offices. Men who had forgotten to carry their classification cards with them were given an opportunity to prove their status; they either called family members to bring their cards downtown or were driven to their homes by officers to retrieve the card.[15]

The dragnet continued on Saturday and Sunday as the force of 300 agents and police broadened the search beyond downtown Milwaukee. They even closed the gates and encircled Athletic Field (eventually known as Borchert Field) between games of a doubleheader involving the Milwaukee Brewers and St. Paul Saints. Several men tried to escape by scaling the fences but gave up when they saw the cordon of police; approximately 500 were taken to the DOJ headquarters. During the three-day effort, nearly 10,000 men were arrested. Most were released, but those who evaded the draft or could not produce a registration card were quickly enlisted into the navy or army. Federal agents staged another slacker raid in early September. They went as far as to interrupt the convention of the International Bible Students' Association at the auditorium and took several men into custody.[16]

Patriots' all-consuming rage against enemy aliens, slackers and malcontents in Milwaukee wasted an inordinate amount of energy and resources. No real traitors were ever apprehended, and the most trivial remarks sparked fisticuffs or invasive investigations. Though such efforts proved misguided against these imagined foes, unprecedented action would be required to cope with a very real, but invisible, threat in the months to come.

10

A new affliction has come upon us.
>William George Bruce, "Days with Children," 1918, Part II, 29

Buoyed by the ever-growing influx of American soldiers, Allied forces seized the initiative in summer 1918, after the German spring offensives ground to a halt on the banks of the Marne only 40 miles from Paris. U.S. Marines distinguished themselves in June during the costly seesaw battle of Belleau Wood, and in mid-July, French and U.S. troops blunted a German attack along the Marne front. Allied assaults along the Aisne-Marne salient pushed the German army back nearly 90 miles by the end of August. Demoralized German soldiers deserted in droves, and Quartermaster General Erich Ludendorff told a stunned Kaiser that only an immediate peace would allow the Germans to salvage anything from the war. Marshal Ferdinand Foch, Supreme Commander of the Allies, was not about to ease the pressure. In mid-September, U.S. troops captured St. Mihiel, followed by the Allies' Meuse-Argonne offensive on September 26—the final assault on the Western front. It soon became clear to the German high command the war was lost. Allied triumphs forced Bulgaria to drop out, and Austria-Hungary announced it would seek a separate peace. Ludendorff informed the Kaiser on September 28 that only immediate surrender could spare the country from devastation. The German chancellor sent a message to Washington in early October offering to negotiate a peace based on President Wilson's Fourteen Points. While Wilson exchanged notes with the Germans, vengeful politicians and citizens in the U.S., France and England denounced the olive branch as a ploy. They would accept only unconditional surrender from the German army. On October 20, the chancellor agreed to send representatives to Paris to discuss an armistice with Allied military leaders.[1]

Improving news from the battlegrounds in Europe did little to alleviate tension in the U.S. According to William George Bruce, government food

and fuel regulations were "coming closer to our door every day." The federal fuel administrator for Wisconsin issued a new order on August 31 calling for the observance of two additional lightless nights on Wednesdays and Thursdays. In addition, the government demanded that starting on September 1 all automobile traffic cease on Sundays. Milwaukee hotels, theaters and amusement halls anticipated doing a brisk business, while an unusually large number of Milwaukeeans left town on Saturday, August 31, to spend the weekend at lake houses or country resorts. The streets of Milwaukee on that first Sunday, Bruce noted, were "as quiet as those of a country village...not a single automobile has passed our door today." The *Sentinel* reported that less than 300 of the approximately 60,000 autos owned in Milwaukee County were used, and those who ventured out on the streets met trouble everywhere they turned. The Mitchell Street Pharmacy posted a sign near the intersection of Mitchell and 11th Avenue (now South 16th Street) that read: "Iron Cross for You! Paint Your Car Yellow. You're Doing Your Bit for the Kaiser, the Beast. You're Using Gas to Stab Our Boys in the Back." Pedestrians jeered at anyone who drove by and called them "slackers." Even physicians making house calls were harassed by overzealous citizens who thought they were violating the fuel order. In addition to verbal abuse, some physicians had bricks thrown at their autos, and one found his tires slashed. The experience was bad enough that many insisted they would not make any further calls on Sundays. As a result, the Fuel Administration developed a special sign for physicians to place on their cars to let people know they needed to be on the road. Similar signs were devised for "Christian Science practitioners."[2]

The road for those who balked at buying Liberty Bonds was just as perilous. The Fourth Liberty Loan was set to begin on September 28, and per William George Bruce, the campaign was so thoroughly planned that those in charge knew what each family in Milwaukee was expected to invest in bonds. Trouble began even before the drive officially started. On September 25, enraged employees at the Milwaukee Harvester factory on Park Street doused four workers with yellow paint and chased them from the plant after they declined to purchase bonds. One of the victims, Anton Hartman, went directly to the district attorney's office and demanded that an arrest warrant be issued. He claimed he told the foreman that he would not buy a Liberty Bond unless the government compelled him because he had a family to support. At that, the foreman told Hartman he could no longer work at the plant. Hartman went to the pay office to collect his wages and when he exited the office, a crowd of 15-20 men waited for him with a can of paint. Hartman grabbed a shovel lying nearby and threatened to kill anyone who tried to harm him. He raced to the sixth floor of the plant with the crowd in close pursuit. As Hartman descended

A float from the 4th Liberty Loan Parade, September 1918, represents the German devastation of neutral Belgium. Depictions like this were only one of the many ways Americans demonized their German enemies. (Photo courtesy of Milwaukee County Historical Society)

a flight of stairs, someone from above dumped the paint on him. The clerk of courts dispatched a policeman to the Harvester plant to investigate, but the employees refused to speak. Consequently, no warrant was issued. The plant superintendent told a *Journal* reporter that the company tried to discourage employees from harassing anyone who refused to buy bonds, but the "boys, however, have taken the matter in their own hands and when employes [sic] make remarks against the Liberty bonds we simply can't hold them then."

Apparently, the company did little to discourage further trouble. The very next day a crowd grabbed another worker and dumped paint over his head and down his shirt. The incidents prompted Mayor Hoan to write Police Chief John Janssen. Hoan remarked that Hartman earned "scarcely enough to keep body and soul together" much less support a wife and children. The conduct of the Harvester mob marked "a stain upon the unequaled reputation of our city for obedience to law and order." Hoan reminded Janssen that President Wilson appealed to the American people to avoid these kinds of confrontations, and the mayor was confident the

police would "leave no stone unturned to ascertain who are the guilty parties and to hold them to strict account for their conduct." Hoan was no doubt disappointed at the end result. It is not clear if the police devoted any further manpower to the episode, but no arrests were ever made.[3]

The mayor's attention, however, was soon distracted by a more elusive and deadly foe. On Sunday, September 15, a laborer from a Great Lakes freighter and a sailor on leave from the Great Lakes Naval Training Station went to the Emergency Hospital on Michigan Street. Dr. B.F. Koch diagnosed both as Milwaukee's first cases of Spanish Flu, a pandemic that ultimately killed more than 50 million people worldwide.[4] It first appeared in eastern Kansas in early 1918 and then infected soldiers at Camp Funston, Kansas, in March. This first wave was rather mild and, thus, went largely unnoticed by the general public. The infected men survived but carried the virus with them to other army camps and also overseas, where it quickly spread among British, French and German troops. It is believed the virus mutated into a more virulent strain that ravaged Europe and spread along international trade routes and naval supply lines, finally returning to the United States in late summer. The ferocity of the disease caught medical professionals off guard. Its symptoms—chills followed by high fever, body aches and runny eyes—mirrored those of the "grippe" or common winter flu, but the Spanish Flu incapacitated victims without warning. Twenty per cent of those infected developed pneumonia, and nearly half of those cases developed heliotrope cyanosis in which the victim's lungs filled with a thick, blackish liquid that turned their skin black-blue. Those cases were usually fatal within 48 hours. In addition, the Spanish Flu was highly contagious and could be spread rapidly through contact with the sick or through sneezing or coughing by an infected person. The virus could linger airborne for hours if not exposed to sunlight; one individual could infect an entire enclosed building.[5]

In the Midwest, the flu first infected sailors, or "Jackies" as they were commonly known, at the Great Lakes Station on September 11. Great Lakes was the largest naval training facility in the world with 45,000 men, and the disease exploded within the camp. One week after the first case, the camp hospital—with only 42 beds—treated 2,600 men. Sick men had to lie on stretchers on the floor, waiting for those in the cots to die. One nurse remembered bodies "stacked in the morgue from floor to ceiling like cord wood." Despite the devastation, furloughs were still being granted, and the men spread the disease to Chicago and Milwaukee. Immediately after the first cases were reported in Milwaukee, Health Commissioner George Ruhland contacted the commandant of the Naval Training Station, who agreed to stop granting leaves and place the entire camp under quarantine until the flu subsided. But the proverbial

genie was out of the bottle. On September 21, the *Leader* reported the number of sick in Milwaukee had increased to 100, including one girl who contracted the flu from her brother who had been on leave from the Great Lakes Station. Other newspapers indicated the total was probably higher because doctors were not compelled by law to report influenza or pneumonia cases. On September 23, Private K.C. Adams of the Marine Corps became the city's first flu-related death. Still, Ruhland reassured city residents there was no need to worry, but he encouraged everyone to avoid crowds and heed Health Department warnings about personal care. Kissing and handshakes, for example, should be abandoned. Above all, he told newspaper reporters, "the public must not allow itself to become stampeded." "No one should be scared by the term 'Spanish' influenza," he added, "for it is the same old influenza."[6]

It certainly seemed as if most Milwaukeeans were unconcerned about the microscopic menace infiltrating the city. They went about their daily routines, focused on the exciting news from the war front and immersed themselves in duties connected to the Fourth Liberty Loan Drive. On September 27, a meeting of loan workers was held at the Strand Theater. Novelist and former Milwaukee newspaper reporter Edna Ferber exhorted the crowd to do its utmost to raise Milwaukee's allotment in one day. At the end of the war, she argued, there would be only two classes of people: those who did their duty and those who did not. The Uihlein family and the Schlitz Brewing Company did their bit by subscribing to $600,000 worth of bonds. The following day, the city staged a massive parade to kick off the loan drive—disregarding Ruhland's warning about crowds. Roughly 25,000 participants and thousands of spectators crammed along city streets provided the perfect breeding ground for the spread of deadly germs.

Some Milwaukee residents, however, were becoming understandably jittery. On September 23, Anita Weschler wrote her husband about Juanita Johnson, who died after developing pneumonia: "It is very sad I think, especially so as she leaves so many small children." Two days later, she watched the funeral procession and noted that Juanita's husband looked as though he had been crying quite a bit. "I have never seen a man who had lost his wife," she wrote, "and can't imagine how most of them act, and feel." A week later, Anita complained about a cold and that her son was sick with a fever, and prayed "that we do not come down with this Influenza, as everybody seems to be having it. There are three right next door at Cottrills sick with it now."[7]

Anita and her son recovered, but the epidemic ripped through the city in early October. The number of cases reported daily exploded from 69 on October 5 to 214 on October 7 to 340 on October 8 and to 453 on

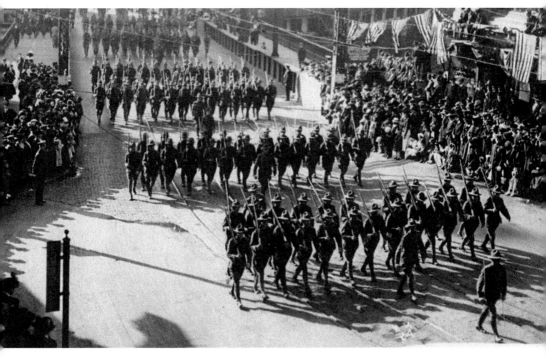

Wisconsin National Guardsmen march through the streets of Milwaukee during the 4th Liberty Loan Parade, September 1918. (Photo courtesy of Milwaukee County Historical Society)

October 11. The total number of cases as of the 11th stood at 2,097 and the number of deaths at 50. An alarmed Common Council met on October 9 and granted Ruhland the power to take any steps necessary to check the flu's spread. Ruhland told the council that if the flu continued to spread at the rate it had in other cities, Milwaukee could expect 40 percent of its population, or 180,000 people, to be affected, resulting in about 2,000 deaths. "We must do all in our power," he concluded, "to prevent such a calamity." Milwaukeeans impressively marshalled every resource possible to combat the epidemic. Ruhland appointed Otto Falk, Carl Herzfeld, Dr. Louis Jermain and Dr. Hoyt Dearholt to an advisory committee to oversee the entire campaign. The committee first moved to expand the city's hospital facilities. Dr. Jermain told a *Sentinel* reporter that Milwaukee had fewer hospitals than any other comparably sized city because most Milwaukeeans were accustomed to receiving medical treatment in their home rather than at a hospital. But with most able-bodied physicians siphoned off for military service, people would have to go to a hospital or do without treatment. All of the city's hospitals, however, were at or beyond capacity. Temporary hospital space was desperately needed. The

advisory committee addressed the latter issue by securing $15,000 from the County Board of Supervisors and a matching amount from the City Council to convert the vacant Nunnemacher home at 17th Street and Grand Avenue as well as two halls in the Milwaukee Auditorium into temporary "isolation" hospitals.[8]

Ruhland, with the backing of Mayor Hoan, the Common Council and Wisconsin State Health Department, adopted extreme measures to check the epidemic. On October 11, he ordered all theaters, movie houses, public dance halls and indoor amusements closed until further notice. A *Milwaukee Sentinel* headline summed up the cheerless mood: "City Again Has 'Joyless' Days: Closing of Theaters and Dances Puts 'Wreck' in Recreation." The *Sentinel* estimated the city's seven theaters and 68 motion picture houses would collectively suffer a loss of $120,000 of daily gross admissions, which deprived the federal government of $18,000 per day in war taxes. The Health Department went further, shuttering the Washington Park Zoo, Mitchell Park Conservatory, bowling alleys, natatoriums and billiard halls. Ruhland also banned special department store sales, football games, boxing matches, flag raising ceremonies, political meetings and all other public gatherings. Anyone violating his orders could be fined up to $100 per day, and if they did not pay the fine, they could be imprisoned in the House of Correction for up to six months.

Ruhland also urged residents to avoid crowding in street cars and elevators, and he closed two core institutions of Milwaukee society—saloons and churches—with certain exceptions. Archbishop Sebastian Messmer, in compliance with Ruhland's decree, announced there would be no public services on Sunday or during the week, though individuals could offer private prayers as long as no large crowd was present. In addition, funerals and weddings could be held only if near relatives attended, and priests could still hear confessions and give Communion. Saloons could remain open as long as they did not allow people to congregate. Customers could enter the premises, buy a drink and leave. Young Rayline Oestreich, a student at the Milwaukee Normal School, noted in her diary that October 13 "sure was a queer Sunday. Not a machine on the street because of the gasoline conservation order. All places of amusement closed because of the 'Flu.' And so we just stayed home. Read & knit all day. Couldn't even go to church because they were closed because of the 'Flu'."[9]

One more Health Department action particularly irritated Rayline. The city closed all 71 public and 61 parochial schools starting Monday, October 14. School Superintendent Milton Potter hoped the children would "find pleasure and profit in reading and playing during this little vacation." The order, however, did not apply to the Normal School. Rayline went to school that day and groused in her diary, "I think it is

mean that normal has to be open when all other schools are closed. Every one has to have his temp taken every day."

Though there undoubtedly was more grumbling by Milwaukee residents, a host of agencies and individual citizens stepped up to participate in the city's wide-ranging mobilization against the flu. School closings enabled teachers to go door-to-door to visit the sick and provide an accurate count of flu cases, which was an immense help to the Health Department. With the city facing an acute shortage of medical personnel—the president of the Board of Trustees for Johnston Emergency Hospital claimed that one-half of the staff provided service to the military—Ruhland reached out to the School Board, which directed physicians and nurses in the schools' Hygiene Department to assist the short-handed isolation hospitals. The commandant of the Naval Training Station dispatched male nurses to Milwaukee, and women and multiple civic groups volunteered to help care for the sick. In addition, the Red Cross motor corps of 18 women and other volunteers provided ambulance services to shuttle the sick from their homes to various hospitals. They answered 875 calls and drove more than 3,000 miles. Anita Weschler praised their work. She saw a nurse and soldier wearing white masks helping a maid into a neighbor's home. Anita commented, "They are certainly doing a lot more work than they figured on, those motor girls, and they are doing a lot of good at that."

It was grueling work for these caregivers, and they placed their own lives at risk. For example, Gertrude Kruse, the visiting nurse for the street car company's employee association, made 287 house calls during October. In several cases, she found entire families—some with six or seven children—all in bed with the flu. On other occasions, the mother was incapacitated while young children "were running around in night clothes and bare feet. These had to be washed, dressed and fed." Neighbors were unwilling to assist these families because they were afraid of catching the dreaded disease. Mattie Fuller also wore herself out. She drove an ambulance all day and all night on October 14, catching a few hours' sleep while still in her uniform. For the next three days, she continued the strenuous work, noting on October 17 that she was "Pretty D- tired!" The next day she went home at noon with the flu. She was in bed with a high fever and pneumonia for a week. The fever finally broke on October 27, and she was able to sit up in bed for a few minutes the next day. Others were not so fortunate. The *Milwaukee Journal* reported the flu infected 43 nurses laboring in four hospitals, and the Milwaukee County Hospital treated 63 nurses in October who became ill. Several perished.[10]

Intertwined with the effort to treat the flu was a massive educational campaign. The Health Department printed leaflets, posters and placards in several languages to inform the public about steps to prevent contracting

the disease. Ruhland provided "talking points" for Milwaukee teachers and clergymen, and the Health Committee of the County Council of Defense devised a plan to send speakers to local factories to give ten-minute talks during the noon hour, while Four-Minute Men lectured theater goers. Milwaukee businesses also furnished literature to employees. For example, the Milwaukee Coke and Gas Company had S.H. Wetzler, the plant surgeon, provide a lengthy discourse in the company publication. He acknowledged there was a rumor that the Germans brought the disease to the U.S. in a submarine operating along the coast, and that a crew came ashore and released the germ. Whether the rumor was true or not, Wetzler asserted, it was vital that Americans do not panic. No matter if "he fight a German or a Germ," the man who worried was half-beaten. Ruhland also enlisted the aid of the city's policemen to enforce the spitting ordnance as a means of halting the flu's spread. The first day, police arrested six men and hauled them to the central police station. They were later released after furnishing a bond of $15. Eight other violators were arraigned in district court and were fined $5 plus court costs.[11]

Despite the city's best efforts, the epidemic scythed through Milwaukee unabated, peaking at 785 cases on October 14. A week later, Ruhland informed the Common Council that a total of 6,000 cases had been officially reported, but he estimated the actual number was closer to 30,000. Moreover, the number of deaths surpassed 350. Milwaukee, however, fared better than other large cities. The Health Commissioner attributed this commendable record to three factors: 1) the early decision to close schools, businesses, etc., 2) cooperation that the Health Department received from the Common Council and other organizations and 3) willingness of Milwaukee citizens to comply with the orders.

Beyond the health hazard, the epidemic disrupted the everyday routines of nearly every Milwaukeean. Ruhland's order to close entertainment and retail businesses forced thousands to scramble for temporary work. In addition to the actors and actresses from the legitimate stage theaters, the managers of the Gayety and Empress theaters noted there were five burlesque companies totaling 120 people stranded in Milwaukee. Some of the male actors toiled in munition factories while a number of actresses found work in other stores or volunteered with the Red Cross to aid in the fight against the flu. Many actresses and actors, however, could not find work because they could not guarantee how long they would be able to remain at a job (or those "unfitted for other employment" as Dan Hoan phrased it) and had to rely on financial support through the Red Cross. By early November, one newspaper estimated that Milwaukee theaters, cafes, billiard and dance halls, and other entertainment businesses lost an aggregate $1 million in revenue.[12]

By the end of October, the epidemic had subsided to the point that Ruhland—after consulting with his advisory council—lifted the ban on public gatherings as of November 4. "After a two months' attack on Milwaukee," crowed the *Journal*, "Gen. Spanish Influenza has been forced to acknowledge defeat and accept Health Commissioner Ruhland's terms for an armistice." Though Ruhland cautioned Milwaukeeans to continue to be careful, avoid crowds and go to bed at the first hint of a cold, he informed Mayor Hoan that the epidemic had been brought to a successful conclusion. City residents, penned up for the better part of three weeks, needed little prodding to flood into the streets and resume their normal lives. And not everyone heeded Ruhland's warning about avoiding crowds. Hundreds of Milwaukee citizens, along with Governor Philipp and his staff, took the opportunity to gather on the slopes of Juneau Park to have themselves filmed as part of a "joy reel" to be shown to Milwaukee soldiers overseas. The city's movie theaters also did a very brisk business. One Marquette University student visited four theaters in one evening. He explained that he was "'Making up for what I missed while I had the flu.'"[13]

Others also made up for lost time. The flu slowed activities of Liberty Bond salespeople, but it did nothing to curb the intimidation that accompanied the drive. Labor leaders complained how company officials at a textile factory hinted that yellow paint could be used on those who did not buy their fair share just as it was at the Milwaukee Harvester works. An employee of the Weinbrenner factory said company officers insisted his department had to purchase $4,000 worth of bonds. Those who did not "would be looked up by the government."[14]

Area farmers also faced intense scrutiny from Liberty Loan "flying squadrons" that swept through Milwaukee County in late October. Trains of automobiles carrying anywhere from 35 to 100 people at a time visited farmers who were deemed "slackers" because they had not purchased their designated share of Liberty Bonds. Typically, a squad of soldiers (sans rifles "because of the sense of intimidation that might arise") in civilian dress carried an American flag at the head of a procession that filed into the farmers' yards. Arrayed in a semi-circle around the flag, the bond workers escorted the farmer to the center of the gathering. Everyone saluted the flag by removing their hats, and then the group's spokesman informed the farmer that he was delivering a message from the government: The U.S. was at war and had two million men fighting in France. They were fighting "for our country, for this flag…and for the liberty of all of us, and for the safety and freedom of our nation and the world." The only way they could have the food, clothes, guns, ammunition and safe passage they needed was through the funds provided through

Liberty Bonds. Milwaukee County's share of the current drive was more than $32,000,000. "We have done our share," he told the farmers, "To this time you have failed or refused to do your share. We have been asked to give you this opportunity to now do your share and do your duty. Are you ready to do this?" After much "persuasion," most farmers relented and bought bonds. Those who did not, however, received a good deal of verbal abuse from squadron members—even threats of physical harm—and the disgrace of having yellow placards posted on their homes that read: "Public notice. The occupant of these premises has refused to buy his fair share of liberty bonds. Do not remove this notice."

Milwaukee's pro- and anti-war newspapers offered wildly divergent views of these proceedings. The *Milwaukee Journal* described them as "solemn, silent and orderly" ceremonies, while the *Milwaukee Leader* labeled them as nothing less than a "reign of terror." But accounts from both sides give the uneasy perception that the squadrons overstepped the bounds of common decency in their dogged pursuit of doing one's fair share. In the Town of Greenfield, a squadron was met by a farmer's wife and son, who both insisted the farmer had left for Hales Corners for grocery supplies. The son's actions aroused the suspicion of the squadron leader, so the group searched the barn, fields and other hiding places before entering the house, where they found the farmer hiding. William Prange, a farmer in the Town of Milwaukee, also received a visit from a flying squadron. Prange told the gathering that he had already purchased a $50 bond despite being in poor health and carrying a mortgage of $2,500. The squadron's spokesman insisted Prange had to buy another $100 worth of bonds. Prange said, given his financial state, that would be impossible, but he did offer to buy another $50 in bonds. The farmer told a *Leader* reporter that the squadron howled at him and said it was all or nothing and to "shut up with that damned bunk and buy that bond." When one of the squadron brandished the dreaded yellow placard, Prange said, "If that is the penalty for my poverty, I can not prevent it." A neighbor who was in the party told Prange to go ahead and sign for the bonds, and he would loan the money without interest. Prange believed the neighbor feared for the farmer's safety.[15]

Not even religious objections stopped the squadrons from enforcing 100 percent participation in the bond drive. At dusk on October 30, a squadron stopped at the farm of William Eschrich. Not finding the farmer at home, the squadron began making its way to a neighboring farm. Along the way, the group encountered Eschrich driving home. James H. Stover—father of Assistant U.S. District Attorney Paul Stover and APL leader John Stover—asked Eschrich to step out of the truck to hear a message from the government. The crowd of 50 arranged themselves in

a semi-circle on the roadway to salute the flag. Eschrich did not remove his hat for the ceremony, and one of the group snatched it from his head. Once the salute was completed, Stover asked Eschrich if he would invest $200 as his fair share of bonds. The farmer refused and explained that he was a member of the Russellite sect and would not conscientiously as a Christian contribute to any purpose that violated one of the greatest commands in the Scriptures: "Thou shalt not kill." Stover remarked there were men in prison in Leavenworth for less than what Eschrich said and reminded the farmer of the Biblical injunction to "render unto Caesar that which is Caesar's" and asked if obedience to Scriptures compelled men to buy bonds. Eschrich replied that he paid his toll to Caesar by paying taxes. If Congress made subscribing to Liberty Bonds law, he would be obligated to obey, but otherwise he would not do so. Anyone who did not buy bonds, Stover snarled, was "no better than a worm of the earth." Others in the crowd called Eschrich a "dirty dog," and someone yelled that he should be hung.

Failing to convince Eschrich to support the war effort, the squadron returned to his farm and set up yellow placards on the premises. Its business concluded, the crowd again assembled to salute the flag. Again, Eschrich did not remove his hat. A deputy sheriff grabbed the hat and flung it to the ground. Stover denounced Eschrich in "scathing language." Another squadron member asked why he did not salute the flag. Eschrich replied he did not worship any earthly thing but only God. He was asked if he would take off his hat in salute to the Christian flag, the cross. "No," he answered, "I respect everything, even the flag, as long as it stands for truth, righteousness and liberty." An incredulous patriot asked if Eschrich thought the American flag did not stand for those things. He responded, "I say today Nations all over the world are killing each other. It is not right. It is not truth." Then someone from the squadron asked the farmer if the Germans came to Milwaukee and dragged Eschrich's wife around like they did in Belgium and cut off his children's hands, would he stand by and let them do it? "Yes sir," he answered. One squadron member remarked, "You have my sympathy." Stover interjected, "Not my sympathy, he has my contempt. I am ashamed of a man who takes such a construction of things as he has done." A *Journal* reporter undoubtedly agreed. He ridiculed Eschrich (though his name was not given in the article) as someone "obsessed with Russellite misconceptions of the Scriptures" who refused to protect his wife or children.[16]

The mood was equally contentious during the fall political campaigns. President Wilson upped the ante by appealing to the American people to elect Democrats to Congress as a show of unity during wartime. The election of a Republican majority to either branch of Congress, he warned,

would be "interpreted on the other side of the water as a repudiation of my leadership." Closer to Milwaukee, the Wisconsin Loyalty Legion, despite reservations by some within the organization, also worked to make loyalty the only issue of the campaigns. In addition to targeting several Wisconsin Congressmen who had voted against American entry into the war, the WLL set its sights on Governor Philipp, whose moderate record reflected an unforgiveable weakness in supporting the war effort. Of course, Victor Berger, vying for a U.S. representative seat from the Fifth District, was also an object of the WLL's wrath.

The campaign itself was rather unusual. The influenza epidemic prevented the usual spate of political rallies. The *Journal* related tongue in cheek that "Politicians have suffered more, perhaps, than anyone else. For three weeks they have been filled with red-hot speeches and have been denied the privilege of an audience." Instead, all sides were limited to the usual partisan bickering in newspapers, campaign flyers and posters. George Russell of Milwaukee complained to Guy Goff in the Judge Advocate General's Office in Washington that one of Victor Berger's Socialist circulars was a "hundred times worse in the way of giving comfort to the enemy" than anything Eugene Debs said. Debs went to prison for his speech, but Berger "goes unscathed because of his powerful position and because people are afraid of him." The government's inaction, Russell claimed, allowed the Socialist Party in Wisconsin to "quadruple during the past year, and has now reached the very menacing figure of over 100,000 votes." Russell and others in the loyalist camp must have been relieved when only a week before the November 5 election, Berger was again indicted by a federal grand jury for violating the Espionage Act. Political enemies circulated a story that Berger was ineligible for political office because he was indicted. A defiant Berger claimed this blatant political effort by the government assured the Socialists' election "beyond a shadow of a doubt." He and his co-defendants were indicted solely because they were Socialists. "An avalanche of Socialist ballots will answer these indictments," he predicted, "Had we been Democrats or Republicans, we never would have been indicted."

Ruhland's lifting the ban on public gatherings the day before the election signaled the start of a frenzied day of campaigning. The *Sentinel* anticipated "one big bang" as all candidates would "tear loose with that one and only speech with which they expect to capture many votes in the present 'speechless' campaign." Election day was equally frenetic. The election results were disastrous for the WLL and the Democrats. At the national level, Republicans, enraged at Wilson for impugning their loyalty, escalated their anti-administration rhetoric and gained nearly 30 seats in the House of Representatives. In Wisconsin, Philipp handily

won re-election as governor, and the Republicans won ten of the state's 11 Congressional seats. The outcome on the local level made Berger seem prophetic. Despite being under indictment, he captured the other Congressional seat, while the Socialist Party swept a whole slate of county and city offices and sent several members to the State Assembly. The *Free Press* deemed the election a "Socialist avalanche," confirming Milwaukee citizen's weariness of food and fuel regulations, unrelenting WLL and loyalist criticism of the city's German-Americans and the silencing of free speech.[17]

Berger's triumph must have been exceptionally sweet. "This is the answer of our state to the indictments," he boasted, "The red glow of the coming day is clearly visible in the state of Wisconsin." But the taste of victory was short-lived. The trial for him and four co-defendants began in a Chicago courtroom on December 9. The brash, controversial publicity hound Judge Kenesaw Mountain Landis presided. According to historian John Gurda, the future Major League Baseball commissioner "made little pretense to objectivity." His disdain for German-Americans and war dissenters was on full display and left little doubt how the 23-day trial would end; it took the jury less than six hours to find Berger and the others guilty of conspiracy to violate the Espionage Act. Landis added insult to injury by sentencing all five to the maximum 20 years' imprisonment at Leavenworth. Berger avoided jail time while the case was appealed, but his troubles were not over. Congress refused to seat him in November 1919, but in a special election, his constituents re-elected him in 1919 by an even larger margin. Again, Congress refused to seat him, so the district went without representation for the entire session. It was not until 1921 that the Supreme Court reversed the conviction. Berger won re-election in 1922 and finally took his place among the country's elected officials.[18]

The contentious election campaign as well as the flu's devastation were additional layers of concern during Milwaukee's "crowded hour," but war news continued to dominate press headlines and the thoughts of local residents. With the flu seemingly receded and the war clearly nearing its pinnacle, Milwaukeeans were primed to unleash an outpouring of emotion seldom seen in the city's history.

11

50 New Years Evenings couldn't make up for this one day.
 Anita Nunnemacher Weschler to Edward Weschler, November 7, 1918

When the calendar flipped to November, it was clear the Central Powers were defeated, and it was only a matter of time before the war mercifully came to an end. Newspaper headlines blared on November 4 that Austria-Hungary, Germany's main ally, had surrendered and given up claims to the cities of Trent and Trieste, northern Italian cities the Habsburgs had controlled since the Napoleonic Wars a century earlier. The news set off a raucous celebration among the Italian community in Milwaukee's Third Ward. The Milwaukee Macaroni Company declared a holiday before the employees arrived for work, and many other businesses followed suit. Students from the Detroit Street School joined the demonstration, cheering the Allies and waving Italian and U.S. flags. Angelo Cerminara, the Italian consul in Milwaukee, declared Trent and Trieste had always longed for their return to the motherland despite Austrian efforts to stamp out their Italian heritage. The news, said Cerminara, was not "felt so much as a military victory as it [was] a moral victory."[1]

 This celebration was a taste of things to come. Three days later, shortly after noon, newsboys began shouting "Extra! Extra! The War Is Over. Germany Surrenders." The *Milwaukee Sentinel* brought out an extra edition that stated the war would end at 2:00 p.m. The *Leader, Evening Wisconsin* and *Milwaukee Daily News* likewise issued extras announcing the end of the war. By 12:30, whistles all over the city began blowing, car horns blared and throngs of jubilant people crowded downtown streets. Someone in a downtown office building opened a window and threw out a basketful of shredded paper. Others immediately picked up the cue and soon the streets "resembled the aftermath of a snow storm." Even the City Hall clock went wild, ringing "50 o'clock and then some." It was soon discovered that two men climbed to the tower and used hammers to "beat

a hymn of victory." Businesses declared a half-holiday, and their employees launched impromptu parades all over the city. The A.J. Lindemann & Hoverson Company band led a procession along Lincoln Avenue from Second Avenue (now South Seventh Street) to Eighth Avenue (now South 13th Street) then up to Mitchell Street. The women from the office banged pots along the way, while Bert Leonhard proudly carried the company service flag, which bore 200 stars. Renditions of "The Star Spangled Banner" and "America" broke out but could barely be heard above the din. Festivities carried on well into the night, as revelers lit bonfires that made Grand Avenue look as if it were "ablaze with red fire."[2]

The unbridled joy convinced Rayline Oestreich that the city had "gone mad, simply mad." Anita Nunnemacher Weschler rescheduled a dentist appointment because her dentist was so excited that "he was afraid that if he did any work that day, he would risk all his patients." Some people were overcome and fainted; others laughed, yelled or "wept with joyous relief from the tension of the war," as Erich Stern's family did. The reactions of a few were more contemplative. The joy that William George Bruce and his wife felt was so intense that they were unable to speak. "Peace," he wrote "meant more to us than we were able to express in words. We breathed a silent prayer of gratitude." Rayline Oestreich's first thought when she heard the news was of a friend who perished in the war: "If only George P. were coming back…." Both she and Anita Weschler worried the news was too good to be true.[3]

It was. A United Press reporter in France had accepted a false cable as fact and immediately spread news of the war's end to the U.S. The Wilson administration quickly dispatched official denials of an armistice, but they were ignored or drowned out by the frenzied celebrations. Of Milwaukee's major daily newspapers, only the *Journal* did not print the unverified story, a fact the paper's editors were only too happy to point out. The following day, the *Journal* chastised its competitors, especially the *Sentinel*, for printing the rumor despite evidence it was false. It was natural for the public to accept the news as valid. When the *Journal* did not add its columns to the "false cry of peace," its offices received several insulting messages, and several of its newsboys received rough treatment at the hands of upset readers who grabbed unsold *Journals* and threw them in the garbage. Once the truth sank in, the *Journal* was vindicated and "disappointment and depression prevailed" throughout the city. Given the glum mood, the paper assured readers that it would print the big news concerning the end of the war as soon as it happened "but not before." All told, the *Journal* estimated the previous day's celebrations cost the city $500,000 and listed several damaging results: 80,000 factory employees stopped working, and nearly every plant in the city closed,

which resulted in a $400,000 loss in production of goods and $200,000 in lost wages. School closures interrupted the work of 1,500 teachers and 70,000 students, while crowds snarled street car traffic for seven hours.[4]

The *Journal* gleefully reprinted statements from prominent citizens who condemned the other papers. Mayor Hoan considered the selling of fake extras "inexcusable" and promised to sign any ordinance the Common Council passed prohibiting the nuisance. The Reverend C.H. Beale of Grand Avenue Congregational Church commented how the whole situation was very unfortunate, but if it was "pure sensationalism, it nearly amounts to a crime." And Judge August Braun advocated that the "author of such a report should be run down and punished."[5]

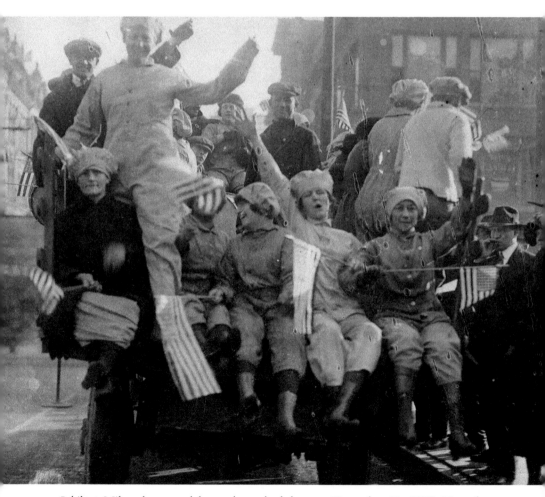

Jubilant Milwaukeeans celebrate the end of the war, November 11, 1918. Note the "womanalls" worn by many women who worked in Milwaukee factories. (Photo courtesy of Milwaukee County Historical Society)

The public outcry did not amount to anything beyond the usual grousing, but distraught locals did not have to wait long for their spirits to be lifted. Shrill factory whistles and wild shouting in the streets awakened everyone at 2:30 a.m. on November 11. Harriet Richardson knew immediately the war was over, but William George Bruce initially thought the whistles meant the departure of soldiers for a military camp. As the noise grew in volume and intensity, however, he and his family came to realize "it meant more."[6]

Assured that the armistice had indeed been signed, Milwaukee again experienced a spree of boisterous partying. Grand Avenue was packed by 3:00 a.m., and William George Bruce arrived downtown in the morning to find clouds of scrap paper raining down from office buildings. Numerous improvised parades marched up and down downtown streets. A contingent of 40 from the city's Jewish community marched down Grand Avenue carrying the American flag and another flag with the Star of David, and the Milwaukee Coke and Gas Company band marched for nine and one-half hours with a one-hour "lunch" break at the Milwaukee Athletic Club. Effigies of the Kaiser suffered many indignities including having his head smashed by a clown who accompanied the Schuster's Department Store band as it marched around the city. City Health Department inspectors carried an effigy around the courthouse, only to have it placed under arrest by Deputy Sheriff Alex Ferdinand. The clerk of courts issued a warrant for first-degree murder, and the dummy was taken to Municipal Judge August Backus who sentenced "Bill Hohenzollern" to be hanged. Needless to say, the "liquids folwed [sic] freely," according to William George Bruce. By 5:00 a.m. men and women lined the bar, two deep, at Henry Wehr's tavern on West Water Street (now Plankinton Avenue) and toasted the end of the war. Bruce joined a lunch crowd at the Athletic Club and narrowly avoided becoming a "hilarious drunk," something he had never been guilty of, by "escaping stealthily." The enthusiasm, he observed, "ran to a hysterical degree." And why not? he asked for it was "the greatest day in the history of the world!"[7]

Erich Stern, however, wondered what motives were behind the crowd's outburst. "Aside from a certain good natured and spontaneous abandonment," he mused, "there was nothing admirable, nothing dignified about the demonstrations; nothing to indicate any deep emotion...no undertone of seriousness of any kind." He thought the most likely feeling was a "thoughtless and vague satisfaction of being 'victorious,'" not unlike college students celebrating a football victory. In addition, he suspected there was a common feeling of "gratified revenge," especially directed against the Kaiser. His own feeling was "one of such unspeakable relief that it left [him] almost numb most of the day," but a feeling of quiet

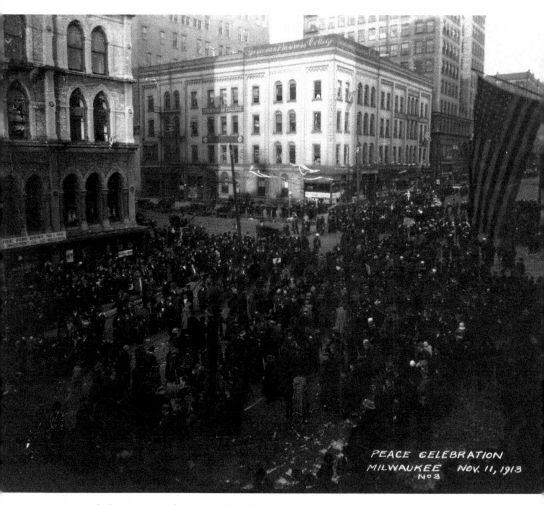

News of the war's end prompted wild celebrations that began very early in the morning and lasted well into the night. (Photo courtesy of Milwaukee County Historical Society)

happiness that the carnage had ended finally came to him. Stern examined the commotion with detached interest and found the "shallowness was repellant and chilled hope." The American people as a whole had not really suffered. They had only "the parade and romance of war," which coincided perfectly with the government's calculated efforts to use the "key of hate" and "key of romance" to play upon people's emotions. He worried what this mindset meant for the post-war world. He mentioned a Milwaukee woman who, "whenever she gets lonesome," would run over to the house of a German-American acquaintance and insult her for a pastime. She would boast how proud she was to be of English descent. "How can she possibly attune her mind to a peace of justice," Stern asked,

"or even conceive faintly what such a peace would be like when she nurses faked photographs of American prisoners of war crucified by the Germans!"[8]

The war's end temporarily blocked any thought of the Spanish Flu, but its specter continued to haunt Milwaukee. On November 14, the *Journal* described the heart-wrenching story of Andrew Klein's family. He, his wife and four young children moved to Milwaukee only two months previous. They were essentially destitute but found lodging in the basement of a house on Grove Street (now South First Street). The flu struck the entire family and claimed the life of Klein's wife. Because he did not have the means to pay for a funeral, her body remained at the city morgue while he tried to raise enough money to prevent her burial in the Potters' Field. The children were taken to the Volunteers of America headquarters on 13th Street until arrangements could be made to care for them. One health officer found their situation "pitiable" and believed it would not be difficult to raise funds to support the family if people knew its "true wretchedness." Klein, he added, was willing to have one or two of the children adopted by someone willing to give them a good home.[9]

Health Commissioner Ruhland acknowledged there would be flu cases all winter but Milwaukeeans did not need to worry about the resurgence of epidemic levels. He changed his tune, however, in a matter of two weeks. The virus mutated once again, launching a third wave that engulfed the country. On November 14, the number of flu cases in Milwaukee had dropped to 64, but the figure climbed steadily thereafter, forcing Ruhland to recall his advisory committee, re-open the Nunnemacher Hospital and warn Milwaukee citizens that the flu had returned. He advised residents not to hold Thanksgiving parties and asked schools to cancel all social functions that were not essential. These halting steps did not stop the disease from returning with a vengeance. During the first week of December, flu cases hovered between 264 to 386 per day; the number peaked at 647 on December 10. The December 4 *Journal* included a full-page ad in which Ruhland scolded Milwaukeeans: "In spite of the repeated warnings of this office, there has been a laxity on the part of the Milwaukee Public in taking precautions to prevent the spreading of Influenza." If city residents did not voluntarily take steps to avoid an even more serious outbreak, Ruhland threatened to close all public gathering places.[10]

One Milwaukee woman did not buy into Ruhland's warnings. She wanted Mayor Hoan to try to stop the "talk" about the flu in the newspapers. "In the first place," she claimed, "the whole thing is German propaganda." The Germans could not defeat the Americans in the war; consequently, "they planned this attack not only on the soldiers but on

the whole American people and here our health boards and papers all fall for it and help to spread the thing by having those great head lines and pages of scare heads and telling how many cases there are." The country's best bacteriologists had not found the germ of this "so-called disease," so would it not be wiser, she asked, "for the health department to THINK RIGHT about this matter and stop spreading disease thought germs and augmenting the fear of the people?"[11]

Fortunately, most Milwaukee residents followed the health commissioner's instructions—at least well enough that Ruhland never issued a full ban. The Health Department did, however, take several steps to curb the epidemic. It urged residents to wear masks and quarantined infected households, posting bright red "INFLUENZA" signs on them.

It required theaters and churches to reduce attendance by roughly 50 percent, filling alternate seats and exclude all children under 15 years old.

INFLUENZA

All persons, except physicians, nurses and clergymen who are in attendance, are hereby cautioned not to enter or leave the house without permission from the Commissioner of Health.

This Placard is posted by order of the Commissioner of Health of the City of Milwaukee, and can be removed only by his order if removed otherwise, occupant of house must report to the Health Office within 24 hours.

Posting eye-catching placards on infected households during the Spanish Flu pandemic of 1918 was one measure taken by Health Commissioner George Ruhland to stop the flu's spread. (Photo courtesy of Milwaukee Health Department)

Ruhland also closed schools and libraries and forbid crowding on street cars and in stores. The poor timing was not lost on William George Bruce. He noted on December 15 that the "sun shines brightly this morning on an influenza stricken community. Never in the history of the city have so many cases of illness been reported....And here it is ten days before Christmas when people are expected to do their shopping in crowded stores and move about in crowded street cars." Realizing city stores would be tempted to ignore the no-crowding order during the height of the Christmas shopping season, the Health Department stationed inspectors at the most prominent establishments. Most businesses and individual citizens cooperated with Ruhland's crusade, but the Health Department investigated quite a few reports of department stores violating the no-crowding rule.[12]

By Christmas Day, the epidemic had essentially run its course. Ruhland lifted the ban on large gatherings, and schools re-opened on January 2. At the close of the year, the disease killed 1,173 Milwaukeeans—23 percent of all flu-related deaths in Wisconsin. Oddly enough, the flu did not prey on the very young or very old; most victims were in the 15-40 age bracket. While the death toll was alarming, the city's death rate—2.56 per 1,000—was the second best ratio in the country. Population density and climate may account for Milwaukee's success, but the Health Department's aggressive measures and cooperation of political leaders, civic organizations and the general public deserved a good deal of credit for reducing the epidemic's impact. Nevertheless, the flu exacted a tremendous emotional and economic toll, not to mention the unfulfilled potential of those who perished. This dramatic experience has been curiously overlooked. One study attributes this selective amnesia to the flu's "elusive nature" and the way it spread "insidiously by means of ordinary coughs and sneezes, borne through communities along the channels of human contact." But it was the Great War, with its crusading energy, despicable villains and brave heroes that overshadowed the worst public health disaster in the country's history and diminished its place in our collective memory.[13]

12

We the members of the Woman's Literary Club of Milwaukee do implore you in the name of the women of the United States and of unborn generations of children to take steps at once to safeguard our soldiers in camp against the vice which leads to this destruction.
Woman's Literary Club of Milwaukee to Secretary of War Newton Baker, May 22, 1917[1]

By framing the war as a crusade to save the world, President Wilson provided the moral impetus to wage a war within the war to elevate American society. The conflict and its all-consuming demands prompted many to suspend, or forget, reform efforts, but Progressives exploited the country's crusading zeal to achieve three interrelated, hard-fought social experiments.

The first was women's well-known struggle for the right to vote, a fight in which Wisconsin women had been engaged since the 1850s. The movement suffered a period of "doldrums" in the late 19th century, but issues arising from the economic and social transformations of the early 20th century provided women with new opportunities to assert their moral influence on American society. Milwaukee's Lutie Stearns championed the right to vote because it would make politics the "translation of Christ's principle into the law of the land," and Victor Berger argued that women should have the ballot "because modern civilization needs the wholesome influence which mothers, wives and sisters can add to our public and political life."[2] As a result, the suffragists' ideology became less threatening to labor unions, intellectuals and Socialists who realized women's votes could help achieve desirable changes. In addition, a new generation of leaders revived the suffrage effort by adopting more aggressive tactics. Women staged parades, made speeches, circulated petitions, sought publicity through the press and on movie screens, went door-to-door

and used newer technologies, such as automobiles, telephones and even airplanes, to spread the suffrage gospel.

The new battle plan provoked a split between more militant women and the more traditional entrenched leadership of the Wisconsin Women's Suffrage Association (WWSA). The former established the Political Equality League to forge an independent path toward gaining the vote. Despite the split, the combined activism of both organizations, along with the Women's Christian Temperance Union and other women's groups, forced the issue to a statewide referendum in 1912. Pro-suffrage forces waged a vigorous campaign, but they could not overcome determined opposition from brewery owners and German-Americans who suspected suffrage was a cloak for Prohibition and curtailing personal liberties. Moreover, Catholic and Lutheran clergy and conservative-minded men balked at the thought of women stepping out of their established domestic sphere to plunge into political affairs. Archbishop Messmer believed men had authority over the family and that divine providence endowed women with a "quiet, soft and sweet" power to influence society but only as man's helpmate, not as an equal.[3]

When the referendum suffered a resounding defeat, the suffrage movement again appeared poised to languish, but the advent of World War I altered the landscape. Many suffragists embraced the preparedness movement and Americanization efforts among immigrants and also supported the Wilson administration when war came, believing that demonstrating loyalty would further their cause. But similar to how the war splintered American labor, Progressives and even Socialists, it did the same to the suffrage movement. Historian Genevieve McBride describes how the war forced many women "to choose between the ballot and their German heritage or their Socialist or progressive politics." To some, their pacifist principles trumped gaining the right to vote. WWSA leaders tried to prevent members from speaking out against the war and to actively expel Socialists. Consequently, Meta Berger and Maud McCreery resigned as first and third vice-presidents respectively of the WWSA in October 1917. Beyond the suspicion she encountered from middle-class suffragists, Berger deemed the organization's efforts too timid. Women should direct all their efforts to gaining the vote as a war measure. "Today more than ever," she urged, "with the young men away to the war, with the changed industrial and economic conditions confronting women, it is more imperative than ever that women should have the ballot to protect themselves and their families." She could not help but note the irony of fighting the war to make the world safe for democracy, but there were millions of women in the U.S. who were "denied the right to participate in their government and cannot express themselves on issues most vital to

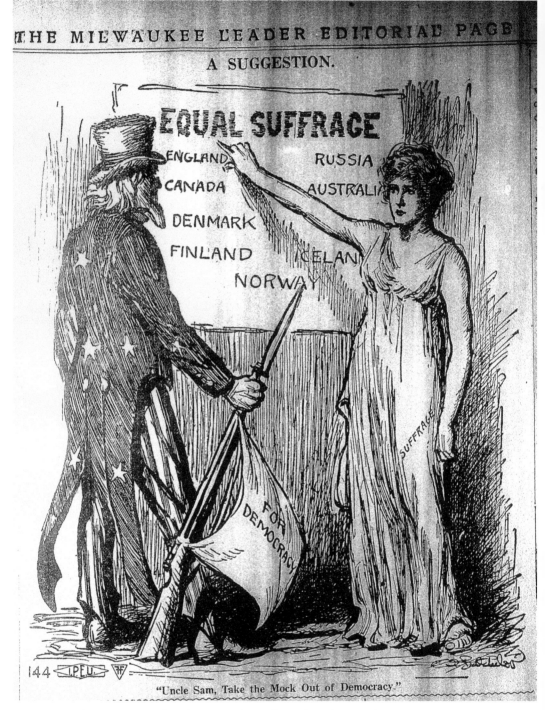

A July 23, 1917, political cartoon from the *Milwaukee Leader* promotes women's suffrage. Women's patriotism and work in American factories gave the suffrage movement the momentum needed to be adopted through the 19th Amendment.

themselves, to their children and to their country." She believed the radical and aggressive work of the National Woman's Party promised a more effective means to publicize the issue. One week after her resignation, she established a Milwaukee chapter.[4]

The response by women to the "changed industrial and economic conditions" of the war lent substantial credence to the argument for women's rights, but it did not overcome stubborn opposition completely. In December 1917, the Wisconsin Association Opposed to Woman's Suffrage adopted the national association's platform that denounced suffragists as "domestic enemies," lumping them in with pro-German, pacifist and Socialist forces. The Wisconsin Association dismissed a proposed federal suffrage amendment as undemocratic and unjust, asserting it would "tremendously increase the racial and all other problems of American democracy." The group announced it stood for the "conservation of the best womanhood of all conditions and stations in life." Nevertheless, President Wilson overcame his own misgivings, endorsed women's suffrage in January 1918 and urged the U.S. Senate to pass an amendment.[5]

Conservative Democrats, however, stalled the bill for months; some patriotic organizations likewise were slow to come around. In June 1918, with the suffrage amendment bogged down in the Senate, Mabel Search, chair of the Milwaukee Branch of the National Woman's Party, chided the Wisconsin Loyalty Legion for not offering its endorsement. "It seems particularly strange to me," she mused, "that an organization such as [the WLL]—organized to follow the president far afield in this war 'for the right of those who submit to authority to have a voice in their government'—should feel itself unable to indorse [sic] so elemental a step in political democracy as equal suffrage." Several trade unions voiced their support "cheerfully and without any hesitation," and she wondered, "if after all, it is not only a matter of actually appreciating the significance of democratic issues and being willing to support them here in Milwaukee as well as in France. In other words, democracy begins at home. Don't you agree with me?"[6]

Senate Republicans, sensing an opportunity to deal a blow to Democrats in the fall 1918 elections, backed suffrage in late August. Wilson's aides urged him to counter the Republicans' thunder and speak out in favor of the amendment. He did so on September 30, calling it crucial to an Allied victory. But he suffered a humiliating defeat when Senate Democrats blocked its passage by two votes. Women's groups in Milwaukee vented their frustration on election day. While workers at polling places handed out red, white and blue tags from the County Council of Defense that read, "An American Citizen. I Have Voted," the Milwaukee chapter of the National Woman's Party stationed members downtown and in business

districts in outlying areas to distribute 8,000 purple and gold tags that read, "I Am a Woman Citizen. I Can Not Vote."

But the day when women could vote was not far off. The Republican landslide victory in 1918 spurred the suffrage movement forward. A federal amendment was proposed early in the 1919 Congressional session, and after much lobbying, was passed. Several states vied to be the first to ratify the 19th Amendment, but Wisconsin and Illinois claimed the honor on June 10, 1919. The following year, Tennessee became the 36th state to ratify, and the amendment became law. It did not transform individual women's lives or the nation as proponents envisioned, but its achievement secured a long overdue right for half of the American population.[7]

Many of the women who fought for suffrage also supported efforts to eliminate alcohol from American life. Even after decades of agitation by temperance supporters, Prohibition had gained little traction in Milwaukee: its largely German population reveled in the *Gemülichkeit* culture of the beer hall; many Catholic and Lutheran churches had a dim view of Prohibition; and brewing beer was one of Milwaukee's most financially lucrative and politically powerful industries. In 1902, one-third of the Cream City's 46 aldermen were saloonkeepers, and Socialists viewed attacks on breweries as attacks on working-class interests. But the temperance movement gained steam nationally during the Progressive Era. Alarmed by the rapid transformation of American culture and influx of huge numbers of eastern and southern European immigrants—who were primarily Catholic—white, middle-class and wealthy reformers of the early 20th century pointed to liquor as the root of all society's ills. Aggressive campaigning by the Women's Christian Temperance Union (WCTU) and Anti-Saloon League (ASL) tapped into this anxiety and allowed these organizations to make inroads at local and state levels. Thirty-seven states had "local option" laws on the books by 1900, and by the time President Wilson declared war, 27 states had gone "dry."

World War I presented a golden opportunity for Prohibitionists to take their crusade national. Milwaukee's Assistant District Attorney Arthur Bartelt neatly summed up arguments to move the effort forward. It seemed ridiculous in the eyes of the public, he wrote, "to ask the house-wives to save a bit of food here and a morsel there when the brewers and distillers consume millions of bushels of grain and rice and thousands of gallons of molasses in the making of beer and whiskey." In addition to wasting grain needed to feed U.S. and Allied military forces as well as starving people in England and France, the end product "reduces the efficiency of workmen and transfers thousands of men from the producing to the non-producing class, makes man kill his fellow man, husband kill his wife and father rape his own daughter."[8] Above all, reformers and military officials

emphasized how alcohol decreased the effectiveness of our military troops.

Not everyone was ready to turn off the spigots just yet. The Milwaukee Chamber of Commerce opposed consideration of any Prohibition legislation. At first, the group pointed to the devastating loss of property and revenue a law would cause as well as the hardship on brewery employees "in view of the trifling conservation effected at such tremendous economic cost." When that tack failed to change minds, H.W. Ladish, Chamber of Commerce president, tried a patriotic appeal. In a telegram to Senators Husting and La Follette, Ladish argued that the American people did not want a national Prohibition law and that the issue would only precipitate a bitter internal distraction at a time when the country should be united toward one purpose: "to uphold our President and to win a great war."

Nevertheless, Congress, swept up in the patriotic fervor, handed several victories to the "drys" during summer 1917. It forbade the sale of liquor to any member of the armed forces, established "dry zones" around military installations and prohibited the use of foodstuffs in the manufacture of distilled spirits. President Wilson aided the cause through a proclamation that limited the alcoholic content of beer to 2.75 percent. Such measures prompted Magnus Swenson of the Wisconsin Council of Defense to boast that, as of November 1917, "not a particle of grain is being used for the distilling of whiskey and the breweries have been greatly curtailed in their output of beer." He vowed that Wisconsin's Council of Defense and Food Administration would do "their utmost to wipe out the liquor traffic in every possible way." German-American domination of the brewing industry provided further ammunition for pro-war, anti-alcohol supporters who suspected that Pabst, Schlitz, Blatz and Miller opposed Prohibition to undermine the government's war effort and advance the pro-German cause.[9]

Milwaukee brewery owners and allied businesses could see the tide turning against them. But they kept up the fight. Again Ladish and the Chamber of Commerce appealed to Senator La Follette and Wisconsin's U.S. representatives to oppose a resolution that would deprive the government of $300 million in annual revenue and "ruin a great industry." Moreover, Ladish insisted that U.S. wartime allies did not find it necessary to stop the manufacture and sale of beer. For its part, the U.S. Brewers' Association took its case to the public. In newspaper ads, it claimed federal law made a distinction between producing hard liquor and "mild beverages" such as beer and light wines. The association welcomed the opportunity to promote "true temperance" (which meant "sobriety and moderation; not Prohibition") and pledged to dissociate

beer from distilled liquor. Congress was not swayed, and on December 22, 1917, it passed a resolution calling for a Constitutional amendment prohibiting the manufacture, sale, transportation and exportation of intoxicating liquors. The vote left brewers bitter and disillusioned. A *Milwaukee Sentinel* reporter noted how beer barons were "indisposed to comment" on the situation. The harsh winter of 1917-1918 already put Milwaukeeans in a glum mood, but it grew exponentially with the realization that if the required number of states ratified the amendment, approximately 6,000 brewery workers would lose their jobs as would employees of Milwaukee's nearly 2,000 taverns and various connected trades, such as coopers, glassblowers and wagon makers.[10]

With the amendment in the hands of state legislatures, "dry" and "wet" forces primed themselves for a spirited fight in Wisconsin amidst an atmosphere heightened by wartime pressures and poisoned by anti-German hostility. The February 28, 1918, edition of the *Milwaukee Leader* included a letter from Miller Brewing employee B.C. Hoppe who objected that if the amendment was adopted it would be "the first instance of a deliberate imposition upon the people of one state of the will of other states." Deprive a man of his glass of beer, he added, "immediately you have aroused his temper—you have attacked the root of personal liberty over which we thrive. You nurse into existence the embryo of hatred and ill-will. You have put into effect a condition resembling autocracy in place of liberal democracy."[11] Hoppe voiced the concerns of most German-Americans and Catholic and Lutheran clergy, but Archbishop Sebastian Messmer also saw the measure as a sectarian attack on the Catholic Church. He went so far as to take the undemocratic step of forbidding priests from allowing Prohibition speeches to be given at any church, school or hall. On the other side, the ASL energetically lobbied state legislators and never failed to make the connection between brewery owners and pro-German interests. Wisconsin industrialist John Strange, a leader of the Prohibition effort, observed that the U.S. had German enemies abroad and "in this country too. And the worst of all our German enemies, the most treacherous, the most menacing are Pabst, Schlitz, Blatz, and Miller." The situation deteriorated further when news broke that the country's most prominent brewery owners had purchased the *Washington Times* in 1915 to blunt ASL and WCTU publicity, but their purpose was twisted by wartime hysteria into something more sinister: spreading pro-German propaganda. The critics' strident outcry prompted a Congressional investigation into the matter in September 1918.

Given the turbulent environment, the "wet" forces had no chance. Complete Prohibition took effect even before the required number of states had ratified the proposed amendment. Aggressive "dry" lobbyists

convinced a pliant Congress to consider—and pass—a bill to halt the manufacture of beer on December 1 and sale of beer on June 30, 1919, "until further orders," ostensibly to conserve feed and fuel for the war effort. A Milwaukee brewer protested to a *Sentinel* reporter, "Our plants can not be used for any other purposes. The machinery is specially built for the manufacture of beer; our vats can not be used for any other line of work, and the big establishments that have paid untold thousands of dollars to the city and to the government will be useless on our hands while the latest order is being obeyed, and their deterioration will be rapid."

When the December deadline arrived, eight breweries closed and roughly 6,500 people were jobless. A *Journal* reporter wrote, "Prince Hops, Old Man Alcohol's most beloved and mildest-mannered offspring, died Saturday midnight." Robert Bartelt, a Pabst Brewing employee for 45 years, could not believe the day had come. He was confident he could find other work, but he feared for the well-being of older employees who would find it difficult to find new jobs. On the other hand, ASL forces rejoiced. R.P. Hutton, drunk with giddiness at the victory, believed most German-Americans would "heave a sigh of satisfied relief at the announcement of the breweries' demise, and will gather around the funeral bier with more thankfulness than ever they welcomed the fumes of beer." Though Hutton overestimated the reception Prohibition would receive, the "drys'" momentum continued. In January 1919, Wisconsin became the 36th state to ratify the 18th Amendment, and Prohibition became the law of the land on January 17, 1920. William George Bruce acknowledged the suffering caused by alcohol, but he condemned the attempt to "regulate the personal habits of man, to determine what he shall, or shall not, eat or drink" as a "radical infraction upon the teachings of the Founders of the Republic." But to rid the nation of the "liquor evil," the Bruce family accepted "self denial as a duty to society."

Bruce asserted that breweries, saloons and distilleries would soon be a thing of the past, but his epitaph was premature. Milwaukee's breweries adopted creative measures to stay afloat. They made chocolate, cheese products, chewing gum or malt syrup; bottled soda water or "near beer;" and even manufactured snowplows. As for the people of Wisconsin, it did not take long for them to become disenchanted with Prohibition. They generally ignored the law's restrictions. In 1926, they voted in favor of amending the Volsted Act to allow the manufacture and sale of beer with 2.75 percent alcohol, and in 1929, they voted to repeal Wisconsin's Prohibition enforcement law. Capping the wave of discontent, Wisconsin Senator John J. Blaine proposed an amendment to repeal Prohibition. Congress quickly passed the measure and sent it to the states. In December 1933, Utah became the 36th state to ratify the 21st Amendment, mercifully pulling the plug on a failed experiment in social control.[12]

The demand for women's rights and claims that liquor hampered the effectiveness of America's armed forces easily blended with the third of the war's grand reforms: the effort to clean up vice (i.e. prostitution and venereal disease), not just among the military but throughout American society. This drive is not as celebrated as suffrage or Prohibition, but the "justice" doled out in its name was especially heavy-handed and delivered another blow to civil liberties.

For ages, critics have condemned prostitution as a moral blight. The Book of Proverbs warns that a "whore is a deep ditch; and a strange woman is a narrow pit. She also lieth in wait as for a prey, and increaseth the transgressors among men."[13] The spread of venereal disease was also considered a "carnal scourge," but prostitution was tolerated as a necessary evil by many municipalities during the Victorian Era. Some argued that it provided an outlet for men's sexual release, thus protecting morally upstanding women from rape and other deviant practices. Rather than eliminate prostitution, some cities regulated it by isolating prostitutes from respectable society into segregated vice districts. In 1900, nearly 100 U.S. cities had distinct vice districts with approximately 100,000 prostitutes. "River Street"—bordered by Oneida (now Wells Street) on the south, Market Street on the east, Juneau Avenue on the north and River Street (now Edison) on the west—was Milwaukee's own "den of iniquity." In the shadow of City Hall, the district contained brothels, hotels and saloons that depended on the sex trade. Some were ramshackle places that catered to working-class clientele; others were more upscale. A late 19th-century "sporting guide" described the establishment of Kittie Williams, Milwaukee's most notorious madam, as "furnished in the most modern style, with the richest and best that wealth can provide, the ceilings and walls being richly embossed in delicate tints of harmonizing colors, with a silver and crystal finish, giving a blending effect of richness and splendor that can be seen in no other place in the city." In addition, her 12 "boarders" were the "brightest, gayest and prettiest to be found in the city." There were other rumors that Williams' brothel had 42 rooms, including a "Roman" room with marble baths, fountains and a sunken floor. Mayor David "All the Time Rosy" Rose boasted about River Street to attract convention crowds to the wide-open town. Police Chief John Janssen was not about to shut down such a lucrative enterprise, but he did try to regulate the practice. To ensure no innocent girls were forced into the "white slave" trade, Janssen required any woman who wanted to work in a brothel to report to him first. If they were experienced, Janssen allowed them to continue plying their trade. If they were not, the police chief saved them from such a shameful fate.[14]

But the tolerant mood concerning prostitution took a decided turn in the early 20th century as Progressive reformers zeroed in on it as the root cause

for the spread of venereal disease. Amid urbanization and industrialization's unsettling disruptions and fears that floods of undesirable immigrants would overwhelm and "pollute the Anglo-Saxon gene pool," medical professionals and purity advocates asserted venereal disease imperiled the very survival of white, middle-class families. Scientific discovery of the bacteria that caused venereal diseases may have caused a shift away from the belief that contracting a social disease was an individual failing, but it also made syphilis and gonorrhea more frightening because the bacteria could go undetected for years. Researchers furthermore linked syphilis to neurological decay, and doctors reported that the disease was filling mental hospitals with one-third of insanity cases. Fearing the country faced a VD epidemic (some thought the rate as high as 20 percent), medical professionals formed numerous social hygiene organizations and launched an education campaign to shed light on this seamier side of American life. They publicized VD's debilitating effects on innocent children and women and censured men who transmitted gonorrhea or syphilis to their wives, thereby robbing them of their primary roles as mothers. Despite the experts' institutionalizing the issue into the realm of social hygiene, social purity advocates still exerted a powerful influence. George Meyer, Chaplain of the House of Good Shepard in Milwaukee, decried parents' carelessness and indifference toward instilling religious values in their children, thus, giving young people free rein to indulge in immoral behavior. Religion, he argued, would "hold back the fallen from falling again and loving his or her life of shame. It will check the worse evil—the crime of the murder of the unborn."[15]

The emerging view of venereal disease as a moral and health threat to families energized reform efforts to clamp down on prostitution to eradicate the primary source of VD. Some historians argue that the emerging obsession with prostitution was a male defensive response or backlash against the economic, social and sexual freedom women gained in the decades prior to World War I. Fearing that the "New Woman" had crossed socially sanctioned boundaries, men used anti-prostitution agitation to fortify the once exclusively male public sphere. This, however, does not account for the mélange of individuals/organizations who backed the effort. Social conservatives, women's groups, suffragists, temperance workers and municipal reformers all had their own agendas they hoped to achieve.[16]

Adding fuel to the fire, Progressives pointed to huge economic losses incurred because of venereal disease. One physician estimated the annual cost to the U.S. at $3 billion, and another report estimated the cost to Wisconsin alone was $76 million per year. Between 1900 and 1916, several states and nearly every major U.S. metropolis formed vice commissions

to investigate and combat prostitution. They all delved into the reasons why women followed this sinful path. Operating from the assumption that no self-respecting woman became a prostitute willingly, reformers concluded that unsavory characters forced women and girls into the profession, giving rise to the perception that the country was experiencing a "white slave" epidemic. Despite scant evidence this type of slavery was widespread, Congress passed the Mann Act in 1910, making it illegal to transport women across state lines for immoral purposes.[17]

Milwaukee Socialists embraced the anti-prostitution/anti-venereal disease crusade. They believed both were the inevitable results of inherent inequities in capitalism that forced women to use sex to earn enough money to live. Victor Berger favored wiping out prostitution but insisted it could not be done unless women were made "economically independent, economically free....You can't do it just by having the chief of police club the poor prostitutes." When the Socialists gained control of City Hall in 1910, they hoped to institute economic changes that would correct those inequities and diminish the causes of prostitution. While they did not "club the poor prostitutes," they did launch an active campaign to shut down the still flourishing "River Street" vice district. Police records from 1911 identified 74 madams operating brothels in the city along with a total of 405 prostitutes working at various establishments. With the avid support of the East Side Advancement Association, which included downtown merchants and manufacturers, the Socialists and District Attorney Winfred Zabel successfully turned off the red lights around City Hall. To further eradicate the memory of the bawdy district, the City Council renamed "River Street" as "Edison Street," hoping to give it a more enlightened connotation. Prostitution in Milwaukee, however, did not disappear. Though Milwaukee police escorted many "shady ladies" to the train station, many remained and adapted to the new circumstances. Some (such as Kittie Williams) operated secret brothels. Others relocated to discreet establishments in the "Badlands" area on the west side of the Milwaukee River, became streetwalkers on city corners, performed in risqué cabaret shows or moved to roadhouses on the city's periphery.[18]

With prostitution and venereal disease still a threat, local and state organizations added to the nationwide wave of vice inquiries. In spring 1913, the Wisconsin legislature appointed a committee, chaired by State Senator Howard Teasdale of Sparta, to investigate white slavery and "kindred subjects." The City Club of Milwaukee conducted a concurrent study but couched its efforts as a more genteel study of "Amusements and Recreation in Milwaukee." Both ensuing reports largely blamed urban conditions for the decline in public morality. Movie theaters, burlesque shows, saloons, roadhouses, parlor houses and even "chop

suey restaurants" offered numerous opportunities for mischief, and automobiles made it easier to get to these places. The Teasdale Committee identified 269 such places in Milwaukee where "immoral practices were openly solicited and carried on." City Club members found two girls at a Milwaukee dance hall with 15 glasses of beer in front of them, competing to see who could drink the most. Two other girls sat in men's laps, and two more inebriated, underage girls were surrounded by a group of boys who were soliciting them. The girls "permitted the vilest liberties" to be taken with them. Women and men of questionable character frequented the dance halls. One city official, when asked how many prostitutes were at a dance hall, replied, "Oh, perhaps 25!" Modern dances also degraded "modesty and moral restraint." The "castle walk" and even the tango resulted in bodies rubbing together and bringing about "aggravated sex-excitement."[19]

Investigations identified a litany of reasons for the moral decay. Many girls were considered "feebleminded" or ignorant about sex, due to parental squeamishness in talking about such matters. Poverty, parental neglect or abuse and Milwaukee's overcrowded housing conditions, which afforded little to no privacy or modesty, forced many young people to find amusement and companionship on city streets. And while a moral double standard encouraged males to seek sexual encounters in order to maintain their health, economic considerations were a crucial factor that motivated many women to work in the sex trade. The average weekly salary for women ranged from $3.00 to $6.00, barely enough to pay for living expenses. The "professional" prostitute's situation stood in stark contrast. The Teasdale Committee found that 15 Milwaukee prostitutes earned anywhere from $16.75 to $44.75 per week from 1909-1910. Beyond the aforementioned issues, the City Club and Teasdale Committee identified alcohol as a pervasive and devastating influence. "Not only do we find that liquor is the immediate cause of the downfall of a very large percentage of girls," wrote the Teasdale Committee, "but also that, once they have started upon a life of immorality, they become addicted to the use of alcohol and that, when they finally become inmates of a house of prostitution, alcoholic drink is one of the chief adjuncts to their business." This connection added another powerful element to Prohibition efforts.[20]

Similar to the suffrage and Prohibition movements, World War I added a sense of urgency to the anti-prostitution cause. The military had always been linked to prostitution. It was an accepted truism that wherever men gathered as an armed force, drinking, gambling and carousing were ever-present companions. Many in the military condoned the activities, especially the carousing because it was believed soldiers needed sex to be an effective fighting force. The threat of being infected with syphilis or

gonorrhea was considered an occupational hazard. But that perception began to change with mounting evidence that venereal diseases drastically impacted an army's capabilities. In 1916, Raymond Fosdick of the American Social Hygiene Association and Dr. M.J. Exner of the YMCA conducted separate surveys of conditions among American troops along the Mexican border during the excursion against Poncho Villa. The widespread debauchery they found in military camps dismayed them. They reported to Secretary of War Newton Baker that the only way to reduce sexual temptation was to give soldiers something else to do. Baker emphasized the need to promote wholesome recreational activities in military camps, and Fosdick proposed a commission to oversee that effort. He also urged that the commission be given the added charge of keeping areas adjacent to the camps free from vice.[21]

Baker did not have to wait long to put the plan in motion. After the U.S. declaration of war, President Wilson desired that mass mobilization of military forces incorporate a moral element to produce sexually pure soldiers worthy of waging a crusade for the world's freedom. Accordingly, Baker established the Commission on Training Camp Activities (CTCA) on April 17, 1917, and he selected Fosdick to lead the organization. The CTCA developed a comprehensive plan of education, recreation and amusements to improve inductees' morality. Fosdick and other CTCA officials wanted to foster a new sense of soldierly manhood that stressed sexual purity, self-control and social responsibility. They partnered with various social organizations, such as the YMCA and Knights of Columbus, to stage athletic contests, organize camp singing, hold chaperoned dances and establish libraries and hostess houses, all to counter the allure of saloons and brothels and to promote a homogenized, middle-class American culture. The CTCA subjected soldiers to a massive educational campaign with graphic lectures, literature and educational films such as "Fit to Fight," which warned about the dangers of contracting syphilis or gonorrhea. Soldiers who succumbed to temptation and became infected were compared to "slackers" or "moral shirkers" because they were not healthy enough to fight with their comrades.[22]

If education and rational persuasion—methods near and dear to Progressives' hearts—did not change soldiers' behavior, then more direct, repressive steps were in order. Congress gave the CTCA coercive ability by inserting riders in the Selective Service Act that prohibited alcohol and prostitution within a five-mile zone around all military installations. For military officials, the need to enforce these conditions was revealed shortly after the first wave of recruits was inducted. In October 1917, Surgeon General of the Army W.C. Gorgas complained that venereal disease was a leading cause of disability in the armed forces. In the first year of the draft,

he recounted, the number of cases of venereal disease on military sick reports was 71,955, and the total number of lost days in military hospitals was 875,553 or 2,399 years.[23]

This unsettling disclosure induced Congress to sanction anti-prostitution efforts, giving the CTCA carte blanche to quash the threat. Early in the war, the concern regarding venereal disease morphed into the idea that prostitutes were German "weapons," deliberately or unwittingly infecting American soldiers to aid the enemy. Not everyone subscribed to this theory, but all agreed on the risks prostitution posed. Field agents worked with military and local law enforcement to shut down 116 red light districts across the country during the war. In their zeal to cleanse military zones, CTCA reformers resorted to sweeping and unflattering characterizations of women. They were considered either morally pure or whores, and the whores were defined broadly as any woman or girl who had sex outside marriage—not just those who accepted money for sex. The CTCA simplistically equated women with loose morals as prostitutes; ergo they had a venereal disease and had to be isolated from military forces and respectable society. There seemed to be little concern for due process. Major Wilbur Sawyer of the Medical Reserve Corps believed it would be better to "eliminate as far as possible legal machinery in the establishment of quarantine for venereal diseases." It was unfortunate, he noted to Milwaukee Health Commissioner Ruhland, that a 1917 Wisconsin law concerning venereal diseases mentioned pardons with regard to people isolated for health reasons and not imprisoned for committing a crime. Sawyer knew it was "exceedingly difficult" to distinguish clearly in venereal disease cases between health and penal measures, but it was a well-established method of handling communicable diseases.[24]

CTCA agents quickly found they had more to contend with than "professional prostitutes." Many young women flocked to military camps to find excitement, adventure or love. Enamored with men in uniform, these "charity girls" or "patriotic prostitutes" as they were called accepted dinners or gifts for sex. This "girl problem" was especially troubling because many came from middle-class backgrounds. The CTCA established a separate Committee on Protective Work for Girls in September 1917 to educate mothers and daughters about the dangers the war posed to their health and purity. Girls also were urged to be careful in their dress and deportment so as not to arouse the sexual passions of soldiers. Failing that, the CTCA hired 150 female protective officers to patrol the military zones and city streets to apprehend wayward girls and return them to their homes.[25]

For all of its efforts, the CTCA had little immediate impact for it did not eliminate the sex trade. As in Milwaukee, resourceful prostitutes

nationwide simply relocated or changed their methods of soliciting customers, operating as streetwalkers or in cheap hotels, saloons or cafés. In addition, rates of venereal disease in the military remained high. Major William Snow, a respected physician and general secretary of the American Social Hygiene Association, claimed the unacceptable situation stemmed from the fact that nearly one-third of inductees had a venereal disease *before* joining the army. It became clear to CTCA officials that the fight against prostitution would have to expand beyond areas around military installations to become a truly national campaign to eliminate this moral blight from American society. They reached out to state and local officials and citizens' groups to launch anti-vice propaganda campaigns and pass social legislation. Widening the campaign's scope resulted in mass arrests, quickly filling local jails and workhouses. Social hygiene experts clamored for the establishment of detention houses and reformatories where girls could be tested for venereal disease and a scientific plan (i.e. moral regeneration) for their futures devised. Few states had adequate facilities, and President Wilson authorized $250,000 in February 1918 for that purpose. In July, Congress upped the ante with the Chamberlain-Kahn Bill, which provided $1 million to build new or update existing reformatories.[26]

With only one military camp within its borders, Wisconsin was not heavily involved with the first phase of the CTCA's anti-venereal disease campaign; however, Secretary of War Baker informed Governor Philipp in late May 1917 that the CTCA's mission could not be fulfilled without the cooperation of local authorities either in communities located near a camp or serving as transit points for large numbers of military personnel. Baker urged the governor to do all he could to arouse cities "to an appreciation of their responsibility for clean conditions" and make sure vice-related laws were enforced in those communities, actions Philipp was more than happy to take. Indeed, the state legislature had already taken steps to address the issue. On May 17, 1917, it passed a law declaring anyone afflicted with gonorrhea or syphilis a "menace to the public health." Physicians were required to report infected patients to the State Board of Health, and if those infected refused treatment, the board could have the individual committed to a county or state institution for treatment until the disease was no longer communicable.[27]

Milwaukee's proximity to the Great Lakes Naval Training Station across the border in Illinois concerned military and city officials as well as reform-minded organizations, and they also addressed the perceived social crisis. In November 1917, the State Council of Defense circulated an appeal in support of a YWCA fund raising drive to protect the health and morals of women crowding into industrial areas as well as the "plastic

girl between TWELVE AND TWENTY, susceptible to any influence, with an erratic and dangerous conception of patriotism." Concurrently, the Milwaukee Social Hygiene Society announced plans for an educational campaign to discuss the "peril to our young womanhood" as well as a determined campaign against venereal disease in army camps and among civilians. Julia Kurtz, a founding member of the society and the head of the Martha Washington Home, told the *Milwaukee Leader* that the group meant to carry on its work "without impairing modesty." She invited adults to a December 11 meeting to hear lectures from authorities about the grave situation. "In this regard we shall have to start calling a spade a spade and look a tremendous evil squarely in the face," she said. At the meeting, Dr. T.L. Harrington discussed the government's program to stamp out venereal disease and used lantern slides to graphically illustrate VD's "ghastly" effects. In addition, plans were announced to host a lecture in January for Milwaukee women and girls by Dr. Rachelle Yarros, a renowned sexual health advocate and co-founder of the American Social Hygiene Association.[28]

City officials also adopted measures to deal with the spread of venereal disease. Since 1916, the Health Department had posted placards around the city with warnings about the dangers of contracting syphilis or gonorrhea and offered its facilities for free consultations. In November 1917, the Common Council pushed things forward. It introduced, and eventually passed, an ordinance directing the health commissioner to post notices in public restrooms, informing people infected or who believed they were infected that they could apply to the Health Department for a lab test as well as a consultation. Sometimes, however, the department took more forceful measures. Commissioner George Ruhland acknowledged in January 1918 that, on occasion, the department confined diseased patients to Milwaukee's contagious disease hospital and would continue to do so until the infection had cleared up. But, he stated, there was "considerable difficulty in generally applying such management towards the diseases in question." It is unclear whether the carrot or stick approaches had any measurable impact, but a U.S. Public Health Service report estimated that the venereal disease rate among the second million men drafted into the military stood at 5.4 percent, while Milwaukee's was 2.55 percent—ninth best among cities of 100,000 to 500,000 residents.[29]

Perhaps the low disease rate allayed any fears Mayor Hoan may have had that a crisis existed or perhaps he resented federal intrusions into local civil matters; regardless, he provided a desultory account of steps the city had taken to control venereal disease. In March 1918, Hoan reported to the Medical Board of the National Council of Defense that Marquette University had established a clinic, and the Milwaukee Social Hygiene

Society had presented a few lectures. But beyond the Health Department posting placards and offering free advice, Milwaukee had no provision for committing diseased individuals to local institutions or for isolating or treating those individuals in public institutions. Dr. Franklin Martin of the Medical Board was not impressed. Milwaukee's provisions for combating venereal disease, he wrote, were "still very inadequate."[30]

Others certainly felt the same and were determined to carry on the fight with or without Hoan's support. In May 1918, the presidents of several women's groups voiced their concern that, after the restricted zone surrounding the Great Lakes Station had been cleared of vice, "inhabitants came to Milwaukee." The women unanimously demanded there be an "intensive campaign to root out these women of questionable character and to purify home and camp conditions." An intensive campaign is exactly what ensued. The Milwaukee Police Department's "morals squad," the Health Department, the Department of Justice, military police and CTCA officials collaborated to sweep the menace from the city's streets. Women arrested on disorderly conduct charges were interrogated by the Department of Justice and then tested for venereal disease by Major Harry Bradley, the police department surgeon. If there was no evidence of syphilis or gonorrhea, the women were fined, usually $10 to $25, and released. If they were infected, they were detained until the disease was no longer communicable.[31]

The campaign escalated in fall 1918. In October, Lieutenant Martin Fritman, provost general at the Great Lakes Station, posted a naval patrol in Milwaukee, but they found no undesirable characters coming from Chicago. In fact, Fritman relayed to the *Sentinel* that "Milwaukee may well be proud of its clean environment." But that assertion rang hollow when news broke that two women enticed 17-year-old Elizabeth Arnold to a roadhouse on Blue Mound Road, where she was held "prisoner" for a week until being rescued by Milwaukee detectives. The two proprietors of the roadhouse were charged with operating a "house of ill fame," and the two women were charged with vagrancy.[32] The case insinuated that the situation in Milwaukee was serious enough for the CTCA to dispatch Roger Flanders in early November to investigate. He found the problem in Milwaukee was "almost entirely a week-end one" as some 1,500 to 2,000 Jackies from the Great Lakes Station flocked to the city. Flanders met with various business groups to secure their cooperation in the anti-vice campaign. The Milwaukee Hotel Men's Association, Brewers' Association, Wholesale and Retail Liquor Dealers' Association and any grocers, department stores and drug stores that sold alcohol agreed to stop selling bottled liquor between 6:00 p.m. Friday and 6:00 a.m. Monday. They also agreed to refuse to deal with anyone they suspected of obtaining liquor for

immoral purposes. Lastly, saloon keepers assured Flanders they would not sell any bottled liquor that was not consumed on the premises.[33]

These measures helped, but liquor was only part of a bigger problem. Flanders noted that, fortunately for military men, Milwaukee had no segregated vice district; nevertheless, prostitutes were easy to find. An abundance of private flats was available for illicit liaisons, numerous streetwalkers openly solicited men and city taxi drivers helped procure prostitutes for men. Equally disturbing to Flanders was the continued inadequacy of the city's provisions to fight vice. He complained to his superiors that Milwaukee still had no detention home, and one was "very much needed." Law enforcement authorities had to use the House of Correction "which does not want female prisoners" and had no medical equipment, the Isolation Hospital which did not "welcome venereal cases," and the Milwaukee County Hospital which had the medical equipment "but no means of detention if girls want to escape." Still, law enforcement detained diseased girls "on pure bluff." Flanders declared to a *Journal* reporter, "The thing must be got at where it starts—on the street." Milwaukee police made commendable efforts, but "these efforts must be pushed to the point of extinction." He secured promises from state, county and city law enforcement officials that they would increase efforts to "patch up the weak spots."[34]

Even the end of the war did not interrupt the government's crackdown. The police department's morals squad made a splash on Armistice Day when it arrested nine "taxi workers" who frequented a café on Sixth Street. Once they received money from the prospective client, they would take a taxi out to the country or to a roadhouse. The nine were charged with disorderly conduct and each fined $10 plus court costs. Despite this victory, several influential religious and civic leaders declared vice conditions in Milwaukee were "deplorable." Judge George Page complained that Milwaukee taxi drivers circulated cards in small towns across the state with the invitation, "When in Milwaukee, call for Driver No. ____, and be assured of a good time." And Pearl Micel, director of the Big Sister movement, protested, "One week we had as many as thirteen [girls] brought back from training camp communities, all of whom were first offenders."[35]

Police Chief Janssen and District Attorney Zabel vehemently denied the situation was as bad as was being claimed, more than likely because they were aware of the full extent of the anti-vice campaign. The rest of Milwaukee found out on December 15 when the *Milwaukee Sentinel* "revealed for the first time" the operation's far-reaching scale. Police Surgeon Harry Bradley told the *Sentinel* that the federal government wanted the stringent measures kept from the public "for definite reasons."

He outlined procedures through which any woman arrested for vagrancy or disorderly conduct was quarantined, tested for venereal disease and held without bail until she was deemed cured. During the preceding year, law enforcement officials had arrested more than 600 women, most of whom suffered from a venereal disease. The "cured" who were not from Milwaukee were sent home, and some of the infected were still being held.[36]

This scene played out across the country. All told, more than 15,500 women (most of whom were young, poor and poorly educated) were arrested and detained throughout the course of the war, and law enforcement was not always careful about whom they snared. A postwar government study of 6,000 detainees found that only 49 percent were professional prostitutes. The remainder were women suspected of loose morals. Overall, only one-third of women detained during the war were charged with prostitution. Thus, the anti-prostitution campaign was another example of government officials resorting to unconstitutional means to conduct the war. Women did not have to commit a specific crime. They could be arrested based on the flimsiest hunches that they were sexually promiscuous. Moreover, the Wassermann test used to determine if a woman was diseased gave many false positive results because it produced positive readings for 21 infectious diseases, not just syphilis and gonorrhea. And the arsenic and mercury treatments used to cure infected women were not only toxic but could also be fatal. The entire program reinforced the double standard of punishing women but not men for sexual behavior.[37]

Not everyone supported the anti-prostitution campaign. Feminists rebuked the policy precisely because it was directed solely at women and men received no comparable punishment. The examination procedure, they asserted, was offensive and an assault on personal liberty. Many attorneys and even some court officials criticized the government's indiscriminate incarceration of working-class, unemployed or unescorted women and holding them without access to an attorney.[38] But the combination of military necessity, patriotism and public health needs drowned out the protests and the campaign proceeded unabated.

Indeed, the anti-vice drive continued even though its immediate military necessity ended with the signing of the armistice. As the war wound down, the Interdepartmental Social Hygiene Board (ISHB)—a combination of military and civilian departments—assumed control of the CTCA's anti-vice effort. The ISHB justified continuing the fight because, if the twin evils of prostitution and venereal disease jeopardized military efficiency during wartime, they presented a "constant menace to the whole population in times of peace." With the $1 million budget from the Chamberlain-

Kahn Act, the ISHB sponsored scientific research that set standards for identifying and tracking venereal diseases as well as for developing more accurate descriptions of the diseases' symptoms. It also continued to work with state and local agencies to isolate infected women and push for new social laws, such as age-of-consent and anti-fornication laws.[39]

In the immediate post-war period, the Wisconsin legislature passed laws that added chancroid to the list of venereal diseases, reinforced provisions to quarantine and examine infected women, required physicians to report venereal disease cases, and prohibited the sale of drugs to treat VD without a physician's prescription. And the State Board of Health established a Bureau of Venereal Diseases on January 1, 1919, to coordinate education programs, advise state legislators and distribute supplies to hospitals and 15 statewide clinics.

At the local level, Harry Bradley urged Milwaukee to stay the course. It was vital, he told the *Sentinel*, that the work persist: "If this city is to have a future generation of which it will be proud this plague must be fought tooth and nail. If the government has seen fit to go into the fight to such an extent to protect its men in uniform, surely this city should safeguard its own people by following the methods used by the government."[40] Local officials took Bradley's message to heart. At the federal government's urging, they continued to arrest "women of doubtful reputation" to prevent them from mingling with discharged soldiers returning to Milwaukee. Mandatory testing also was established practice by this time. George Ruhland and the Health Department led the city's other efforts to deal with the challenge. Ruhland asked for, and the City Council authorized, a $30,000 fund to establish a downtown clinic to treat military personnel. Within two years, Milwaukee counted a total of four health clinics. Ruhland and Harry Bradley helped form a committee to press the state legislature to pass a more stringent quarantine law, among others. The committee was also charged with formulating plans to protect the returning soldiers' health. Lastly, Ruhland argued for the construction of separate facilities at South View Hospital (formerly called the Isolation Hospital) on Mitchell Street and 19th Avenue (now South 24th) to treat VD patients.[41] This last measure illustrates that the harsh attitude toward "wayward women" that crystallized during the war lingered well beyond the armistice. Ruhland's plan was to have a building "entirely separate from the rest of the hospital" and preferably constructed "at the rear of the present east wing." It should have "barred windows to properly house the inmates suffering with these diseases, for the reason that it is necessary usually to keep them under strict surveillance and restraint, from communicating with the outside world."[42]

Without the energy from the war effort, this prevailing attitude drained the nation's support for the social hygiene campaign. The League of

Women Voters indicated it would support efforts to halt syphilis and gonorrhea, but only if measures were applied equally to men. After time allowed war-time passions to subside, even state legislatures questioned some of the ISHB's proposed laws.[43]

The war's three great social experiments produced mixed results at best. Only the suffrage movement did not compromise individual rights or economic prosperity, but because suffrage, Prohibition and moral purity campaigns were so intertwined, even the suffragists' legacy was somewhat tainted. No matter how well-intentioned, few actions emerged unblemished from the war's super-heated environment. That was only one of the war's distressing aspects.

13

> I'll tell what you got out of this war. You lost your liberties. About 700,000 spies were watching you. Men were arrested for saying things to their neighbors. This was not a war to make the world safe for democracy. Well you got prohibition and 'flu', all you got out of this war, prohibition and 'flu'.
>
> <div align="right">Victor Berger, speech, ca September 1919[1]</div>

Shortly after New Year's Day, 1919, William George Bruce rejoiced that peace had returned. "The carnival of destruction is ended," he wrote. After tallying the conflict's horrific human cost, he bemoaned, "What a commentary on civilization! What a crime against Christianity!" He also pointed to the alarming increase in divorces and swelling criminal statistics as evidence that the war lowered social and moral standards. "The only consolation that can come to us here," he mused, was "found in the thought that a better world may grow out of the great conflict, and that the generations of the future may profit by the lessons of war and weld the nations of the earth into a compact of everlasting peace."[2] Bruce must have been sorely disappointed with what actually happened.

The euphoria that erupted with the armistice failed to quell the anger, hysteria and bitterness that sprouted during the war. Indeed, those emotions received a new burst of energy, with the rise of the "new Satan" of Bolshevism replacing the "Old Devil" Kaiser. As a result, a profound disillusionment enveloped many Americans. Erich Stern lamented in late November 1918 that his sense of nationalistic patriotism had been "blotted out in me; perhaps only eclipsed?" He felt "like a member of a despised & downtrodden, almost enslaved, race in a country that was once its very own, and now seems half foreign." German-Americans had to "fight the battles of our masters & to pay for their wars, but we are not safe from the dirtiest insults from the dominating race or from the lesser

racial groups who have for the time being been flattered & coddled into turning on us too."[3]

Some Milwaukeeans advocated for post-war tolerance toward their German-American neighbors. Patrick Cudahy, owner of the meatpacking plant, wrote to the *Sentinel* shortly after the armistice. Now that peace was assured, he implored Milwaukeeans to "quit the propaganda of hatred, and begin a propaganda of kindness and love." It was proper to demonize the enemy during war if you wanted "a lot of men to kill another lot of men," but now that the killing was over, Cudahy wrote, "let us quit this yapping parrot talk about the cruelty of the Germans. We have made ourselves offensive to a lot of very fine people in this country." Believing German-Americans should not be made to suffer for the acts of egotistical political/military leaders, he concluded that German people were "like all other people—some good and some bad." Three weeks later, Cudahy again wrote the *Sentinel*: "I certainly started something when I wrote that 'love and kindness' letter." He acknowledged that he received a few supportive letters, but most were not so complimentary. One writer called him a "Mick" and asked if he was trying to increase his "sausage trade." While Cudahy wrote his initial letter on impulse, he had no regrets for what he said. "There should be no place in an American's heart for hatred," he chided, and if abusing Germans was patriotism, it was "of the cheap vulgar kind." As a supposedly Christian nation, Americans should pray to God to forgive our trespasses as we should forgive those who trespass against us. "Do we forgive," he asked, "or are we hypocrites?"[4]

Forgiveness was far from the minds of local patriots, evident by the anti-German and anti-Socialist sentiment that lingered long after the war concluded. In February 1919, the acting company at the Pabst Theater decided to stage plays in German to raise funds in support of destitute actors and actresses. Pabst Manager Franz Kirchner thought, with the war over, resuming plays in German would not cause any problems. The move, however, raised howls of protest from various civic groups. The board of managers of the Wisconsin Society of the Sons of the American Revolution, for example, denounced the plan because the stock company was composed of German enemy aliens "to whom we owe neither support nor assistance at this time." Because the U.S. was technically still at war with Germany—no peace treaty had as yet been signed—and the German language was the means through which the enemy prosecuted the war in Europe and carried out espionage in America, the board felt staging plays in German would be a "source of reproach to us by the true Americans of the other cities and states of the Union" as well as a "source of humiliation to our brave soldier and sailor boys who return from their heroic fight against our German enemies."[5]

A meeting was held at the Hotel Pfister on February 15 to give the general public the opportunity to voice its opinions on the matter of German language performances. James Stover, leader of the flying squadrons during the fall Liberty Loan campaign, chaired the gathering. He wondered why it was necessary to have a benefit performance "for a great lot of alien enemies that have been living on this community here and none of them have a right to be here, except that we have allowed them to be here." Why, he asked, could they not have worked in Milwaukee shops or factories for high wages? He added that they "loll around here and drink their beer and talk their language and help to carry on propaganda of Germanism here in Milwaukee and then ask us to give a benefit for them in their own language, that they may have some money with which to live a little longer." Every shot fired at his sons in France, Stover charged, was ordered in the German language. His blood boiled "at the idea that this miserable language in this country should be assisted" and steps should be taken to stop the Pabst Theater's plan. The resolution adopted at the meeting mimicked that of the Sons of the American Revolution. Frank Hoyt of Milwaukee was the only one to object. Amid boos and cat-calls, he argued that most German-Americans were loyal to the U.S., and many had served in the military; trying to force Americanism upon them "with a club" would fail. He pleaded for the crowd to "think calmly before you throw such a fire brand as these resolutions will be into this city and into this state."

Roger Sammond, a member of the 32nd Division, asked if the men of the 32nd heard Milwaukee was "starting up speaking German and starting more German-Americanism, what do you think they will say after all they have gone through?" To the enthusiastic cheers of the crowd, he concluded, "I think something more active than a protest ought to be done about it." Captain Russell Johnson also rebuked Hoyt and blamed the "other side of the fence" for starting the fire brand. Why did they have to put on a German play in the German language? Johnson warned that if protests like this were not sufficient, men and women so nauseated by the situation would themselves act. "That," he said, "is where the fire brand is coming from." No one should be so foolish to think the American people would not protest a German theatrical performance while American boys were still in France. "It is just truly rotten, that is all." The resolution received only two dissenting votes, and a copy was presented to the theater company's board of directors. In view of the numerous protests, the board recommended the actors postpone the benefit until a formal peace between the U.S. and Germany had been reached.[6]

Nearly a year later, animosity toward all things German remained in full force. In October 1919, a band of soldiers pointed a canon toward

the Pabst Theater to protest the staging of another play in the German language. Clearly, the war-time hysteria provoked a deep-seeded change in the city's cultural and built landscape. Strident demands for 100 percent Americanism overwhelmed Milwaukee's distinctly German stamp, as businesses, schools, organizations and even families changed names. German theater, music, literature and the teaching of the language succumbed, never fully recovering.[7]

Dan Hoan and fellow Socialists likewise experienced suspicion and scorn after the war ended. On January 11, 1919, Hoan spoke at a Socialist rally and condemned Victor Berger's trial and conviction. An agent from the Military Intelligence Division noted the meeting was rife with "much talk of a loose nature," and one speaker urged that "'the people' arm themselves in any manner possible." That statement caused the agent to recommend the immediate removal of 1.5 million grenades stored at the Briggs Loading Company plant. The storage of explosives at the Briggs factory was widely known and caused "considerable uneasiness to agents and officers of the various local Government offices as well as to some of the conservative citizens of Milwaukee." It was suggested that the weapons be relocated to an arsenal or other location "where their presence will not constitute a potential menace to the community."[8]

Hoan's participation in the Socialist meeting sparked concerns of another sort. The mayor was part of a committee of leading citizens who planned a series of homecoming celebrations for Milwaukee's returning veterans. The first was slated to be held at the auditorium on January 18, 1919. Hoan and Governor Philipp were to be the keynote speakers, but a few days before the event, the *Journal* protested the mayor's involvement because of his role during the earlier rally. Military Intelligence Agent John Ferris and a group of U.S. Army officers also met with Hoan and demanded that he resign from the reception committee, charging that he had derided the government, the Constitution and the courts. Hoan denied the accusations and refused to step down. The mayor explained that he had attended the rally to protest a policy that set aside the Constitution and punished people for expressing their honest opinions. He added that the committee had selected him as chairman, and he would step down only if requested to do so by the committee. Ferris sputtered that it "was easy to pack such a committee with a bunch of pro-Germans and hangers-on." Hoan countered that the Military Affairs Committee of the County Council of Defense had picked most of the members, who had proudly supported the war effort. The officers threatened to stage a separate rally if the mayor did not resign, to which Hoan replied that he would gladly do anything he could to make their celebration a success. At that point, Ferris and the others departed, no doubt determined to prevent Hoan from greeting the troops.

On the day of the gathering, the pressure on Hoan mounted. Pastor Paul Jenkins of Immanuel Presbyterian Church, who served as chaplain for Base Hospital 22 in France, resigned from the reception committee. "I have no alternative," he wrote, "but to feel that, in the light of certain recent events in our city, I cannot in honor serve on this Committee as at present constituted." At the auditorium that evening, Hoan, Philipp and other members of the committee entered the stage from the wing at 8:45. A mixture of cheers, hisses, whistles and cat-calls from the capacity crowd greeted them. After a brief concert, 1,500 soldiers, sailors and marines filed into the main hall. As Hoan stood to welcome the servicemen, the *Journal* reported Captain R.J. Sercombe stepped forward on the stage, raised his hand and demanded the mayor stop "in the name of the cause for which the boys had fought overseas." At that, the crowd "hissed and howled, shouted and whistled, stamped and sang." Sensing the futility of the moment, Hoan returned to his seat. The band struck up the "Star Spangled Banner," after which Governor Philipp addressed the throng. Following Philipp's speech, cries and threats came from the soldiers to have Hoan forcibly removed from the stage. Nothing transpired, however. Years later, Hoan called the occasion the "most exciting meeting I ever attended." "If anyone had exploded a firecracker in that hall...there would have been a panic and maybe some shooting...But I stayed on and presided."

The gathering was equally exciting for the soldiers, but for a different reason. "A more fortunate meeting," declared Captain Sercombe, "could not have been held." The servicemen appreciated the homecoming and were glad to know the people supported them while they were away. "But best of all," Sercombe related, "the disloyal element in Milwaukee knows from now on the American spirit in Milwaukee is going to assert itself. We are not going to keep silent any longer. We are to call the bluff of any man who attempts to kill the true spirit of Americanism that rules among the thinking people—the big majority in Milwaukee."[9]

Sercombe apparently forgot not only how the "big majority in Milwaukee" re-elected Hoan mayor the previous year but also all the work Hoan did in support of the war with the Council of Defense. The combative mayor no doubt wanted to lash out at his critics, but he took the high road. He issued a statement the following morning, expressing his pleasure that the large gathering of citizens and returning soldiers made the reception such a "grand and remarkable success," though he regretted he did not have the privilege of welcoming the returning soldiers. He blamed the uproar on the "false and vicious statements" spread by the press, but he was proud he performed his duties as chairman to the best of his ability.[10]

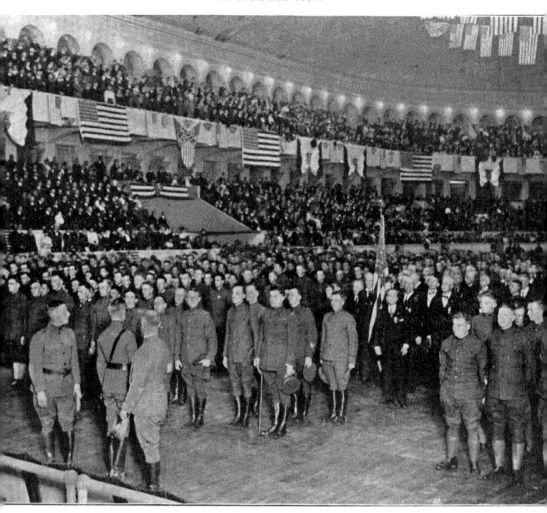

Homecoming for returning Wisconsin soldiers at the Milwaukee Auditorium, January 1919. The soldiers booed Mayor Hoan from the stage, a stark example of the lingering bitterness toward those who opposed the war. (Photo from *Doings in Grain at Milwaukee*, February 1919, Milwaukee Grain Exchange Collection, Milwaukee County Historical Society)

The non-stop political pressure during and after the war weakened the Socialist Party and altered its very nature. The defections of A.M. Simon, Winfred Gaylord, et al, fractured any sense of unity within Berger's reformist wing. The rise of a more assertive radical wing, which was closer to the IWW and the Bolsheviks, further tarnished the party. Despite Berger's condemnation of Soviet-style Communism, government and patriotic opponents lumped the conservatives and radicals together into a monolithic post-war bogeyman. In December 1918, Milwaukee's resident Military Intelligence Division agent did not believe Bolshevism gained much ground in Milwaukee. Only "isolated rumors of a vague nature" from unreliable sources offered hints this dangerous "ism" was present.

But most who followed such matters believed the Bolsheviks would conceal their extreme principles "under the more conservative cloak of Socialism." Thus handicapped, the conservative reformers among the Socialists never recovered their pre-war dominance, and Berger himself became a peripheral figure. He could only watch his life's work crumble. The radicals left the Socialists in September 1919 to form the Communist and Communist Labor parties, reducing the number of dues-paying Socialists by 75 percent. The nation's growing unease concerning Communism erupted in a "Red Scare" during 1919-1920. Starting in November 1919, the Department of Justice launched a series of raids to squash radicalism in the U.S. Milwaukee was a part of the most extensive raid on January 2, 1920. Police and government agents rounded up more than 40 suspects who believed in "rabid, red Bolshevism."[11] Despite the setbacks, the Socialist Party was not completely dead. Berger served in Congress until 1928, and Dan Hoan occupied the mayor's office until 1940, but as historian John Gurda described, the "grandiose visions of the cooperative commonwealth vanished into the inhospitable air over postwar America."[12]

Milwaukee's labor movement—closely tied to the fate of the Socialists—also suffered. The war made concrete gains for labor possible, including the right to organize, higher wages and an eight-hour work day. The Federated Trades Council and union workers, however, complained the increased salaries barely outpaced the soaring cost of living. In view of the enormous profits reeled in by Milwaukee factories (roughly $740 million in 1918 alone), labor pressed management to raise wages even more and resorted to work stoppages when deemed necessary. There were 54 strikes in 1918, but they involved a relatively minor number of workers. For the most part, city workers honored the no-strike call of the federal government and did not disrupt vital production of goods for the military. A growing segment within the unions adopted a more patriotic mindset, thanks in no small part to the efforts of Samuel Gompers and the American

Federation of Labor. This trend cracked the once formidable bond between union workers and Socialists. At war's end, Milwaukee industrial workers insisted they had fulfilled their full duty during the emergency and were in no mood to backtrack now that peace had come. Milwaukee manufacturers were just as determined to reassert their pre-war status. They and other state employers united in a new open-shop offensive. Calling it the "American Plan," they not-so-subtly linked union activity with the fear of Communist revolution. With the federal government's enthusiastic support, Milwaukee's industrial barons used lockouts, boycotts, injunctions and labor spies to prevent closed union shops and deflate labor's assertiveness during the 1920s. Union membership in Milwaukee declined from a high of 35,000 in 1920 to 20,000 in 1932. Labor's activism was not revived until the economic devastation of the Great Depression.[13]

Though women's part in unionized labor was minimal, their work in Milwaukee's factories was vital to the city's war-time production, and they received abundant praise from employers. Evinrude Motors had 200 women working in its plant, and Superintendent E.P. Gleason tipped his cap to them: "They do more work and are steadier than men." Stephen Briggs, president of the Briggs & Stratton Company, lauded, "We find women labor mighty satisfactory all the way through....They show up better Monday mornings, are more ambitious and will stick to a job better."[14] By and large, women received the same wages as men, and many were grateful for the opportunity to be in the workforce. Hattie Kingdom, a 63-year-old woman who operated a lathe for Evinrude, found machine work more interesting than her previous job working on a loom at a textile plant, and the higher pay was even more incentive to stick with it. Her colleagues Anna Steche and Vera Hovey echoed Hattie's sentiment.

Despite their preferences, the tributes to their patriotism and the quality of their work, women were typically the first to be laid off once the federal government terminated contracts shortly after the war ended. Most bosses, men in the shops and government officials expected women to go back to their pre-war jobs or socially sanctioned roles. Milwaukee factories dismissed an estimated 2,000 female workers by the end of 1918. Several rationales were offered to justify the trend. "Outwardly there would seem to be no special reason why woman should not retain the industrial independence which she had gained," wrote an MID agent in Milwaukee. "Actually, however, there arises the question of her physical ability to withstand the wearing life of the factories and the effect of these unusual physical efforts upon the next generation." Ellen Sabin, president of Milwaukee-Downer College, felt pride in the "ability that women have shown in this crisis to meet unaccustomed demands." "But let the truth

never be obscured," she added, "that the essential work of the home, the physical and spiritual care of its members, the conservation of all we really value, is woman's distinctive work. If this responsibility is neglected, what does anything else avail?" Given these widely accepted sentiments, many women could not have been surprised when they were laid off. Some returned to their former lives willingly, others grudgingly, but some protested loudly. Though women gained little that lasted for themselves, they smoothed the way for the next generation of Rosie the Riveters who would answer the country's call.[15]

Victor Berger narrowed the end results of the war to Prohibition and flu, but in truth the conflict had many and widely divergent consequences. On one hand, power, which was "widely dispersed and shared" prior to the conflict, was organized and concentrated in the hands of the government after the war. It also accelerated the concentration of wealth in the hands of fewer people. On the other hand, the war's feverish repression gave birth to the modern civil liberties movement. That welcome development aside, the post-war failure of President Wilson's peace efforts, widespread race riots and labor unrest, the frightening specter of Bolshevism, the onset of Prohibition, and foundering of Progressive ideals all contributed to a sense that the war that was supposed to "make the world safe for democracy" and "end all other wars" accomplished neither.[16]

Erich Stern offered a stark and bleak summation of this derailed crusade. In early January 1919, he learned of Victor Berger's conviction and wrote, "After all the perversion & inversion and destructive acts striking at everything that America has meant in the past—after all that I still found a further capacity for intense shame, deep humiliation, & an immense bitterness born of injustice and wrong." As he walked home in the frigid night, he passed by the Elks' Clubhouse. A light from the building illuminated in "flaming brilliance" a large American flag that fluttered in the biting northwest wind. Seeing the flag, a symbol he had worshipped his entire life, so unexpectedly made him "for an instance recoil and it but added to the revolt which was surging in my soul."[17] For all the sacrifices, anxiety, acrimony, patriotism, and hysteria, the supreme disillusionment with American democracy was the bitterest fruit of Milwaukee's—and the country's—crowded hour.

END NOTES

ABBREVIATIONS USED:

AMA: Archdiocese of Milwaukee Archives
LOC: Library of Congress
MARC: Milwaukee Area Research Center
MCHS: Milwaukee County Historical Society
MPL: Milwaukee Public Library
MUA: Marquette University Archives
RG: Record Group
WHS: Wisconsin Historical Society

INTRODUCTION

1 "Charity Bazaar is Ready for Opening," *Milwaukee Sentinel*, March 2, 1916; "12,000 See War Relief Bazaar Opening," "Unique 'Garten' Delights Public," "Visitors are Many at Alt Heidelberg," "Stern Dedicates Huge Iron Cross," ibid., March 3, 1916; "Carnival Spirit Reigns on Last Night of Bazaar," ibid., March 8, 1916; "Crowds at the Bazaar Overflow the Streets," *Milwaukee Journal*, March 5, 1916; "Midnight Sees End of Bazaar," ibid., March 7, 1916; "Bazaar Ends in a Whirl of Fun," ibid., March 8, 1916; "Bazaar Draws Capacity Crowd to Auditorium," March 3, 1916, in Milwaukee Features Clippings File - "Bazaar," MCHS; John Gurda, *The Making of Milwaukee* (Milwaukee, WI: Milwaukee County Historical Society, 1999), 222; John Joseph Starzyk, "Milwaukee and the Press, 1916: The Development of Civic Schizophrenia," (M.A. Thesis, Marquette University, 1978), 9-13.
2 "Legion May Bar German Plays in Milwaukee," *Milwaukee Journal*, October 30, 1919; "City to Get Gun Legion 'Captured,'" ibid., October 31, 1919; William George Bruce, *I was Born in America: Memoirs of William George Bruce* (Milwaukee: The Bruce Publishing Company, 1937), 297-300.
3 Harvey W. Getzloe, "Milwaukee's Honored Dead," *Milwaukee Sentinel*, February 23, 1919.

CHAPTER 1

1. Bruce, *I was Born in America*; "Milwaukee's Grand Old Man," *Milwaukee Journal*, March 17, 1946.
2. William George Bruce, "Milwaukee: A Great Industrial City," in *Wright's Directory* (Milwaukee: Wright Co., 1916).
3. Christopher Chan, "Mass Consumption in Milwaukee: 1920-1970," (Ph.D. Dissertation, Marquette University, 2013), 26-27, 167-72; Carl F. Purin, "Random Notes at Eighty," Unpublished manuscript 305, MCHS, 16, 22-23.
4. Ibid., 18-19, 25-27; Ewald E. Bethke, "The Memoir of Ewald E. Bethke," Unpublished manuscript 599, MCHS.
5. "Horses and Mules Take a Fall, but Automobiles are Climbing," August 29, 1916, Milwaukee Features Microfilm, MCHS, Roll 387; "Automobiles," *Annual Statistical Report by the Assessor of Incomes*, 1916, Milwaukee County, Assessor Collection, MCHS, 14, 22.
6. Lulu Bredlow, "A History of the German Theater of Milwaukee from 1850 to 1935," (M.A. Thesis, Northwestern University, 1936), 64; Matthew J. Prigge, *Outlaws, Rebels, & Vixens: Motion Picture Censorship in Milwaukee, 1914-1971* (Milwaukee: Conway Street Press, 2016), 5-25; Larry Widen and Judi Anderson, *Silver Screens: A Pictorial History of Milwaukee's Movie Theaters* (Madison: Wisconsin Historical Society Press, 2007), 49, 56-61; "Movie Houses are in Danger of Too Much Popularity," *Milwaukee Journal*, January 12, 1914; "Takes Out Film," ibid., January 19, 1914; *Amusements and Recreation in Milwaukee: A Bulletin of the City Club*, 1914, in City Club of Milwaukee Collection, MARC, Box 55, File: Printed Publications; G.R. Radley to Mayor-Elect Dan Hoan, April 7, 1916, and Annual Report of Motion Picture Commission for 1916, both in Daniel W. Hoan Collection, MCHS, Box 4, File 124.
7. H. Russell Zimmermann, *Magnificent Milwaukee: Architectural Treasures, 1850-1920* (Milwaukee: Milwaukee Public Museum, 1987), xii; Harold M. Mayer, "By Water, Land and Air: Transportation for Milwaukee County," in *Trading Post to Metropolis: Milwaukee County's First 150 Years*, ed. Ralph M. Aderman (Milwaukee: Milwaukee County Historical Society, 1987), 340; John R. Ottensmann, *The Changing Spatial Structure of American Cities* (Lexington, MA: D.C. Heath and Company, 1975), 31-32; John D. Buenker and Beverly J.K. Buenker, eds. *Milwaukee in the 1930s: A Federal Writers Project City Guide* (Madison: Wisconsin Historical Society Press, 2016), xxiv-xxvi.
8. Bayrd Still, *Milwaukee: The History of a City* (Madison, WI: The State Historical Society of Wisconsin, 1948), 453-54.
9. Gurda, *The Making of Milwaukee*, 66,176; idem, *The West End: Merrill Park, Piggsville, Concordia* (University of Wisconsin System Board of Regents, 1980), 23-27.
10. Harry H. Anderson and Frederick I. Olson, *Milwaukee: At the Gathering of the Waters* (Tulsa, OK: Continental Heritage Press, 1981), 93, 97; Gurda, *The Making of Milwaukee*, 59-65, 133-36; Still, *Milwaukee: The History of a City*, 453-54; Donald Pienkos, "Politics, Religion, and Change in Polish Milwaukee, 1900-1930," *Wisconsin Magazine of History*, vol. 61, n. 3 (spring 1978): 178-82, 196-204; "An American Born in Poland," Walter Zukowski Papers, MARC, 21-40; Anthony J. Kuznlewski, "Milwaukee's Poles, 1866-1918: The Rise and Fall of a Model Community," in *Milwaukee Stories*, Thomas J. Jablonsky, ed. (Milwaukee, WI: Marquette University Press, 2005), 228-41;

Michael Kruska to Attorney General Thomas Gregory, April 5, 1917, in RG 65, Records of the Federal Bureau of Investigation, Old German Files, Case 8000-1105.

11 The most in-depth studies of Milwaukee's Jewish community are Louis J. Swichkow and Lloyd P. Gartner, *The History of the Jews of Milwaukee* (Philadelphia: The Jewish Publication Society of America, 1963) and John Gurda, *One People, Many Paths: A History of Jewish Milwaukee* (Milwaukee: Jewish Museum Milwaukee, 2009).

12 Albert Cosimo Meloni, "Milwaukee's 'Little Italy,' 1900-1910: A Study in the Origins and Struggles of an Italian Immigrant Colony," (M.A. Thesis: Marquette University, 1969), 3-8, 18-21; George La Piana, *The Italians in Milwaukee Wisconsin: General Survey* (Prepared under the direction of the Associated Charities, 1915), 5-6, 8-13; Gurda, *The Making of Milwaukee*, 175-76; Mario A. Carini with Austin Goodrich, *Milwaukee's Italians: The Early Years* (Milwaukee: The Italian Community Center of Milwaukee, 1999), 23-39; Diane C. Vecchio, *Merchants, Midwives, and Laboring Women: Italian Migrants in Urban America* (Urbana, IL: University of Illinois Press, 2006), 25-30.

13 Sally M. Miller, *Victor Berger and the Promise of Constructive Socialism, 1910-1920* (Westport, CT: Greenwood Press, Inc., 1973), 20-21.

14 Matthew Frye Jacobson, *Whiteness of a Different Color: European Immigrants and the Alchemy of Race* (Cambridge, MA: Harvard University Press, 1998), 13-14, 39-68; Gerd Korman, *Industrialization, Immigrants and Americanizers: The View from Milwaukee, 1866-1921* (Madison: The State Historical Society of Wisconsin, 1967), 41-46; William R. Walker, "Only the Heretics are Burning: Democracy and Repression in World War I America," (Ph.D. Dissertation, University of Wisconsin-Madison, 2008), 11-16; Daniel G. Donalson, "'A Convenient Engine of Oppression': Personal Uses of the Espionage and Sedition Acts of World War I," (Ph.D. Dissertation, University of Houston, 2009), 63-98; Meloni, "Milwaukee's 'Little Italy,'" 38-42; La Piana, *The Italians in Milwaukee Wisconsin*, 52-53; RG 65, Records of the Federal Bureau of Investigation, Old German Files, Case 171482.

15 Merchants & Manufacturers Association of Milwaukee, *Made in Milwaukee*, 1917.

16 Robert E. Weems, Jr., "Black Working Class, 1915-1925," in *Milwaukee Stories*, ed. Jablonsky, 259-62; idem, "From the Great Migration to the Great Depression: Black Milwaukee, 1915-1929," (M.A. Thesis, University of Wisconsin-Milwaukee, 1982), 12-16; Joe William Trotter, Jr., *Black Milwaukee: The Making of an Industrial Proletariat, 1915-1945* (Urbana, IL: University of Illinois Press, 1985), 8-32; Thomas R. Buchanan, "Black Milwaukee, 1890-1915," (M.A. Thesis, University of Wisconsin-Milwaukee, 1973), 1-137; *Annual Report of the Commissioner of Health of the City of Milwaukee*, 1918, 38-39.

17 Frederick I. Olson, "City Expansion and Suburban Spread: Settlements and Governments in Milwaukee County," in *Trading Post to Metropolis*, ed. Aderman, 21-22, 49-50; Anderson and Olson, *Milwaukee: At the Gathering of the Waters*, 79; *Caspar's Official Map of the City of Milwaukee and Vicinity* (Milwaukee: C.N. Caspar Co., 1916); *Map of the City of Milwaukee, 1912* (Milwaukee: C.N. Caspar Co., 1912).

18 Carl D. Thompson, "Socialists and Slums—Milwaukee," *The Survey*, vol. 25 (December 3, 1910): 367-69; Milwaukee Health Department, *Housing Conditions in Milwaukee*, 1916, 3-4, 12; Werner Hegemann, *City Planning for*

Milwaukee: What It Means and Why It Must be Secured, (a report submitted to the Wisconsin Chapter of the American Institute of Architects, the City Club, the Milwaukee Real Estate Association, the Westminster League and the South Side Civic Association, Milwaukee: February 1916), 20.
19 John McCarthy, *Making Milwaukee Mightier: Planning and the Politics of Growth, 1910-1960* (Dekalb, IL: Northern Illinois University Press, 2009), 4-6, 18-19.
20 Thompson, "Socialists and Slums," 374-76; Milwaukee Health Department, *Housing Conditions in Milwaukee*, 7-9, 11; "Many Thousand Families in City in Actual Want," *Milwaukee Leader*, April 7, 1917; "Family Incomes in Milwaukee," no date, City Club of Milwaukee, MARC, Box 2, File 1.
21 "The New Street-Lighting System of Milwaukee," *Electrical Review and Western Electrician*, 1 April 1916, 579.
22 Elizabeth Jozwiak, "Politics in Play: Socialism, Free Speech, and Social Centers in Milwaukee," *Wisconsin Magazine of History*, vol. 86, n. 3 (spring 2003): 10-20; McCarthy, *Making Milwaukee Mightier*, 15-18; "Advocates Plan for Hull House," *Milwaukee Sentinel*, September 27, 1902; H.H. Jacobs, "The Wisconsin University Settlement," April 5, 1905, University Settlement House Collection, MCHS, Box 1, File 1; *Club Life Souvenir Edition, 1902-1922*, ibid., Box 1, File 2.
23 *Annual Report of the Commissioner of Health of the City of Milwaukee*, 1918, 36-37; Milwaukee Health Department, *Housing Conditions in Milwaukee*, 7-9; Brigitte Marina Charaus, "What Lies Beneath: Uncovering the Health of Milwaukee's People, 1880-1929," (Ph.D. Dissertation, Marquette University, 2010), 98-103, 117.
24 Bill Hooker, *Glimpses of an Earlier Milwaukee* (Milwaukee: The Milwaukee Journal Public Service Bureau, 1929), 1; Oscar Ameringer, *If You Don't Weaken: The Autobiography of Oscar Ameringer* (New York: Greenwood Press, 1940), 288.
25 John Gurda, comp., "Roots in the River: Milwaukee Rediscovers Its Other Shoreline," in *Cream City Chronicles: Stories of Milwaukee's Past* (Madison: Wisconsin Historical Society Press, 2007), 74; *Bulletin of the Milwaukee Health Department*, vol. 6, nos. 2-3 (February-March 1916): 2.
26 Charaus, "What Lies Beneath," 13-15, 163-73, 232-34; La Piana, *The Italians in Milwaukee Wisconsin*, 14; Thompson, "Socialists and Slums," 374-76; Alfred C. Clas, "Civic Improvement in Milwaukee, Wisconsin" (a printed address delivered before the Greater Milwaukee Association, December 14, 1916); McCarthy, *Making Milwaukee Mightier*, 28-29.
27 Gurda, *The Making of Milwaukee*, 202-4; Floyd John Stachowski, "The Political Career of Daniel Webster Hoan," (Ph.D. Dissertation, Northwestern University, 1966), 16-18; Eric Fure-Slocum, "Milwaukee Labor and Urban Democracy," in *Perspectives on Milwaukee's Past*, ed. Margo Anderson and Victor Greene (Urbana, IL: University of Illinois Press, 2009), 51-56.
28 Frederick I. Olson, "The Milwaukee Socialists, 1897-1941," (Ph.D. Dissertation, Harvard University, 1952), 17-23; Miller, *Victor Berger and the Promise of Constructive Socialism*, 16-28; Denis Timlin Rice, "Berger, His Party, and the First World War: The Tribulations of a Socialist, 1914-1920," Unpublished manuscripts 272, MCHS, 6-8, 72; Gurda, *The Making of Milwaukee*, 204-11; "A Political Grab Bag," Edwin J. Gross Papers, WHS, Box 1, File 1; Doris Berger's unpublished biography of Victor Berger, chapter 8, Victor Berger Papers, WHS; Roderick Nash, "Victor L. Berger: Making Marx Respectable," *Wisconsin Magazine of History*, vol. 47, no. 4 (summer

1964): 301-2; Ameringer, *If You Don't Weaken*, 293-94; Aims McGuinness, "The Revolution Begins Here: Milwaukee and the History of Socialism," in *Perspectives on Milwaukee's Past*, ed. Anderson and Greene, 84-86.

29 Dan Hoan to Orlando Weber, June 10, 1938, Hoan Collection, MCHS, Box 24, File 591.

30 Stachowski, "The Political Career of Daniel Webster Hoan," 3-14; Edward Kerstein, *Milwaukee's All-American Mayor: Portrait of Daniel Webster Hoan* (Englewood Cliffs, NJ: Prentice-Hall, Inc., 1966), 3-37, 45-49; Michael E. Stevens, "'Give 'em Hell Dan!' How Daniel Webster Hoan Changed Wisconsin Politics," *Wisconsin Magazine of History*, vol. 98, no. 1 (autumn 2014): 18-19; Gurda, *Making of Milwaukee*, 220-21; Frederic Heath to John G. Gregory, March 31, 1944, John G. Gregory Papers, MCHS, File: Correspondence (General), 1931-1944.

31 Olson, "The Milwaukee Socialists," 18; Stevens, "'Give 'em Hell, Dan!" 19-21; Kerstein, *Milwaukee's All-American Mayor*, xiv-xv, 77; Stachowski, "Political Career of Daniel Webster Hoan," 3-4; Gurda, *Making of Milwaukee*, 206; Hoan to Mrs. Henry B. Losey, April 29, 1914, Hoan Collection, MCHS, Box 11, File 270; H. Russell Austin, *The Milwaukee Story: The Making of an American City* (Milwaukee: The Milwaukee Journal, 1946), 174-75; Steven M. Avella, *In the Richness of the Earth: A History of the Archdiocese of Milwaukee, 1843-1958* (Milwaukee, WI: Marquette University Press, 2002), 410-16; Pienkos, "Politics, Religion and Change in Polish Milwaukee," 182-95.

CHAPTER 2

1 Paul W. Glad, *The History of Wisconsin*, vol. V: *War, a New Era, and Depression, 1914-1940*, gen ed. William Fletcher Thompson (Madison: State Historical Society of Wisconsin, 1990), 12-16.

2 Morehouse to Stern, December 10, 1915; Stern to Morehouse, December 22, 1915; Morehouse to Stern, December 23, 1915; Stern to Morehouse, December 26, 1915; all located in Erich C. Stern Papers, MCHS, Mss-1407, File: Correspondence, 1914-1919, K-O; Jack Stark, "The Striving of Erich Stern," *Milwaukee History*, vol. 17, no. 2 (summer 1994): 57-64; "Erich Stern, 90, Dies: Served as Lawmaker," *Milwaukee Journal*, February 19, 1969.

3 For the activities of German agents in the U.S., see Henry Landau, *The Enemy Within: The Inside Story of German Sabotage in America* (New York: G.P. Putnam's Sons, 1937); Chad Millman, *The Detonators: The Secret Plot to Destroy America and an Epic Hunt for Justice* (New York: Little, Brown and Company, 2006), 3-98; Tracie L. Provost, "The Great Game: Imperial German Sabotage and Espionage against the United States, 1914-1917," (Ph.D. Dissertation, University of Toledo, 2003).

4 Woodrow Wilson: "Address at Milwaukee," January 31, 1916, posted online by Gerhard Peters and John T. Woolley, *The American Presidency Project*, posted at http://www.presidency.ucsb.edu/ws/?pid=65389; "Thousands Try to Hear Wilson," *Milwaukee Journal*, January 31, 1916, 1; Starzyk, "Milwaukee and the Press, 1916", 6-7; Walker, "Only the Heretics are Burning," 21-29.

5 Robert W. Wells, *The Milwaukee Journal: An Informal Chronicle of Its First 100 Years* (Milwaukee: Milwaukee Journal, c1981), 96-97; Jean Louise Berres, "Local Aspects of the 'Campaign for Americanism': The Milwaukee Journal in World War I," (Ph.D. Dissertation, Southern Illinois University at

Carbondale, 1978), 25-34, 51-92; Starzyk, "Milwaukee and the Press, 1916," 7; Will C. Conrad, Kathleen F. Wilson and Dale Wilson, *The Milwaukee Journal: The First Eighty Years* (Madison: The University of Wisconsin Press, 1964), 86-89.

6 Erich Stern to August S. Lindemann, August 2, 1916, Stern Papers, MCHS, File: Correspondence, 1914-1919, D-J; "Churches Ask Wilson to Keep Nation Out of War," *Milwaukee Free Press*, April 24, 1916, 1; Clipping from John G. Gregory Collection, MPL, Box 4a; Starzyk, "Milwaukee and the Press, 1916," 13-18.

7 Federated Trades Council to Wisconsin Branch, National Security League, June 9, 1916, in Federated Trades Council of Milwaukee Collection, MARC, Box 6, Minutes of Executive Board Meetings, Oct. 17, 1915-Jan. 3, 1923.

8 Hoan to W. Rufus Abbott, May 19, 1916; Milton C. Potter to Hoan, July 6, 1916; Hoan to Potter, July 8, 1916; statement of Osmore R. Smith, all in Hoan Collection, MCHS, Mss-0540, File: World War I – Preparedness, 1916-1917; Stachowski, "The Political Career of Daniel Webster Hoan," 69-71; Robert C. Reinders, "Daniel W. Hoan and the Milwaukee Socialist Party During the First World War," in *Wisconsin Magazine of History* (autumn 1952): 48-49; Starzyk, "Milwaukee and the Press, 1916," 23-24; "Loyalty of City Proved to Nation," July 16, 1916, Milwaukee Features Microfilm, MCHS.

9 Rice, "Berger, His Party and the First World War," 21-23; Olson, "The Milwaukee Socialists," 341-42.

10 Eugene Debs to Hoan, August 11, 1916; Hoan to Debs, August 15, 1916; Debs to Hoan, August 17, 1916, all in Robert J. Constantine, ed., *Letters of Eugene V. Debs* (Urbana, IL: University of Illinois Press, 1990), vol 2: 251-53; Reinders, "Hoan and the Milwaukee Socialist Party," 49; Hoan to Eugene Debs, August 15, 1916, Hoan Collection, MCHS, Box 11, File 281; *The People's Bulletin*, July 22, 1916, and Hoan to F.A. Tingley, all in Hoan Collection, MCHS, Box 36, File 911.

11 Clifford L. Nelson, *German-American Political Behavior in Nebraska and Wisconsin, 1916-1920* (University of Nebraska-Lincoln, Publication No. 217, 1972), 2.

12 Still, *Milwaukee: History of a City*, 455; Starzyk, "Milwaukee and the Press, 1916," 18-22, 24-31; Robert A. Witas, "'On the Ramparts': A History of the Milwaukee Sentinel" (M.A. Thesis, University of Wisconsin-Milwaukee, 1991), 61; Linda Marie Bos, "Let Us Act Promptly: School Sisters of Notre Dame and World War I," in *U.S. Catholic Historian*, vol. 12, no. 3 (summer 1994): 74-75. A federal grand jury indicted Jacobson the following June. Milwaukee ministers who attended the meetings disavowed any traitorous intent. The Rev. C.D. Reichle, pastor of Salem Evangelical Church, commented that the prevailing feeling was that "neither Great Britain nor Germany should dictate the policies of the United States." See "Ministers are Astonished," *Milwaukee Journal*, June 15, 1917.

13 Justus D. Doenecke, *Nothing Less Than War: A New History of America's Entry into World War I* (Lexington: The University Press of Kentucky, 2011), 250-77.

14 John M. Work, "The First World War," *Wisconsin Magazine of History*, vol. 41, no. 1 (autumn 1957): 32-33.

15 "Complete Report. National League for Woman's Service in Wisconsin from March, 1917, to July, 1919," in John W. Mariner Papers, MARC, Box 10, File 5: National League for Women's Service – Miscellaneous Reports and

Minutes; Hoan to Women's Club of Wisconsin, February 15, 1917, in ibid., Box 4, File 1: National League for Women's Service – Correspondence; Liza Tuttle, *A Club of Their Own: 125 Years of the Woman's Club of Wisconsin* (Milwaukee: The Woman's Club of Wisconsin, 2000), 53-57; Reinders, "Hoan and the Milwaukee Socialist Party," 49; *Marquette Tribune*, March 19, 1917, 1.

16 John G. Gregory, *History of Milwaukee* (Chicago: The S.J. Clarke Publishing Company, 1931), 4:472-80; Lorin Lee Cary, "The Wisconsin Loyalty Legion, 1917-1918," *Wisconsin Magazine of History*, vol. 53, no. 1 (autumn 1969): 35-36; Francis Bloodgood, "Wheeler Peckham Bloodgood of Milwaukee," Pamphlet Collection, WHS.

17 RG 65, Records of the Federal Bureau of Investigation, Old German Files [hereafter cited simply as "Old German Files"], Cases 1105 and 8000-1105.

18 Ibid, Cases 8000-1105 and 8000-20117; William H. Thomas, Jr., *Unsafe for Democracy: World War I and the U.S. Justice Department's Covert Campaign to Suppress Dissent*, Studies in American Thought and Culture, ed. Paul Boyer (Madison: The University of Wisconsin Press, 2008), 133-35.

19 "Plan to Speed Up Preparedness," *Milwaukee Journal*, March 24, 1917; United States Senate, 65th Congress, 2nd Session, *Hearings before the Committee on Military Affairs*, S. 4364 (Washington, D.C.: Government Printing Office, 1918), 21; George F. Kull, "Wisconsin Loyalty Legion," *The Wisconsin Blue Book, 1918* (Madison: Democrat Printing Company, 1919), 415; RG 65, Old German Files, Case 8000-1105; Joan M. Jensen, *The Price of Vigilance* (Chicago: Rand McNally & Company, 1968), 27-28; "Philipp Replies to Spooner," *Milwaukee Journal*, August 23, 1918.

20 "Memoranda of Meeting Sunday Night, April 1st," Charles King Papers, WHS, Box 2, File 1; King to General Barry, April 2, 1917, Newton Diehl Baker Papers, LOC, Personal Correspondence, "B" 1917; Charles King, "Memories of a Busy Life," *The Wisconsin Magazine of History*, vol. 6 (1922-1923): 185-87.

21 T.H. Barry to Secretary of War Baker, April 2, 1917, Baker Papers, Personal Correspondence, "B" 1917; Barry to Charles King, April 3, 1917, and Holway to King, April 2, 1917, King Papers, Box 2, File 1: Correspondence, 1916-1917.

22 Bill Mills, *The League: The True Story of Average Americans on the Hunt for WWI Spies* (New York: Skyhorse Publishing, 2013), 7-23; RG 65, Old German Files, Case 8000-1105; Jensen, *Price of Vigilance*, 17-25. John Lord O'Brian, head of the War Emergency Division in the U.S. Department of Justice, praised the APL as the only effective private organization that helped the DOJ. Other groups "seriously hampered" government officials because they were composed of "earnest but credulous amateurs." See "The Experience of the Department of Justice in Enforcing War Statutes, 1917-1918," in John Lord O'Brian Papers, Charles B. Sears Law Library, University at Buffalo School of Law.

23 National Emergency Committee, Socialist Party to Robert La Follette, March 29, 1917, in La Follette Family Papers, LOC, Box 40, File: Group Letters; Karen Falk, "Public Opinion in Wisconsin During World War I," *The Wisconsin Magazine of History*, vol. 25, no. 4 (June 1942): 394-95; Miller, *Victor Berger and the Promise of Constructive Socialism*, 148.

24 J.F. Moran, Sales Manager, Marlin Arms Corporation, to Secretary of the Chamber of Commerce, March 29, 1917, in Milwaukee Grain Exchange Collection, MCHS, Box 4, File 5.

CHAPTER 3

1. *Milwaukee Journal*, April 6, 1917, 16; "Food Shortage in City is Laid to Buying Mania" and "Soaring Flour Prices Force Bakers to Close," *Milwaukee Sentinel*, April 17, 1917, 1.
2. William George Bruce, "Days with Children," 1917, Part I, William George Bruce Collection, MCHS.
3. Christopher Capozzola, *Uncle Sam Wants You: World War I and the Making of the Modern American Citizen* (New York: Oxford University Press, 2008), 6-8; Kimberly Jensen, *Mobilizing Minerva: American Women in the First World War* (Urbana, IL: University of Illinois Press, 2008), 11-12; Walker, "Only the Heretics are Burning," 7-9.
4. Capozzola, *Uncle Sam Wants You*, 8.
5. United States Senate, 65th Congress, 2nd Session, *Hearings before the Committee on Military Affairs*, S. 4364, 6-7; "Council of Defense History" and Meeting Minutes of the County of Milwaukee County Council of Defense, April 30, 1917 and May 3, 1917 in Hoan Collection, MCHS, File: Defense-Milwaukee County Council of Defense. It must be noted that the State Council of Defense often complained about the Milwaukee County Council of Defense's penchant for acting independently and refusing to cooperate with the State Council. The State Council attributed this to the Socialists within the County Council, who "have very little regard for anybody or organization other than their own." See Andrew H. Melville, Secretary, Wisconsin State Council of Defense, to W.S. Gifford and George F. Porter, Council of National Defense, July 20, 1917, in Wisconsin, State Council of Defense Collection, World War I, WHS, Box 9, File 4.
6. Herbert N. Laflin to Governor E.L. Philipp, April 11, 1917, in E.L. Philipp Papers, WHS, Box 4. See also John Manschot to Philipp, April 11, 1917, ibid., and George Morton to Senator Paul Husting, April 12, 1917, Paul Oscar Husting Papers, WHS, Box 11, File 1.
7. Meirion Harries and Susie Harries, *The Last Days of Innocence: America at War, 1917-1918* (New York: Random House, 1997), 90-98; Capozzola, *Uncle Sam Wants You*, 23-30; Robert L. Hachey, "Dissent in the Upper Middle West during the First World War, 1917-1918," (Ph.D. Dissertation, Marquette University, 1993), 103-12; David Traxel, *Crusader Nation: The United States in Peace and the Great War, 1898-1920* (New York: Alfred A. Knopf, 2006), 278-82.
8. "One Man Held in Anti-Draft Probe," *Milwaukee Sentinel*, May 31, 1917; Report of William H. Steiner, April 11, 1917, RG 65, Old German Files, Case 8000-1105.
9. Guy Goff to Hon. John W. Davis, May 23, 1917, ibid.; Newton Baker to President Wilson, July 23, 1917, in Baker Papers, Personal Correspondence, "W"-July 1917; General Crowder to Governor E.L. Philipp, May 31, 1917 and Philipp to Crowder, June 2, 1917, in Philipp Papers, Box 4.
10. United States House of Representatives, 66th Cong., 1st sess., *Certified Copy of the Testimony of Victor L. Berger at the Trial of the Case of the U.S. vs. Berger et al. in the U.S. District Court for the Northern District of Illinois, Eastern Division*, 30 December 1918 (Washington, D.C.: Government Printing Office, 1918), 30-31.
11. "Milwaukee Calm as Men Register" and "Saloons Close All Day, First Time on Record" in *Milwaukee Sentinel*, June 6, 1917, 4; Weekly Report, June 9, 1917, in Wisconsin, State Council of Defense Collection, General

Correspondence, Box 9, File 9; King, "Memories of a Busy Life," 187-88. Prior to the draft, the Department of Justice carried out a nationwide raid against draft resistors. By June 2, federal agents had arrested more than 300 people. See Hachey, "Dissent in the Upper Middle West," 138-45.

12 Newton Baker to President Wilson, July 23, 1917, Baker Papers, Personal Correspondence, "W"-July 1917.

13 Milwaukee County Council of Defense Weekly Reports: June 30, 1917, July 7, 1917, July 21, 1917, and September 22, 1917, in Wisconsin, State Council of Defense, World War I: General Correspondence, WHS, Box 9, File 4-8; Report of the Secretary of the National League for Women's Service in Wisconsin, March 1, 1918, in Edessa Kunz Lines Papers, MU, Box. 1, File 1; Milwaukee County Council of Defense, Outline for Address, Hoan Collection, File: Defense-Milwaukee County Council of Defense, 1917-1918; Archbishop S.G. Messmer to Dearly Beloved Brethren, October 28, 1917, Sebastian G. Messmer Papers, AMA, Box 1, File 5; "Our Service Flag Dedication," *The Tattler* (North Division High School newspaper), December 1917, in Yearbooks Collection, MCHS; Milwaukee-Downer College Report of the War Work Committee for Year 1917-18, Milwaukee-Downer College Collection, MARC, Series 1, Box 6, File 9; Mrs. John Mariner to Grace Parker, November 23, 1917, Mariner Papers, Box 4, File 1; "The Boys! How Milwaukee Meets Them—A Tribute," *Civics & Commerce*, October 1918, in Metropolitan Milwaukee Association of Commerce Collection, MCHS.

14 Milwaukee County Council of Defense Weekly Reports: June 30, July 7, July 14, July 21, 1917, in Wisconsin, State Council of Defense Collection, Box 9, File 4-8; Memorandum on Development of the Bureau of Labor and War Time Service, no date; and State Council of Defense to the Sheriffs and Chiefs of Police, August 9, 1917, all in Hoan Collection, MCHS, File: Defense-Milwaukee County Council of Defense; Chester F. Rohn to Gentlemen, June 27, 1917, Wisconsin, State Council of Defense Collection, Box 9, File 4; "Negro Population in City Increased by 600-Sullivan," *Milwaukee Leader*, July 26, 1917; "Negroes Imported to Replace White Workers, Coleman," *Milwaukee Leader*, August 24, 1917; "Negro Population Here Only 2,000," *Milwaukee Sentinel*, November 1, 1917; *Milwaukee Sentinel*, September 24, 1918; Gurda, *Making of Milwaukee*, 257; David M. Kennedy, *Over Here: The First World War and American Society* (New York: Oxford University Press, 1980), 279-84; Weems, "From the Great Migration to the Great Depression," 16-29; Trotter, *Black Milwaukee*, 39-55.

15 Victoria Brown, *Uncommon Lives of Common Women: The Missing Half of Wisconsin History* (Madison, WI: Wisconsin Feminists Project Fund, 1975), 44-46; Stuart Stotts, "A Thousand Little Libraries: Lutie Stearns, The Johnny Appleseed of Books," *Wisconsin Magazine of History*, vol. 90, no. 2 (winter 2006-2007): 39-42, 46-47.

16 "Abolish Skirts, Wear Overalls, Man Advocates," *Milwaukee* Sentinel, May 20, 1917; "Up to the Women to Fill Men's Jobs," *Milwaukee Sentinel*, July 25, 1917; "Sees Effort to Get Cheap Labor," *Milwaukee Leader*, July 19, 1917; "Women Take Places of Men Called to Serve Nation," *Milwaukee Sentinel*, August 11, 1917; "Women Prove Capable in Machine Shop Work," *Milwaukee Sentinel*, August 15, 1917; "Miss Stearns the Modern Woman," *Milwaukee Sentinel*, August 30, 1917; Undated note, Lines Collection, Box 1, File 4: National League for Women's Service, Milwaukee, WI, Correspondence Received, 1914-1938; Carrie Brown, *Rosie's Mom: Forgotten Women Workers of the First World War* (Boston: Northeastern University Press, 2002), 3-18;

The Lindemann Sparks, vol. 1, no. 3 (September 1917) in William L. Pieplow Collection, MCHS.

17 Harries, *The Last Days of Innocence*, 178-81; Milwaukee County Council of Defense Weekly Reports: July 14, 1917, Hoan Collection, File: Defense-Milwaukee County Council of Defense; Milwaukee County Council of Defense Weekly Reports: July 28, 1917 and August 11, 1917, in Wisconsin, State Council of Defense Collection, Box 9, File 9; Secretary to James A. Reed, June 20, 1917, Hoan Collection, File: Correspondence-Business, May-Dec. 1917; "Spy Bureau will Help Employers Spot Agitators," unidentified newspaper clipping, November 15, 1917, in Milwaukee Features Files, Roll 451; "Unionism Loyal," *Milwaukee Journal*, June 28, 1917; "Expect Federal Mediator in City," *Milwaukee Leader*, July 19, 1917.

18 Milwaukee County Council of Defense, Outline for Address, Hoan Collection, File: Defense-Milwaukee County Council of Defense, 1917-1918; *Doings in Grain at Milwaukee*, vol. 6, no. 12 (January 1918): 18-19, Milwaukee Grain Exchange Collection, Box 5; Milwaukee County, *Report on Twenty Months of War-Time Service in Milwaukee, May 1st, 1917 to January 1st, 1919*, 23-29; "City's Trade for Year: $595,520,102," *Milwaukee Sentinel*, December 20, 1917.

19 Milwaukee County Council of Defense Weekly Reports: July 7, 1917, Wisconsin, State Council of Defense Collection, Box 9, File 9; Erika Janik, "Food will Win the War: Food Conservation in World War I Wisconsin," *Wisconsin Magazine of History*, vol. 93, no. 3 (spring 2010): 18-21, 26; Matthew Richardson, *The Hunger War: Food, Rations and Rationing, 1914-1918* (Barnsley: Pen & Sword Military, 2015), 241-46; *The Comet* (West Division High School newspaper), vol. 8, no. 1 (October 1917): 31-32, Yearbooks Collection.

20 Report on Mass Meeting, Davidson Theatre, April 20, 1917, and Mrs. John Mariner, State Chairman, National League for Woman's Service in Wisconsin, to Maude Wetmore, May 17, 1917, in Mariner Papers, Box 4, File 1; *Milwaukee Journal*, May 10, 1917, 6; Report of the Secretary of the National League for Women's Service in Wisconsin, March 1, 1918, Lines Papers, Box 1, File 1.

21 Hoover to Gregory, August 10, 1917, Gregory Papers, Box 1, File 9: Business Letters Received, 1916-1926; Kennedy, *Over Here*, 117-19; Harries, *The Last Days of Innocence*, 154-63; Neil M. Heyman, *Daily Life During World War I* (Westport, CT: Greenwood Press, 2002), 205-7; Richardson, *The Hunger War*, 246-49.

22 Milwaukee County Council of Defense Weekly Reports: June 30, July 7, July 14, July 21, 1917, in Hoan Collection, File: Defense-Milwaukee County Council of Defense; see also letters of October 29, November 2 and November 7, 1917, ibid.; "Household Census Not Investigation," *Milwaukee Sentinel*, July 27, 1917; Mrs. John W. Mariner to Mrs. H.H. Morgan, State Council of Defense, August 21, 1917, Mariner Papers, Box 4, File 1; Instructions to Workers on the Signing of the Hoover Pledge Cards, in Wisconsin, State Council of Defense Collection, Box 9, File 5; Capozzola, *Uncle Sam Wants You*, 95-103; Celia Malone Kingsbury, *For Home and Country: World War I Propaganda on the Home Front* (Lincoln: University of Nebraska Press, 2010), 27-55.

23 Osmore Smith, Secretary, County Council of Defense, Welfare Department, to Dear Madam, August 21, 1917, and Food Regulations Governing All Public Eating Houses, no date, in Hoan Collection, File: Defense-Milwaukee County

Council of Defense; "Food Conservation-What to Save," in Wisconisn, State Council of Defense Collection, Box 9, File 5; Proclamation from Magnus Swenson, September 14, 1917, in Charles H. Beale Collection, MCHS; "Hotel Managers Experiment with Recipes for Bread," *Milwaukee Sentinel*, August 19, 1917; Janik, "Food will Win the War," 22-23; R.B. Pixley, *Wisconsin in the World War* (Milwaukee: The Wisconsin War History Company, 1919), 118-19.

24 *Milwaukee Journal*: April 16, 1917, 1; May 14, 1917, 5; May 19, 1917, 1; June 20, 1917, 4 and July 25, 1917, 1; Hoan to State Conservation Commission, May 18, 1917, in Wisconsin, State Council of Defense Collection, Box 9, File 9; Common Council Resolution, December 4, 1916, and High Cost of Living Commission to Hoan, February 19, 1917, Hoan Collection, File: High Cost of Living Commission, 1916-1919; Committee to Hoan, July 1917, ibid., File: World War I-Food Board, 1917-1918; Hoan telegram to Senators La Follette and Husting, July 18, 1917, ibid., File: U.S. Senate, 1915-1950; Gurda, *Making of Milwaukee*, 229; Pixley, *Wisconsin in the World War*, 55-56; City Sealers Report, Milwaukee, Department of Health Collection, MCHS, Scrapbook: Articles, 1913-1923; Milwaukee County, *Report on Twenty Months of War-Time Service*, 12; "First Partial Report of the Committee on Food Conditions," *Proceedings of the Common Council of the City of Milwaukee*, August 27, 1917, 412-13; Richardson, *The Hunger War*, 236-40.

25 "Milwaukee Loans U.S. $17,352,000," *Milwaukee Sentinel*, June 15, 1917; *The Conveyor*, November 1917, in Milwaukee Coke and Gas Company Collection, MCHS; Glad, *The History of Wisconsin*, vol. V: *War, a New Era and Depression*, 43-45; Hachey, "Dissenters in the Upper Middle West," 186-210; Kennedy, *Over Here*, 99-106; "Milwaukee has had Big Part in Winning War," *Wisconsin News*, November 11, 1918.

CHAPTER 4

1 Bruce, "Days with Children," 1918, Part I, 32-33, Bruce Collection.
2 "Pastor Charged with 'Disloyalty,'" *Milwaukee Leader*, March 16, 1918; Report of William S. Fitch, May 17, 1917, RG 65, Old German Files, Case 8000-17644. In his dissertation, Daniel Donalson examined a sample of 151 cases under the Espionage and Sedition acts and found that 17 percent involved some sort of personal retribution and not actual espionage or disloyalty. See Donalson, "A Convenient Engine of Oppression."
3 Robert H. Wiebe, *The Search for Order, 1877-1920*, The Making of America series, gen. ed. David Herbert Donald (New York: Hill and Wang, 1967), 287-90; Kennedy, *Over Here*, 45-53; H.C. Peterson and Gilbert C. Fite, *Opponents of War, 1917-1918* (Madison: University of Wisconsin Press, 1957), 12-13; Ronald Schaffer, *America in the Great War: The Rise of the War Welfare State* (New York: Oxford University Press, 1991), 13-26; Walker, "Only the Heretics are Burning," 1-9, 508-23; Harries, *The Last Days of Innocence*, 293-96; Traxel, *Crusader Nation*, 315-17; Geoffrey R. Stone, *Perilous Times: Free Speech in Wartime, From the Sedition Act of 1798 to the War on Terrorism* (New York: W.W. Norton & Company, 2004), 4-5.
4 Woodrow Wilson, *War Messages*, 65th Cong., 1st Sess., Senate Doc. No. 5, Serial No. 7264, Washington, D.C., 1917, posted online at http://wwi.lib.byu.edu/index.php/Wilson's_War_Message_to_Congress.

5 Michael Kruszka to Attorney General Thomas Gregory, April 7, 1917, RG 65, Old German Files, Case 8000-1105; Report of John Carter, December 8, 1917, ibid., Case 8000-121883. See also Case 327227.

6 John Stevens, "When Dissent was a Sin in Milwaukee," *Milwaukee Sentinel*, March 10, 1966; Kingsbury, *For Home and Country*, 6; "Kaiser's Face Put off Jacob Best's Store Wall," *Milwaukee Sentinel*, August 8, 1917; August 8, 1917 entry, Erich Cramer Stern Papers, MARC, Box 16, File 7; "German Labels to be Prohibited," *Christian Science Monitor*, June 17, 1917, in RG 165, Records of the War Department General and Special Staffs, Military Intelligence Division Correspondence, Box 3340, File 10495-75 to 10495-84.

7 *Germania-Herold* editorial, July 12, 1917, cited in Nelson, *German-American Political Behavior*, 34; see also ibid., 26-28.

8 RG 65, Old German Files: Case 20117, Case 8000-1105, Case 8000-12994 and Case 8000-20117.

9 Ibid., RG 65, Old German Files, Case 8000-1105; Report of Chas. L. Harris, November 30, 1917, RG 165, Military Intelligence Division Correspondence, Box 3340, File 10495-15 to 10495-34.

10 RG 65, Old German Files, Case 8000-1105; "War Talk Sends Men to Hospital," *Milwaukee Sentinel*, May 14, 1917.

11 Gerhard Becker, "The German-American Community in Milwaukee during World War I: The Question of Loyalty," (M.A. Thesis, University of Wisconsin-Milwaukee, 1988), 74-78; Wells, *The Milwaukee Journal*, 111; "Tires of His German Name; Now is French," *Milwaukee Sentinel*, November 16, 1917; "Many Milwaukeeans Change Their Names," *Milwaukee Free Press*, June 9, 1918; "Wife Gets Divorce on Condition She Alters 'Kaiser' Name," *Milwaukee Leader*, September 18, 1918; Anita Weschler to Edward Weschler, June 25, 1918 and June 26, 1918, Nunnemacher/Weschler Family Papers, MCHS, Box 4, File 96.

12 *Annual Report of the Attorney General of the United States, 1918* (Washington, D.C.: Government Printing Office, 1918), 56-58; H.A. Sawyer, U.S. Attorney, to Winfred Zabel, Milwaukee District Attorney, June 1, 1917, RG 65, Old German Files, Case 8000-1105.

13 For a complete list of interned enemy aliens, see RG 65, Old German Files, Case 8000-78249.

14 Jensen, *Price of Vigilance*, 160-61; *Annual Report of the Attorney General of the United States, 1918*, 31-32; "Barred Zone Order to Hit 10,000 Alien Enemies," *Milwaukee Sentinel*, June 9, 1917; "Practically All of Milwaukee in Barred War Zone," *Milwaukee Leader*, June 13, 1917; "Entire City is in Alien Barred Zone," *Milwaukee Sentinel*, June 14, 1917; "Milwaukee Engineer will be First Sent to Detention Camp," *Milwaukee Leader*, June 20, 1917; Bos, "Let Us Act Promptly," 83-86; Carl Diederichs to Paul Husting, Husting Papers, Box 11, File 6; "Need Not Register as Enemy Aliens," *Milwaukee Sentinel*, July 27, 1917; "8,500 'Enemies' in County," *Milwaukee Journal*, September 12, 1917; Bruce, "Days with Children," 1917, Part II, 13-14, Bruce Collection; Report of William H. Steiner, November 13, 1917, RG 165, Military Intelligence Division Correspondence, Box 3340, File 10495-53 to 10495-74; "German Doctor is in Jail," *Milwaukee Journal*, April 23, 1918; RG 65, Old German Files, Case 8000-20571.

15 Nelson, *German-American Political Behavior*, 30-33; Report of Henry McLarty, June 28, 1918, RG 65, Old German Files, Case 238845; Avella, *In the Richness of the Earth*, 422-28.

16 Proceedings of the Board of School Directors, Milwaukee, Wisconsin, July 7, 1908-June 30, 1909, Milwaukee Public Schools Collection, MCHS, 570;

"Drop German in Four Grades," *Milwaukee Journal*, April 13, 1917; "Teacher is Not Reappointed," *Milwaukee Journal*, July 1, 1917.

17 "Only English in the Grades," *Milwaukee Journal*, June 16, 1917; "Aim is to Keep Germans Alien," *Milwaukee Journal*, June 30, 1917; Becker, "German American Community in Milwaukee," 42-45. Later in the war, even Pieplow thought it unfair to force Italian, Polish, Slavonian children, etc., to learn German because they then had to master two new languages rather than one. See "Is Now Against German Study," *Milwaukee Journal*, September 18, 1918.

18 "Foreign Language Fight is Opened," *Milwaukee Sentinel*, June 28, 1917; "7,277 Fewer Now Take German," *Milwaukee Journal*, September 8, 1917; "Report to End German Study Made," *Milwaukee Sentinel*, October 24, 1917; *Milwaukee Free Press*, January 16, 1918, in Stern Papers, Box 16, File 8; "Potter Asks Curbing of German on Playground," *Milwaukee Leader*, June 15, 1918; "English Only to be Taught In Schools," *Milwaukee Free Press,* August 11, 1918; "Requests Study of German be Restored," *Milwaukee Sentinel*, February 2, 1918; "Order German War Songs Torn From School Books," *Milwaukee Leader*, September 13, 1918; Stevens, "When Dissent was a Sin in Milwaukee;" Gurda, *Making of Milwaukee*, 225; "Hate Propaganda is Advanced Peg," *Milwaukee Leader*, February 16, 1918; "German Abolished in Milwaukee Schools," *Milwaukee Sentinel*, August 7, 1918.

19 Becker, "German-American Community in Milwaukee," 71-74, 185.

20 Ibid., 47-69, 90-97; "To the Public," *Milwaukee Journal*, September 22, 1917; Editorial, *Milwaukee Journal*, September 23, 1917; "Rollicking Fun Opens German Year at Pabst," *Milwaukee Sentinel*, September 24, 1917; Editorial, ibid., September 25, 1917; Loyalty League Resolution, June 8, 1918, Wisconsin, War History Commission Collection, Series 1706, WHS, Box 3, File: Correspondence, 1918; Editorial, *Milwaukee Journal*, June 8, 1918; Bredlow, "A History of the German Theater of Milwaukee," 71-72.

21 Carl Wittke, "American Germans in Two World Wars," *Wisconsin Magazine of History*, vol. 27, no. 1 (September 1943): 9-11; Capozzola, *Uncle Sam Wants You*, 174-77; Julius Gugler to Ellen Burns Sherman, June 23, 1917, in Gugler Lithographic Company Collection, MCHS, Box 1, File 6; Frederick W. von Cotzhausen, "On My 80th Anniversary, July 21, 1918," in Otto J. and Louise Schoenleber Papers, MPL, Box 1, File 10.

22 "Drafted Man Found with Carbolic Acid Bottle by His Side," *Milwaukee Leader*, February 20, 1918; "Son Called to Colors; Father Kills Self," *Milwaukee Journal*, April 24, 1918; "Riebe's Death Due to Son's Draft, Belief," *Milwaukee Sentinel*, August 8, 1917; Memorandum No. 1104, January 21, 1918, in Wisconsin, War History Commission Collection, Series 1696, Box 2; *Annual Report of the Commissioner of Health of the City of Milwaukee,* 1917, 80; "Every One Invited to Slacker Hunt," *Milwaukee Sentinel*, August 14, 1917. In July, the *Milwaukee Journal* reported that the number of marriage licenses issued in April, May and June was 619 fewer than the previous year, attributing the decrease to the high cost of living and the unsettled conditions caused by the war. But the Reverend G.K. Rubrecht surmised that the reduced numbers in April and May were due to men marrying even earlier in the spring to avoid military service. "Fewer Wed Now," *Milwaukee Journal*, July 3, 1917; George F. Kull to John Stover, May 2, 1918, in Wisconsin. War History Commission Collection, Series 1706: Loyalty Legion Correspondence and Miscellaneous Papers, Box 1, File: Correspondence, September 16-29, 1917.

23 Kull to Stover, ibid.; Walker, "Only the Heretics are Burning," 362-65; Orlando Hollway to Henry F. Cochems, January 14, 1919 and Governor

Philipp to Cochems, January 15, 1919, both in Berger Papers, General Correspondence, Reel 15; RG 65, Old German Files, Case 8000-231281, 62; "Every One Invited to Slacker Hunt," *Milwaukee Sentinel*, August 14, 1917; *The Conveyor*, July 1917, Milwaukee Coke and Gas Company Collection; Anita Weschler to Edward Weschler, July 17, 1918, Nunnemacher/Weschler Family Papers, Box 4, File 97.

24 Miller, *Victor Berger and the Promise of Constructive Socialism*, 165-75; Hachey, "Dissent in the Upper Middle West," 79-92; United States House of Representatives, 66th Cong., 1st sess., *Certified Copy of the Testimony of Victor L. Berger*, 16-18; Gurda, *Making of Milwaukee*, 227-28; Peterson and Fite, *Opponents of War*, 8-9; Kerstein, *Milwaukee's All-American Mayor*, 91-95.

25 Miller, *Victor Berger and the Promise of Constructive Socialism*, 49-50, 54-55, 120, 150, 155-56; Kent and Gretchen Kreuter, *An American Dissenter: The Life of Algie Martin Simons* (Lexington: University of Kentucky Press, 1969), 1-165; Elmer A. Beck, *The Sewer Socialists: A History of the Socialist Party of Wisconsin, 1897-1940*, vol. 1: *The Socialist Trinity of the Party, the Unions and the Press* (Fennimore, WI: Westbury Associate Publishers, 1982), 166-69; Algie M. Simon to Adolph Germer, April 25, 1917 and May 5, 1917, in Berger Papers, General Correspondence, Reel 15; Report of R.B. Spencer, April 18, 1918, RG 65, Old German Files, Case 8000-3341; "Simons Attacks Berger in Letter," *Milwaukee Sentinel*, May 25, 1917; Algie Simons to Paul Husting, September 27, 1917, Husting Papers, Box 12, File 2.

26 Beck, *The Sewer Socialists*, 170-75.

27 "Proceedings, Emergency Convention of the Socialist Party of America, at St. Louis, 1917," Algie and May Wood Simon Papers, WHS, Box 1, File 5; Senator Paul Husting to Winfield Gaylord, April 22, 1917, Husting Papers, Box 36, Letter Book, February-April 1917, 950-51; Hachey, "Dissent in the Upper Middle West," 124-25; Henry Frederick Bedford, "A Case Study in Hysteria: Victor L. Berger, 1917-1921," (M.A. Thesis, University of Wisconsin, 1953), 25-26; Miller, *Victor Berger and the Promise of Constructive Socialism*, 154; W.R. Gaylord, "What Happened in St. Louis?," *Milwaukee Journal*, May 6, 1917.

28 Victor Berger to Morris Hillquit, May 10, 1917, Socialist Party Papers, MCHS, Box 8, File 182; J.E. Harris, Walter Wyrick, Leo Wolfsohn and Claude Diegle to Victor Berger, April 20, 1917, Berger Papers WHS; F.P. Hopkins to Paul Husting, June 21, 1917, Husting Papers, Box 11, File. 4; "Quits Socialists as Anti-American," *Milwaukee Sentinel*, June 15, 1917; An American Socialist to Victor Berger, July 6, 1918, Socialist Party Collection, Box 8, File 196.

29 Kimberly Swanson, ed. *A Milwaukee Woman's Life on the Left: The Autobiography of Meta Berger* (Madison: State Historical Society of Wisconsin, 2001), 67-70; Doris Berger, unpublished biography of Victor Berger, Berger Papers, Chapter VI: Notes and Fragments; Kerstein, *Milwaukee's All-American Mayor*, 90; Edwin J. Gross, "Public Hysteria: First World War Variety," *Historical Messenger* (June 1961): 5; Edwin Gross Biographical Sketch, Gross Papers, Box 1, File 1; Marion Ogden to Stern, November 4, 1917 and November 19, 1917, Stern Papers, Box 12, File 6; Margaret to Stern, January 9, 1918 and Hink to Stern, January 15, 1918, ibid., Box 12, File 7; Erich Stern to Hornell Hart, September 8, 1917 and Stern to My Dear Dorothy, November 18, 1917, ibid., Box 12, File 6; Journal entry, May 1, 1918, ibid., Box 16, File 8; Secretary of University Club to Erich Stern, February 16, 1918, and April 12, 1918, Lucia K. and Erich C. Stern Collection, MPL, Box 4, File 17.

30 Kennedy, *Over Here*, 25-27; Peterson and Fite, *Opponents of War*, 14-17; Stone, *Perilous Times*, 158-80; Schaffer, *America in the Great War*, 27-30; Stevens, "When Dissent was a Sin in Milwaukee;" Donalson, "A Convenient Engine of Oppression," 26-27, 99-134; Telegram from Victor Berger to *Chicago Examiner*, May 6, 1917, Socialist Party Collection, Box 8, File 182.

31 Victor Berger to Albert Burleson, July 12, 1917, Socialist Party Collection, Box 8, File 184; July 10, 1917 entry, Stern Papers, Box 16, File 7; Hachey, "Dissent in the Upper Middle West," 323-28; Rice, "Berger, His Party, and the First World War," 47-51.

32 Thomas, *Unsafe for Democracy*, 24-30. Citizens often used the terms "Secret Service" and "Department of Justice" interchangeably. Even more confusion was caused by APL agents calling themselves "Secret Service." See Jensen, *Price of Vigilance*, 32-50.

33 Theodore Kornweibel, Jr., *"Investigate Everything": Federal Efforts to Compel Black Loyalty During World War I* (Bloomington, IN: Indiana University Press, 2002), 2-31; Karl Schauermann to Robert La Follette, May 18, 1917, La Follette Family Papers, Series B82, File: 1917, Schauermann, Karl; "Acts of Federal Agents Probed," *Milwaukee Sentinel*, August 11, 1917; "Says La Follette Plays Politics," ibid., August 12, 1917; Jensen, *Price of Vigilance*, 169.

34 Kennedy, *Over Here*, 78-83; Jensen, *Price of Vigilance*, 147-54; Donalson, "A Convenient Engine of Oppression," 21-22; Thomas, *Unsafe for Democracy*, 31-56; Report of William Fitch, March 16, 1917 and April 14, 1917, RG 65, Old German Files, Case 8000-352; Fitch to A. Bruce Bielaski, April 26, 1917, ibid., Case 8000-1105.

35 Report of Ralph Izard, November 12, 1917, RG 165, War Department General and Special Staffs, Military Intelligence Division Correspondence, Box 3339, File 10495-1 to 10495-14; Peterson and Fite, *Opponents of War*, 17-20, 196-207; Capozzola, *Uncle Sam Wants You*, 119-31; "Fined for Remark about Soldiers," *Milwaukee Sentinel*, October 31, 1917; Editorial, *Milwaukee Journal*, September 27, 1917.

36 Stevens, "When Dissent was a Sin in Milwaukee;" Report of Julius Rosin, July 22, 1917, RG 65, Old German Files, Case 27473.

CHAPTER 5

1 Gross, "Public Hysteria," 3-4; "Socialists in 'Council'," *Milwaukee Journal*, July 31, 1917, and " Praise Senator, Hit War Plans," *Milwaukee Journal*, August 11, 1917, in Gross Papers, Box 2, Political, Etc. Scrapbook, 1911-1920; Arthur Sweet to Erich Stern, August 1, 1917, Lucia K. and Erich C. Stern Papers, Box 4, File 17; July 9, 1917 and August 7, 1917 entries, Stern Papers, Box 16, File 7; Victor Berger to Morris Hillquit, August 11, 1917, Socialist Party Collection, Box 8, File 185; Editorial, *Milwaukee Journal*, September 20, 1917.

2 That same day, Governor Philipp received a telegram that urged him to prevent the People's Council from meeting in Milwaukee because the "temper of our people creates grave danger of personal violence to seditious speakers." See Wade H. Richardson to Emanuel Philipp, August 31, 1917, Wisconsin, Governor, Investigations: 1851-1959, Series 81, Box 28, File 8.

3 Hachey, "Dissent in the Upper Middle West," 368-78; Gross, "Public Hysteria," 5-6; Miller, *Victor Berger and the Promise of Constructive Socialism*, 175-77; Arthur W. Thurner, "The Mayor, the Governor, and the

People's Council," *Journal of the Illinois State Historical Society*, vol. 66, no. 2 (summer 1973): 126-43; "People's Council Convention will be in Hudson, Wis.," *Milwaukee Leader*, August 30,1917; "People's Council May Come to Milwaukee" and "Socialist Gang has Uneasy Time of It," in *Milwaukee Sentinel*, August 31, 1917; "Danger in Outburst at Pacifists' Train," *Milwaukee Journal*, August 31, 1917; "Pacifist Meet in Chicago is Brought to End," *Evening Wisconsin*, no date, Gross Papers, Box 2, Political, Etc. Scrapbook, 1911-1920; Edwin Gross to William Mauthe, August 27, 1917, ibid., Box 1, File: Correspondence, 1902-1922; "Meeting Barred by Gov. Philipp," *Milwaukee Journal*, September 1, 1917; Work, "The First World War," 37-38.

4 Gross, "Public Hysteria," 6; "Governor Defines Freedom of Speech," *Milwaukee Sentinel*, September 19, 1917; "Philipp Replies to Haessler in Letter to Press," *Milwaukee Leader*, September 19, 1917; "Steffens Heeds Philipp's Request," *Milwaukee Sentinel*, September 22, 1917; September 26, 1917 entry, Stern Papers, Box 16, File 7: Clippings and Journal.

5 Robert Tanzilo, *The Milwaukee Police Station Bomb of 1917* (Charleston, SC: The History Press, 2010), 14-18, 37-54; Dean A. Strang, *Worse than the Devil: Anarchists, Clarence Darrow and Justice in a Time of Terror* (Madison: The University of Wisconsin Press, 2013), 16-19, 44-66; "Federal Agents Raid 3 Places as I.W.W. Quarters," *Milwaukee Sentinel*, September 6, 1917; John D. Stevens, "Wobblies In Milwaukee," *Historical Messenger*, vol. 24, no. 1 (March 1968): 27; "Gun Fight Occurs In Bay View," *Milwaukee Sentinel*, September 10, 1917; Ralph Izard to Dr. P.L. Prentice, September 20, 1917, RG 65, Old German Files, Case 8000-1105; Anthony J. Farina, *"I Must, I Must, I Must": The Story of the Italian Evangelical Church of Wisconsin* (Sun Prairie, WI: Commission on Archives and History, Wisconsin Conference United Methodist Church, ca. 2008), 79-86; Jensen, *Price of Vigilance*, 57-81.

6 Cary, "The Wisconsin Loyalty Legion, 1917-1918," 36-38; "The Work of the Wisconsin Loyalty Legion Report," Wisconsin, War History Commission Collection, Series 1705, Box 2, File: Wis. Defense League: Incorporation of Loyalty Legion; Wisconsin Loyalty Legion articles of organization, Husting Papers, Box 12, File 1; Glad, *The History of Wisconsin*, vol. V: *War, a New Era and Depression*, 28-39.

7 Cary, "Wisconsin Loyalty Legion," 38-39; Victor Berger to Meta Berger, August 23, 1917, Berger Papers, Family Correspondence (Microfilm Reel 5); Guy Goff to Col. William Cronyn, September 7, 1917, Gregory Papers, File: Correspondence, 1911-1920; Hachey, "Dissent in the Upper Middle West," 420-21.

8 George Morton to Executive Committee, Loyal Legion, August 28, 1917, Wisconsin, War History Commission Collection, Series 1706, Box 1, File: Correspondence, August 17- September 15, 1917; Cary, "Wisconsin Loyalty Legion," 39.

9 Ibid., 40; Wisconsin Loyalty Legion to Samuel Gompers, September 17, 1917 and Wisconsin Loyalty Legion to Frank Weber, September 28, 1917, Wisconsin, War History Commission Collection, Series 1706, Box 1, File: Correspondence, September 16-29, 1917; Report of Executive Committee Meeting, October 15, 1917, ibid., Series 1705, Box 2, File: Wisconsin Defense League: Incorporation of Loyalty Legion; "Trades Council Gets a Shock," *Milwaukee Journal*, September 18, 1917; Thomas J. Mahon, Wisconsin Loyalty Legion, to Dan Hoan, September 25, 1917, Hoan Collection, File 227; Victor Berger to Robert La Follette, February 2, 1918, Socialist Party Collection, Box 8, File 191.

10 Victor Berger to Albert Burleson, September 17, 1917, Socialist Party Collection, Box 8, File 186; Victor Berger to Meta, September 25, 1917, Berger Papers, Family Correspondence; Hachey, "Dissent in the Upper Middle West," 323-28, 332-36; Rice, "Berger, His Party, and the First World War," 47-51; Gurda, *Making of Milwaukee*, 229-30; Nichali Michael Ciaccio, "Because It Had to Be: The *Milwaukee Leader*, Socialism and the First World War," (B.A. Honors Thesis, University of Wisconsin-Milwaukee, 2005), 72; Beck, *The Sewer Socialists*, 128-29; Miller, *Victor Berger and the Promise of Constructive Socialism*, 198-201; "Mayor Protests Action on Leader," *Milwaukee Sentinel*, October 5, 1917; "Berger Exposes Plan to Cut Off Leader's Support," *Milwaukee Leader*, October 27, 1917; Berger to Dear Comrade and Report of Ralph Izard, October 17, 1917, RG 65, Old German Files, Case 22353; Berger to Arthur Brisbane, October 23, 1917, Socialist Party Collection, Box 8, File 187; Swanson, ed., *A Milwaukee Woman's Life on the Left*, 70-71; "The Patriotism of *The Milwaukee Journal*," *Milwaukee Leader*, December 12, 1917; Olson, "The Milwaukee Socialists," 370-72.

11 "School Directors to Circulate Own Loyalty Petition," *Milwaukee Leader*, October 24, 1917; "Schools to Help Teach Loyalty," *Milwaukee Journal*, October 24, 1917, Pieplow Collection, File: General Clippings, 1917-1923; "Legion is Firm," *Milwaukee Journal*, October 25, 1917.

12 *Wisconsin Memorial Day Annual, 1919* (Madison, WI: Democrat Printing Co., 1919), 58; "School Loyalty Pledge Ready," *Milwaukee Journal*, November 9, 1917.

13 November 11, 1917 entry, Stern Papers, Box 16, File 7; Ernst Goerner to Dan Hoan, December 10, 1917, Hoan Collection, File: World War I, General Material, 1916-1921; RG 65, Old German Files, Case 8000-5025.

14 "Alien Teachers School Topic" and "School Teacher is an Alien," *Milwaukee Journal*, October 28, 1917; "Friends Come to Teacher's Defense," *Milwaukee Sentinel*, October 29, 1917; "Eighteen Alien Teachers Found," *Milwaukee Sentinel*, October 30, 1917; "Directors Resent Loyalists' Probe in School Affairs," unidentified clipping, October 29, 1917, Pieplow Collection, File: General Clippings, 1917-1923; August 8, 1917 entry, Stern Papers, Box 16, File 7; "Pieplow Assails Loyalty Legion in Vigorous Letter," *Milwaukee Leader*, November 12, 1917; Proceedings of the Board of School Directors, Milwaukee, Wisconsin, July 1st, 1917-June 30th, 1918, Milwaukee Public Schools Collection, 124, 145-47.

15 W.S. Goodland to John Stover, November 13, 1917, Wisconsin, War History Commission Collection, Series 1706, Box 1, File: Correspondence, October 1917; "Vote to Censure Principal," *Milwaukee Journal*, November 20, 1917 and "Stover Gets More Than He Expected in Oesau Charges," *Milwaukee Leader*, November 1917, in Pieplow Collection, File: General Clippings, 1917-1923; Proceedings of the Board of School Directors, Milwaukee, Wisconsin, July 1st, 1917-June 30th, 1918, Milwaukee Public Schools Collection, 182.

16 A.M. Briggs to Charles D. Frey, January 5, 1918; Frey to Briggs, January 7, 1918; and Briggs to Frey, January 10, 1918, all in Charles Daniel Frey Papers, Charles E. Young Research Library, University of California-Los Angeles, Box 1, File 9.

17 Report of Julius Rosin and Ralph Izard to Hinton Clabaugh, November 10, 1917, in RG 65, Old German Files, Case 8000-80653; Arthur Shutkin obituary, *Milwaukee Sentinel*, March 4, 1952.

18 Dmowski was eventually ordered deported, and he left voluntarily for the Soviet Union in October 1920. See RG 65, Bureau Section Files, Case 202600-23.

19 "Raid Meeting of Socialists," *Milwaukee Journal*, November 9, 1917; "Officers in Raid to be Arrested," ibid., November 10, 1917; "Zabel Flayed for Allowing Four Arrests," *Milwaukee Sentinel*, November 12, 1917; "Zabel Criticised [sic] For Men's Arrest," *Milwaukee Sentinel*, November 13, 1917; Statement by Edmund T. Melms, Edmund T. Melms Papers, MCHS, Box 1, File 4; Fred Lorenz to Robert La Follette, November 14, 1917, La Follette Family Collection, Series B, File: 1917, General Correspondence Lor-Lov; Report of J.M. Carter, November 27, 1917, RG 65, Old German Files, Case 88007; "Zabel Seeks to Drop Cases of Four Officers," *Milwaukee Sentinel*, November 19, 1917; "Jail Melms and Acquit 4 Deputies," ibid., November 22, 1917; "Deputies Vindicated; Melms is Arrested," *Milwaukee Free Press*, November 23, 1917 and "Suit Against Page and M'Manus May Follow by Melms," *Milwaukee* Leader, June 14, 1918, in Melms Papers, Box 1, File 11.

20 "Milwaukee Man is Killed on *Antilles*," *Milwaukee Sentinel*, October 22, 1917; "Milwaukee Man Killed in France," *Milwaukee Sentinel*, November 19, 1917; "Honor Soldier Dead in France," ibid., November 27, 1917; "Milwaukee's First World War Hero," ibid., April 11, 1954.

21 Strang, *Worse than the Devil*, 19-22, 34-37; Tanzilo, *Milwaukee Police Station Bomb*, 60-77; *Milwaukee Leader*, November 26, 1917; William J. Carey to A. Bruce Bielaski, November 25, 1917, RG 65, Old German Files, Case 90844; Ralph Izard to A. Bruce Bielaski, November 27, 1917, ibid., Case 8000-1105; Various reports, ibid., Case 90844; Report of H.H. Stroud, December 22, 1917, ibid., Case 118692; Report of J.M. Carter, December 6, 1917, ibid., Case 119418.

22 Famed Attorney Clarence Darrow handled the appeal and in April 1919, the Wisconsin Supreme Court overturned convictions for nine of the defendants, asserting that no conspiracy was proved and, thus, they were improperly convicted. Their freedom, however, was short-lived, as the U.S. Immigration Service deported them as alien anarchists. The other two had their sentences commuted by Governor Blaine in February 1922; they, too, were deported. See Strang, *Worse than the Devil*, 137-92; Tanzilo, *Milwaukee Police Station Bomb*, 91-95.

23 Strang, *Worse than the Devil*, 107-36; Tanzilo, *Milwaukee Police Station Bomb*, 79-90, 103-5; Carl Haessler to Roger Baldwin, American Civil Liberties Union (ACLU), January 12, 1918, American Civil Liberties Union Records: Subgroup 1, The Roger Baldwin Years, Reel 5, Vol. 38; Haessler to Baldwin, April 30, 1918, ibid.; Report of H.H. Stroud, January 18, 1918, RG 65, Old German Files, Case 90844; "Remember Our Milwaukee Comrades," *The Social War Bulletin*, vol. 1, no. 5 (August 1918), in ibid., Case 8000-34743; "Two Bombs at Home of District Attorney," *Milwaukee Journal*, April 16, 1918; "Zabel Again Threatened in Letters," *Milwaukee Free Press*, May 7, 1918.

24 Izard to A.B. Bielaski, November 1, 1917, RG 65, Old German Files, Case 11883; Izard to Bielaski, November 20, 1917, ibid., Case 88007; November 20, 1917 entry, Stern Papers, Box 16, File 7; H.L. Ashworth to Magnus Swenson, December 14, 1917, Wisconsin, State Council of Defense Collection, Box 15, File 7; Editorial, *Milwaukee Journal*, December 26, 1917.

25 "Poisonous Talk Aids Enemy, Says Simons," *Milwaukee Sentinel*, October 7, 1917; Stover Fearful Lest Some 'Traitor' Cause Him to Commit Murder," *Milwaukee Leader*, December 29, 1917; Memorandum re F. Mastalski, November 19, 1917, RG 65, Old German Files, Case 8000-1105.

26 Victor Berger to Doris Berger, November 15, 1917 and Meta Berger to Victor Berger, December 4, 1917, Berger Papers, Family Correspondence; "Senator Arnold Urges Philipp to Check 'Loyalists'," *Milwaukee Leader*, December 27, 1917.

CHAPTER 6

1. "First Snowfall of Season is Recorded," *Milwaukee Sentinel*, October 19, 1917; October 29 and October 30, 1917 entries, Harriet Fyffe Richardson Diary, MCHS; "Icy Blasts Send Mercury Down" and "Seven Men Perish in Gale on Lake," *Milwaukee Sentinel*, December 9, 1917; "Mr. Milwaukee Struggles to Work in Snow," *Milwaukee Leader*, December 13, 1917; "Severe Cold Brings Suffering to Poor; 10 Below Forecast," *Milwaukee Free Press*, December 29, 1917; "The *Milwaukee Sentinel* 1918 Annual Trade Review," *Milwaukee Sentinel*, January 1, 1918.
2. Hoan to Frank Fischer, October 5, 1917, Hoan Collection, Box 11, File 270; Osmore Smith to the Food Board, October 12, 1917, ibid., Box 36, File 906-907; "Sell Foodstuffs Direct to People," *Milwaukee Sentinel*, October 12, 1917; "Chicago Food Plan to be Tried Here," *Milwaukee Sentinel*, December 9, 1917; "Housewives Plan Further Protest Against Price List," *Milwaukee Leader*, December 13, 1917; "Save Sugar, is New Appeal by Van Scoy," *Milwaukee Sentinel*, October 23, 1917; Osmore Smith to Dear Sir, December 1917, Wisconsin, State Council of Defense Collection, General Correspondence, Box 9, File 4.
3. Telegram from E.L. Philipp to Dr. Charles McCarthy, August 31, 1917 and Circular from W.N. Fitzgerald to County Fuel Administrators, December 8, 1917, both in Philipp Papers, Box 4; "No Coal Shortage Here Says Defense Council," *Milwaukee Sentinel*, September 24, 1917; "Advises Thrift in Coal Supply," *Milwaukee Sentinel*, December 19, 1917; "Coal Famine May Grip Milwaukee Without Relief," *Milwaukee Leader*, December 17, 1917; "Severe Cold Brings Suffering to Poor; 10 Below Forecast," *Milwaukee Free Press*, December 29, 1917.
4. "Coal Famine May Grip Milwaukee Without Relief," *Milwaukee Leader*, December 17, 1917; "Lightless Order Goes into Effect," *Milwaukee Sentinel*, December 17, 1917; Order of the U.S. Fuel Administrator, November 9, 1917 and W.N. Fitzgerald to County Fuel Administrators, December 15, 1917, both in Philipp Papers, Box 4, File: Correspondence; "Poor of City to be Given Coal," *Milwaukee Sentinel*, December 6, 1917.
5. George C. Ruhland, "The Water Problem," *Bulletin of the Milwaukee Health Department*, vol. 8, no. 1 (January 1918): 3; "Boil the Water for Drinking," *Milwaukee Journal*, December 26, 1917.
6. "Coal Situation is Acute," *Milwaukee Journal*, January 7, 1918; "Eight Below Zero, Weather Forecast" and "All Trains Stalled; No Relief Seen," *Milwaukee Sentinel*, January 12, 1918; January 12, 1918 entry, Richardson Diary; Bruce, "Days with Children," Part I, 1918, 51-53, Bruce Collection; "Polar Bears at Zoo Enjoy Low Temperature," *Milwaukee Sentinel*, January 13, 1918; "January Mercury Stayed Near Zero," *Milwaukee Sentinel*, February 1, 1918.
7. Bruce, "Days with Children," 1918, Part I, 54, 68, Bruce Collection.
8. Ibid.; "133,000 Wage Workers In Milwaukee," *Milwaukee Sentinel*, January 17, 1918; "Business Men to Carry out Fuel Mandate," ibid., January 18, 1918; Editorial, *Milwaukee Leader*, January 17, 1918.

9 Thomas Fleming, *The Illusion of Victory: America in World War I* (New York: Basic Books, 2003), 174, 180-81; Kennedy, *Over Here*, 123-25; Harries, *The Last Days of Innocence*, 193-204.

10 Milwaukee County Council of Defense Weekly Report, January 19, 1918, Wisconsin, State Council of Defense Collection, Box 9, File 4; "Little Work for the Idle," *Milwaukee Journal*, January 18, 1918.

11 "City Marts Selling Rough Fish See Riots," *Milwaukee Leader*, January 18, 1918; "Milwaukee is Eating 11,000 Pounds of Horse Meat Each Thirty Days," ibid., February 2, 1918; Bruce, "Days with Children," Part I, 1918, 65-67, Bruce Collection; Ralph Izard to A.T. Van Scoy, January 8, 1918, RG 4, U.S. Food Administration, General Correspondence, Box 28, File 88; *Annual Report of the Commissioner of Health of the City of Milwaukee*, 1918, 63; Willits Pollock to Andrew Melville, March 2, 1918, Wisconsin, State Council of Defense Collection, Box 9, File 4; "Food Violations are Growing Here" and "Calls up Nine on Food Orders," *Milwaukee Sentinel*, February 14, 1918.

12 Erich Stern to Voters, December 1917, Lucia K. and Erich C. Stern Papers, Box 4, File 17; "The St. Louis Platform on Which Melms Stands, and a Letter from a Lafollette Leader Indorsing Melms," *Milwaukee Journal*, December 31, 1917; Herbert Laflin to Erich Stern, January 2, 1918; Stern to Laflin, January 7, 1918; Stern to Walter Stern, January 10, 1918; Stern to My Dear "Soc," February 8, 1918; University Club Members to J.V. Quarles, Jr., March 23, 1918; Erich Stern to Board of Directors, University Club, April 2, 1918, all in Lucia K. and Erich C. Stern Papers, Box 4, File 17; Reprint of Stern letter, *Marquette Tribune*, January 17, 1918.

13 Stern to Board of Trustees of the Milwaukee Citizens' Bureau of Municipal Efficiency, January 10, 1918; Stern to Walter Stern, January 10, 1918; and Stern to Herbert Noonan, S.J., January 12, 1918, all in Lucia K. and Erich C. Stern Papers, Box 4, File 17; "Move to Dismiss Law Teacher," *Milwaukee Journal*, January 3, 1918; "Stern to Stay," *Milwaukee Journal*, January 19, 1918; Samuel Rubin, "The Journal's Confession," *Milwaukee Leader*, January 24, 1918.

14 "Stands on Party Platform," *Milwaukee Journal*, December 28, 1917; "The Party Will Stand No Wobbling," *Milwaukee Leader*, December 28, 1917; Stachowski, "Political Career of Daniel Hoan," 74-76; Minutes of Advisory Committee to the Mayor, December 31, 1917, City Club of Milwaukee, Box 5, File: Advisory Committee to Mayor, Minutes and Correspondence, 1917-1920; Statement by Daniel W. Hoan, January 4, 1918, Hoan Collection, Box 32, File 815; Leo Tiefenthaler to Hoan, December 31, 1917 and Minutes of Advisory Committee to the Mayor, January 11, 1918, Hoan Collection, Box 1, File 3; Hoan to George Leonard, January 10, 1918, ibid., Box 11, File 283; Olson, "The Milwaukee Socialists," 348-49; Rice, "Berger, His Party, and the First World War," 52-53.

15 Beck, *The Sewer Socialists*, 193; Meta Berger to Doris Berger, January 12, 1918, Berger Papers, Family Correspondence; "Mayor Hoan and Berger on Verge of Split," *Milwaukee Sentinel*, December 29, 1917; "Mayor's Views Control in City Campaign?" *Milwaukee Journal*, January 6, 1918; "Hoan Takes Same General Stand as Party Platform," *Milwaukee Leader*, January 5, 1918; "Vote to Accept Mayor's Views," *Milwaukee Journal*, January 12, 1918; "Hoan's Advisers Overwhelmingly Favor His Stand," *Milwaukee Leader*, January 12, 1918; "Mayor Opposes Berger's Stand," *Milwaukee Sentinel*, January 5, 1918; W.A. Hall to Dan Hoan, January 14, 1918 and J.E. Dodge to Hoan, January 15, 1918, Hoan Collection, Box 9, File 228.

16 "Stover Goes over Top; Captures Another Trench," *Milwaukee Leader*, January 19, 1918; "Lawyer will Take Off Iron Cross Ring," *Milwaukee Journal*, January 19, 1918.

17 "Woman Removed to Hospital from Federal Bldg. Charges Violence Used by U.S. Sleuth," *Milwaukee Leader*, February 14, 1918; "Izard's Assistants Express Themselves on Stripping Rings," ibid., February 14, 1918; "Alleged Brutal Methods Used by King to be Sifted," ibid., February 15, 1918; "Izard Holds King Blameless upon Violence Charge," ibid., February 16, 1918; Report of Ralph Izard, February 18, 1918, RG 65, Old German Files, Case 22355; "The Attorney General Should Investigate," *Milwaukee Leader*, February 19, 1918.

18 "Vote is Delayed," *Milwaukee Journal*, February 12, 1918; "Hoan Tells Why," ibid., March 7, 1918; *Proceedings of the Common Council of the City of Milwaukee for the Year Ending April 16, 1918*, 1061, 1162-63; Ernst Gőrner to Milwaukee Common Council, February 11, 1918 and February 21, 1918, Emil Seidel Papers, MARC, Box 2, File 2.

19 "Submarine Attack on American Transport Nets Probable Toll of 145 U.S. Soldiers; Wisconsin Troopers Reported on Board" and "City Relatives of Badger Troopers Anxious for News," *Milwaukee Leader*, February 7, 1918; "Loss of Life in The *Tuscania* Disaster May Go as High as 200," *Milwaukee Journal*, February 8, 1918; "Bury 12 Wisconsin Men in Scotland," ibid., February 13, 1918; "No Place on the Fence for Any," ibid., February 8, 1918.

CHAPTER 7

1 Fleming, *The Illusion of Victory*, 195-96, 205-8.

2 "Political Drive is on in City," *Milwaukee Sentinel*, February 24, 1918; "Draft Platform," *Milwaukee Journal*, February 27, 1918; "Platform of Socialist Party for Municipal Election," ibid., March 3, 1918; Opening Speech Campaign 1918, March 1, Hoan Collection, Box 3, File 86.

3 "Milwaukee Attack on Our Nation," *Milwaukee Journal*, March 4, 1918; "May Ask Hoan to Resign," ibid., March 9, 1918; Herman Wagner and Herbert Laflin to Dan Hoan, March 9, 1918 and Hoan to Wagner and Laflin, March 13, 1918, Hoan Collection, Box 9, File 228; "Good Bloodgood Loves Hoan; Bad Bloodgood Hates Hoan," *Milwaukee Leader*, March 9, 1918.

4 Gurda, *Making of Milwaukee*, 230; Editorial, *Milwaukee Leader*, March 11, 1918; Telegram from Dan Hoan to Adolph Germer, March 13, 1918, Hoan Collection, Box 36, File 927; Walker, "Only the Heretics are Burning," 316-22.

5 Committee on Administration to Executive Committee, Milwaukee County Council of Defense, March 13, 1918, Wisconsin, State Council of Defense Collection, Box 9, File 4; Dan Hoan to Executive Committee, Milwaukee County Council of Defense, March 13, 1918, Hoan Collection, Box 9, File 228; "Hoan Defies Defense Council to Still His Voice Against Profiteers as It Bars Him and All Socialists from Its Committees," *Milwaukee Leader*, March 14, 1918; Reinders, "Daniel W. Hoan and the Milwaukee Socialist Party," 53.

6 Special Meeting of the Milwaukee Council of Defense, March 14, 1918 and "The Action Which Deposed the Mayor as Chairman of the Council of Defense," no date, both in Hoan Collection, Box 13, File 333; "Mayor Off War Work Board," *Milwaukee Journal*, March 14, 1918; Milwaukee County Council of Defense Weekly Report, March 16, 1918, Wisconsin, State Council of Defense Collection, Box 9, File 8; Statement by W.P. Bloodgood of Milwaukee

A Crowded Hour

7 J.P. Schreiner to Dan Hoan, March 15, 1918, Hoan Collection, Box 11, File 283; Stachowski, "Political Career of Daniel Hoan," 77-83; Olson, "The Milwaukee Socialists," 349-55; "Fight on Mayor in Court," *Milwaukee Journal*, March 18, 1918; "Home Guards with Brass Band Make Deliberate Attempt to Break up Socialist Meeting," *Milwaukee Leader*, March 19, 1918.

8 "Army Law for Milwaukee; Defense Head Also Seeks the Indictment of Mayor Hoan," *New York Times*, March 22, 1918; "Socialist Primary Banquet Gives Bloodgood Nightmare of Revolt and Firing Squad," *Milwaukee Leader*, March 22, 1918; Statement by W.P. Bloodgood of Milwaukee, World War I Collection, File 21; "Did Not Call For Martial Law," *Milwaukee Journal*, March 22, 1918; Bloodgood to H.A. Sawyer, U.S. District Attorney, March 21, 1918, Wisconsin, State Council of Defense Collection, Box 15, File 4; Walker, "Only the Heretics are Burning," 257-65.

9 March 23, 1918 journal entry, Stern Papers, Box 16, File 8; "Philipp Says State will Back Choice of People at Election," *Milwaukee Leader*, March 22, 1918.

10 "The One Man for Mayor," *Milwaukee Journal*, March 11, 1918; "Loyalty Legion, Afraid of Berger, Pleads for Fusion," *Milwaukee Leader*, March 23, 1918; Wheeler Bloodgood to Dear Sir, March 28, 1918, Socialist Party Collection, Box 8, File 192.

11 Dan Hoan to Mrs. N.O. Slater, March 25, 1918, Hoan Collection, Box 3, File 86; Hoan to Dear Sir, March 28, 1918, ibid., Box 28, File 711A; Nelson, *German-American Political Behavior*, 39-40; Olson, "The Milwaukee Socialists," 352-54.

12 Kennedy, *Over Here*, 237-38; Hachey, "Dissent in the Upper Middle West," 356-65; Cary, "Wisconsin Loyalty Legion," 42-44; Glad, *The History of Wisconsin*, vol. V: *War, a New Era and Depression*, 45-50; "Riot Threats Rife; Socialists Cancel S.S. Armory Meet" and "Vandals Deface Berger Posters," *Milwaukee Leader*, March 30, 1918; Nelson, *German-American Political Behavior*, 36-39; Speech at Bahn Frei Turn Hall, April 1, 1918, Berger Papers, Roll 28; Gurda, *Making of Milwaukee*, 230; O.L. Stevens to George Kull, April 15, 1918, Wisconsin, War History Commission Collection. Series 1706, Box 2, File: Correspondence, April 1918; Olson, "The Milwaukee Socialists," 354-57; Robert S. Maxwell, *Emanuel L. Philipp Wisconsin Stalwart* (Madison: The State Historical Society of Wisconsin, 1959), 161-63.

13 Eric Chester, "Traitors, Spies and Military Tribunals: The Assault on Civil Liberties During World War I," *New Politics*, vol. 14, no. 2 (winter 2013); United States Senate, 65th Congress, 2nd Session, *Hearings before the Committee on Military Affairs*, S. 4364, 5, 9, 21.

14 Chester, "Traitors, Spies and Military Tribunals."

15 United States Senate, 65th Congress, 2nd Session, *Hearings before the Committee on Military Affairs*, S. 4364, 9-11, 15-16, 30.

16 Chester, "Traitors, Spies and Military Tribunals;" Jensen, *Price of Vigilance*, 120-21.

CHAPTER 8

1 Minutes of Meeting of the Newly Organized Publicity Committee of the Milwaukee County Council of Defense, April 10, 1918, Milwaukee Grain Exchange Collection, Box 4, File 4.

2 Dan Hoan to Thomas Atkinson, April 19, 1918, Hoan Collection, Box 27, File 693.
3 "Why Attack German Born? Asks Falk," April 22, 1918, newspaper clipping in Otto H. Falk Collection, MCHS, Box 1, Scrapbook, 1917-1923; *Congressional Record*, 65th Congress, 2nd Session, vol. LVI, 7684-90; "Congress Hears Bloodgood and Journal Scored," *Milwaukee Free Press*, June 13, 1918 and "*Milwaukee Journal*'s Hypocrisy Exposed," ibid., June 23, 1918.
4 "Iowa Merchants May Boycott Milwaukee," *Milwaukee Journal*, April 17, 1918.
5 *Official Bulletin of the Milwaukee County Council of Defense*, February 7 and February 14, 1918, and Milwaukee County Council of Defense Weekly Report, April 20, 1918, in Wisconsin, State Council of Defense Collection, Box 9, File 4; Harold H. Seaman to Morris Fox, April 23, 1918, ibid., Box 2, File: Correspondence, April 1918; August Vogel to Dear Sir, March 14 and March 16, 1918, Hoan Collection, Box 13, File 333; Milwaukee County Council of Defense, Memorandum on Washington Information Bureau for Milwaukee Manufacturers, ibid.; *Official Bulletin of the Milwaukee County Council of Defense*, August 29, 1918, Hoan Collection, Box 35, File 901.
6 "Report of Committee on Co-ordination of Work of Men's and Women's Liberty Loan Committees," March 1918, World War I Collection, File 21; *Municipal Affairs*, May 11, 1918, in Wisconsin, War History Commission Collection, Series 1706, Box 5, File: Milwaukee County Ward and Precinct Chairman; "102 Divisions in Loan Parade," *Milwaukee Journal*, April 12, 1918; "Milwaukee's Patriotic Host 25,000 Strong Marches in Great 'Back Uncle Sam' Appeal," ibid., April 14, 1918; *The Comet* (West Division High School newspaper), May 1918; Hachey, "Dissenters in the Upper Middle West," 211-27; Oscar Traczewitz, William Kurth and T. Gifford to Meta Berger, April 22, 1918, in Berger Papers, General Correspondence; "Demands Pupils in Class be Guarded from Humiliation," *Milwaukee Leader*, May 3, 1918; "Painted Yellow When They Fail to Buy Bonds," *Milwaukee Journal*, April 21, 1918; "Vote Against Loyalty Book," *Milwaukee Free Press*, May 21, 1918; Milwaukee Public Schools, President's Address, June 29, 1918, Pieplow Collection, File: Milwaukee Board of School Directors-Pieplow Speeches, ca. 1908-1919.
7 Editorial, *Milwaukee Journal*, May 30, 1918.
8 Elizabeth Upham Davis Biographical Notes, WHS.
9 S____ (name indecipherable), United Slavs, to Wheeler Bloodgood, June 15, 1918, in Wisconsin, War History Commission Collection, Series 1706, Box 5, File: Milwaukee County Ward & Precinct Chairman; "Slavs Pledge Full Loyalty," *Milwaukee Sentinel*, June 10, 1918; "Slavs Dedicate Lives to U.S.," *Milwaukee Journal*, June 10, 1918; Gurda, *Making of Milwaukee*, 226.
10 Report of William George Bruce, August 5, 1918, RG 165, Military Intelligence Division Correspondence, Box 3340, File 10495-85 to 10495-97.
11 "Chicken Dinner on Sunday is in Vogue," *Milwaukee Free Press*, April 28, 1918; Bruce, "Days with Children," 1918, Part II, 7, Bruce Collection; Anita Weschler to Edward Weschler, June 21, 1918, Nunnemacher/Weschler Family Papers, Box 4, File 96.
12 Jeanette Fillman vs. William Fillman, Milwaukee County Circuit Court Case 52640, MCHS; *Official Bulletin of the Milwaukee County Council of Defense*, August 29, 1918, Hoan Collection, Box 35, File 901; "New Problems of Poverty and Crime Result from War," unidentified clipping, May 2, 1918, Milwaukee Features Microfilm, Roll 451; *Milwaukee Leader* editorial, May 22, 1918.

13 "Milwaukee Landmark, Jewish Ghetto, May Soon Pass Away," *Milwaukee Leader*, May 22, 1918; "Dixie is Reproduced in Milwaukee's Negro Colony," *Milwaukee Free Press*, June 17, 1918; "Offended by Article Ridiculing Negroes," *Milwaukee Journal*, June 25, 1918.

14 "Plan Better Housing for Negroes Here," *Milwaukee Sentinel*, September 17, 1918.

15 Dan Hoan to D.W. Norris, May 21, 1918, Hoan Collection, Box 18, File 449; "The Housing Problem," editorial, *Milwaukee Leader*, June 28, 1918; William Schuchardt to Paul Gauer, Hoan Collection, Box 18, File 449; Report of William Schuchardt, September 25, 1918, ibid.; Gurda, *Making of Milwaukee*, 264-65.

16 "25 Per Cent of Drug Stores in City for Sale," *Milwaukee Leader*, May 17, 1918; Harries, *The Last Days of Innocence*, 283-85.

17 George McKowen, Hummel and Dowling, to M.E. Roussellot, August 16 and August 28, 1918, and Roussellot to McKowen, August 30, 1918, in RG 165, Records of the War Department General and Special Staffs, Military Intelligence Division Plant Protection Section, Chicago District Office, Box 10, File Hummel & Dowling; "'Work or Fight' is New Order," *Milwaukee Journal*, May 23, 1918; "Women to Take Places of Men," *Milwaukee Free Press*, May 25, 1918; "Call for Women Unprecedented; Wages Climbing," ibid., June 11, 1918; "8,000 Women Fill Jobs of Men Here," *Milwaukee Leader*, July 18, 1918; Anita Weschler to Ted Weschler, July 12, 1918, Nunnemacher/Weschler Family Papers, Box 4, File 97; Milwaukee County Council of Defense Weekly Report, June 8, 1918, in Wisconsin. State Council of Defense Collection, Box 9, File 8; "Replace Men by Thousands," *Milwaukee Journal*, September 22, 1918; "Women Replace Men on Trucks," *Milwaukee Sentinel*, October 1, 1918.

18 Assistant Secretary, Industrial Commission, to Miss E.N. Matthews, October 7, 1918, Wisconsin Industrial Commission Collection, WHS, Box 88, File C412.7; "War Work for Most Children in Vacation," *Milwaukee Free Press*, June 21, 1918; "4,070 Child Labor Permits: Record," *Milwaukee Leader*, July 9, 1918.

19 Kennedy, *Over Here*, 66-73; Walter Distelhorst to Dear Sir, December 19, 1917 and Chester F. Rohn to Gentlemen, December 17, 1917, Hoan Collection, Box 13, File 333; Frank W. Cobb to A.M. Simons, July 3, 1918, Wisconsin, War History Commission Collection, Series 1706, Box 5, File: Milwaukee County Ward and Precinct Chairmen; Korman, *Industrialization, Immigrants and Americanizers*, 107-8, 136-85.

20 Osmore R. Smith, *Food Markets and Marketing in Milwaukee*, (City of Milwaukee: November 20, 1918), 1-7.

21 Milwaukee County Council of Defense Weekly Report, June 1, 1918, in Wisconsin, State Council of Defense Collection, Box 9, File 8; Proceedings of the Board of School Directors, Milwaukee, Wisconsin, July 1st, 1917-June 30th, 1918, Milwaukee Public Schools Collection, 245-48, 285-86; *Official Bulletin of the Milwaukee County Council of Defense*, February 21, 1918, in Wisconsin, State Council of Defense Collection, Box 9, File 4; Minutes of Meeting of the Bureau of Education, January 23, 1918, Milwaukee-Downer College Collection, Series 1, Box 6, File 8; "Fifty Boys are Off for Farms," *Milwaukee Journal*, April 14, 1918; "Mrs. Berger Hits Embryo Military Plan for Schools," *Milwaukee Leader*, February 12, 1918; *The Comet* (West Division High School newspaper), May 1918.

22 "Violated Rules," *Milwaukee Journal*, June 28, 1918; A.T. Van Scoy to Magnus Swenson, June 25, 1918 and undated report, both in RG 4, U.S.

Food Administration, General Correspondence, Box 29, File 88; Van Scoy to Swenson, October 1, 1918 and October 21, 1918, ibid.; Charles H. Tenney to A.T. Van Scoy, December 19 and December 21, 1918, RG 4, U.S. Food Administration, Enforcement Division, Box 9, File "J."

CHAPTER 9

1. "Near-Riot in Downtown Café," *Milwaukee Free Press*, May 23, 1918; RG 65, Old German Files, Case 209320.
2. *Laws of Wisconsin, 1918*, Chapter 13, posted online at http://docs.legis.wisconsin.gov/1917/related/acts/18firstssact013.pdf; Stone, *Perilous Times*, 184-91; Journal, 85, in Work Papers, MPL; Walker, "Only the Heretics are Burning," 231-57; *Annual Report of the Attorney General of the United States, 1918*, 18; Thomas, "Unsafe for Democracy," 146-71; O'Brian's comment quoted in Donalson, " A Convenient Engine of Oppression," 24.
3. "Cursing U.S. Brings Him Blow from Fist and Fine of $25," *Milwaukee Journal*, March 6, 1918; "Disloyal Remark Leads to Prison," *Milwaukee Sentinel*, August 7, 1918.
4. Minutes of Wisconsin Loyalty Legion, April 29, 1918, Wisconsin, War History Commission Collection, Series 1706, Box 1, File: Minutes, 1917-1918; "Slurs Poland's Army—Riot Near," *Milwaukee Sentinel*, August 5, 1918.
5. "German-English Academy Boys Rebel at Name," *Milwaukee Journal*, March 8, 1918; "Deutscher Club is No More," ibid., April 16, 1918; "'Germania' Taken From Germania Building," *Milwaukee Free Press*, May 16, 1918; "Britisher Would Purge Milwaukee," *Milwaukee Leader*, May 18, 1918; "Not a German Athens," *Milwaukee Journal*, June 11, 1918.
6. Walker, "Only the Heretics are Burning," 79-80; "Relations Tightened for German Alien," *Milwaukee Sentinel*, January 5, 1918; "Waterfronts to be Prohibited to Alien Wednesday," *Milwaukee Leader*, January 8, 1918; Milwaukee County Council of Defense Weekly Report, Wisconsin, State Council of Defense Collection, Box 9, File 4; Commander S. _____ (name indecipherable) to Colonel Van Deman, January 18, 1918, RG 165, Records of the War Department General and Special Staffs, Military Intelligence Division Correspondence, Box 3340, File 10495-35 to 10495-52; Annual Report, Milwaukee Association of Commerce for 1918, Metropolitan Milwaukee Association of Commerce Collection; "Aliens Held for Picketing Plant," *Milwaukee Leader*, January 31, 1918; "Many Aliens are Rounded Up," ibid., April 10, 1918; "Hold Aliens on Several Charges," *Milwaukee Sentinel*, April 11, 1918; "Bar Alien-Enemy from Lake Boats," *Milwaukee Leader*, May 20, 1918; Edessa K. Lines to Dear Madam President, June 13, 1918, Mariner Papers, Box 4, File 2; "Alien Enemies in Milwaukee Begin Listing with U.S.," unidentified clipping, February 4, 1918, Milwaukee Features Microfilm, "World War I;" *Official Bulletin of the Milwaukee County Council of Defense*, July 18, 1918.
7. Four Milwaukee companies had assets seized: The John Barth Company, Barth Manufacturing Company, Park Hill Land Company and Pabst Brewing. See *Alien Property Custodian Report* (Washington, D.C.: Government Printing Office, 1919), 297, 337-38 and *Report of the Alien Property Custodian, April 10, 1922*, Senate Document 181, 67th Congress, 2nd Session (Washington, D.C.: Government Printing Office, 1922), 77, 454-60.
8. "Hold 2 Million for Aliens," *Milwaukee Journal*, March 21, 1918; A. Mitchell Palmer to Dear Sir, no date, Hoan Collection, Box 35, File 895; *Alien Property*

Custodian Report, 9, 15; *Report of the Alien Property Custodian, April 10, 1922*, 454-57; Edwin M. Borchard, *Memorandum in Support of the Return of the Sequestrated Private Property Now Held by the United States Government Based upon the Hearings on the Winslow Resolution, H.J. 364.*, January 1923, Berger Papers, WHS.

9 RG 65, Old German Files, Case 8000-13082; *Alien Property Custodian Report*, 603; "German Doctor is in Jail," *Milwaukee Journal*, April 24, 1918; "Doctor Ordered Interned," ibid., May 24, 1918; William Bross Lloyd to Victor Berger, May 31, 1918, Socialist Party Collection, Box 8, File 194.

10 RG 65, Old German Files, Case 215035.

11 "Held on Charge of Sabotage," *Milwaukee Journal*, June 7, 1918; "First Man on Sabotage Charge is Arrested Here," *Milwaukee Leader*, June 8, 1918; RG 21, Records of the U.S. District Court, Eastern District of Wisconsin, Milwaukee, Final Record Books-Criminal, 1887-1919, Vol. L; Report by David Groh, Agent-in-Charge, June 28, 1918, in RG 165, Records of the War Department General and Special Staffs, Military and Intelligence Division, Plant Protection Section, Box 2, File: Bailey Mfg. Co.; Report by Groh, August 21, 1918, ibid., Box 1, File: Allis-Chalmers Co.; Reports by Groh, John Ferris and John Allen, June 5, 1918, ibid., Box 11, File: George Lamios.

12 "Shop Conditions in City Worst in Country is Claim," *Milwaukee Leader*, September 20, 1918; October 4, 1918, clipping from *Milwaukee Leader* and Report by E.W. Day, November 11, 1918, both in RG 165, Records of the War Department General and Special Staffs, Military and Intelligence Division, Plant Protection Section, Box 4, File: Briggs Loading; "More Wages, Not Longer Days, Need of Woman Labor," *Milwaukee Leader*, July 20, 1918; "Brewery Electrical Workers on Strike," *Milwaukee Free Press*, May 16, 1918.

13 *The Conveyor*, October 1918, Milwaukee Coke and Gas Company Collection; Report of John Ferris, April 13, 1918, and Memo from David Groh, Agent-in-Charge, April 25, 1918, both in RG 165, Records of the War Department General and Special Staffs, Military and Intelligence Division, Plant Protection Section, Box 10, File: Kearney & Trecker; Report of John Ferris, April 8, 1918, ibid., Box 15, File: Pawling & Harnischfeger; Memo from David Groh, May 11, 1918, ibid., Box 21, File: Wisconsin Motor Co.; "Shipping Board Speaker Replies to 800 Workers," *Milwaukee Sentinel*, August 11, 1918; William B. Rubin to Newton Baker, Secretary of War and Rubin to W.B. Wilson, Secretary of Labor, July 6, 1918, in RG 165, Records of the War Department General and Special Staffs, Military and Intelligence Division, Plant Protection Section, Box 16, File: Rubin, W.B.; Harries, *The Last Days of Innocence*, 285-89.

14 Report of John Stover, July 24, 1918, RG 65, Old German Files, Case 8000-254258; R.B. Spencer to A.B. Bielaski, September 17, 1918, ibid., Case 286674.

15 Harries, *The Last Days of Innocence*, 291; Supplement to Memorandum No. 1235, April 10, 1918, Wisconsin, War History Commission Collection, Series 1696, Box 2, File: Rules, Forms, Memoranda, Jan. 1, 1918-April 30, 1918; "Teamwork Again Wins for City," *Milwaukee Sentinel*, June 6, 1918; "4,051 Registered," *Milwaukee Journal*, June 6, 1918; "Net on Slackers Closes; Many are Taken by Police," *Milwaukee Leader*, July 19, 1918; "Draft Scoop in Milwaukee Lands 2,000," *Milwaukee Sentinel*, July 20, 1918; "More Seized in Slacker Raid," *Milwaukee Journal*, July 20, 1918; Mills, *The League*, 79-100.

16 "Draft Raids are Resumed; Jails Filled," *Milwaukee Sentinel*, July 20, 1918; "Renew Drive Against All Draft Evaders," ibid., July 21, 1918; "Thousands

More Taken in Raid," *Milwaukee Journal*, July 21, 1918; "Still on Trail of Slackers," ibid., July 22, 1918; "30 of 2,000 Taken in Draft Roundup Held on Charges," unidentified clipping, July 22, 1918, Milwaukee Features Microfilm, "World War I;" RG 65 Old German Files, Case 63296.

CHAPTER 10

1. Fleming, *Illusion of Victory*, 205-8, 212-14, 222-32, 265-74, 285-90.
2. "City Prepares for Autoless Day," *Milwaukee Sentinel*, September 1, 1918; Bruce, Days With Children," 1918, Part II, 15, Bruce Collection; "Two More Lightless Nights a Week," *Milwaukee Journal*, September 1, 1918; "City Complies with Request of Government," *Milwaukee Sentinel*, September 2, 1918; "Signs to Show Doctors aren't Wasting Fuel," *Milwaukee Journal*, September 6, 1918.
3. "Workers Given Coat of Yellow," *Milwaukee Journal*, September 26, 1918; "Another is Given Coat of Yellow," ibid., September 27, 1918; "More Warrants Asked," ibid.; "Yellow Paint Smeared over 4 Workmen," *Milwaukee Sentinel*, September 26, 1918; "Painting Case Stirs Up Hoan," ibid., September 28, 1918; Hoan to John Janssen, September 27, 1918, Hoan Papers, Box 26, File 660.
4. Estimates for the number of people killed worldwide range from 20 million to 100 million. See John M. Barry, *The Great Influenza: The Epic Story of the Deadliest Plague in History* (New York: Viking, 2004), 4-5, 396-98.
5. "New Disease in Milwaukee," *Milwaukee Journal*, September 16, 1918; Steven Burg, "Wisconsin and the Great Spanish Flu Epidemic of 1918," *Wisconsin Magazine of History*, vol. 84, no. 1 (autumn 2000): 39, 41-42; Alfred W. Crosby, *America's Forgotten Pandemic: The Influenza of 1918*, 2nd ed. (Cambridge, UK: Cambridge University Press, 2003), 17-55; Nancy K. Bristow, *American Pandemic: The Lost Worlds of the 1918 Influenza Epidemic* (New York: Oxford University Press, 2012), 3-4, 43-45; Barry, *The Great Influenza*, 91-99, 169-93.
6. Ibid., 201-2, 335-38; Crosby, *America's Forgotten Pandemic*, 57; "Prepare to Battle 100 Cases Here of Spanish Influenza," *Milwaukee Leader*, September 21, 1918; "Jackies Blamed for Influenza," *Milwaukee Sentinel*, September 18, 1918; "Hundred Ill of Influenza in Milwaukee," ibid., September 25, 1918; "Influenza Checked at Great Lakes," ibid., September 23, 1918; "Boston Schools Closed as Epidemic Takes Toll of 100 Dead in 24 Hours," ibid., September 24, 1918; "Spanish Influenza May Stop 'Shore Leave'," *Milwaukee Journal*, September 18, 1918; "Flue is the Grip," ibid., October 1, 1918.
7. "Liberty Loan Drive to Open Saturday with Huge Parade," September 27, 1918, in "Liberty Bonds," Milwaukee Features Microfilm; "Take $600,000 in Liberty Bonds," *Milwaukee Journal*, September 28, 1918; "Vast Throngs Cheer City's Loan Pageant," *Milwaukee Sentinel*, September 29, 1918; "25,000 Take Part in Parade Opening Liberty Bond Campaign," *Milwaukee Journal*, September 29, 1918; Anita Weschler to Edward Weschler, September 23, 1918, September 25, 1918, and October 1, 1918, Nunnemacher/Weschler Family Papers, Box 4, File 99 and File 100; "Drastic Steps to Check Influenza," *Milwaukee Sentinel*, October 6, 1918.
8. "Facilities Scarce in City Hospitals" and "Spanish Grippe Epidemic Grows," *Milwaukee Sentinel*, October 7, 1918; "Ruhland Sounds Warning on 'Flu'" and "Influenza May Close City Schools," ibid., October 8, 1918; "Unite Forces to

Check Influenza," ibid., October 9, 1918; *Bulletin of the Milwaukee Health Department*, vol. 8, no. 10-11 (October-November 1918): 3-4; *Proceedings of the Common Council of the City of Milwaukee*, October 9, 1918.

9 "Disease Peril Rouses Whole City to Fight," *Milwaukee Sentinel*, October 10, 1918; "City Starts Big Battle on Influenza," "Theaters Hard Hit by Closing Order," "Influenza Closing Order Broadened by Dr. Ruhland; Public Funerals Banned," and "City Again has 'Joyless' Days," ibid., October 11, 1918; "City Extends Grippe Edict on Meetings" and "Schools Ordered Closed by Dr. Ruhland in City's Fight on Influenza Peril," ibid., October 12, 1918; *Proceedings of the Common Council of the City of Milwaukee*, October 9, 1918; Burg, "Wisconsin and the Great Spanish Flu Epidemic," 47; Judith Walzer Leavitt, *The Healthiest City: Milwaukee and the Politics of Health Reform* (Princeton, NJ: Princeton University Press, 1982), 229-31; October 13, 1918 diary entry, Rayline D. Oestreich Papers, MCHS, Box 2.

10 "Disease Peril Rouses Whole City to Fight," *Milwaukee Sentinel*, October 10, 1918; "Schools Ordered Closed by Dr. Ruhland in City's Fight on Influenza Peril," ibid., October 12, 1918; *Proceedings of the Board of School Directors, Milwaukee, Wisconsin, July 1st, 1918—June 30th, 1919*, 121-23; October 14, 1918 diary entry, Oestreich Papers, MCHS, Box 2; Burg, "Wisconsin and the Great Spanish Flu Epidemic," 47-48; *Proceedings of the Common Council of the City of Milwaukee for the Year Ending April 15, 1919*, 554; Captain W.A. Moffet to Dan Hoan, October 10, 1918 and report of George C. Ruhland, October 21, 1918, in Hoan Collection, Box 18, File 427; Leavitt, *The Healthiest City*, 232-33; "An Active Month," *Rail and Wire*, December 1918, Milwaukee County Transit Collection, MCHS, Box 3, File 3; October diary entries, Clyde and Mattie Fuller Collection, MCHS; "Fail To Report 'Flu' Cases," *Milwaukee Journal*, October 15, 1918; Anita Weschler to Edward Weschler, October 25, 1918, Nunnemacher/Weschler Family Papers, Box 4, File 100; Milwaukee County Hospital Female Register, 1917, Milwaukee County, Institutions and Departments Collection, MCHS.

11 Burg, "Wisconsin and the Great Spanish Flu Epidemic," 47-48; "Influenza May Close City Schools," *Milwaukee Sentinel*, October 8, 1918; "Whole City to Fight 'Flu'," *Milwaukee Journal*, October 8, 1918; *The Conveyor*, November 1918, Milwaukee Coke and Gas Company Collection; "City Extends Grippe Edict on Meetings," *Milwaukee Sentinel*, October 12, 1918; "Eight Pay $5 Fines in Anti-Spitting Crusade," *Milwaukee Journal*, October 12, 1918.

12 George Ruhland to the Common Council, October 21, 1918, Hoan Collection, Box 18, File 427; *Bulletin of the Milwaukee Health Department*, vol. 8, no. 10-11 (October-November 1918): 3-4; "Many Actresses in Stores While Influenza Ban On," *Milwaukee Leader*, October 28, 1918; "Influenza Ban Off Tomorrow; Loss $1,000,000," November 3, 1918, clipping, Falk Collection, Box 1, Scrapbook, 1917-1923; "Red Cross Provides Funds for Actors," *Milwaukee Sentinel*, November 7, 1918; Hoan to William Schmidt, December 7, 1918, Hoan Collection, Box 18, File 427.

13 "'Gen. Influenza' Surrenders," *Milwaukee Journal*, November 3, 1918; Leavitt, *The Healthiest City*, 233; *Proceedings of the Common Council of the City of Milwaukee for the Year Ending April 15, 1919*, 587-88; Ruhland to Dan Hoan, November 8, 1918, Hoan Collection, Box 18, File 427; *Marquette Tribune*, November 7, 1918; "Heaven's Tears Mingle with Milwaukee Smiles for Boys 'Over There'," *Milwaukee Free Press*, November 4, 1918; "All Theaters Reopen to Capacity Crowds," *Milwaukee Sentinel*, November 5, 1918.

14 "Use Intimidation in Selling Bonds," *Milwaukee Leader*, October 3, 1918.
15 "Bond 'Slacker' Round-Up is On," *Milwaukee Journal*, October 29, 1918; "'Wouldn't Protect Own Wife'," ibid., October 31, 1918; "Farmer Buys Bonds after Label Threat," *Milwaukee Free Press*, October 31, 1918; "Liberty Bonders Bring Reign of Terror to Close," *Milwaukee Leader*, October 31, 1918; "Shut That Damned Bunk and Buy Bond Bonders Tell Man," ibid., November 2, 1918; "Religious Views Prevent Buying Bond; Is Reviled," ibid., November 4, 1918; "Flying Squadron Rounds Up Eleven," *Milwaukee Sentinel*, November 1, 1918; Hachey, "Dissenters in the Upper Middle West," 211-27.
16 "'Wouldn't Protect Own Wife'," *Milwaukee Journal*, October 31, 1918; "Liberty Bonders Bring Reign of Terror to Close," *Milwaukee Leader*, October 31, 1918; "Religious Views Prevent Buying Bond; Is Reviled," ibid., November 4, 1918.
17 Fleming, *Illusion of Victory*, 291-93; Glad, *The History of Wisconsin*, vol. V: *War, a New Era and Depression*, 50-53; George F. Kull to My Dear Mr., October 9, 1918 and Wheeler Bloodgood to Kull, October 9, 1918, both in Wisconsin, War History Commission Collection, Series 1706, Box 1, File: Minutes, 1917-1918; F.W. Rehfield to Dear Sir, October 18, 1918, Socialist Party Collection, Box 8, File 199; *Milwaukee Leader*, October 28, 1918; "Candidates Plan Rousing Finish," *Milwaukee Sentinel*, November 1, 1918; "Gen. Influenza Surrenders," *Milwaukee Journal*, November 3, 1918; *Milwaukee Free Press*, November 6, 1918; George Russell to Guy Goff, October 8, 1918, RG 65, Old German Files, Case 8000-3341; Kennedy, *Over Here*, 240-41; "Socialists Ready for Poster Vandal," *Milwaukee Leader*, October 24, 1918; Cary, "Wisconsin Loyalty Legion," 45-50; Gurda, *Making of Milwaukee*, 230; Miller, *Victor Berger and the Promise of Constructive Socialism*, 206-7.
18 Victor Berger telegram to New York Volkszeitung, November 6, 1918, Socialist Party Collection, Box 8, File 200; Olson, "The Milwaukee Socialists," 381-90; Miller, *Victor Berger and the Promise of Constructive Socialism*, 207-13; Gurda, *Making of Milwaukee*, 230-31; Hachey, "Dissent in the Upper Middle West," 365-68.

CHAPTER 11

1 "Austria Surrenders All to Gain Armistice" and "'Little Italy' Celebrates," *Milwaukee Journal*, November 4, 1918.
2 "War is at End," *Milwaukee Leader*, November 7, 1918; "Germany Surrenders," *Milwaukee Sentinel*, November 7, 1918; "City Thrown into Delirium of Peace Joy," ibid., November 8, 1918; "Milwaukee Goes Wild over News That War has Come to an End," November 7, 1918, clipping in Gregory Collection, Box 4a; *The Lindemann Sparks*, December 1918, in Pieplow Collection, Box 3, File 60.
3 "Milwaukee Goes Wild over News That War has Come to an End," November 7, 1918, clipping in Gregory Collection, Box 4a; Bruce, "Days with Children," 1918, Part II, 56-57, Bruce Collection; diary entry, Oestreich Collection; Anita Weschler to Edward Weschler, November 7, 1918, Nunnemacher/Weschler Collection, Box 4, File 101; November 7, 1918 journal entry, Stern Papers, Box 16, File 11.
4 "The Story of a Fake That Fizzled," *Milwaukee Journal*, November 8, 1918, Extra Edition.

5 "City Aroused over Peace Canard," ibid.
6 Bruce, "Days With Children," 1918, Part II, 67-68, Bruce Collection; November 11, 1918 diary entry, Richardson Collection.
7 "City to Stage Huge Parade," "'Der Tag' in Milwaukee" and "Kaiser Sentenced to be Hanged in Milwaukee," *Milwaukee Journal*, November 11, 1918; Robert W. Wells, *This is Milwaukee* (Garden City, NY: Doubleday & Company, Inc., 1970), 187-89; *The Conveyor*, December 1918, in Milwaukee Coke and Gas Company Collection; Bruce, "Days with Children," 1918, Part II, 68, Bruce Collection.
8 November 14 and November 24, 1918 journal entries, Stern Papers, Box 16, File 11.
9 "Entire Family Flu Victims," *Milwaukee Journal*, November 14, 1918. For a discussion of how social class, poverty and race affected the epidemic's impact, see Bristow, *American Pandemic*, 61-74.
10 Ruhland advertisement, *Milwaukee Journal*, December 4, 1918.
11 Imogene Weatherbee to Dan Hoan, December 12, 1918, Hoan Collection, Box 9, File 229.
12 "Flu Danger Past, Says Ruhland," *Milwaukee Journal*, November 14, 1918; *Milwaukee Leader*, November 28, 1918, in Stern Papers, Box 16, File 11; "Flu Situation Getting More Serious," *Milwaukee Journal*, November 29, 1918; Bruce, "Days with Children," 1918, Part II, 88, Bruce Collection; *Annual Report of the Commissioner of Health of the City of Milwaukee*, 1918, 127; "Schools Closed to Stop Flu," *Milwaukee Journal*, December 10, 1918; Leavitt, *The Healthiest City*, 234-37; Official Publication No. 6 on Influenza Epidemic, Milwaukee Public Schools Collection, Box 28, File: Health Dept., 1918-1921; Barry, *The Great Influenza*, 373-74.
13 Burg, "Wisconsin and the Great Spanish Flu Epidemic of 1918," 38-41, 50-51, 55; Leavitt, *The Healthiest City*, 237-39; *Annual Report of the Commissioner of Health of the City of Milwaukee*, 1918, 3, 75, 77; "City Second in Flu Fight," *Milwaukee Journal*, December 31, 1918; Crosby, *America's Forgotten Pandemic*, 311-325.

CHAPTER 12

1 Woman's Literary Club of Milwaukee to Secretary of War Baker, May 22, 1917, RG 165, Reports Relating to Training Camp Activities, Box 10, File Wisconsin.
2 Lutie Stearns, "My Seventy-five Years: Part II, 1914-1942," in *Wisconsin Magazine of History*, v. 42, no. 4 (summer 1959), 282; Victor Berger to editor, *Literary Digest*, January 10, 1918, Socialist Party Collection, Box 8, File 190.
3 James I. Clark, *Wisconsin Women Fight for Suffrage* (Madison: The State Historical Society of Wisconsin, 1956), 4-6, 8-17; Theodora W. Youmans, "How Wisconsin Women Won the Ballot," *The Wisconsin Magazine of History*, vol. 5, no. 1 (September 1921): 19-23; Genevieve G. McBride, *On Wisconsin Women: Working for Their Rights from Settlement to Suffrage* (Madison: The University of Wisconsin Press, 1993), 197; John D. Buenker, *The History of Wisconsin*, vol. IV: *The Progressive Era, 1893-1914*, gen. ed. William Fletcher Thompson (Madison: State Historical Society of Wisconsin, 1998), 345-52; Avella, *In the Richness of the Earth*, 420-21; Glad, *The History of Wisconsin*, vol. V: *War, a New Era and Depression*, 104-9.

4 McBride, *On Wisconsin Women*, 278-82; Youmans, "How Wisconsin Women Won the Ballot," 29-30; Kathleen Kennedy, "Loyalty and Citizenship in the Wisconsin Woman's Suffrage Association, 1917-1919," *Mid-America*, vol. 76, no. 2 (spring/summer 1994), 111-28; Idem, *Disloyal Mothers and Scurrilous Citizens: Women and Subversion During World War I* (Bloomington: Indiana University Press, 1999), 11-15; Meta Berger to Executive Board of the Woman's Suffrage Association, October 8, 1917, in Berger Papers, General Correspondence; "Mrs. Berger Says Wisconsin Suffragettes are Not Sufficiently Radical to Suit Her," *Milwaukee Sentinel*, October 9, 1917; Swanson, ed., *A Milwaukee Woman's Life on the Left*, xiii-xx.
5 "Call Suffragists Domestic Enemies," *Milwaukee Sentinel*, December 6, 1917; Fleming, *The Illusion of Victory*, 279.
6 Ibid.; Mabel Search to G.F. Kull, June 4, 1918, Wisconsin, War History Commission Collection, Series 1706, Box 3, File: Correspondence, May 1918.
7 Fleming, *The Illusion of Victory*, 260; "Woman's Party Tags; They Slip One Over," *Milwaukee Leader*, November 5, 1918; Clark, *Wisconsin Women Fight for Suffrage*, 18-19; Glad, *The History of Wisconsin*, vol. V: *War, a New Era and Depression*, 109.
8 Arthur H. Bartelt to Charles McCarthy, June 23, 1917, Charles McCarthy Papers, WHS, Box 15, File 2.
9 H.W. Ladish telegrams to Robert La Follette, Paul Husting, et al, June 26, 1917, and July 31, 1917, in Milwaukee Grain Exchange Collection, Box 4, File 4; Magnus Swenson to Beatrice Seering, November 7, 1917, RG 4, U.S. Food Administration, Records of the Wisconsin State Food Administrator, Box 15, file 32C; Paul W. Glad, "When John Barleycorn Went into Hiding in Wisconsin," *Wisconsin Magazine of History*, vol 68, no. 2 (winter 1984-1985): 123-28; Elizabeth Jozwiak, "Bottoms Up: The Socialist Fight for the Workingman's Saloon," *Wisconsin Magazine of History*, vol. 90, no. 2 (winter 2006-2007): 12-14; Fleming, *Illusion of Victory*, 280-82; John Gurda, *Miller Time: A History of Miller Brewing Company, 1855-2005* (Milwaukee: Miller Brewing Company, 2005), 93-98; Thomas C. Cochran, *The Pabst Brewing Company: The History of an American Business* (New York: New York University Press, 1948), 304-23; Glad, *The History of Wisconsin*, vol. V: *War, a New Era and Depression*, 88-96; Avella, *In the Richness of the Earth*, 421-22; Wells, *This is Milwaukee*, 189-91.
10 H.W. Ladish telegram to Robert La Follette, et al., December 13, 1917, Milwaukee Grain Exchange Collection, Box 4, File 4; Still, *Milwaukee: The History of a City*, 491-92; "The Brewers to the Public," *Milwaukee Leader*, November 27, 1917; "View Dry Bill's Passage as Blow," *Milwaukee Sentinel*, December 18, 1917.
11 B.C. Hoppe to Editor, *Milwaukee Leader*, February 28, 1918.
12 "Beer Making Ordered Stopped by Dec. 1," *Milwaukee Sentinel*, September 7, 1918; "Prince Hops Dies; 6,500 Orphans," *Milwaukee Journal*, December 1, 1918; Glad, "When John Barleycorn Went into Hiding," 128-36; Glad, *The History of Wisconsin*, vol. V: *War, a New Era and Depression*, 94-96; Gurda, *Miller Time*, 98; Cochran, *The Pabst Brewing Company*, 321-23; Gurda, *The Making of Milwaukee*, 236-39, 297-98; Still, *Milwaukee: The History of a City*, 492-94; Bruce, "Days with Children," 1919, Part I, 16-17, Bruce Collection.
13 Proverbs, 23: 27-28 (King James Version).
14 Paul H. Hass, "Sin in Wisconsin: The Teasdale Vice Committee of 1913," *Wisconsin Magazine of History*, vol. 49, no. 2 (winter 1965-1966): 138-39; James John Bergman, "From River Street to Every Street: The Termination of

Milwaukee's Segregated Vice District," (M.A. Thesis, Marquette University, 1984), 2-4; Still, *Milwaukee: The History of a City*, 426-27; *The Sporting and Club House Guide to Milwaukee* (Rochester & Taylor, 1889), 13-15, MCHS.

15 Allan M. Brandt, *No Magic Bullet: A Social History of Venereal Disease in the United States Since 1880* (New York: Oxford University Press, 1985), 7-23; Abigail Claire Barnes, "Pure Spaces and Impure Bodies: The Detention of Prostitutes in the U.S. during World War One," (Ph.D. Dissertation, University of California, Los Angeles, 2010), 76-86; Hass, "Sin in Wisconsin," 138-39; George Meyer to Mr. Robison, July 6, 1914, Wisconsin Legislature: Investigations, WHS, Box 19, File 2/3/1/3-8.

16 Barbara Antoniazzi, *The Wayward Woman: Progressivism, Prostitution and Performance in the United States, 1888-1917* (Madison, NJ: Fairleigh Dickinson University Press, 2014), 2-5; Barnes, "Pure Spaces and Impure Bodies," 110-15; Barbara Meil Hobson, *Uneasy Virtue: The Politics of Prostitution and the American Reform Tradition* (New York: Basic Books, Inc., 1987), 150-54.

17 Brandt, *No Magic Bullet*, 33-34; Bergman, "From River Street to Every Street," 9-12; *Report and Recommendations of the Wisconsin Legislative Committee to Investigate the White Slave Traffic and Kindred Subjects* (Madison, 1914), 133-34.

18 Report and Recommendations of the Wisconsin Legislative Committee, 209-12; Victor Berger quoted in Hass, "Sin in Wisconsin," 149; Still, *Milwaukee: The History of a City*, 426-27; Bergman, "From River Street to Every Street," 1, 15-27. Bergman asserts that the Socialists were not responsible for closing the vice district; rather, he contends that "fusionists" politicians who defeated the Socialists in the 1912 election accomplished it. The Teasdale Committee, however, indicates the clamp down occurred in 1911.

19 "Amusements and Recreation in Milwaukee," A Bulletin of the City Club, City Club of Milwaukee Collection, Box 55, File: Printed Publications, 1913-1915; Report of the City Club on Public Amusements and Morals on Dance Halls and Public Morals, Wisconsin Legislature: Investigations, Box 19, File 2/3/1/3-8; *Report and Recommendations of the Wisconsin Legislative Committee*, 38-79; Hass, "Sin in Wisconsin," 139-42; David J. Pivar, *Purity and Hygiene: Women, Prostitution, and the "American Plan," 1900-1930* (Westport, CT: Greenwood Press, 2002), 177-183.

20 *Report and Recommendations of the Wisconsin Legislative Committee*, 100-24, 151; Hass, "Sin in Wisconsin," 145-51; "Amusements and Recreation in Milwaukee," 22-27.

21 Brandt, *No Magic Bullet*, 52-61; Nancy K. Bristow, *Making Men Moral: Social Engineering during the Great War* (New York: New York University Press, 1996), 1-8; Barnes, "Pure Spaces and Impure Bodies," 129-35.

22 Brandt, *No Magic Bullet*, 56-70; Bristow, *Making Men Moral*, 18-23, 30-33; 42-43, 85-90.

23 Brandt, *No Magic Bullet*, 70-73, 92-95. In "Pure Spaces and Impure Bodies," Abigail Barnes asserts Snow's and Gorgas' figures were inflated to fit the political purposes the Wilson administration needed at the time. Induction physicals were poor sources of data because they were cursory exams conducted by volunteer doctors who were overwhelmed by the sheer number of draftees. In fact, other contemporary studies contradicted Snow's claim, reporting disease rates under three percent. Moreover, venereal diseases ranked sixth (syphilis) and seventh (gonorrhea) behind tuberculosis, heart disease, flat feet, ear infections and hernias. These facts were downplayed, and Snow's and

Gorgas' results were promoted to give the impression that the venereal disease epidemic depleted military efficiency, thus constituting a national emergency.

24 Hobson, *Uneasy Virtue*, 165-68; Wilbur A. Sawyer to George Ruhland, February 28, 1918, RG 62, Records of the Council of National Defense, General Medical Board, Series 11BC-A2, Box 442, File: Milwaukee, Wisconsin.

25 Barnes, "Pure Spaces and Impure Bodies," 27-32; Bristow, *Making Men Moral*, 91-103, 113-20; Brandt, *No Magic Bullet*, 80-84; Hobson, *Uneasy Virtue*, 175-79.

26 Brandt, *No Magic Bullet*, 73-80, 87-89; Barnes, "Pure Spaces and Impure Bodies," 25-26, 112, 143-49; *Annual Report of the Surgeon General of the Public Health Service of the United States for the Fiscal Year 1919* (Washington, D.C.: Government Printing Office, 1919), 234-36.

27 Newton Baker to E.L. Philipp, May 26, 1917, Philipp Papers, Box 4, File: Correspondence; *Laws of Wisconsin, 1917*, Chapter 235.

28 Wisconsin State Executive, National War Council to the Clergy of Wisconsin, November 8, 1917, Wisconsin, State Council of Defense Collection, Woman's Committee Records, Series 1649, Box 11, File 17; Circular to Madam President, November 2, 1917, ibid., Box 5, File 3; "Hygiene Society Seeks Ways to Aid Girls," *Milwaukee Journal*, November 11, 1917; "Local Society to Fight Social Evil," *Milwaukee Leader*, December 6, 1917; "Discuss Plans to Eradicate Disease," *Milwaukee Sentinel*, December 12, 1917.

29 George Ruhland to H.H. Moore, Council of National Defense, February 14, 1918, RG 62, Records of the Council of National Defense, General Medical Board, Series 11BC-A2, Box 442, File: Milwaukee, Wisconsin; Ruhland to Rupert Blue, Surgeon General, January 15, 1918, RG 90, General Records of the Public Health Service, General Records of the Venereal Disease Division, Legislative Files-Legal Files, Box 308; *Proceedings of the Common Council of the City of Milwaukee, 1917*, 755, 828, Ordinances, 118.

30 Hoan to H.H. Moore, Council of National Defense, March 6, 1918 and Dr. Franklin Martin to Hoan, March 18, 1918, both in RG 62, Records of the Council of National Defense, General Medical Board, Series 11BC-A2, Box 442, File: Milwaukee, Wisconsin.

31 "Women Vote to Investigate Vice in Milwaukee," *Milwaukee Leader*, May 21, 1918; "U.S. Combats Vice by Drastic Steps," *Milwaukee Sentinel*, December 15, 1918.

32 "Naval Officer Lauds Police of Milwaukee" and "Girl Held Prisoner in Road House," both in *Milwaukee Sentinel*, October 31, 1918. See also RG 65, Old German Files, Cases 284347, 302169, 302484, 309623, 311126 and 8000-254164. Prostitution was not a crime, but individual prostitutes were generally prosecuted as vagrants, an outgrowth of British common law. See Thomas C. Mackey, *Red Lights Out: A Legal History of Prostitution, Disorderly Houses and Vice Districts, 1870-1917* (New York: Garland Publishing, Inc., 1987), 28-92.

33 Roger Flanders, Report on Milwaukee, November 2-18, 1918, RG 165, Records of the War Department General and Special Staffs, Law Enforcement Division Field Reports, Box 26; "Federal Agents in City to Lead Fight on Vice," *Milwaukee Journal*, November 9, 1918; "Hotel Men Join Fight on Vice," ibid., November 12, 1918.

34 "'Vice Must Go in Milwaukee,' Says Army Man," *Milwaukee Journal*, November 13, 1918; Roger Flanders, Report on Milwaukee, November 2-18, 1918, RG 165, Records of the War Department General and Special Staffs, Law Enforcement Division Field Reports, Box 26.

35 "Moral Crusade Nets City Treasury $90 in Fines from 9 Women," *Milwaukee Leader*, November 12, 1918; "Vice Conditions Terrible, Judge Page Declares," *Milwaukee Journal*, December 13, 1918; "Opinion on City Morals Varies," ibid., December 14, 1918; "Vice Wave Laid to Liquor," ibid., December 15, 1918; "Much Vice Here Preventable," ibid., December 16, 1918.
36 The Milwaukee Police Department arrested a total of 230 women in 1917 for either being an inmate of or keeping a disorderly house/house of ill fame. In 1918, the number was 227. See *Annual Report of the Chief of Police of the City of Milwaukee,* 1917, 12-13, and ibid., 1918, 12.
37 "U.S. Combats Vice by Drastic Steps," *Milwaukee Sentinel*, December 15, 1918; Barnes, "Pure Spaces and Impure Bodies," 3-4, 29-30, 68, 86-100, 120-30; Report of Progress, Field Service, Women and Girls, Interdepartmental Social Hygiene Board, March 1, 1919-May 1, 1919, in RG 24, Records of the Bureau of Naval Personnel, Morale Division, Entry 410, Box 35, File 345.
38 Brandt, *No Magic Bullet*, 85-87; Barnes, "Pure Spaces and Impure Bodies," 157-65; Pivar, *Purity and Hygiene*, 212-25; Hobson, *Uneasy Virtue*, 168-71.
39 Ibid., 137-49; "Standard Forms of Laws" (Washington: War and Navy Departments, Commission on Training Camp Activities, 1918), 5.
40 "U.S. Combats Vice by Drastic Steps," *Milwaukee Sentinel*, December 15, 1918; *Annual Report of the Surgeon General of the Public Health Service of the United States for the Fiscal Year 1919*, 289-90; Biennial Report, Wisconsin State Board of Health Bureau of Venereal Diseases to C.C. Pierce, Assistant Surgeon General U.S. Public Health Service, March 3, 1921, in RG 90, General Records of the Public Health Service, General Records of the Venereal Disease Division, Box 113, File 247.4.
41 George Ruhland to Leo Tiefenthaler, City Club of Milwaukee, November 4, 1919, City Club of Milwaukee Collection, Box 8, File 5; State Board of Health to W.D. Owens, Navy Department, May 22, 1919, in RG 24, Records of the Bureau of Naval Personnel, Morale Division, Entry 410, Box 35, File 345; Biennial Report, Wisconsin State Board of Health Bureau of Venereal Diseases to C.C. Pierce, Assistant Surgeon General U.S. Public Health Service, March 3, 1921, in RG 90, General Records of the Public Health Service, General Records of the Venereal Disease Division, Box 113, File 247.4; "City to Guard Returning Men from All Vice," *Milwaukee Journal*, November 25, 1918; "Health of Men to be Guarded," ibid., December 7, 1918; "Make Plans to Protect Soldiers from Vice," ibid., December 17, 1918; *Annual Report of the Commissioner of Health of the City of Milwaukee,* 1918, 30.
42 Ibid.
43 Barnes, "Pure Spaces and Impure Bodies," 179-82.

CHAPTER 13

1 Speech by Victor Berger, ca. September 1919, Speeches and Writings by Berger, Berger Papers, Roll 28.
2 Bruce, "Days with Children," 1919, Part II, 19-20, Bruce Collection.
3 Peterson and Fite, *Opponents of War*, 285-96; Nelson, *German-American Political Behavior*, 52-56; November 24, 1918 journal entry, Stern Papers, Box 16, File 11.
4 Patrick Cudahy to the Editor, *Milwaukee Sentinel*, November 15 and December 7, 1918.
5 "Score Plays in German," *Milwaukee Journal*, February 14, 1919; "German Play for Benefit is Opposed," *Milwaukee Sentinel*, February 14, 1919.

6 Minutes of a Protest Meeting, February 15, 1919, in German-American Collection, MCHS, Box 1, File 13; "Protests Halt German Play," *Milwaukee Journal*, February 16, 1919; "More Opposition to German Play," *Milwaukee Sentinel*, February 15, 1919; "German Benefit Play Called Off after Protests," *Milwaukee Sentinel*, February 16, 1919.
7 Gurda, *The Making of Milwaukee*, 225-26, 233.
8 Report from E.W. Day to David Groh, January 17, 1919, RG 165, Records of the War Department General and Special Staffs, Military Intelligence Division, Plant Protection Section, Box 4, File: Briggs Loading.
9 Hoan to the Executive Committee of the Community Homecoming Celebration, January 17, 1919, Hoan Collection, Box 36, File 908; Paul Jenkins to Walter Distelhorst, January 18, 1919, ibid.; Stachowski, "Political Career of Daniel Hoan," 85-86; Reinders, "Daniel W. Hoan and the Milwaukee Socialist Party During the First World War," 55; Kerstein, *Milwaukee's All-American Mayor*, 209; "Giant Crowd Hisses Mayor Hoan Down at Auditorium as Soldiers and Sailors Get Greatest Ovation Ever," *Milwaukee Journal*, January 19, 1919; Olson, "The Milwaukee Socialists," 390-91.
10 "Hoan, Undaunted by Riot Campaign, Welcomes Troops" and "Mayor Issues Statement on Soldier Meet," *Milwaukee Leader*, January 20, 1919; Hoan Statement, Hoan Collection, Box 35, File 895.
11 "62 Reds in City to be Deported," *Milwaukee Sentinel*, January 3, 1920; Glad, *The History of Wisconsin*, vol. V: *War, a New Era and Depression*, 67-73; "59 Radicals in County Jail; 47 Others Escape," *Milwaukee Journal*, January 4, 1920.
12 Miller, *Victor Berger and the Promise of Constructive Socialism*, 227-44; Report of E.W. Day to David S. Groh, December 2, 1918, RG 165, War Department General and Special Staffs, Military Intelligence Division, Plant Protection Section, Box 13, File Miscellaneous (1 of 2); Gurda, *The Making of Milwaukee*, 231-33.
13 Report of E.W. Day to David S. Groh, December 2, 1918, RG 165, War Department General and Special Staffs, Military Intelligence Division, Plant Protection Section, Box 13, File Miscellaneous (1 of 2); Gurda, *The Making of Milwaukee*, 243-44; "City has Huge Mill Output," *Milwaukee Journal*, December 31, 1918; Still, *Milwaukee: The History of a City*, 496-97; Thomas W. Gavett, *Development of the Labor Movement in Milwaukee* (Madison: The University of Wisconsin Press, 1965), 126-37; Robert W. Ozanne, *The Labor Movement in Wisconsin: A History* (Madison: The State Historical Society of Wisconsin, 1984), 56-57, 103-6.
14 "Women Play Great Part Here in Munitions Work," *Milwaukee Sentinel*, December 15, 1918.
15 Ibid.; Brown, *Rosie's Mom*, 159-84, 197; "City has Huge Mill Output," *Milwaukee Journal*, December 31, 1918; Report of E.W. Day to David S. Groh, January 9, 1919, RG 165, Records of the War Department General and Special Staffs, Military Intelligence Division, Plant Protection Section, Box 13, File: Miscellaneous; Report of the Committee on Education, October 11, 1918, Milwaukee-Downer College Collection, Series 1, Box 8, File 4; *Seventh Annual Report of the Citizens' Committee on Unemployment*, July 1, 1918, to June 30, 1919, 6-7; James L. Abrahamson, *The American Home Front: Revolutionary War, Civil War, World War I, World War II* (Fort Lesley J. McNair, Washington D.C.: National Defense University Press, 1983), 95-96.
16 Harries, *The Last Days of Innocence*, 8; Stone, *Perilous Times*, 230; Fleming, *The Illusion of Victory*, 394-401; Kennedy, *Over Here*, 86-92.
17 January 10, 1919 journal entry, Stern Papers, Box 17, File 2.

BIBLIOGRAPHY

BOOKS

Abrahamson, James L. *The American Home Front: Revolutionary War, Civil War, World War I, World War II*. Fort Lesley J. McNair, Washington, D.C.: National Defense University Press, 1983.

Ameringer, Oscar. *If You Don't Weaken: The Autobiography of Oscar Ameringer*. New York: Greenwood Press, 1940.

Anderson, Harry H. and Frederick I. Olson. *Milwaukee: At the Gathering of the Waters*. Tulsa, OK: Continental Heritage Press, 1981.

Antoniazzi, Barbara. *The Wayward Woman: Progressivism, Prostitution, and Performance in the United States, 1888-1917*. Madison, NJ: Fairleigh Dickinson University Press, 2014.

Austin, H. Russell. *The Milwaukee Story: The Making of an American City*. The Milwaukee Journal, 1946.

Avella, Steven M. *In the Richness of the Earth: A History of the Archdiocese of Milwaukee, 1843-1958*. Milwaukee, WI: Marquette University Press, 2002.

Axelrod, Alan. *Selling the Great War: The Making of American Propaganda*. New York: Palgrave MacMillan, 2009.

Barry, John M. *The Great Influenza: The Epic Story of the Deadliest Plague in History*. New York: Viking, 2004.

Beck, Elmer A. *The Sewer Socialists: A History of the Socialist Party of Wisconsin, 1897-1940*. Vol. 1: *The Socialist Trinity of the Party, the Unions and the Press*. Fennimore, WI: Westburg Associates Publishers, 1982.

Brandt, Allan M. *No Magic Bullet: A Social History of Venereal Disease in the United States Since 1880*. New York: Oxford University Press, 1985.

Bristow, Nancy K. *American Pandemic: The Lost Worlds of the 1918 Influenza Epidemic*. Oxford: Oxford University Press, 2012.

Bristow, Nancy K. *Making Men Moral: Social Engineering during the Great War*. New York: New York University Press, 1996.

Brown, Carrie. *Rosie's Mom: Forgotten Women Workers of the First World War*. Boston: Northeastern University Press, 2002.

Brown, Victoria. *Uncommon Lives of Common Women: The Missing Half of Wisconsin History*. Madison, WI: Feminists Project Fund, 1975.

Bruce, William George, ed. *History of Milwaukee City and County*. 3 vols. Chicago: The S.J. Clarke Publishing Company, 1922.

Bruce, William George. *I was Born in America: Memoirs of William George Bruce*. Milwaukee: The Bruce Publishing Company, 1937.

Buenker, John D. *The History of Wisconsin*. Vol. IV: *The Progressive Era, 1893-1914*. William Fletcher Thompson, gen. ed. Madison: State Historical Society of Wisconsin, 1998.

Buenker, John D. and Beverly J.K. Buenker, eds. *Milwaukee in the 1930s: A Federal Writers Project City Guide*. Madison: Wisconsin Historical Society Press, 2016.

Capozzola, Christopher. *Uncle Sam Wants You: World War I and the Making of the Modern American Citizen*. New York: Oxford University Press, 2008.

Carini, Mario A. with Austin Goodrich. *Milwaukee's Italians: The Early Years*. Milwaukee: The Italian Community Center of Milwaukee, 1999.

Clark, James I. *Wisconsin Women Fight for Suffrage*. Madison: State Historical Society of Wisconsin, 1956.

Cochran, Thomas C. *The Pabst Brewing Company: The History of an American Business*. New York: New York University Press, 1948.

Conrad, Will C., Kathleen F. Wilson and Dale Wilson. *The Milwaukee Journal: The First Eighty Years*. Madison: The University of Wisconsin Press, 1964.

Constantine, J. Robert, ed. *Letters of Eugene V. Debs*. Vol 2: 1913-1919. Urbana, IL: University of Illinois Press, 1990.

Controvich, James T. *The United States in World War I: A Bibliographic Guide*. Lanham, MD: The Scarecrow Press, 2012.

Crosby, Alfred W. *America's Forgotten Pandemic: The Influenza of 1918*. 2nd ed. Cambridge University Press, 2003.

Doenecke, Justus D. *Nothing Less Than War: A New History of America's Entry into World War I*. Lexington, KY: The University Press of Kentucky, 2011.

Farina, Anthony J. *"I Must, I Must, I Must": The Story of the Italian Evangelical Church of Wisconsin*. Sun Prairie, WI: Commission on Archives and History, Wisconsin Conference United Methodist Church, 2008.

Fleming, Thomas. *The Illusion of Victory: America in World War I*. New York: Basic Books, 2003.

Ford, Nancy Gentile. *The Great War and America: Civil-Military Relations during World War I*. Westport, CT: Praeger Security International, 2008.

Foss-Mollan, Kate. *Hard Water: Politics and Water Supply in Milwaukee, 1870-1995*. West Lafayette, IN: Purdue University Press, 2001.

Gavett, Thomas W. *Development of the Labor Movement in Milwaukee*. Milwaukee: The University of Wisconsin Press, 1965.

Glad, Paul W. *The History of Wisconsin*. Vol. V: *War, a New Era, and Depression, 1914-1940*. William Fletcher Thompson, gen. ed. Madison: State Historical Society of Wisconsin, 1990.

Gregory, John G. *History of Milwaukee, Wisconsin*. 4 vols. Chicago: The S.J. Clarke Publishing Company, 1931.

Gurda, John, comp. *Cream City Chronicles: Stories of Milwaukee's Past*. Madison: Wisconsin Historical Society Press, 2007.

Gurda, John. *The Making of Milwaukee*. Milwaukee, WI: Milwaukee County Historical Society, 1999.

Gurda, John. *Miller Time: A History of Miller Brewing Company, 1855-2005*. Milwaukee: Miller Brewing Company, 2005.

Gurda, John. *One People, Many Paths: A History of Jewish Milwaukee*. Milwaukee: Jewish Museum Milwaukee, 2009.

Gurda, John. *The West End: Merrill Park, Pigsville, Concordia*. University of Wisconsin System Board of Regents, 1980.

Harries, Meirion and Susie Harries. *The Last Days of Innocence: America at War, 1917-1918*. New York: Random House, 1997.

Heyman, Neil M. *Daily Life During World War I*. Westport, CT: Greenwood Press, 2002.

Hoan, Daniel W. *City Government: The Record of the Milwaukee Experiment*. New York: Harcourt, Brace and Company, 1936.

Hobson, Barbara Meil. *Uneasy Virtue: The Politics of Prostitution and the American Reform Tradition*. New York: Basic Books, Inc., 1987.

Hooker, Bill. *Glimpses of an Earlier Milwaukee*. Milwaukee: The Milwaukee Journal Public Service Bureau, 1929.

Jablonsky, Thomas J. *Milwaukee's Jesuit University: Marquette, 1881-1981*. Milwaukee, WI: Marquette University Press, 2007.

Jacobson, Matthew Frye. *Whiteness of a Different Color: European Immigrants and the Alchemy of Race*. Cambridge, MA: Harvard University Press, 1998.

Jensen, Joan M. *The Price of Vigilance*. Chicago: Rand McNally & Company, 1968.

Jensen, Kimberly. *Mobilizing Minerva: American Women in the First World War*. Urbana, IL: University of Illinois Press, 2008.

Kennedy, David M. *Over Here: The First World War and American Society*. New York: Oxford University Press, 1980.

Kennedy, Kathleen. *Disloyal Mothers and Scurrilous Citizens: Women and Subversion During World War I*. Bloomington: Indiana University Press, 1999.

Kerstein, Edward. *Milwaukee's All-American Mayor: Portrait of Daniel Webster Hoan*. Englewood Cliffs, NJ: Prentice-Hall, Inc., 1966.

Kingsbury, Celia Malone. *For Home and Country: World War I Propaganda on the Home Front*. Lincoln: University of Nebraska Press, 2010.

Korman, Gerd. *Industrialization, Immigrants and Americanizers: The View from Milwaukee, 1866-1921*. Madison: State Historical Society of Wisconsin, 1967.

Kornweibel, Theodore, Jr. *"Investigate Everything": Federal Efforts to Compel Black Loyalty During World War I*. Bloomington, IN: Indiana University Press, 2002.

Kreuter, Kent and Gretchen. *An American Dissenter: The Life of Algie Martin Simons*. Lexington: University of Kentucky Press, 1969.

Kuhlman, Erika. *Of Little Comfort: War Widows, Fallen Soldiers, and the Remaking of the Nation after the Great War*. New York: New York University Press, 2012.

Landau, Henry. *The Enemy Within: The Inside Story of German Sabotage in America*. New York: G.P. Putnam's Sons, 1937.

La Piana, George. *The Italians in Milwaukee Wisconsin: General Survey*. Prepared under the direction of the Associated Charities, 1915.

Leavitt, Judith Walzer. *The Healthiest City: Milwaukee and the Politics of Health Reform*. Princeton, NJ: Princeton University Press, 1982.

Luebke, Frederick C. *Bonds of Loyalty: German-Americans and World War I*. Dekalb: Northern Illinois University Press, 1974.

Mackey, Thomas C. *Red Lights Out: A Legal History of Prostitution, Disorderly Houses and Vice Districts, 1870-1917*. New York: Garland Publishing, Inc., 1987.

Maxwell, Robert S. *Emanuel L. Philipp, Wisconsin Stalwart*. Madison: State Historical Society of Wisconsin, 1959.

McBride, Genevieve G. *On Wisconsin Women: Working for Their Rights from Settlement to Suffrage*. Madison: The University of Wisconsin Press, 1993.

McCarthy, John. *Making Milwaukee Mightier: Planning and the Politics of Growth, 1910-1960*. Dekalb, IL: Northern Illinois University Press, 2009.

Miller, Sally M. *Victor Berger and the Promise of Constructive Socialism, 1910-1920*. Westport, CT: Greenwood Press, Inc., 1973.

Millman, Chad. *The Detonators: The Secret Plot to Destroy America and an Epic Hunt for Justice*. New York: Little, Brown and Company, 2006.

Mills, Bill. *The League: The True Story of Average Americans on the Hunt for WWI Spies*. New York: Skyhorse Publishing, 2013.

Nelson, Clifford L. *German-American Political Behavior in Nebraska and Wisconsin, 1916-1920*. University of Nebraska-Lincoln, Publication No. 217, 1972.

Olmsted, Kathryn S. *Real Enemies: Conspiracy Theories and American Democracy, World War I to 9/11*. New York: Oxford University Press, 2009.

Ottensmann, John R. *The Changing Spatial Structure of American Cities*. Lexington, MA: D.C. Heath and Company, 1975.

Ozanne, Robert W. *The Labor Movement in Wisconsin: A History*. Madison: State Historical Society of Wisconsin, 1984.

Peterson, H.C. and Gilbert C. Fite. *Opponents of War, 1917-1918*. Madison: University of Wisconsin Press, 1957.

Pivar, David J. *Purity and Hygiene: Women, Prostitution, and the "American Plan," 1900-1930*. Westport, CT: Greenwood Press, 2002.

Pixley, R.B. *Wisconsin in the World War*. Milwaukee: The Wisconsin War History Company, 1919. Prigge, Matthew J. *Outlaws, Rebels, & Vixens: Motion Picture Censorship in Milwaukee, 1914-1971*. Milwaukee: Conway Street Press, 2016.

Richardson, Matthew. *The Hunger War: Food, Rations and Rationing, 1914-1918*. Barnsley: Pen & Sword Military, 2015.

Schaffer, Ronald. *America in the Great War: The Rise of the War Welfare State*. New York: Oxford University Press, 1991.

Stevens, Michael E., ed. *The Family Letters of Victor and Meta Berger*. Madison: State Historical Society of Wisconsin, 1995.

Still, Bayrd. *Milwaukee: The History of a City*. Madison: State Historical Society of Wisconsin, 1948.

Stone, Geoffrey R. *Perilous Times: Free Speech in Wartime, From the Sedition Act of 1798 to the War on Terrorism*. New York: W.W. Norton & Company, 2004.

Stone, Geoffrey R. *War and Liberty: An American Dilemma: 1790 to the Present*. New York: W.W. Norton & Company, 2007.

Strang, Dean A. *Worse Than the Devil: Anarchists, Clarence Darrow and Justice in a Time of Terror*. Madison: The University of Wisconsin Press, 2013.

Swanson, Kimberly, ed. *A Milwaukee Woman's Life on the Left: The Autobiography of Meta Berger*. Madison: State Historical Society of Wisconsin, 2001.

Swichkow, Louis J. and Lloyd P. Gartner. *The History of the Jews in Milwaukee*. Philadelphia: The Jewish Publication Society of America, 1963.

Tanzilo, Robert. *The Milwaukee Police Station Bomb of 1917*. Charleston, SC: The History Press, 2010.

Thomas, William H., Jr. *Unsafe for Democracy: World War I and the U.S. Justice Department's Covert Campaign to Suppress Dissent*. Studies in American Thought and Culture. Paul Boyer, ed. Madison: The University of Wisconsin Press, 2008.

Traxel, David. *Crusader Nation: The United States in Peace and the Great War, 1898-1920*. New York: Alfred A. Knopf, 2006.

Trotter, Joe William, Jr. *Black Milwaukee: The Making of an Industrial Proletariat, 1915-1945*. Urbana, IL: University of Illinois Press, 1985.

Tuttle, Liza. *A Club of Their Own: 125 Years of the Woman's Club of Wisconsin*. Milwaukee: The Woman's Club of Wisconsin, 2000.

Vecchio, Diane C. *Merchants, Midwives, and Laboring Women: Italian Migrants in Urban America*. Urbana, IL: University of Illinois Press, 2006.

Weiss, Elaine F. *Fruits of Victory: The Woman's Land Army of America in the Great War*. Washington, D.C.: Potomac Books, Inc., 2008.

Wells, Robert W. *The Milwaukee Journal: An Informal Chronicle of Its First 100 Years*. Milwaukee: Milwaukee Journal, c1981.

Wells, Robert W. *This is Milwaukee*. Garden City, NY: Doubleday & Company, Inc.,

1970.

Widen, Larry and Judi Anderson. *Silver Screens: A Pictorial History of Milwaukee's Movie Theaters*. Madison: Wisconsin Historical Society Press, 2007.

Wiebe, Robert H. *The Search for Order, 1877-1920*. The *Making of America* series, gen. ed. David Herbert Donald. New York: Hill and Wang, 1967.

Zimmermann, H. Russell. *Magnificent Milwaukee: Architectural Treasures, 1850-1920*. Milwaukee: Milwaukee Public Museum, 1987.

ARTICLES

Bos, Linda Marie. "Let Us Act Promptly: School Sisters of Notre Dame and World War I." *U.S. Catholic Historian* vol. 12, no. 3 (summer 1994): 73-86.

Bruce, William George. "Milwaukee: A Great Industrial City." *Wright's Directory*. Milwaukee: Wright Co., 1916.

Burg, Steven, "Wisconsin and the Great Spanish Flu Epidemic of 1918." *The Wisconsin Magazine of History* vol. 84, no. 1 (autumn 2000): 36-56.

Cary, Lorin Lee. "The Wisconsin Loyalty Legion, 1917-1918." *Wisconsin Magazine of History* vol. 53, no. 1 (autumn 1969): 33-50.

Chester, Eric. "Traitors, Spies and Military Tribunals: The Assault on Civil Liberties During World War I." *New Politics* vol. 14, no. 2 (winter 2013): 77-89.

Edwards, John Carver. "The Price of Political Innocence: The Role of the National Security League in the 1918 Congressional Election." *Military Affairs*, v. 42, no. 4 (December 1978): 190-96.

Falk, Karen, "Public Opinion in Wisconsin During World War I." *The Wisconsin Magazine of History* vol. 25, no. 4 (June 1942): 389-407.

Fure-Slocum, Eric. "Milwaukee Labor and Urban Democracy." In *Perspectives on Milwaukee's Past*, ed. Margo Anderson and Victor Greene, 48-78. Urbana, IL: University of Illinois Press, 2009.

Gale, Zona. "Milwaukee." *Good Housekeeping*, vol. 50, no. 3 (March 1910): 317-25.

Glad, Paul W. "When John Barleycorn Went into Hiding in Wisconsin." *The Wisconsin Magazine of History* vol. 68, no. 2 (winter 1984-1985): 119-36.

Gross, Edwin J. "Public Hysteria: First World War Variety." *Historical Messenger* (June 1961): 2-8.

Hass, Paul H. "Sin in Wisconsin: The Teasdale Vice Committee of 1913." *Wisconsin Magazine of History* vol. 49, no. 2 (winter 1965-1966): 138-51.

Janik, Erika. "Food will Win the War: Food Conservation in World War I Wisconsin." *Wisconsin Magazine of History* vol. 93, no. 3 (spring 2010): 16-27.

Jozwiak, Elizabeth. "Bottoms Up: The Socialist Fight for the Workingman's Saloon." *Wisconsin Magazine of History* v. 90, no. 2 (winter 2006-2007): 12-23.

Jozwiak, Elizabeth. "Politics in Play: Socialism, Free Speech, and Social Centers in Milwaukee." *Wisconsin Magazine of History* vol. 86, no. 3 (spring 2003): 10-21.

Kennedy, Kathleen. "Loyalty and Citizenship in the Wisconsin Woman's Suffrage Association, 1917-1919." In *Mid-America*, vol. 76, no. 2 (spring/summer 1994): 109-31.

King, Charles. "Memories of a Busy Life." *The Wisconsin Magazine of History* vol. 6 (1922-1923): 165-88.

Kull, George F. "Wisconsin Loyalty Legion." In *The Wisconsin Blue Book, 1919*. Madison: Democrat Printing Company, 1919: 415-16.

Kuznlewski, Anthony J. "Milwaukee's Poles, 1866-1918: The Rise and Fall of a

Model Community." In *Milwaukee Stories*, ed. Thomas J. Jablonsky, 228-41. Milwaukee, WI: Marquette University Press, 2005.

Mayer, Harold M. "By Water, Land, and Air: Transportation for Milwaukee County." In *Trading Post to Metropolis: Milwaukee County's First 150 Years*, ed. Ralph M. Aderman, 324-86. Milwaukee: Milwaukee County Historical Society, 1987.

McGuinness, Aims. "The Revolution Begins Here: Milwaukee and the History of Socialism." In *Perspectives on Milwaukee's Past*, ed. Margo Anderson and Victor Greene, 79-106. Urbana, IL: University of Illinois Press, 2009.

Nash, Roderick. "Victor L. Berger: Making Marx Respectable." *Wisconsin Magazine of History* vol. 47, no. 4 (summer 1964): 301-8.

Olson, Frederick I. "City Expansion and Suburban Spread: Settlements and Governments in Milwaukee County." In *Trading Post to Metropolis: Milwaukee County's First 150 Years*, ed. Ralph M. Aderman, 1-89. Milwaukee: Milwaukee County Historical Society, 1987.

Pienkos, Donald. "Politics, Religion, and Change in Polish Milwaukee, 1900-1930." *Wisconsin Magazine of History* vol. 61, no. 3 (spring 1978): 178-209.

Reinders, Robert C. "Daniel W. Hoan and the Milwaukee Socialist Party During the First World War." *Wisconsin Magazine of History* vol. 36, no. 1 (autumn 1952): 48-55.

Stark, Jack. "The Striving of Erich Stern." *Milwaukee History* vol. 17, no. 2 (summer 1994): 51-68.

Stearns, Lutie E. "My Seventy-five Years: Part II, 1914-1942." *Wisconsin Magazine of History* vol. 42, no. 4 (summer 1959): 282-87.

Stevens, John D. "Wobblies in Milwaukee." *Historical Messenger* vol. 24, no. 1 (March 1968): 23-27.

Stevens, Michael E. "'Give 'em Hell, Dan!' How Daniel Webster Hoan Changed Wisconsin Politics." *Wisconsin Magazine of History* vol. 98, no. 1 (autumn 2014): 16-27.

Stotts, Stuart. "A Thousand Little Libraries: Lutie Stearns, The Johnny Appleseed of Books." *Wisconsin Magazine of History* vol. 90, no. 2 (winter 2006-2007): 38-49.

Thompson, Carl D. "Socialists and Slums – Milwaukee." *The Survey*. vol. 25 (December 3, 1910): 367-76.

Thurner, Arthur W. "The Mayor, the Governor, and the People's Council." *Journal of the Illinois State Historical Society* vol. 66, no. 2 (summer 1973): 125-43.

Vaughn, F.A. and A.J. Sweet. "The New Street-Lighting System of Milwaukee." *Electrical Review and Western Electrician* (1 April 1916): 579-82.

V.L.B. "The Policy and Practice of the United States in the Treatment of Enemy Private Property." In *Virginia Law Review*, vol. 34, no. 8 (November 1948): 928-43.

Weems, Robert E., Jr., "Black Working Class, 1915-1925." In *Milwaukee Stories*, ed. Thomas J. Jablonsky, 258-66. Milwaukee, WI: Marquette University Press, 2005.

Wittke, Carl. "American Germans in Two World Wars." *Wisconsin Magazine of History* vol. 27, no. 1 (September 1943): 6-16.

Work, John M. "The First World War." *Wisconsin Magazine of History* vol. 41, no. 1 (autumn 1957): 32-33.

Youmans, Theodora W. "How Wisconsin Women Won the Ballot." *Wisconsin Magazine of History* vol. 5, no. 1 (September 1921): 3-32.

DISSERTATIONS/THESES

Barnes, Abigail Claire. "Pure Spaces and Impure Bodies: The Detention of Prostitutes in the U.S. during World War One." Ph.D. Dissertation, University of California, Los Angeles, 2010.

Becker, Gerhard. "The German-American Community in Milwaukee during World War I: The Question of Loyalty." M.A. Thesis, University of Wisconsin-Milwaukee, 1988.

Bedford, Henry Frederick. "A Case Study in Hysteria: Victor L. Berger, 1917-1921." M.A. Thesis, University of Wisconsin, 1953.

Bergman, James John. "From River Street to Every Street: The Termination of Milwaukee's Segregated Vice District." M.A. Thesis, Marquette University, 1984.

Berres, Jean Louise. "Local Aspects of the 'Campaign for Americanism': The Milwaukee Journal in World War I." Ph.D. Dissertation, Southern Illinois University at Carbondale, 1978.

Bredlow, Lulu. "A History of the German Theater of Milwaukee from 1850 to 1935." M.A. Thesis, Northwestern University, 1936.

Buchanan, Thomas R. "Black Milwaukee, 1890-1915." M.A. Thesis, University of Wisconsin- Milwaukee, 1973.

Chan, Christopher. "Mass Consumption in Milwaukee: 1920-1970." Ph.D. Dissertation, Marquette University, 2013.

Charaus, Brigitte Marina. "What Lies Beneath: Uncovering the Health of Milwaukee's People, 1880-1929." Ph.D. Dissertation, Marquette University, 2010.

Ciaccio, Nichali Michael. "Because It Had To Be: The *Milwaukee Leader*, Socialism and the First World War." B.A. Honors Thesis, University of Wisconsin-Milwaukee, 2005.

Donalson, Daniel G. "'A Convenient Engine of Oppression': Personal Uses of the Espionage and Sedition Acts of World War I." Ph.D. Dissertation, University of Houston, 2009.

Ferguson, Paul-Thomas. "Leisure Pursuits in Ethnic Milwaukee, 1830-1930." Ph.D. Dissertation, Marquette University, 2005.

Hachey, Robert L. "Dissent in the Upper Middle West during the First World War, 1917-1918." Ph.D. Dissertation, Marquette University, 1993.

Meloni, Albert Cosimo. "Milwaukee's 'Little Italy,' 1900-1910: A Study in the Origins and Struggles of an Italian Immigrant Colony." M.A. Thesis, Marquette University, 1969.

Olson, Frederick I. "The Milwaukee Socialists, 1897-1941." Ph.D. Dissertation, Harvard University, 1952.

Provost, Tracie L. "The Great Game: Imperial German Sabotage and Espionage against the United States, 1914-1917." Ph.D. Dissertation, University of Toledo, 2003.

Stachowski, Floyd John. "The Political Career of Daniel Webster Hoan." Ph.D. Dissertation, Northwestern University, 1966.

Starzyk, John Joseph. "Milwaukee and the Press, 1916: The Development of Civic Schizophrenia." M.A. Thesis, Marquette University, 1978.

Walker, William R. "Only the Heretics are Burning: Democracy and Repression in World War I America." Ph.D. Dissertation, University of Wisconsin-Madison, 2008.

Weems, Robert E., Jr. "From the Great Migration to the Great Depression: Black Milwaukee, 1915-1929." M.A. Thesis, University of Wisconsin-Milwaukee, 1982.

Witas, Robert A. "'On the Ramparts': A History of the Milwaukee Sentinel." M.A. Thesis, University of Wisconsin-Milwaukee, 1991.

PAMPHLETS

Bloodgood, Francis. "Wheeler Peckham Bloodgood of Milwaukee, 1871-1930." Pamphlet Collection, WHS.
Clas, Alfred C. "Civic Improvement in Milwaukee, Wisconsin." A printed address delivered before the Greater Milwaukee Association, December 14, 1916.
Hegemann, Werner. *City Planning for Milwaukee: What It Means and Why It Must be Secured*. A report submitted to the Wisconsin Chapter of the American Institute of Architects, the City Club, the Milwaukee Real Estate Association, the Westminster League and the South Side Civic Association. Milwaukee: February 1916.
Merchants & Manufacturers Association of Milwaukee. *Made in Milwaukee*. 1917.
"Standard Forms of Laws." Washington: War and Navy Departments, Commission on Training Camp Activities, 1918.
Wisconsin Memorial Day Annual, 1919. Madison, WI: Democrat Printing Co., 1919.

MANUSCRIPTS

American Civil Liberties Union Records: Subgroup 1, The Roger Baldwin Years, Princeton University, Princeton, NJ.
Baker, Newton Diehl Papers, LOC.
Beale, Charles H. Collection, MCHS.
Berger, Victor Papers, WHS.
Bethke, Ewald E. Memoir, MCHS.
Bruce, William George Collection, MCHS.
City Club of Milwaukee Collection, MARC.
Davis, Elizabeth Upham Biographical Notes, WHS.
Ebersol, Eugene World War I Letters and Ephemera, 1918, WHS.
Falk, Otto H. Collection, MCHS.
Federated Trades Council of Milwaukee Collection, MARC.
Frey, Charles Daniel Papers, Charles E. Young Research Library, UCLA.
Fuller, Clyde and Mattie, Collection MCHS.
German-American Collection, MCHS.
Gregory, John G. Collection, MPL.
Gregory, John G. Papers, MCHS.
Gross, Edwin J. Papers, WHS.
Gugler Lithographic Company Collection, MCHS.
Haessler, Carl Collection, MARC.
Hoan, Daniel W. Collection, MCHS.
Husting, Paul Oscar Papers, WHS.
King, Charles Papers, WHS.
La Follette Family Papers, LOC.
LaPhilliph, Robert Snover Collection, MARC.
Lillydahl Family Papers, WHS.
Lines, Edessa Kunz Papers, MUA.
Mariner, John W. Papers, MARC.
McCarthy, Charles Papers, WHS.
Melms, Edmund T. Papers, MCHS.
Messmer, Sebastian G. Papers, AMA.
Metropolitan Milwaukee Association of Commerce Collection, MCHS.
Milwaukee Coke and Gas Company Collection, MCHS.
Milwaukee County Assessor, MCHS.
Milwaukee County Circuit Court, MCHS.

Milwaukee County Coroner's Inquests, MCHS.
Milwaukee County Institutions and Departments Collection, MCHS.
Milwaukee County Transit Collection, MCHS.
Milwaukee Department of Health Collection, MCHS.
Milwaukee-Downer College Collection, MARC.
Milwaukee Grain Exchange Collection, MCHS.
Milwaukee Public Schools Collection, MCHS.
Mothers and Wives of Soldiers of the Twenty-first Ward, 1917-1919, MPL.
Nunnemacher/Weschler Family Papers, MCHS.
O'Brian, John Lord Papers, Charles B. Sears Law Library, University at Buffalo School of Law.
Oestreich, Rayline D. Papers, MCHS.
Philipp, Emanuel L. Papers, WHS.
Pieplow, William L., MPL.
Pieplow, William L. Collection, MCHS.
Purin, Carl F. Collection, MCHS.
Rice, Denis Timlin. "Berger, His Party, and the First World War: The Tribulations of a Socialist, 1914-1920." Unpublished Manuscripts #272, MCHS.
Richardson, Harriet Fyffe Diary, MCHS.
Schoenleber, Otto J. and Louise Papers, 1884-1967, MPL.
Seidel, Emil Papers, MARC.
Simons, Algie M. and May Wood Papers, WHS.
Socialist Party Papers, MCHS.
Sporting and Club House Guide to Milwaukee (Rochester & Taylor, 1889), MCHS.
Spott, Barney F. Papers, MARC.
Stern, Erich Cramer Papers, MARC.
Stern, Erich C. Collection, MCHS.
Stern, Lucia K. and Erich C. Collection, MPL.
Stewart, Charles D. Collection, MPL.
Strehlow, August Collection, MPL.
Thornberry Family Papers, WHS.
University Settlement House Collection, MCHS.
Williams, Clifton Collection, MPL.
Wisconsin. Department of Industry, Labor and Human Relations. Subject Files, Series 1006, WHS.
Wisconsin. Governor. Investigations: 1851-1959. Series 81, WHS.
Wisconsin. Insurance Department. Fire Investigation Reports and Case Files, Series 1060, WHS.
Wisconsin. Legislature. Investigations: 1837-1945, 1967, WHS.
Wisconsin. State Council of Defense Collection, World War I, WHS.
Wisconsin. War History Commission Collection, WHS.
Work, John M. Papers, MPL.
World War I Collection, MCHS.
Yearbooks Collection, MCHS.
Zukowski, Walter Papers, MARC.

NARA Records

Record Group 4. Records of the U.S. Food Administration. Records of State Food Administrations. Records of the Wisconsin State Food Administrator.
Record Group 4. Records of the U.S. Food Administration. General Correspondence

of the State Office, 1917-1919.
Record Group 4. Records of the U.S. Food Administration. General Correspondence of the Enforcement Division, 1917-1919.
Record Group 21. Records of the U.S. District Court, Eastern District of Wisconsin, Milwaukee. Final Record Books-Criminal, 1887-1919. Vol. L.
Record Group 24. Records of the Bureau of Naval Personnel, Morale Division.
Record Group 62. Records of the Council of National Defense, General Medical Board.
Record Group 65. Records of the Federal Bureau of Investigation. Bureau Section Files.
Record Group 65. Records of the Federal Bureau of Investigation. Old German Files.
Record Group 87. Records of the Department of the Treasury. Secret Service Division. Reports of Agents on Special Investigations, 1871-1933.
Record Group 90. Records of the Public Health Service. General Records of the Venereal Disease Division.
Record Group 165. Records of the War Department General and Special Staffs. Military Intelligence Division Correspondence, 1917-1941.
Record Group 165. Records of the War Department General and Special Staffs. Military Intelligence Division, Plant Protection Section, Chicago District Office, Correspondence, 1918-1919 (NARA-Great Lakes Region, Chicago).
Record Group 165. Records of the War Department General and Special Staffs. Records of the Commission on Training Camp Activities.
Record Group 181. Records of Naval Districts and Shore Establishments, 9th Naval District, Great Lakes, IL. Great Lakes Naval Training Station, Great Lakes, IL. Office of the Commandant. General Correspondence and Records of Great Lakes Naval Training Station (NARA-Great Lakes Region, Chicago).

NEWSPAPERS

Marquette Tribune
Milwaukee Features Clipping File, MCHS
Milwaukee Free Press
Milwaukee Journal
Milwaukee Leader
Milwaukee Sentinel
New York Times
Wisconsin News

CITY MAPS

Caspar's Official Map of the City of Milwaukee and Vicinity. Milwaukee: C.N. Caspar Co., 1916.
Map of the City of Milwaukee, 1912. Milwaukee: C.N. Caspar Co., 1912.

GOVERNMENT PUBLICATIONS/DOCUMENTS

Alien Property Custodian Report. Washington, D.C.: Government Printing Office, 1919.
Annual Report of the Attorney General of the United States, 1918. Washington, D.C.: Government Printing Office, 1918.
Annual Reports of the Chief of Police of the City of Milwaukee, 1916-1918.

Annual Reports of the Commissioner of Health of the City of Milwaukee, 1916-1918.
Annual Report of the Surgeon General of the Public Health Service of the United States for the Fiscal Year 1919. Washington, D.C.: Government Printing Office, 1919.
Annual Statistical Report by the Assessor of Incomes. Milwaukee County, 1916. Assessor Collection, MCHS.
Bulletins of the Milwaukee Health Department, 1916-1918.
Congressional Record. 65th Congress, 2nd Session. Vol. LVI.
Laws of Wisconsin, 1918. Chapter 13. Posted online at http://docs.legis.wisconsin.gov/1917/related/acts/18firstssact013.pdf.
Milwaukee. Bureau of Municipal Research. *Milwaukee's Ash Problem.* 1914-1915.
Milwaukee. Department of Public Works. *Modern Method of Municipal Refuse Removal by White Trucks and Trailers: Survey of Garbage Collection City of Milwaukee.* 1919.
Milwaukee. Health Department. *Housing Conditions in Milwaukee.* 1916.
Milwaukee. Mayor's Housing Commission. *Report of the Housing Commission.* 1918.
Milwaukee County. *Report on Twenty Months of War-Time Service in Milwaukee, May 1st, 1917 to January 1st, 1919.* 1919.
Proceedings of the Common Council of the City of Milwaukee, 1917-1919. Phoenix Printing Co., Milwaukee.
Report of the Alien Property Custodian, April 10, 1922. Senate Document No. 181, 67th Congress, 2nd Session. Washington, D.C.: Government Printing Office, 1922.
Report and Recommendations of the Wisconsin Legislative Committee to Investigate the White Slave Traffic and Kindred Subjects. Madison, 1914.
Seventh Annual Report of the Citizens' Committee on Unemployment, July 1, 1918 to June 30, 1919.
Smith, Osmore R. (Secretary of Milwaukee County Council of Defense). *Food Markets and Marketing in Milwaukee.* City of Milwaukee. November 20, 1918.
United States House of Representatives. 66th Cong., 1st sess. *Certified Copy of the Testimony of Victor L. Berger at the Trial of the Case of the U.S. vs. Berger et al. in the U.S. District Court for the Northern District of Illinois, Eastern Division.* Washington, D.C.: Government Printing Office, 1918.
U.S. Congress. House of Representatives. *Hearings before the Select Committee on Expenditures in the War Department.* 66th Cong., 1st sess., Serial 1 – Part 9, 1919.
United States Senate. 65th Cong., 2nd sess. *Hearings before the Committee on Military Affairs.* Washington, D.C.: Government Printing Office, 1918.
Woodrow Wilson. "Address at Milwaukee," January 31, 1916. Posted online by Gerhard Peters and John T. Woolley, *The American Presidency Project* at http://www.presidency.ucsb.edu/ws/?pid=65389.
Woodrow Wilson. *War Messages,* 65th Cong., 1st Sess. Senate Doc. No. 5, Serial No. 7264. Washington, D.C., 1917. Posted online at http://wwi.lib.byu.edu/index.php/Wilson's_War_Message_to_Congress.